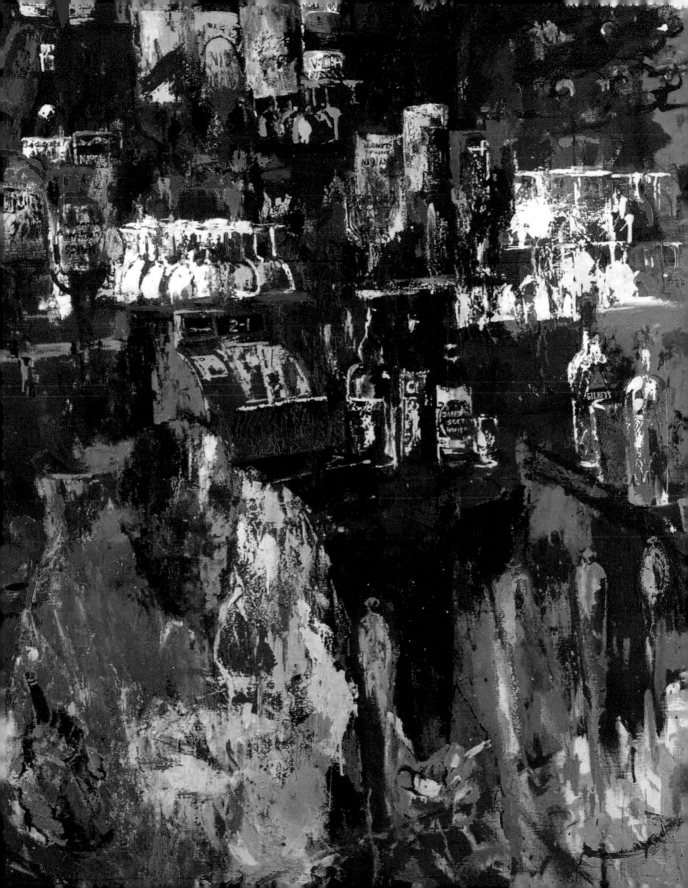

All Told

My Art *and* Life Among Athletes, Playboys,
Bunnies, *and* Provocateurs

LeRoy Neiman

LYONS PRESS

Guilford, Connecticut

An imprint of Globe Pequot Press

Lyons Press is an imprint of Globe Pequot Press.

Frontispiece: *The Grenadier Bar* by LeRoy Neiman. Enamel and oil on Canvas, 1961. © LeRoy Neiman
The name, image, and likeness of Muhammad Ali are provided courtesy of Muhammad Ali Enterprises LLC.
Newport Jazz Festival® is a registered service mark of Newport Festivals Foundation, Inc. under license from Fesitval Productions, Inc. and George Wein.

Collaborating writer/editor: Patty Otis Abel

Text design: Sheryl Kober
Layout artist: Mary Ballachino
Project editor: Kristen Mellitt

Library of Congress Cataloging-in-Publication Data is available on file.

ISBN 978-0-7627-7837-9

Printed in the United States of America

10 9 8 7 6 5 4 3 2 1

To all those who have taken pleasure in my art

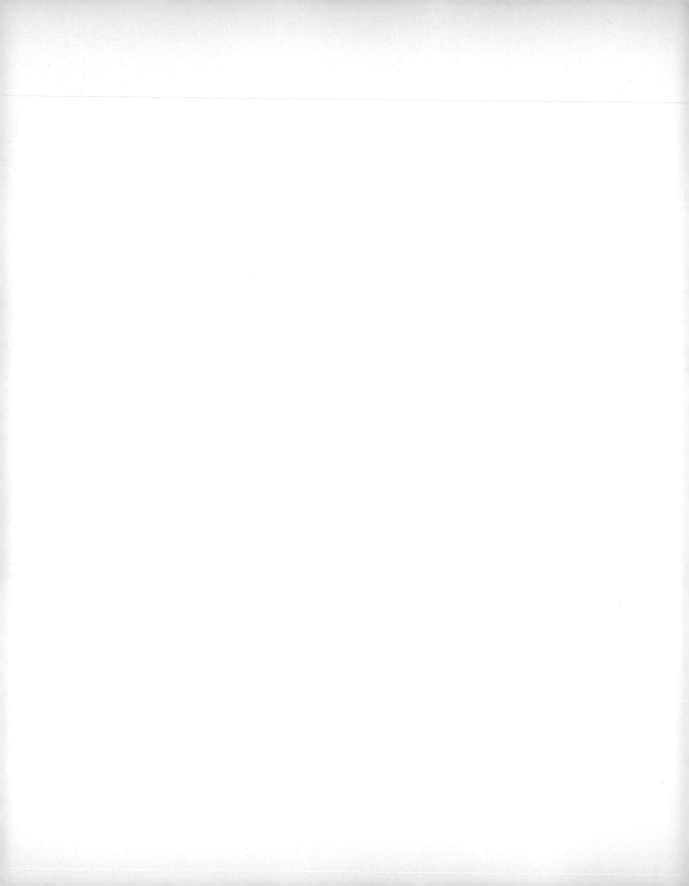

Contents

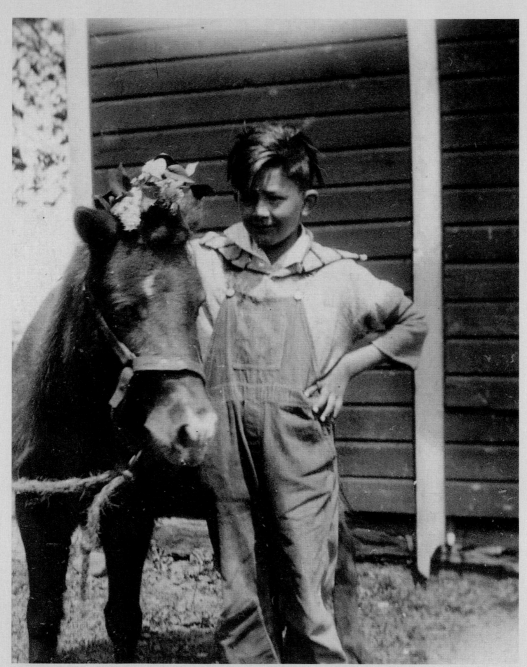

My pony and I on the Braham Farm, 1929. Author's Collection

Unauthorized Beginning

My life story begins with a headlong rush, hurtling down the road in a midnight escape by horse and buggy. It's May 6, 1919, and my mother, Lydia Sophia Serline's, seventeenth birthday. She's eloping, bless her rebellious soul, with my father, Charles Julius Runquist. He's forty-five years old, but that doesn't bother her. My mom wasn't choosy—there weren't that many eligible bachelors from which to choose—the Great War had taken a toll on the male population. Charlie was no bargain, but he was her ticket out of Braham, Minnesota, where recreation consisted of Sunday sermons, church picnics, barn dances, and brawling plow boys. The nearest movie house featuring Saturday night silents was fifteen miles down the road in Mora. Lydia just wanted to get the hell out of Dodge. Her one driving thought was to get off the farm, and away from her repressive background, and break free from the puritanical shackles of her Minnesota farm kin. Not even Samuel Beckett could have imagined anything so bleak as the dialogue between two Scandinavian farmers meeting at a crossroads. My mother knew she had to get out of Braham, and fast.

That must've been one of the last American elopements by horse and buggy—it's like something out of a Western. In fact, the Wild West—which actually took place in the Midwest—had only ended a few years earlier. Bat Masterson died the year I was born. Frank, Jesse James's brother, had died in 1915 and Buffalo Bill two years later; Annie Oakley went to the big roundup in the sky in 1926; and Wyatt Earp joined her the year of the stock market crash. Tom Mix made it all the way to 1940 and into the movies, to boot. Charlie Runquist was no cowboy, but he drank like an old cowhand and led a rough life. I liked him well enough, but he was no role model.

Lydia is urging on the horses, sitting next to my wayward, devil-may-care dad, and they're both heading for the bright lights of Duluth, Minnesota. Duluth wasn't

exactly the big city, but it would do—even though there were too many Norwegians and it was too cold. It was so cold that the water on Lake Superior froze into waves, just like in a Hokusai print.

The honeymoon in Duluth was short-lived. Charlie wasn't exactly what he appeared to be. He was more drifter than dedicated dad, his prospects were none, and the buggy, it turned out, was on loan from Charlie's wildly successful brother, John, who had raised himself from teenage horse trader to big-time railroad contractor. Charlie's only contribution to the marriage was to sire three kids in quick succession. My brother Earl arrived in 1920, followed by me on June 8, 1921. Our sister, little Phyllis Mae, died at three months without even a photograph to claim her existence. By then Charlie had left to pursue his former life of drifting and carousing, managing draft horses, and, when his luck ran out, working for brother John.

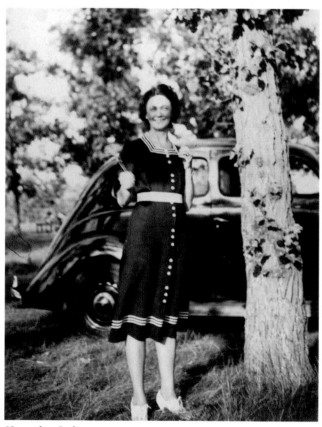

My mother, Lydia. Author's Collection

Charlie had been a disappointment and Duluth a bust—not exactly the city of Lydia's dreams. When she made up her mind that things were going to change, Lydia didn't fool around. She set off on a quest for a better life, heading downstate to St. Paul/Minneapolis, a city so big it needed two names. She was a young girl with two small boys in tow, no financial support from Charlie, and nothing but pity from her family, but she was determined. Overnight, she went from farm girl to full-blown '20s child. My mother was a prime example of the new species: the flapper. She bobbed her hair, took to the Charleston, entered dance marathons, and became a real boop-boop-a-doop. She never drank and I never heard her swear, but she was always up for having fun.

Not everybody appreciated Lydia's spunk, zest for life, or her changing husbands in midstream when they

didn't measure up. Even if a husband was a loser, among the lower classes it was the woman who got branded when there was a divorce. Divorcées were considered wanton women. My mother's rural roots and lack of education just fueled more biting gossip. Her response was to write it off as envy and cultivate her talent for turning heads. "Ah, they're just jealous," she'd say, "because we're having so much fun and they're not."

My mother was a reckless woman, but I loved her. She was wild and irresponsible, got married several times. Feisty, she wouldn't put up with this or that guy's nonsense. She was a big influence on me. Her influence came through her independent spirit. And she was headstrong. She'd fight with the guy she'd married and kick him out, just like that. I'm not like that—I don't fight—but she was a freewheeling soul and that's what I got from her.

My mother was a kind of gypsy—we were endlessly moving, and inevitably downhill. I always hung out with these rough and ready guys on the street, and I don't know why. I guess I just liked my life better that way. They were tough kids—when they got on the street, they'd hit anybody, and I took my lumps from them, afraid of them and liked them—both.

I hung around with gangs but my brother, Earl, was different; he didn't get involved in things like that. It never appealed

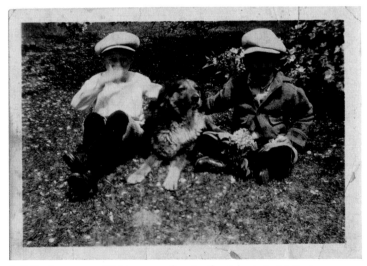

Left: Earl, age seven. Right: me, age five. April 24, 1927. Author's Collection

to him. Why my brother never hung out with me, I couldn't tell you. Why I fell in with the people I did, I can't explain either. Admittedly they had an adventurous lifestyle. I feel like my rough and tumble youth in St. Paul was similar to that of the Hollywood actors who came from the Lower East Side—Jewish tough guys, but really smart. When you're young, say, twenty-five or so, you've really got to walk into it, whatever it is, knowing they're going to kick you around, lie to you—it's all part of the game. By the time I was in my twenties, I was comfortable with these people; I knew how to avoid certain things and also how to get into it.

During summer vacation we'd go out to my grandmother's farm and work there, and that was a switch. I had a good life because I knew both kinds of people—the tough kids in the city and the farm kids with their animals in the country. I was lucky that way. Growing up in the city, everybody I knew was poor and down-and-out, and not many people had a farm to go to like I did. A farm was really something to have in your life. It was almost snobbish in my neighborhood to come from a farm family. My mother loved to send us to her parents' big farmhouse, but what with her divorces, things were often difficult because her parents didn't approve of her shenanigans.

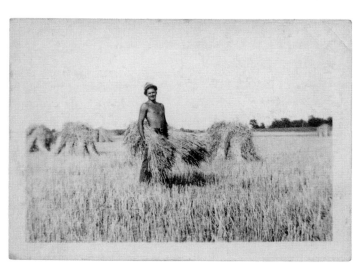

Shucking grain on my grandfather's (J. Oscar Serline) farm in Braham, Minnesota. July 22, 1938. Author's Collection

Country life was full of diversions. I remember especially three kinds of animals on the farm: the rooster, the horse, and the bull. The rooster used to chase me around like crazy, crowing cock-a-doodle-do, and when I was a little kid I thought he was saying something nasty to me, like if he caught me he'd eat me. That's a very early memory. The work horses on the farm were really big, that was my introduction to the horse. Then as time went on, I noticed draft horses in the city pulling milk wagons and ice wagons, and that was my second group of horses.

The third group was the racetrack thoroughbreds, and those were nervous horses, high-strung horses, and delicate. Then there was the bull—real scary, and almost mythological, like the Minotaur in Picasso's etchings. I think of these creatures symbolically in my life, like some people I've met: Some are like the rooster, others are like the bull, and others the horse.

My earliest memory from those farm days was when my grandmother, whom I never cared for, decided one night she was going to teach me how to tell time. That was very meaningful. Time! What was that? It was both mysterious and practical. I can't remember what age I was, but I was young, and I'd watch the hands move on the grandfather clock as the pendulum swung back and forth, tic-tock-tic-tock.

My mother used to raise canaries. She had them all over the house, and so when I got some money I went out and bought a bird for her. I told the pet store owner that I wanted a canary that really sang or any bird that was a good singer. I got her a canary, and that bird sang all the time! Finally my mother got irritated with the bird, and she'd put a cover on the cage at night; as time passed she'd keep the cover on longer and longer.

My mother was as beautiful and spirited as a thoroughbred pawing the ground. She soon caught the eye of what she hoped would be a reliable, responsible bread-winner, a Polish-German-American leather factory foreman, Jack Neiman. He seemed a pretty safe bet. Bypassing bothersome adoption legalities, my mother changed our surname from Runquist to Neiman, a terrible thing to do to a kid when he's eight years old. And my brother and I were expected to become Catholics like our new father.

Marriage added a brief illusion of security as the Roaring Twenties rattled on faster and looser around us: bootlegging, speakeasies, gangland shoot-outs, flappers outrageously flouting convention, defying the old pieties, dancing the Charleston to le jazz hot, as the biggest bull market in American history climbed higher and higher and further out onto the edge of the precipice. All I, as a young buck, picked up from the frenzy and the wild trends was an atmosphere of heady excitement. Curious and impressionable, I had a street kid's experience of the runaway '20s.

St. Paul's art deco courthouse was my theater, and the cast of characters was a stunning parade of underworld celebrities: murderers, bank robbers, extortionists, racketeers, and bootleggers. When they weren't in the witness box telling outrageous lies, they were holding court in local speakeasies called "blind pigs," whose customers included "Scar Face" Al Capone and Benjamin "Bugsy" Siegel ("Father of the Las Vegas Strip"—he was also nuts, hence his nickname).

This little kid's eyes were getting bigger and bigger reading about gangsters with gats, spats, homburgs, diamond tie pins, and Duesenbergs. John Dillinger was our folk hero. He was such a legend that we'd get a thrill from poking our fingers into the bullet holes where he'd shot up some joint. He was so cool that while on the lam he'd stroll over to the Keller Golf Course and play a few rounds of golf. We loved that because he was one of us, and here he was playing on these fancy people's golf course.

The Roaring Twenties were so infectious that they blew right into our house. Jack's basement home brew flowed, the Victrola jitterbugged, and Earl and I watched from our perch at the top of the stairs as Jack and Lydia made whoopee.

The Twenties were filled with larger-than-life characters and one of the most enduring for me was F. Scott Fitzgerald, who came right there from my hometown of St. Paul, Minnesota, writing the great American novel. Fitzgerald is still a favorite writer—I got into him after the war and read him to this day to get a real feel for what the high life was like in those days.

Fitzgerald made glittering New York high society hum in the magazines, jazz added the soundtrack to the raucous carryings-on, and there was no way of knowing that a Black Tuesday in October 1929 would usher in my poverty-stricken teens. On that terrible day the Twenties' train to glory and wretched excess crashed into history.

That was my next big lesson: the Crash. Don't count on anything. I'd already lost my dad and had to change my name and my religion, and on top of all that the world fell apart overnight. Black Tuesday soon trickled down to the St. Paul neighborhood of hapless immigrants that we called home, unofficially known as Frogtown.

Doomed by the Depression and Jack's unemployment and quarrelsome drinking, the Neiman marriage was on the rocks. The most vivid example of desperation brought on by the Depression that I ever saw was my last memory of Jack sliding a Gillette Blue Blade along the rim of a water glass, round and round in endless rotations, to sharpen the edge of the blade and eke out a few more shaves.

Twice-divorced Lydia now moved us from duplex to walk-up and finally to a one-room apartment. Determined to do anything rather than be dependent on charity, she took a job working nights as a cocktail waitress, inspiring a renewed chorus of neighborly condemnation whenever a customer dropped her off after work at two in the morning.

Working-class fathers hung around the house or at the corner bar. Beers were a nickel, shots fifteen cents, but most men didn't even have two nickels to rub together. The thing I remember today about people then is the humiliation—not being able to afford a five cent cigar or a tune on the nickelodeon like "Beer Barrel Polka" or "Roll Out the Barrel."

We looked up to anyone who had some flash in those spare and unsentimental times, so the guy who lived across the street was a superstar. He rode a flashy motorcycle with an Indian head on the gas tank, and competed in hill climbing events at the Indian burial mounds on the outskirts of town. When he roared down the street with his knockout wife straddling him on the back of the bike, he was transcendent.

The Volstead Act had been passed in 1919, implementing the prohibition of selling or serving alcohol. But during the Depression, people needed alcohol. And any time you ban something, people want it all the more, plus it creates gangsters, criminals, and bootleggers. The scum of the earth crawl out from under their rocks, and they're only too happy to kill and maim to get you what you want.

In my mind, I can see myself standing at the bar in Frogtown with a cast of despondent characters. I say characters rather than clientele, because any bar in the lower depths, and especially during the Depression, was theater. That's where the Roaring Twenties went and where flashy small-time hustlers, stool pigeons, mutts, and rummies acted out their dreams. You're in a bar. You tell a story. It's a tall tale, but as long as happy hour is going on, everybody buys it, so it becomes true.

Guys always boasted about the big-time gangsters they knew. Some guy would ask, "So, did you ever meet Dillinger?" And the other barfly would say, "Why Dillinger, he and I were . . ." and go into a big long story. But you knew if he met Dillinger in broad daylight, he wouldn't have known the guy from Matrimonial Vow in the fourth at Belmont. Mostly these guys would be out on the sidewalk in front of

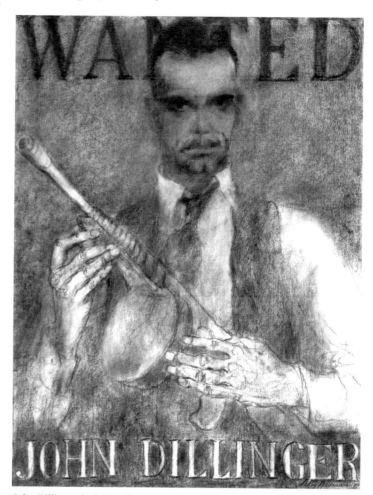

John Dillinger *by LeRoy Neiman. Charcoal on Paper, 1997.* Author's Collection

the tavern, useless and purposeless, when we passed on our way to school—and still there on our way home.

Bartenders held court in the taprooms, local catchalls for small-time politicians, collarless priests, off-duty cops and firefighters, ex–prize fighters, and all manner of

poets who'd practice their BS on a captive audience. One old rummy named Terry, the map of Ireland all over his face, started every day drowning the shamrock with a boilermaker—a bourbon and beer. Two shots, one for each eye. Our gang adopted his favorite swill, Old Grand Dad, figuring the best testimonial was an old drunkard's. And who would know better? So that became our poison of choice.

We kids were not miserable like our elders. We made the most of what was available and didn't long for more. Anyway, we had more serious things to attend to: play. As I was to learn later on when I started reading Johan Huizinga's erudite study *Homo Ludens* (Man at Play)—his theory that play was a formative element in the creation of culture—child's play is serious business and not as trivial as you might think. Give a little kid a fancy toy in a big box, and just as often he'd play with the cardboard box. No one was giving us fancy big toys, and there were no TV commercials to tell us what fantastic toy or video game we couldn't afford. To this day I'm an improvising opportunist, always after new escapades and often inviting myself into scenes of leisure. I paint people at play.

And as teenagers we had better games—real fun. Old farts were always telling us to study hard, play fair, and be careful. But I ask you, what could be more fun than riding boxcars? For weekend kicks, my buddy Gus Herman and I used to hop freights to Duluth, Grand Forks, sometimes as far as Chicago. A freight train is rolling slowly through the station, or lumbering up an incline, and you run alongside out of breath, grab the edge of the boxcar, and climb in. Looking out the open sliding door, it's like a movie flashing by. And for interesting conversation, what could be more interesting than hobnobbing with bitter, whisky-swigging drifters inside empty boxcars? As strange or treacherous as these hobos could be, they were generally good company. But every stolen pleasure has its price. The nastiest guys in our fun and games were the yard dicks, thugs hired by the railroad to walk the tracks, swinging menacing sticks. They'd give an evil chuckle when they'd catch you. They'd beat freeloaders about the legs and watch them flee cursing and half-limping down the track, laughing their heads off, too lazy to take chase.

It wasn't just kid's stuff, riding the rails. This was the Depression—guys who couldn't get a job would hop freight cars. Being part of a group, even that group, was a good feeling. It felt protective to have them around. They were bad guys, but they weren't bad company, they just didn't have anything—they were always out for the main chance—and you didn't want to get in their way.

Ah, the romance of the railroad hobo! Immortalized by Woody Guthrie, Jimmie Rodgers (the Flying Brakeman), and Bob Dylan, and in other songs by less

celebrated bards, like "Rumbling Boxcar" by Iowa Blackie. But unlike our hapless traveling companions, the noble hobos, we knew we had a home to thumb a ride back to, and our adventures were only temporary.

Another cheap thrill was cars. No kid had a car in those days, so road time involved an element of chicanery. To get ahold of some wheels, we'd head for a used car lot, send the oldest-looking guy among us over to some trusting salesman, and cadge a test drive in one of his spiffed-up jalopies. Waiting around the corner for the first asthmatic strains of a tin lizzie, we'd pile in and cruise for girls, reappearing after hours of joy-riding or when the gas ran out.

Eventually, after we ran through all the gullible used car salesmen in town, a half dozen of us pitched in ten bucks apiece and bought a 1929 Model A Ford. In this jalopy we were kings of the road. Even though it was just a big square metal box with an engine on the front, it beat its predecessor the Model-T, which basically looked like a cartoon car. We'd scrape up enough coins to fill the tank, head out to the fairground's dirt track, and open up that "bucket of bolts" like she was a Duesenberg. My idol in those days was Sig Haugdahl, a race car champ who broke open stock car racing as a sport. I was Sig breaking the land speed record at 180 mph at Daytona, dreaming fast and furious daydreams. I'd do my Haugdahl imitation when it was my turn in the Ford, spinning around the oval, foot-braking the turns, and skidding in clouds of dust as I chomped down on my cigar.

My penchant for cigars started back then too. On days when I was feeling flush, I'd ante up from the nickel Harvester or White Owl to a dime Dutch Master, aping the high rollers who ostentatiously displayed the pricier cigar in their shirt pockets, relighting those fat crisp stogies down to a stub that singed eyelashes and eyebrows.

There'd be some big racing champions out there and they'd talk to you, give you advice about racing. Don't take chances, they'd say, it's a dangerous sport—not that they took much notice of their own warnings. Two drivers out there both got killed racing.

Outside the track, there was no fixed course, no dream, no direction. But I was always checking things out. When I'd pass the mansions on well-to-do Summit Avenue with their yapping pooches and manicured lawns, I was never envious, just curious. I had heard enough about the loveless lives of the folks on the hill, but how could they be worse than ours down in gasoline alley? A lifetime later, when I saw that world up close enough to paint its brash, brassy life of conspicuous consumption, I never lost sight of what it looked like from the bottom up.

Our lives were aimless and dream-laden. Imagination comes out of not having things. I'm a painter of imaginary people and places. I don't mean they weren't there, it's just they weren't there quite the way I painted them. When you paint a scene, you've got to put in what isn't there as well as what is—nobody can paint reality, anyway. Even if you could, who would want to look at it? It was around this time that I began to get curious about what art was. One of my first questions about painting was: How the heck did they do that?

I used to go all on my own to the state capitol, which was about six blocks away from the slum where I lived, to see the paintings of the governors. There were about ten of them, and some wore glasses. I'd look at the gilt-framed oils of past state governors, all so dignified, staring back at me, and wonder how the artists painted transparent eyeglasses on their stern faces. How in the hell did they paint glass—something that isn't there? The eyeglasses were indicated by a couple of lines, but how did they get this effect? In the dim, polished marble halls of the domed Beaux Arts State Capitol, the governors would look down at me, raising their eyebrows as if to say, "What have we here?"

"It's that Neiman kid again. What's he want? Doesn't he realize he'll never get into our club?"

"Tell us, boy, why are you looking at us like that?"

"Oh, sir, it's really nuttin'. I just was wonderin' how in heck they painted your eyeglasses?"

"I'm afraid that's a little out of our jurisdiction, young man, that's what they call, uh, 'art.'"

"Art, huh? So, who knows how to do that?"

"Well, artists of course. Bohemian fellows, nude models, funny hats, wild behavior, and turpentine, they say." They all had a big guffaw at that.

Their formidable mugs came to mind in '99, when I painted a five-by-four-foot expressionistic portrait of Minnesota's Governor Jesse "The Body" Ventura from sketches I'd done of him at the National Press Club in Washington D.C. No eyeglasses there. But subsequently, I did portraits of TV personalities who wore glasses. I painted them live, and when I got to their glasses my whole life passed before my eyes and I went back to those governors in the capitol. But what the hell can you do? After I'd done a portrait of one of them, I gave him the painting, and he said, "What I like best about the painting is the glasses—how'd you do that?" And the truth is, I don't know!

Those eyeglasses! That was when I realized: Oh, that's what painting is, it's making invisible things visible. Without realizing it, I had come to the conclusion there and then that art was a form of magic. With a painting you could make glass visible. I was magnetically attracted to this idea.

Paintings also created a little world—or a very big one—I could crawl into. Paintings were windows into places I'd never seen or even heard of, didn't even know existed in most cases, and probably would never get to see. Whenever I enter a new scene I'm about to paint, it's like going into a dark bar. You walk in, and at first you can't see anything, but slowly your eyes become accustomed to the light and you make out faces and how these people are interacting, and you size up the situation.

At City Hall, I studied my first sculpture, *Indian God of Peace*, carved by Swedish sculptor Carl Milles out of polished Mexican onyx, weighing sixty tons and three stories high, a stylized art deco representation of a plains warrior. Now this was epic. It was damn impressive—like a piece of Mount Rushmore right there in St. Paul. How did anybody ever get the idea to create a sculpture of an Indian seven times—at least—actual size? I know Rodin made his sculptures slightly larger than life size to give them mythical weight—and also to prove to skeptical critics that he hadn't just made casts of his models (that was how lifelike he made them). But this was monumental, sort of Egyptian in scale—wide-screen before there were wide screens—because that's what had happened to the Old West. Cowboys and Indians were gone. They were legends, and anything that has vanished starts growing in your mind. I'd think about all that when I came to paint the legends of my era, Sinatra and Ali and the Beatles. When you paint subjects like that, you have to somehow include the charisma they exude in person—without having to make them three stories high.

On weekends I'd spend endless hours poring over art books at the St. Paul Public Library. Even in black-and-white reproductions, the images came to teeming life in my imagination. The rare color plate made exotic places bloom as if I had fallen through time into the page. I got hooked on the Ottoman Empire—its sultans, conquests, and florid embellishments. From the exotic Ottoman Empire anything fantastic, ornate, and opulent appealed to me. By the time I emerged from this fantasy world of harems and minarets and the glittering palaces out of *The Thousand and One Nights,* I was Turkish. Neiman wasn't my real name, it was Suleiman; when my ancestors arrived at Ellis Island, the immigration official just copied it

down wrong. I began telling my friends I was a direct descendant of Suleiman the Magnificent. For a time I tried planting the idea in my friends' minds that I was of noble Turkish descent, and they started calling me "Turk."

In the Catholic Church, with its elaborate vestments, gold chalices, crosses, candlesticks, and gaudily painted plaster statues of the beatified, I found another exotic world full of mystery and ceremonial splendor, right there in St. Paul.

I'd begun to draw by now, just sketches of characters I made up and copied, but I wanted to bring them to life and knew the medium to do that: comic strips. Comic strips were like mini movies, hand-drawn talkies. They played a big role in shaping my first visual impressions too. I took to the sprawling, scratchy style of cartoon artist George Storm, creator of the Bobby Thatcher strip about a teenage Depression dropout. I experimented with the style of Percy Crosby's romping "Skippy," a rambunctious fifth-grader, which was a kind of precursor to *Peanuts* and the *Katzenjammer Kids.*

I started to draw a cartoon of my own featuring Abraham Lincoln. I don't even know why I did it. He was dressed all in black, and he was tall. I'd have him walking around the street meeting other comic book characters. I drew it six days a week in black and white, and on Sunday I'd do the strip in color because that's the way they did it in the Sunday newspapers. I'd have Abe Lincoln interact with Moon Mullins, a roguish character, and Joe Palooka, who was a fighter, or Tilly the Toiler, a working girl like Rosie the Riveter, but more fashionable. Some of these characters have endured, like Popeye and Mickey Mouse, but most of them are now forgotten. I drew cartoons all the time. When I discovered art, it gave me my own world where I could escape and not have to talk to anybody or deal with anything. It was my own private universe

I was hooked. I was always drawing—at home, after school, on weekends, whenever. My mother never praised or encouraged me, but she didn't discourage me either. Between putting food on the table and avoiding the wrath of the neighbors, she wasn't distracted by my extracurricular art. Other people would say, "Oh, he can draw!" But my mother thought that any kid could draw if he wanted to. It's always been one of my hang-ups. She wasn't at all sentimental about the drawings I did as a kid. Later on, when I was looking for those drawings and couldn't find them, she said, "I threw them out!"

The Devil had cast a pall. The new age of the Depression was the price to pay for the big, loud, boozy binge of the Roaring Twenties. Now it was all dark, no way out. The grimmer things got, the more I retreated into my imaginary world. Paradoxically, the Depression created unexpected freedoms. People left you alone. They had their own problems. None of the things we now think of as nurturing creativity were there: positive reinforcement from your family, encouragement from your teachers. But, oddly enough, for me that indifference inspired creativity. Rather than grumble about my fragmented family and the disadvantages of poverty—sure, marriages frayed and teenagers strayed—I want to thank all those who left me alone and didn't lay their expectations on me. The one good thing the Depression did was to spawn a culture of individualism.

There was no life plan, no career plan. Those who were hard hit blamed themselves for their plight, not the government, greedy Wall Street speculators, or God. Everyone kept quiet, too embarrassed to admit their shame. But I was free to choose, free to draw, free to pursue whatever I wanted at my own pace.

There was no one around saying, "Why are you copying this comic book junk? You should be emulating the old masters." No one criticized me, no one praised me. I was left entirely to my own devices. With art, I was in a world of my own devising, distanced from the failure and hopelessness around me.

There's always that one person in your life who knows, who sees that spark in you and encourages it, and in my life that was Sister Marie de Lourdes. When I was in the sixth grade, she saw a crayon drawing I'd done of a school of northern trout from Milles Lacs Lake and submitted it to a national competition. It won a prize—not that anybody at school, or at home, noticed. Sister Marie was beautiful, in her mid-twenties, and one of the few nuns who didn't smack us around with rulers, and I'd often hang out with her after school to draw with crayons and colored chalks. She was the guardian angel who had recognized something in me I hadn't known myself. Years later, when she sent me a letter congratulating me on my achievements, I was more moved by it than I've been by fan mail, prizes, or praise from presidents.

Other role models were few and far between—at least at that time. Out of the past I found some comfort in the lives of saints—not that I aspired to sainthood exactly, but I liked their stories. Every saint has to have a vita, a story written about them before they can be canonized. One of the appealing things about the saints was that many of them had started out as bad apples, the most infamous being Saint

Augustine himself, who'd been a thief, liar, and fornicator—as dissolute a character as only the fourth century AD knew how to make them. And he ended up Bishop of Hippo in North Africa and wrote the first tell-all autobiography in history—his Confessions—and another book about how to get into heaven, if that's your bag.

Not only did many saints lead shady lives, but after being struck by lightning (or guilt, which often amounted to the same thing), they also subsequently suffered dramatic and grisly fates. This was gruesome stuff—beheading, stoning, burning at the stake, death by arrows, by flaying, the upside-down cross, being sawn in half, fed to the lions, and other manners of horrible death that is unpleasant to contemplate. Add a mob of grimacing, sneering, evil Goths and Huns and you've got yourself an unbeatable picture.

In the paintings of martyrs, there are more evil-looking thugs wielding horrible instruments of torture with meaner looks than any beat-up boxer's mug you ever saw. The martyrdoms painted by Hieronymus Bosch and Pieter Bruegel make your hair curl. Blood and gold leaf make for some excellent pictures, which may be why the painters of the middle ages and the Renaissance specialized in martyrdoms.

During the seemingly endless altar action at Sunday Mass, I'd read about the saints, and figured that even if I'd been bad I'd probably turn out okay in the end. But I wasn't ready yet for the lightning bolt of conversion—like Saint Augustine wisely said, "Save me, Oh Lord, from my life of sin—but not just yet!"

Using this sort of logic, I convinced myself that gangsters could fall in the saints category too. They were bad (but good at crime), they were martyrs (but to dubious causes), and they were colorful dandies in spats and homburg hats and big cigars and fancy cars, hanging out with big-bosomed dames and playing high-stakes games.

The movies made gangsters glamorous, and then the gangsters began trying to live up to the flamboyant lives they saw in the movies. To a poor kid growing up on the streets, they were thrilling characters who came to almost as grisly ends as the saints of old—mowed down by Gatling guns, hung up on meat hooks, garroted, poisoned, knifed in the back, and murdered in the sack. Legs Diamond got it in an Albany boardinghouse, the FBI gunned down Dillinger in Chicago, Bonnie and Clyde got riddled with bullets on the road, and, in perhaps the cruelest fate of all, Alphonse Capone got nailed by the IRS—as nasty an end as any martyr could merit.

Saints, certified sinners, sports heroes, and CEOs (with a flair for creative accounting) all had one thing in common: charisma (and tons of dough, mostly).

I've always been magnetically attracted to these guys: casino czars, political power-houses, show biz divas, Wall Street whizzes, ruthless impresarios, mob bosses, Hollywood hustlers, and mega-buck gamblers—in short, bigwigs. My earliest example of the double-breasted, Daddy Warbucks breed was my Uncle John.

Uncle John was the first big shot I ever knew. He was from an era when this kind of guy could create a town out of thin air—like Grasston, Minnesota, which was basically Uncle John as a town. I've had a soft spot for big shots ever since.

A born dealmaker, John Runquist left Sweden at sixteen with little schooling and a krona in his pocket. A precocious talent for horse trading soon made him enough money to send for the rest of the family. Forever after, they would venerate him for his generosity or curse him for his miserly ways, depending on whether he was in the mood to dole out cash to his ne'er-do-well relatives. As big a figure as he cut, he had a knack for making himself invisible when he wanted to. Just at the moment people asked him for a handout, Uncle John was history.

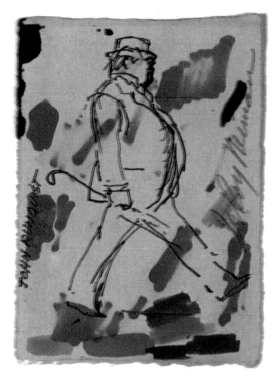

John Runquist *by LeRoy Neiman. Marker and Felt Pen on Paper, 1982.* Lynn Quayle's Collection

He literally was a horse trader and his empire was built around horses: dray horses, harness horses, and trotters that he'd race at county fairs. He'd branched out from there into road and railway construction, contracting big jobs as far away as Cuba. He'd practically built the town of Grasston, Minnesota—not three miles from my mother's birthplace—from the ground up. He supplied the timber, the stone, the concrete, and the labor. It was his fiefdom, and he ruled over it like a feudal lord. He was a small-town version of the Donald Trump of his day. And every big shot worth his salt, from Tutenkamen to Trump, has to have a building with his name on it. So there it was—drum roll!—the Runquist Building, all two stories of it, bearing his name in granite above the entrance. Into those two floors he managed to squeeze a bank, general store, doctor's office, confectionary, casket company, and opera house. And not only that, in 1901 he built a barn for raising racehorses. A plaque in Grasston to this day celebrates "the businessman" who used

"44 freight cars of sandstone in the foundation" (all drawn there by noble work-horses who don't even get a mention).

By the time I got to know him, Uncle John looked like a huge predatory bird. He was heavyset and robust, and lived large—boozing, broads, wheeling-dealing, self-inflating speeches. He put up a big front—posturing like a Scandinavian P. T. Barnum in straw hat and cigar—whether he had just made a big score or gone broke (which happened more than once). He made money and he lost money and then he'd make money again. He'd go up and down because he was a gambler, a real entrepreneur. He was a risk-taking let-'er-rip kind of guy. Not an actual game-table gambler, but he would take big chances on deals. He used to talk to me about his exploits, advise me. I admired him for that, and still think about him all the time. The impression he made on me was indelible. All the big shots I've known since, they're the same way. Meeting Uncle John was a turning point for me.

Whenever I walked into his office, he'd eye me warily through thick-lensed glasses that magnified his beady eagle eyes. I knew that he'd leveled that steely-eyed gaze at his competitors and more often than not shriveled them up. When I was on the receiving end of that gaze, I was scared out of my wits, but when he called me *poilkin,* Swedish argot for "kid," it was like the sun coming out on a stormy day. I even suspected he liked me.

The summer I turned fifteen, I chauffeured my uncle around in his big maroon Packard. We were cruising down Superior Street in downtown Duluth when he said, "Poilkin, pull over here." We were in front of a big fancy joint with its name, "Flame Restaurant," spelled out in neon on the roof. It was the swankiest place I'd ever seen. I was awed by everything in the joint—big leather banquettes, bouquets of flowers, and uniformed waiters—so I mimicked Uncle John's long strides as he walked over to our table.

Over lunch, Uncle John ranted to me about my lazy family and all their sponging. "It's Uncle John this, Uncle John that. I'm a monkey's uncle is what I am. How'd I ever deserve such an ungrateful brood of layabouts?" He denounced his dissolute brother for leaving my mother. "Jeez, she's a swell-looking dame, what'd he go and leave her for? Ya don't wanna follow in his footsteps or you'll end up like him." He peeked under the table and saw my scuffed shabby boots. "Aw, ya can't walk around like that, kid, people gonna take ya for a hobo." He took me down the street to a swanky shoe store and told the salesman to fit me for a new pair of shoes. He tossed my worn-out shoes over his shoulder and said, "Forget 'em, this is the

start of your new life, kid. Next thing you know you'll be setting up in business for yourself. Your father," he added, "he's a bum, don't listen to him."

Okay, so my father wasn't exactly a role model for me. Like my Uncle John, he was a Swede who had come over from the old country and picked up the language but still had an accent. I worked on the railroad with my dad one summer, and when I was fourteen he took me to a bordello—his idea of a treat. He must have thought he was doing me this great favor, taking me to a whorehouse as a birthday present. It was an American Indian bordello. The women, they could hardly speak English! Nothing romantic about that place whatsoever. These women would sit out along the railroad and pick up the gandy dancers, the men who worked laying and maintaining the tracks.

My father wasn't big on ambition, but he'd read. He didn't understand English all that well, but he'd pick up anything—a newspaper, a magazine, a book—and he'd read it, cover to cover. Amazing! I don't know how he did it. He was never around long enough for me to know him. My mother had married him to get off the farm. He was a don't-give-a-shit guy, but I liked him.

I idolized my uncle but didn't tell him that I had no intention of becoming a businessman. Still, I probably did get some of Uncle John's DNA, because by age ten I'd already set up shop on St. Vincent's playground plying my trade as a tattoo artist to my witless classmates. My method was crude but highly popular. I'd take a steel-tip pen, dip it in an open inkwell hidden in my pocket, and then scratch the skin of my intended victim until he bled—the incision forming a scar that looked more like an inoculation scab than a tattoo, but my customers weren't fussy. They wanted Popeye or Betty Boop inscribed on their young flesh and didn't care how I did it, and at three cents a pop, it was cheap. I was a wild success until my art blew up into blistering infections the size of balloons, and sooner than you can say "Show me a man with a tattoo and I'll show you a man with an interesting past," Sister Francis Regis, veil flapping, rosary chattering, swooped down the line of my customers wielding her ruler and sputtering, "Wait till I find the little devil who did this and I'll give him a thwacking he won't forget!" And, like many a misunderstood artist before and since, I was deprived of my means of buying chewing gum by an unappreciative critic.

My last ventures into the illustrated skin trade took place much later in life, in Vegas, appropriately enough, on some highly intimate canvases. One evening a lady of the night asked me if I'd give her a tattoo related to her trade.

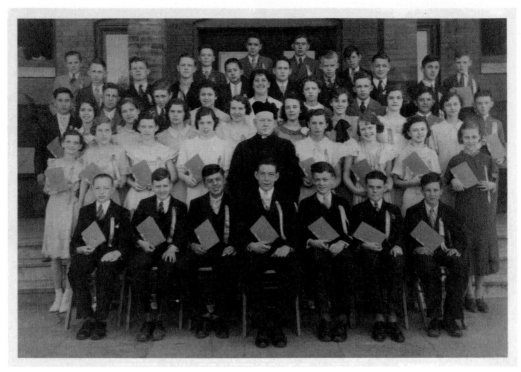

My 8th grade graduation from St. Vincent's. Author's Collection

"What would you like it to say?"

"PAY UPON ENTRANCE"

"Ha-ha! Where do you want it?

"Where do you think?" she said, pointing to her crotch.

I begged off, saying that it was a little too close to her place of business and my hand might shake. A few years later, I was backstage at Caesars Palace in Cher's dressing room—she was wearing even less than my previous customer. When I showed her the charcoal sketch I was making, she studied it and frowned. "You've left something out, LeRoy, what kind of an artist are you? Anybody who knows me will never guess you did it from life if you omit this," she said, and opening her legs wide pointed to a tiny flower tattoo on her inner thigh. Sheepishly, I studied the little flower and planted it right where it belonged.

Rewind to 1933. We're back in Frogtown. I'm twelve years old and already an operator. I talked Bart Reiger, owner of the corner grocery store, into letting me illustrate his merchandise. "I can do you a cow that will sell a pint of milk, a pig

that will make your customers want to buy a pound of bacon, and a turkey that'll remind them they invited Uncle Harold and Aunt Maude for Thanksgiving."

"If you can do that for thirty-five cents, you got the job."

Deal. That has to be the cheapest advertising job ever, but making a calcimine mixture from chalk and water kept my costs down.

Then along came an assignment that was really up my alley: Midgets! Freaks! Sword swallowers! Fire eaters! Hootchie cootchie girls! The Royal American Side-shows had rolled into town, and I got to hang around and sketch the strange acts and oddities that were part of the traveling carnival. Who could ask for better subjects than these?

The first year I worked at the Royal American, I talked the carny into letting me touch up the painting of the tattooed lady, a massive decorated tarp that stretched above Ripley's Believe It Or Not. I told him I'd been a tattoo artist, which was a big fib but got me the job anyway. Working around a circus, you've got to be inventive. The following year they asked me, "Can you do blood?"

"Can I do blood? That's one of my specialties, why, at Halloween I'd scare the living daylights out of kindly old ladies with bowls of candy, showing up with chain-sawed-off limbs and . . ."

Okay, that got me the job, but now how was I going to do this? I mixed up fake blood for the sawed-off lady by soaking red crepe paper in pails of water, and it looked good enough to pass as the real thing, especially when a crosscut saw was passing through the assistant's torso, she was screaming in pain, her legs thrashing, and my fake blood was splattering the surrounding glass (which I had to clean up between each show).

Years later, when I was hanging out at the Playboy mansion in Holmby Hills, Hef's randy herd of pet monkeys, endlessly mounting each other, brought back one of my favorite memories of the carnival—helping out with the Monkey Show. I worked at the monkey sideshow when I was a kid, from about sixteen on. They could be nasty because if you came too close, they swiped at you. But there's no animal more fascinating than a monkey. They're us! Hef had hundreds of monkeys, and he loved watching them. He'd fall over laughing at their antics. They embodied the primeval Playboy Philosophy, and we're still trying to catch up with them as far as getting rid of repression is concerned. But they're also ornery as hell and can get testy. The trainer of the Monkey Show had scratch scars all over his hands and arms from mean, bickering monkeys, his face was a mass of cross-hatching. But he loved those lascivious simians and I liked them too. I'd have liked to have one if I had a

decent house. Great, great creatures. Fast and tricky. Baboons, they're the original hanger-outers.

My favorite part of the carnival was the fan-dancing spitfire Sally Rand. Sally was a little woman who did a striptease act with big feathered fans. She was curvaceous, extremely well-endowed, and very short. Sally was maybe going on forty years old, still exercising and in great shape. She was a star to herself, and she wanted to be treated that way. Every time Sally Rand would come to town, they'd do a story on her in the paper. "Sally Rand! Tonight, doing her naked dance! Limited engagement!" Big story! And then you'd meet her and see this frisky little thing. When she wasn't on the stage, she was such a little woman, but she could get herself all revved up. It looked like she was completely nude behind those fans, but she was in a body stocking. My job was to clean up her backstage area. It had to be spotless in case she happened to touch anything—she had a phobia about that.

There were even children's rhymes about Sally Rand and her fan:

> *Sally Rand has a fan,*
> *If it drops—oh man!*
> *Sally Rand has lost her fan,*
> *Give it back you nasty man.*

When the Royal American wasn't in town, Sally stripped at the Mystic Caverns, one of a string of speakeasies carved in the sandstone cliffs along the Mississippi bluffs with names like The Castle Royal, Hollyhocks Casino, and Boulevards of Paris on the marquees. The Sally Rand Show was a hit with the posh crowd at Caverns. She was fancy-grade goods, all right, and demanded the respect required of a queen. When the carnies got fresh with her, she'd put them in their place.

Anyway, when the circus would get ready to pull out of town, we'd get hired for the evening to tear down the tents. It took about twenty-five guys. One time I saw the sword swallower fighting with one of the guys on the crew. We were bringing the sword swallower's big bag of swords out, and these guys were arguing. Right in the middle of the fight the sword swallower throws his swords out of the bag, backs into a shadow and leaps out with a sword, brandishing it, screaming, "I'll get you, you son-of-a-bitch!" Then he takes off after him, sword flashing like in a movie, and in your mind you could hear old movie music welling up in the background.

Sally Rand and the brawling sword swallower were memorable, and broads and fighting—specifically, boxing—have been two of my principal interests in life. I can clearly remember the first time I heard the rough music of gloves pounding a punching bag at the Blair Street Tavern down the street as regulars worked out to the accompaniment of "The Gang's All Here!" on the jukebox. I was drawn to that steady background rhythm the way other people were to boogie-woogie. Boxing was a way out of the slums for street kids—a hard way to make an easy living, as the saying went—and during the Depression, pugs were invariably recruited from the underprivileged. We looked up to these guys, who were for the most part street hooligans in Everlast mitts. A cauliflower ear in those days was a badge of honor.

Boxers were my heroes. They were uneducated, but even when there was no money around they were pulling down big bucks. That was one of the only ways that you could raise yourself up in the Depression: fight. If you were a kid on the streets, you'd box, and some kids were naturals—I was not one of them! Billy Miske was from our neighborhood—he fought Jack Dempsey. They all had fighters' faces and they were all mean bastards.

Tommy Gibbons's brother Mike and Mike O'Dowd were fancy, "scientific" Irish boxers—all that meant was that they would slip punches and all. Mike Gibbons was the big local hero. Tommy flunked the championship, but after he fought he became mayor or sheriff or something—parlayed boxing into a political career for himself. But Mike was the real thing, a dandy. He'd walk out, take out his training handkerchief, strut around.

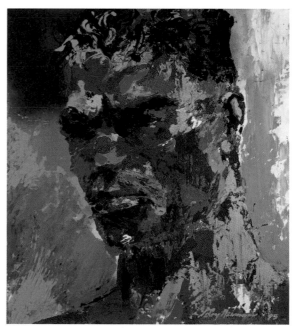

Jack Dempsey *by LeRoy Neiman. Enamel and Acrylic on Board, 1995.* Author's Collection

Given the hard times, there were a lot of pretty desperate characters clawing their way out of Frogtown, and some great boxers came out of St. Paul. You fought your way out of the mean streets. These guys were desperados—it was either beat your opponent or the lobster shift at Schmidt's brewery. That's how the great Jack Dempsey started out, throwing down challenges in saloons: "I can't sing and I can't dance, but I can lick any SOB in the house." Tommy Gibbons and Billy Miske

were among the truly notable brawling bruisers in St. Paul at that time. Both got to be contenders and both fought Dempsey, who held the world heavyweight title for seven years from 1919 to 1926. That was the top of the heap. Miske fought Dempsey three times, once in St. Paul. Eventually he was knocked out in the third round of a 1920 title fight in Benton Harbor, Michigan, by the "Manassa Mauler," as they called Dempsey after his hometown in Colorado. To this day, I've never seen a better mashed-in fighter's mug than Billy Miske's—sculpted and molded by jabs and right hooks in a hundred scrappy bouts until it looked like a caricature of an old boxer's rough and tumble life.

The Irish boxers were the champion pugs in those days. They weren't big punchers—they developed their own slyboots techniques, which is why they called Mike Gibbons "the St. Paul Phantom." He'd been former middleweight champion of the world and was the smartest and fanciest of the fancy footwork school of St. Paul pugilism—on account of he created it. Slip, feint, shift, duck, just jab and counter was their sly style. He owned Gibbons Gym (formerly the Rose Room for its long-faded floral wallpaper), a dreary no-frills center of serious sweat, sparring, slugging, and other arts and bruises of the sweet science.

Gibbons came up rough and ruthless to become the Blarney king of Rice Street by provoking tough guys into making bloody-knuckled dopes of themselves. His gimmick was to stand on an open handkerchief against a brick wall and bet big bruisers they couldn't knock off his derby hat. "Aw, c'mon, give it a shot, ya big jerk. I can't even move me feet now, can I? Fifty cents says you're not man enough!" And he'd just stand there without budging off the handkerchief and slip, duck, and dodge punches until his challenger's fists were broken and bloodied from hitting the bricks. He was a hell of a guy, like a character out of an American tall tale—Mike Fink or Paul Bunyan to us kids—so when Mike Gibbons kicked you out of his gym for sparring in the ring or pounding the heavy bag without paying a locker fee, you'd boast to your friends about it.

Then we'd head to St. Vincent's where one of the priests supervised a boxing program in the church basement. Better to let the little brats have at it in padded gloves than out on the street getting themselves involved in bare-knuckle brawls where they're likely to fall in with bad company and get recruited into a life of crime. I soon developed my own scientific approach: a powder-puff left jab—something I came by naturally. Its sole purpose was to keep my opponent at arm's length and avoid getting clobbered while I got in a few feeble jabs. But even that didn't help—I was constantly getting whacked. I loved boxing, I just didn't like to fight.

Boxing wasn't the only time-squandering activity available to the feckless youth of Frogtown. There was the Recreation Center in the Hamm Building on St. Peter Street, a so-called sports club, but really just another nefarious hangout for layabouts. The sporting activities consisted of billiards, a bowling alley, a cigar stand, backroom card games, and an illegal gambling operation. It would be hard to say what you'd have to do to get kicked out of a joint like that.

Then there were pool halls. Pool halls are ideal locations for studying the seedier sides of human nature. As the philosopher Blaise Pascal pointed out: "So wretched is man and so frivolous is he that, the least thing, such as playing billiards is sufficient enough to amuse him." And, if I may ask, how did he come to this grim assessment unless he had himself partaken in the smoky, degenerate atmosphere of the pool hall?

Pool was big in those days. There were hundreds of pool halls in St. Paul—sometimes referred to as "St. Pool." Jean-Paul Sartre could have based all nine hundred pages of *Being and Nothingness* on a single afternoon spent in a St. Peter Street pool hall, where an impressive amount of skill about nothing was exerted on green felt by pool sharks and hustlers who could run the table.

But that's just my point, what could be more existential than pool? Many of my first lessons in the philosophy of beating someone at their own game were learned in billiard parlors. I was mesmerized by slick-shooting snooker sharks plying their effortless elbow-craft in shady downtown joints, surrounded by wised-up sharpies betting on corner-pocket outcomes in their pungent street argot. Many of these wagering denizens of pool halls preferred betting on the outcome of a numbered ball more than anything else, if only for the chance to outsmart someone.

Their body language while engaged in this activity was a sight to behold. I avidly studied their mannerisms—it was better than any life-drawing class. I can still go back to when I was a kid, invisible to the ferociously focused adults, watching with awe as a player, wreathed in a cloud of cigar smoke and anticipation, is circling the table, visor-shaded eyes never leaving the line of play, leaning over the table to invisibly influence the ball through mental radar, leaning nonchalantly back, and then with cool aplomb making his move. In the blink of an eye and the flash of a cue stick, he's pocketed the yellow-striped 9-ball! Deftly circling the table again like a bird of prey, he addresses the cue ball . . . Time is suspended, all street talk is hushed. With almost supernatural sleight of hand he sinks the ball with a nearly impossible banked shot as onlookers nod and peel off rolls of bills to pay off their debts. I soaked this stuff up like crazy. I could rerun

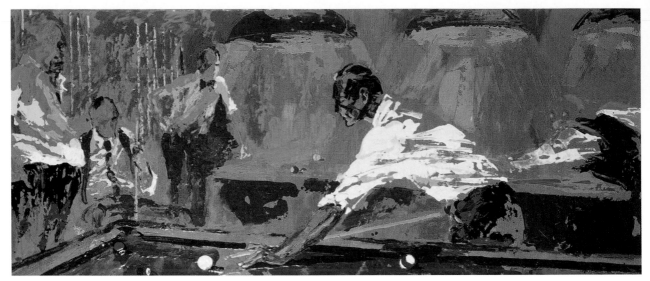

Pool Hall *by LeRoy Neiman. Enamel and Acrylic on Board, 1975.* © LeRoy Neiman

these melodramas of clinking balls in my mind at will, and sketched it all years later from memory.

The color and smell of pool chalk alone is like Proust's madeleine to me. It summons up a whole rakish world. I've used pool cue chalk cubes as a mysterious blue element in my pastels, and the immaculate white of the cue ball positively shines against the green felt of a billiard table, standing out like a golf ball on the green or a baseball scooped out of the dust in the infield. Now that cue balls are made from plastic resin, they radiate; earlier on they were made from elephant tusks and gave off a soft ivory glow.

My first billiards commission was at New York's McGirr's in the early '60s. I knew Willie Mosconi—I'd sketched him at Bessinger's in Chicago—the rest of the players were unknown to me. But they were all characters—pool is a floating theatrical company of wise guys and smooth operators. Dandified and stylish, these guys were a pleasure to draw—even the way they chalked their cues was a form of personal signature. Billiard players were stars on their own green felt stages. Like mobsters and hookers they all had nicknames—Minnesota Fats and Handsome Danny (Jones)—that went along with their legendary reps, like the time Willie Mosconi pocketed 526 balls in one game. They had a slow-motion grace about them as they drifted around the table like sharks circling a coral reef. I got to know a few of them. They were easy to get along with but with that edge of wariness, always taking your

measure. I played some rotation and 8-ball myself, fancied myself a bit of a pool shark, and bought a table for my New York studio during the billiard frenzy, but still, pool never pulled me in like boxing.

I went to a Catholic school due to my mother's marriage to my Catholic stepfather. I'm still a believer, though my brother took it way more seriously than I did—he was nuts about religion. Even so, back in those days I had no idea who I was or what I wanted to do, but I knew what I didn't want to do: stay in school. The great world outside called to me and I went—otherwise known as dropping out, a big fad at the time. I soon found out life on the outside wasn't quite as glamorous as I'd imagined.

If school had seemed dreary and pointless, the hopeless trek to the Hamm's or Schmidt's Brewery with fifty or so defeated, despondent other guys for a handful of part-time menial jobs was desperately depressing. I was just another out-of-work jerk. If you got lucky, what did you get? Monotonous work—rolling out barrels of suds that you weren't allowed to drink—inside one of those grim, Gothic, redbrick dungeons that were indistinguishable from the penitentiary. At least you'd had your fun by the time they put you in the slammer.

Every day was another chance to get turned away from work I didn't want anyway. Then I was forced to spend the day shooting rotation or 8-ball at the pool hall, or setting up pins by hand at Bilbo's Bowling Alley, trying to avoid the lane charge. FDR came up with this New Deal scheme where the government would hire you to do stuff that probably didn't need doing, to keep wayward youth off the streets and disgruntled grown men from having dark thoughts. There was revolution in the air in those days—the Soviets had taken power in Russia, and Hitler had grabbed control of Germany. I'd gotten tired of endless days of recreation anyway, and as soon as I heard of it, I signed up for the Civilian Conservation Corps, which was a youth camp about as far from the temptations of the city as can be imagined—an outpost deep in the northern Minnesota woods run by the US Army. The only other life form between the camp and the closest town of Ely were forty-pound northern pike, nasty brown bears, and scraggly deer struggling to survive the sub-zero temperatures, plus hearty Finnish lumberjacks with their strange saunas.

The Civilian Conservation Corps was a camp set up for kids with no money. When a family was broke or on relief, the kids would go to the CCC. Roosevelt had

set up this camp for boys, and it worked! When I got to the CCC camp, I became the camp artist. Out of a whole 250 kids, it was an amazing feeling.

I illustrated the camp's monthly newspaper, *The Baptism Blade,* a small, mimeographed newsletter printed on color paper stock. It was there that I realized I could draw. The other kids couldn't do that, and nobody questioned me about how I did it. That was fine with me.

You could say about the CCC what they said about the British Army: There was nothing to do, but they got up early to do it. It's freezing cold! It's the crack of dawn! And there's some huge, loutish, and loud US Forest Ranger shouting at you at the top of his lungs. "Wakey! Wakey! You worthless, bottom-feeders and urban scum, get them snowshoes and army-issue uniforms on, girls, we're going for a little stroll in the woods. NOW!"

Why, officer, we youths are not exactly groomed for this type of thing, trudging through massive ice-encrusted six-foot-deep snowdrifts, weighed down with two-man band saws, axes, and pruning poles. Isn't this more a career opportunity for lumberjacks? Questions occurred to me that I never intended to ask, such as, "You really want us to chop down trees—isn't that dangerous?"

Yell "TIMBER!" at the top of your lungs and run like hell.

Our job was to sever tree limbs and saw and chop timber, and the ranger's job was to chew us out whenever we paused. "I want to hear those saws 'ZZZZZZ-ing!' I want to see those stumps only six inches off the ground!" he'd yell, his words freezing in the frigid air vapor, like balloons in a comic strip.

But there in the frozen woods of northern Minnesota, I discovered I had two talents that would serve me well in the army and keep me out of harm's way: painting and cooking. Besides working on the camp newsletter, I also got to practice the so-called culinary arts, using my fellow campers as guinea pigs.

After that I headed back to St. Paul, trying to get by as best I could—odd jobs, odd hours, meals few and far between. I had no one to tell me what I should do, so I had to figure it out on my own. With no parental advice or adult supervision, a great opportunity opened up for me to either screw up or find my way.

The one job I held for any length of time was as a paper baler for the Waldorf Paper Company, at forty-five cents an hour plus guaranteed retirement at sixty-five with pension. Well, I just couldn't wait that long for the gold watch, and hell, even a stint in the army could beat that. Across the Atlantic a war had been going on for a few years now, and the US of A had signed on to defeat the evil Nazi hordes. The army would change a lot of things forever—nothing would ever be the same again,

including me. I was swept away by the turn of events and soon the saintly city, the great river, and my feckless youth would be just a memory. When in my twenties, I didn't know that another world existed out there, and when I found it, God, it was so great, it was unbelievable—waiting there for me to catch up.

The images of art deco speakeasies, dandyish mobsters, big shots, booze, and toxic blondes never left me though. Eventually I would bring that dazzling world back to life in my paintings of man at play. Still, the Depression had cast a pall over everything—especially over those of us at the very bottom of the heap—so I never guessed that one day I would encounter the extraordinary characters and their pleasure-seeking world that I'd only heard rumors about as a teenager. But it was there somewhere—and it would find me.

Drifter to Drafted

I didn't exactly choose the army. It chose me. But when I got my draft notice classified A1, I knew it was for me. It made me realize I was going to do something about my situation in life, and I did. The army was the real deal. And while I had no particular regard for the institution, I served in the army for myself. You had to make an adjustment to go into the army—discipline and such—but I welcomed all of it. I didn't do well and I didn't try any harder than anyone else, but I felt it was the right thing to do, and the army was quick to acknowledge my drawing and painting ability.

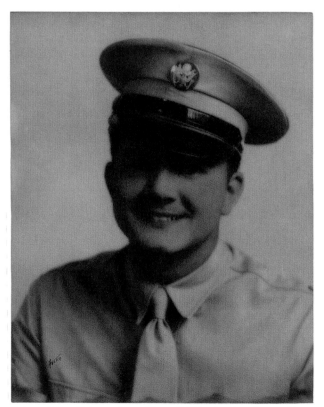

Private LeRoy Neiman, Camp Haan, California. June 8, 1943. My twenty-second birthday, before departing for Europe.
Author's Collection

I reported for induction at Fort Snelling on July 23, 1942. I went from being a drifter going nowhere fast to being a hero (sort of). I had a go at changing history—maybe not all by myself—I fought at the battle of Normandy, I slogged through the Ardennes, and I celebrated the liberation of Paris on the streets with beautiful French girls throwing flowers at me. I said good-bye to my first true love and discovered what I really wanted to do with my life.

I entered the army by way of the Ramsey County Jail. I had gotten drawn into a pointless brawl over some B-girl in a bar the night before induction. My bad old ways were following me right up

to the last minute. The bar fight spilled out into an alley, and the cops showed up and threw us all in the cooler. I told them they had no right to put me in the can when tomorrow I was going to go into the army to fight the war. They held me for a night. There was nothing romantic about jail. I told the judge that while I'd like to stay, I had to go and, well, save France.

Just like in the movies, I had to leave my girl behind. My steady was a buxom blonde who modeled herself after sweater girl Betty Grable, you know, one of those well-endowed girls who puts on a tight sweater so she could show off her assets. When I got my conscription letter telling me that I had to report to active duty, I bought Lorayne an ankle chain with our names engraved on a gold-plated heart. I swore eternal love and she promised to wait for me, and to clinch it she placed an engagement photo in the *St. Paul Dispatch*. Don't believe everything you read in the newspaper.

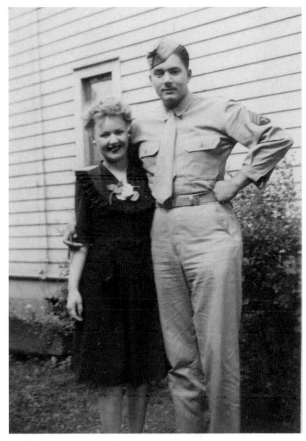

With Lorayne. Author's Collection

While I eagerly awaited the ego-crushing experience the army had promised me in the brochure, I was sent for basic training at Camp Callan in California. Heading to L.A. on leave, I got my first rude awakening as to the way the really modern cats rolled. Here I was, a gawky rube in my ill-tailored suit and new crew cut, walking into the Hollywood canteen. Jeez, how was I going to compete for dames with 4-F zoot-suiters in oversize jackets with padded shoulders and exaggerated lapels, strutting around in baggy, high-waisted trousers hung with looping watch chains? Air force officers jitterbugged in snappy full dress while leatherneck Marines from neighboring Camp Pendleton crowed with Marlon Brando cool. It was painfully obvious that I was looking for love in all the wrong places and in all the wrong clothes.

Basic training was basically miserable: a twenty-six-mile hike double-time up and down a Pacific shoreline bluff under scorching sun with full field pack, newly

designed "pisspot" helmet, and rifle. There's always some guy in your company with a scheme to get around things, and they discovered me soon enough. I came up with this ingenious idea to take out all the gear from your backpack and then fill it with blown-up army-issue condoms. This worked pretty well until the drill sergeant spotted our bouncing packs and—expletives deleted—said, "All right, you wise guys, now I'm gonna have to add a few more pounds to your pack."

The army is kind of like life if you took all the fun out of it: no women, no booze, no gambling—theoretically. It's life in miniature, where the pecking order is laid out pretty brutally—just like the chickens on my grandma's farm—society reduced to its most basic nature as depicted in Balzac novels and Daumier caricatures.

Where was I going to fit into this new environment? Unless I was going to follow the monotonous fate of all the other grunts, I realized I had to have a gimmick. So I grabbed a couple of KP tutorials and, inflating my expertise (the culinary experience that I gained at CCC camp), applied to Cook and Bakers School. I was sent to Camp Haan near San Bernardino to join the recently activated 461st Coast Artillery battalion. There I learned that cooking has a nasty resemblance to an autopsy table at the coroner's office. Much of my training involved the unsavory art of cutting up carcasses, bones, gristle, and ham hocks. But I also learned how to make soup stocks, baked breads, and pastries. The good thing was that, aside from having to watch aircraft identification films, we were spared most of the compulsory training exercises that the rest of the troop was subjected to.

In the kitchen brigade, you got four days a week to goof off, and the Fiesta Lounge in Riverside, a favorite hunting ground, was the place to be. The best method for picking up

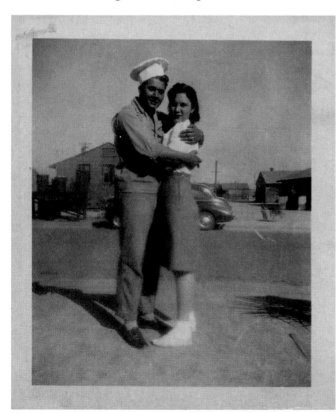

With Dot at Camp Haan, California, 1942. Author's Collection

dames is confidence. You can wear all the Zoot Suits and fancy clothes you like, but if you ain't got that zing then it don't mean a thing. I had not been in the army that long but it had already boosted my self-esteem to the point where I thought of myself as a master chef and an artist of great promise (more on this subject to come). Soon enough, what do I spy but a forty-something knockout from San Bernardino swiveling on a bar stool, and not only is she a babe, but she also has serious wheels—an orange and black Lincoln convertible. When she picked me up at the base for one of our dates, you should have seen the look on the guys' faces from my platoon. Suddenly my esteem with the rest of the outfit shot sky high.

Afternoons we would go back to her place for sweaty assignations in her living room. As soon as I got there, she would turn up the radio, but I could still hear noises coming from the floor upstairs. "What's with that?" I asked. "Oh, that's my husband, but don't worry, he's bedridden. Just turn up the radio. I love that song, 'Sentimental Journey.'" She wasn't that sentimental about her husband, apparently. Although I was curious about the arrangement she had made regarding her extra-curricular activities, there are some things you would rather not know about in great detail, so I did not ask.

I quickly learned that army mess hygiene was not high on the list of army regulations priorities. Whether it was the sarge in charge dipping the ladle in your soup, tasting it, and spitting the rest back into your stock pot, or a career chicken colonel fastidiously passing his white-gloved hand over the chopping surface while his pooch was pissing on the meat block leg, little was sanitary.

Complaints to the chef from the officers' mess were handled with equal finesse. Tenderizing a steak sent back by some uppity lieutenant claiming it was too tough was summarily dealt with. The top chef would stab it off the plate, throw it on the floor, give it a good stomping, reheat it, and send it back. "See how he likes it now!"

Later, when I was studying anatomy as a student at the Art Institute of Chicago, the craggy, antique Professor Schroeder would draw lines right on the body of the Rubenesque model with colored chalk to mark where the muscles attached to the bones. That reminded me of the way the mess sergeant would chalk sides of beef and lamb carcasses for chopping into steaks, flanks, and shanks. The unsettling revelation came to me that life is skin deep, and whether pig, cow, or buxom blonde model in your life class, underneath a thin layer of skin there's nothing but gristle, muscle, and bone.

Napoleon observed that an army marches on its stomach, and an army cook— along with hookers and other camp followers—marches right behind that army.

Forget about candles and napkins and the wine list, you set up mess halls and field kitchens wherever you can—in the back of a truck, on a troop train, on the ship's deck in German-infested Atlantic waters, in an aerodrome Quonset hut, in a tent at Lands' End on a snowy Christmas Day. Nobody knows the problems a mess cook faces. All they want to know is, "Where's the fuckin' grub?"

The best example I can give you is a field kitchen set up in one of the wildest places on earth. It's one-hundred-plus degrees in the Mojave desert where we're doing maneuvers in Death Valley, and the Jell-O won't set. How uncooperative. I mean, you don't want enlisted men complaining that your Jell-O is runny. Desperate, we ordered KPs to dig a big hole in the scorching sand to cool and shelter it from the relentless heat. Exhumed the next morning at 0600 hours, the damn stuff is still liquid. So what did we do? We served it as a luncheon beverage. Sometimes, if a dish doesn't work out, just rename it, like the English do: bubble and squeak, ploughman's lunch, bread pudding.

The kind of wisdom you gather from serving up army grub for three years is pretty basic stuff. Like the advice of a dying mess sergeant, immortalized in a dog-eared paper sign hung above our field kitchen. "Men," he said, "always slice the meat a little thinner." I'm not entirely sure what it means myself, but it sounded profound at the time.

Back at Camp Haan, after months of combat training, classroom drills in aircraft identification, and assistant ACK-ACK firing, the 461st was ready to ship out. But before setting off for Europe—aka ETO—we were stationed at Camp Shanks, New Jersey. I should explain here that the army's idea of language is based on acronyms. It gives the user a sense of importance and lends a hint of clandestine operation to the most mundane activity. Also, you don't have to talk so much. ETO, for example, stands for European Theater of Operations. What kind of theater could that be? That's right, the war zone. WACs, which officially stood for Women's Auxiliary Corps, in the vulgar vernacular was known as. . . . Oh, never mind.

Camp Shanks wasn't far from Manhattan, and like the condemned man's last meal the army would take us into the city. We headed out to the fancy midtown bars and restaurants in military uniform just to show the slackers and cafe society toffs that we were real men on a real mission, while they were weasels. They took us to Jack Dempsey's, the Latin Quarter, all the swell joints. "Unhook that 14k-gold chain, civilian, and let our men in uniform go in and get shit-faced and make fools of themselves!" Even the imperial tuxedoed door domo at the Stork Club became deferential in the presence of men in full dress uniforms. That night, Walter

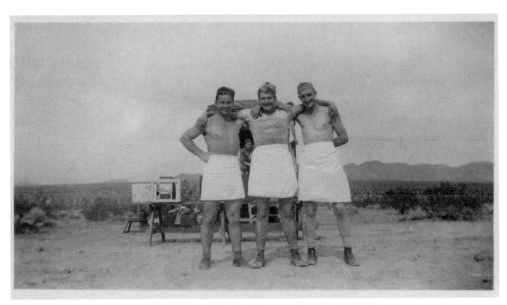

From left to right: Unknown, me, and Louis Bock in Death Valley, California, April 1943.
Author's Collection

Winchell must have been hiding out in the CR room declaiming his rat-a-tat-tat 197-words-per-minute prose: "Broadway is a main artery of New York life—the hardened artery. . . . She's been on more laps than a napkin. . . . I usually get my stuff from people who promised somebody else that they would keep it a secret." We did get to see the ritzy bôites and swanky joints, but forget about fraternizing or trying to get to first base with the mink-swaddled high-priced dames that littered these posh rooms. Instead, we saddled up to the bar and hung out in the cocktail lounges with broads we could afford. A good time was had by all. If I could have remembered it, I would have quoted that line the gladiators used to say: "*Morituri te salutant*—those who are about to die salute you," but nevertheless it was a swell farewell to the grand old USA.

On July 17, 1943, the 461st boarded the *Aquatania* and headed for England along with a contingent of WACs. Grunts like us were stowed in steerage along with a company of truculent Australians and a cargo of stock mutton (when the boat docked in Australia, they'd come on board together). The only way to tell the difference was that the Aussies spoke a horrible dialect called Strine (an approximation of how they pronounced the name of their country). We kibitzed with the Australians and ate the mutton. The officers got better grub, but they had to pay

for theirs, a system that I never understood since they were laying down their lives like the rest of us.

A week later the *Aquatania* was escorted into the Firth of Clyde under cover of British fighter planes and Royal Navy submarines. We docked in Greenstock, Scotland, and were ferried ashore under gloomy, spiked gray skies, then herded onto troop trains bound for the air force base in Warrington, England, where we were stationed in Quonset huts and ordered to protect the base with the ACK-ACK 40 millimeter guns. We got our first taste of what lay in store for us when the flying fortresses took off on bombing missions over Europe, and only half returned. The invasion of France was imminent, but no one wanted to think too much about that.

"War is hell," and pat phrases like that don't come anywhere near the real thing. War is an abstraction to most people—"War in the Pacific," "WWII at your neighborhood cinema"—until you're in it, and then it's pure terror and every fluid in your body turns to adrenaline. We knew for whom the bell tolls but none of us wanted to dwell on it—and besides it would have put a dent in our fun. Fun in wartime is always more fun because tomorrow . . . but let's not go there.

In no time we familiarized ourselves with the pubs in Warrington and then moved on to commandeer the Long Bar in Manchester, but we were hell-bent for Liverpool, a tacky English resort on the Irish sea with a landmark replica of the Eiffel Tower. We weren't after that kind of sightseeing, however. In Liverpool, we hoped to sight willing damsels swanning on the seafront promenade, lingering under garish arcades, or jitterbugging in the dance parlors—an abundance of young working-class girls on holiday.

In the eyes of many Americans today, it seems, someone's status as an army soldier isn't as impressive as it used to be. But during World War II you felt you were important—it was the war to save civilization. We spent a year in England before we went in for the invasion, and as oafish as we were, the English people really respected us, and the English girls were all over us because their boyfriends and brothers were away fighting and getting killed. Any time you'd be with a girl, she'd talk about some member of her family who'd been killed or wounded.

A major activity was figuring how to get off base to take advantage of the local talent. Sculpture has never been my forte, but lust is the mother of invention, and I soon became proficient at shaping pillows and bedclothes into a semblance of sleeping GIs. We had dates—the Women's Land Army—they were the source of inspiration. While our clones slept under GI blankets, we were out carousing off base. The night before the 461st was ordered to depart for Wales, we were confined

to quarters, lights out at ten o'clock. At 10:30 I was shaken awake by a Captain Hammond (good thing it was the real me!). He had a secret mission that he wanted me to help him carry out. "Do I need security clearance?" I asked.

"Not exactly an army mission, Neiman," he said.

"Oh, that kind of rendezvous, sir!"

He'd cadged a jeep from the motor pool and needed someone to drive him to Blackpool for a final hot date with his lady. I didn't have an army driver's license or any experience driving on the "wrong" side of the road, but what did that matter? It was night, and I was on a mission. As it happened, my current main squeeze was in Blackpool that night too. Mission accomplished.

We fired our guns for the first time in Aberystwyth on the West Coast of Wales, which was all very exciting if artillery is your bag. But far more interesting, and the really big hit, was the coffee wagon we set up in Truro on Lands' End. Laurence Olivier and Vivien Leigh, who were on holiday in the nearby village, began showing up. They stopped by frequently to boost our morale (and sample my excellent army-brewed coffee, no doubt). Sir Larry would give impromptu recitations from Shakespeare's *Henry V,* which he was filming at the time: "In peace there's nothing so becomes a man as modest stillness and humility: but when the blast of war blows in our ear . . ." and so on.

The only other entertainment available was paperbacks distributed by the army. Evelyn Waugh's satirical novels may have seemed wicked to the Mayfair crowd, but they weren't exactly my cup of tea. So when the wildly condemned best-selling shocker, Kathleen Winsor's *Forever Amber,* about a seventeenth-century wench who sleeps her way to the top of English society, turned up, it got passed around and around. By the time it got to me, it fell open automatically to the naughty bits (all two of them).

They used to say that the ideal girlfriend was a nymphomanic who owned a liquor store, and at our final camp at South Petherton, Somerset County, I came as close to achieving that as I was ever going to get. My village sweetheart was Dorothy, and her dad owned an apple orchard that supplied cider for the town pub across from our kitchen.

Everywhere we went, we heard songs from the American hit parade: "Sentimental Journey," "I'll Walk Alone," and "I'll Never Smile Again." Only "Milkman Keep Those Bottles Quiet, I'm On My Milk Diet" was verboten, but not because it had raunchy lyrics—it was a Bing Crosby song, after all, about a guy who's been working in the factory all day, building fast tanks and bombers and needs his sleep.

The army didn't like people complaining about, well, anything, but especially about building tanks and bombers—as the Brits used to say, "Mustn't grumble!"

Every morning we would wave to a cheery band of Italian prisoners of war passing by the galley on their way to their wartime labor site, trying to tell themselves they were grateful that they were sharing their fate with the Brits instead of some godforsaken sand dune in North Africa with Germans barking commands at them.

South Petherton wasn't that far from London, and thus was an excellent place from which to sally forth in search of gin and sin. Movies, more pub and club crawling, and more *voulez-vous coucher avec moi* type rendezvous. We got to go to the Odeon Cinema where Hitchcock's thriller *Lifeboat,* starring Tallulah Bankhead, was playing. Its message—who was going to stay alive and who was going overboard—was perilously close to our own situation. The best place to find local talent or un-uniformed Wrens (Women's Royal Navy Service) looking to have a good time with a GI was in Trafalgar Square near the seven-foot-high plaster statues of Limey soldiers presenting arms.

In London there was the constant ear-splitting wail of sirens, and people running down stairs to spend the night in the Underground as a temporary bomb shelter. High drama in the streets and Shakespeare in the theaters. They say the show must go on, although you know the one thing that really doesn't have to go on is the show—but try telling that to an actor. One night at a performance of Shakespeare's *As You Like It* at the Scala Theatre, air-raid sirens began howling in the final act. As theatergoers hightailed out of there, Frederick the Usurper stepped to the front of the stage and in a loud stentorian voice announced, "THE PLAY WILL CONTINUE!"

After a night spent in a blackout bomb shelter, I emerged at dawn to a scene of absolute desolation. Everywhere burning buildings were collapsing, with flames shooting up, smoke blanketing the sky, and the London Fire Brigade manning hoses, desperately trying to keep the scattered infernos under control. It was the terrifying paintings of hell by Hieronymus Bosch come hideously to life.

That day, March 15, 1944, the *Evening Standard's* headline screamed: NINE DOWN IN LONDON AIR RAID—FIERCE BATTLES OVER BRITAIN—9 RAIDERS DESTROYED LATE LAST NIGHT—7 BY MOSQUITO NIGHT FIGHTERS—2 BY INTRUDERS "COVERING" THE ENEMY. Headlines weren't happening somewhere else anymore. I'd gone from drifting on the sidelines of life to being in the hellish thick of it.

When priests, rabbis, and ministers show up offering prayers and blessings, and then they shave everybody's head in your battalion, you know your time has come—and your number may soon be up. Even Last Card Louie could see that something was up with that. We were conveyed to a giant staging area on the south coast of England, where we would sweat it out for several more days wondering who would be the next in line. Sociologists have recently come up with the concept of the negative queue. There are bus queues and queues to get into movies where you want to be right up front, then there are the queues you would rather be at the end of, like for the dentist or an execution, and this was one of those. What we didn't know was that in the first two days of the invasion alone, two hundred thousand men and nineteen thousand vehicles had already landed on the Nor-

Soldier in Chow Line *by LeRoy Neiman. Pastel on Paper.* Author's Collection

mandy beaches. While we waited and cooked up grub around the clock in huge hangars, serving breakfast, lunch, dinner, and then breakfast all over again, anxiety ran rampant through the camp. With no booze and no broads, food was the only thing to soothe our racing minds.

June 10, 1944. As tanks, guns, trucks, and mess wagons headed for the staging area at Weymouth, tensions mounted. There was feverish gambling—craps

and poker games broke out all over the place. Then they started handing out condoms—millions of packages of condoms. What were we going to do, fuck the enemy to death? The rubbers weren't, regrettably, for their usual purpose—they were to put over the muzzles of our M1 rifles to keep out water and sand. I used them to protect my cigars.

At the Normandy invasion there were troops from New Zealand, Norway, Poland, France, Australia, Canada, Holland, Belgium, and England. A crazy rumor circulated through the troops that the occupying Germans had become soft from living in Paris—a fate we would all have liked to suffer. Everybody was on the alert, and one of the things that kept us on our toes was the possibility that General Eisenhower could show up anywhere at any moment, visiting men at airfields, on ships, in hospitals, and at quartermaster depots. A letter from the general was delivered to every man before boarding for the invasion. At the top of the letter, in which Ike asked for a blessing from the Almighty, was a flaming sword.

The anxiety surrounding the invasion had been so intense that I was almost relieved when our hour finally arrived—until I found myself pitching on the icy waters of the English Channel, landing craft on all sides, dive bombs tracing overhead. At last the French coastline appeared, the sky overcast and gloomy. The beach that lay before us was a sheet of pure terror. We knew many had died only days earlier. Scrambling down a rope ladder, I leaped onto a heaving launching raft that thudded against

SUPREME HEADQUARTERS ALLIED EXPEDITIONARY FORCE

Soldiers, Sailors and Airmen of the Allied Expeditionary Force!

You are about to embark upon the Great Crusade, toward which we have striven these many months. The eyes of the world are upon you. The hopes and prayers of liberty-loving people everywhere march with you. In company with our brave Allies and brothers-in-arms on other Fronts, you will bring about the destruction of the German war machine, the elimination of Nazi tyranny over the oppressed peoples of Europe, and security for ourselves in a free world.

Your task will not be an easy one. Your enemy is well trained, well equipped and battle-hardened. He will fight savagely.

But this is the year 1944! Much has happened since the Nazi triumphs of 1940-41. The United Nations have inflicted upon the Germans great defeats, in open battle, man-to-man. Our air offensive has seriously reduced their strength in the air and their capacity to wage war on the ground. Our Home Fronts have given us an overwhelming superiority in weapons and munitions of war, and placed at our disposal great reserves of trained fighting men. The tide has turned! The free men of the world are marching together to Victory!

I have full confidence in your courage, devotion to duty and skill in battle. We will accept nothing less than full Victory!

Good Luck! And let us all beseech the blessing of Almighty God upon this great and noble undertaking.

Dwight D Eisenhower

Letter from Eisenhower to the troops. Author's Collection

our boat, my helmet jiggling loosely on my tender bald head, all my worldly possessions on my back. There was one horrible battle when we were landing in the water—German artillery and machine gun fire was killing soldiers to the right and left, a bloodbath.

It was June 12, D-Day plus six. I was twenty-three years and four days old, landing on Omaha Beach. Happy birthday, LeRoy! As I waded to shore, my one irrational hope was that my prized cigars would survive the crossing.

In Normandy every midnight came the endless deafening drone of Luftwaffe Messerschmitts, which we dubbed "Bed Check Charlie." They buzzed overhead like demonic mosquitoes threatening annihilation. The amount of explosives that went off every time a bomb detonated was so huge you could measure its distance by the strength of the earth's vibrations under you. Between the bombs and our artillery, it was a heavy-metal conversation in hell. We answered back with heavy artillery, and burp guns filled the void. As we inched toward Paris, bombarded by constant shelling, nature itself attacked us with pounding rains and swarms of attack bees that would mass around an open can of K rations, making even eating a battle. One moonless night my second cook, Corporal Charles Smith, took a swig from a confiscated bottle of rosé that a swarm of drunken bees were inhabiting, and within minutes his face swelled up like a balloon.

Wherever we went, houses were being bombed, razed, bulldozed, and blown up. To break their own feelings of desolation and helplessness, the peasants invited us into their stone houses to share a pot of whatever meager scraps of food they had simmering over an open hearth. We would sit at their table or on a dirt floor or wooden plank surrounded by sheep and goats and pigs and cows brought in to warm the houses in winter—and now kept there to protect them from poaching and gunfire. None of us spoke French, but who needed language? Food, friend, fire. The troops wolfed down the K rations but weren't so keen on army-issue Spam, so we bartered gum and candy bars for fresh farm eggs and crusty, just-baked bread. We'd hold the silk stocking for Paris—along with a good supply of cider and Calvados.

We straggled along the hedgerows from village to village, witnessing unrelenting destruction. Churches, homes, and villages were shattered. Roads and fields were choked with bloated carcasses of cattle. Dead Germans littered the roads with their punctured helmets and burned-out tanks. Sometimes it was local farmers mistakenly killed by our own guns. The suffering was unspeakable.

Our troops did really bad stuff too. You responded to situations without any thinking involved, just raw instinct. It's a life-and-death situation, you could be

killed at any moment, civilization's about to collapse. All the rules are suspended during a war. One night a couple guys got drunk, they had a rifle, and what the hell—they shot the place up.

Another time in western France, near Luxembourg, I was with a guy in a house with this girl—just a couple of guys out to get laid. What the hell's the difference, you know, we didn't care. After an hour or so we hear clomp-clomp-clomp downstairs. Loud raucous talk in German. The girl was German too, so we were in a hair-raising situation. Was she going to turn us in? How could she help us even if she wanted to with a house full of German soldiers downstairs? She showed us a back staircase that went through the kitchen. As we crept through the kitchen, I brushed my elbow against a pot and it crashed to the floor. The Germans were shouting, "*Was ist los? Was ist los?*" But by the time they barged in the kitchen we'd got outside, and the girl was standing there explaining it was just a pot that had fallen down. She'd helped us escape, but for the next half mile or so we were paranoid that she might have snitched and they would come looking for us. Finally, out of breath, we sat down by the side of the road. I pulled out a couple of cigars, we smoked them to celebrate, and had a good laugh. Joking around, "Was pussy really worth getting killed for?" we asked. And then unanimously we both shouted, "Yes!" Pete began coughing. He was an older guy, and he wasn't in good shape. I looked over at him, and I saw a look of horror in his eyes. "What's the matter, Pete?" I asked.

"My teeth, godammit!"

"What about them?"

"I left them back there."

"Oh, shit. But, Pete, you gotta ask yourself, do you really . . ."

"Man, I gotta go back and get 'em," he said.

I thought he was out of his mind, but he couldn't imagine his life without his teeth, so off he went. I don't know whether he made it or not—ours was a big battalion and there were a lot of different campaigns going on—but I never saw him again.

⌇

By late August we had reached the outer limits of Paris, but Ike had made an agreement that the Free French Army should supply the troops to enter Paris first in a blaze of glory. When our convoy of half-tracks finally rolled into the city, ecstatic Parisians ran alongside, greeting us and waving tricolored flags. Paris was a party. As long as you could avoid the diehard German snipers, life was good. Wine flowed and the women flirted with us outrageously, despite the edict of the treacherous

collaborator Marshal Pétain that Frenchmen (and women) should fight to the last stand with the Germans. All that evaporated immediately. But you couldn't help but notice the number of turbans covering the heads of certain women—they'd had their heads shaved for sleeping with German soldiers.

Paris! City of Light! City of Art! I was overwhelmed by its physical beauty, and its ancient monuments—Montmartre, Sacre Coeur Cathedral, Notre Dame, Saint Sulpice, the Louvre. The facade of Palais Garnier, home of the Paris Opera, was staggering. (I flash forward to when I painted that grand marble staircase, surrounded by busts of famous composers, baroque pillars, statues of saints, and the décolletage of Paris doyennes attending a performance of *La Bohème,* displaying their jewels like the ribbons and metals of victorious generals.) I had just gotten acclimatized to the fleshpots of Paris when we were dispatched across France in hot pursuit of the Germans. But there was compensation. Along the way, we passed through the champagne region, loaded up our trucks with bubbly, and spent the journey noisily popping as we passed around magnums to toast our loot.

It was a great experience, the army, and it's where I did my first artwork that more eyes got to see. The paintings were pretty good, and overnight I had fans. Any free time I had, I would get up on a ladder and cover the mess hall walls with dreamy wedges of cheesecake and glistening turkeys. Or in my free time I would make pencil sketches of guys on parade, guzzling Lucky Lager in the PX at night, or I'd make drawings of their wives or girlfriends from snapshots to send back home to Sheboygan, Biloxi, and Boise. I was always drawing some picture for a guy of his mother, sister, girlfriend, or wife based on a photograph. I didn't have to do it, I wanted to do it. I felt like a special guy because I was the kid who painted.

During the war, I became an army artist. There were other artists, like Bill Mauldin, an infantryman cartoonist, guys who had been to art school, but I had none of that. I just drew from life. Up to this point I was completely self-taught.

After Normandy, Red Cross volunteers surfaced periodically with donuts, coffee, tea, and sympathy. And then in Namur I met Ida, a resourceful American Red Cross worker who became my main squeeze and, after being impressed with my paintings on the mess hall walls, managed to wrangle a transfer for me to Eupen, Belgium, where I could paint a mural at the Red Cross Donut Dugout in the Pontzen Hotel, now a center for the troops coming off the line. I made a drawing with epic possibilities along the length of the Donut Dugout wall. One day while up on a ladder snapping chalk lines that I used to scale up the drawing, I spotted a German girl in the cafeteria. She was chatting with a couple of dog faces. I could

see that she was charming them, but there was something in her face that spoke of profound melancholy. I was determined to get to know this girl with the sad smile of the Renaissance Madonna.

I learned that she had lost her two children and her parents during the bombing of Aachen, and then her husband and brother fighting the Nazis. She had lost everything and was all alone in the world—and, for more mundane reasons, so was I. Annie would be my wartime love.

As Annie and I threw ourselves into an intense, steamy affair and settled into a cozy life together at the Pontzen, thoughts of my outfit—huddled in the cold while sous-chef Charles Smith rationed out packaged chow with numb fingers—barely crossed my mind. The only thing I was curious about was Ida's nonchalant reaction to my liaison with Annie. Was she too worldly, too noble, to notice how smitten I was with Annie? Wasn't she the least bit jealous?

One afternoon on the scaffold, as I was painting frisky little nudes jumping through king-size donut holes (were these frolicsome nymphs the first blush of my seductive little imp, the Femlin, on *Playboy*'s Party Jokes page?), I looked down and saw Marlene Dietrich watching me work. "Bravo!" she said, applauding vigorously. "What marvelously naughty creatures you have created there. I adore them!" Marlene had come to Eupen with a USO show at great danger to herself—she was on Hitler's death list, branded as a traitor to Germany. After that afternoon, Marlene showed up for coffee nearly every day to see how my frisky gamines were coming along, and often in the company of Ida, who was in unusually high spirits—which I put down to celebrity fever.

Then one day, on a break from the mural, I happened to stop by Ida's apartment. I knocked. No response. Again I knocked. And then, as I'd done many times before, I pushed open the door. Peering into the darkened room, I saw two heads looking at me from rumpled pillows. Ida, my Red Cross angel, was between the sheets with Lola of *The Blue Angel*. Well, that was something you didn't see in Duluth too often. I turned on my heels and gingerly pulled the door closed. I was getting the impression there were wilder things out there in the world than I'd conceived of in my Midwestern imagination. I was wising up fast. Stranger adventures than that would soon come my way.

Life with Annie was heaven. I conveniently forgot I was AWOL and she and I settled into domestic bliss as war seethed around us. Days were spent finishing up the mural and tending to a sideline business we'd rigged up with the locals, distributing cognac. At night Annie and I cuddled in bed, two misplaced souls comforting

one another. Then one evening, we heard an alarming sound, the distant drone of war planes. Soon the Pontzen shook to its foundation as planes zoomed and strafed the building. We flattened ourselves against the wall, groped for the stairs, plunged down three flights to the cellar, and huddled near the coal bin. We heard tanks rumbling above us. Not our friendly Rhinos—the M4 Sherman tanks fitted with hedgerow-breaching "tusks"—these were Tigers, the dreaded German blitzkrieg panzer tanks.

We heard heavy footsteps overhead, and our hearts were in our mouths. "Sheiss! It's the Jerries!" Annie whispered. "Stay here!" In horror, I watched her ascend the stairs. I heard the door open to a burst of harsh German voices, then slam shut. I was alone in the coal bin. Worse than the stomping of jack-booted German officers, all was now deathly still. Hours passed. Thoughts of fear and paranoia alternated in my brain. God help me, but one moment I was thinking, "Is Annie safe? What will they do with her if they suspect anything?" while the next minute, "Is she going to betray me? She's German, isn't she? Why wouldn't she turn me in? We're all out to save our own skin in situations like this." I was in the worst dilemma you can ever be with your lover. Forget about stuff you think about in civilian life, like, is she cheating on me? That's just ego. I'd already betrayed her in my mind the moment I'd asked myself, "Can I trust her?" But I had no choice. I was running out of hope—worse, I was running out of luck. I crouched there for hours, reviewing my fate. Then miraculously, Annie appeared like a goddess with food and Rhine wine. The officers were in high spirits, she told me, because their tanks were nearing Antwerp, and everything was under the control of good German steel. Now I had to trust her—didn't I?

Hours agonizingly multiplied into days. It was dark and dank, with only a sleeping cot and squat latrine—and my black thoughts. Aside from Annie showing up regularly with food and reassurance, my only company was a rat scuttling nearby. Eventually you can get used to anything, but just when I began to think, "This hellhole isn't so bad," chaos broke loose. I heard bone-rattling bursts of gunfire in the street, then shouting Germans followed by frantic scurrying upstairs. I peered through a crack in the boarded cellar window and what I saw was too good to be true. The Germans were desperately scrambling onto their swastika-emblazoned motorbikes and heading out of town. In their wake, dozens of small tanks were rolling in. The Brits had arrived.

I emerged from my subterranean prison and resumed life with Annie. Why mention to the occupying Brits that I was a deserter, and someone who had barely

thought about his own platoon while living in sin with a foreign—in fact, German—national? Tah-tah, and good luck to you, lads. Brits gone, we settled back into the absurd normalcy of wartime housekeeping—again short-lived—but what did we expect, there was a war on. One cold winter morning as we were crunching through the snow, hand-in-hand on a cognac delivery, a jeep swerved to a stop in front of me. "Sir!" the MP at the wheel called out to me. "Does this street take us toward Malmedy?"

Without hesitation—and like a perfect idiot—I called back in a classic Midwestern twang, "I think so, sir." As the words left my lips I realized I'd sealed my fate.

"You sound like a GI," the MP challenged. In that instant I'd forgotten any lessons in subterfuge the war had taught me and forfeited my freedom in the bargain. "What are you doing here, soldier? Where's your unit?" he asked.

And, like a dope, I answered, "I live here." Jeez! In short order I was bundled into the jeep and escorted back to the Pontzen to pick up my gear. Under guard, I dragged my uniform and carbine out from under our bed and made a quick change from civilian to army issue. The last thing I remember was the figure of Annie getting smaller and smaller on the snow-covered street. Oh my god, what had I done?

I was hustled into an artillery outfit attached to the infantry (I had no idea what company, platoon, or squad). All I knew was that it was bitterly cold, and I was on frozen, snow-covered ground in the dense forest of the Ardennes with grenades and machine gun and mortar fire sounding on all sides. The Luftwaffe dropped bombs, enemy flares fired. I was a nobody again with lots of company, namely, confused and disoriented misfits like myself. The most demoralizing element was that we—the average American Joes—were so easily cloned. So many American-speaking German paratroopers wearing US Army issue had been dropped in behind the lines, and looked and talked and chewed gum just like us, that GIs had to check each other's identification. It was a real-life version of *Invasion of the Body Snatchers*. And even the uniformed Nazis out there pounded us relentlessly. There was no hiding from the enemy, and only the occasional shack or barn to duck into for temporary relief from the icy winter.

Gripping the carbine that was by now nonfunctional in my hands, I scrambled down embankments and rolled into ditches. I had become the Joe or Willie, a slogging foot soldier, unshaven despondent grunt, straight out of a Bill Mauldin cartoon. No amount of training could ever have prepared me for this. I was cold, utterly exhausted, totally disoriented.

The German sons-of-bitches had opened a new offensive on December 16. Though we were ignorant of the numbers—thank god!—the Wehrmacht had poured in two hundred thousand men and one thousand tanks onto the battlefield, and just at the point bad weather had hampered Allied air and supply operations. By December 22 the Allies were surrounded but did not surrender. Somehow we made it to Christmas. On that day I was near Malmedy, just twenty miles south of Annie's hometown of Aachen.

Only a year before, our gun crews had been in a snowy Land's End, tuning in Christmas carols on the wireless. Now the mood was grim and desperate, and "Praise the Lord and Pass the Ammunition" was the mood of the hour. It was hell on earth and the earth was freezing over. It was an Allied victory, but at a terrible cost. By the conclusion of the Battle of the Bulge in January, seventy thousand of our men had been killed, wounded, or missing.

I was listed as a missing person, and, since my outfit and I had lost track of one another, I was moved "repple depple" from one replacement depot to another. My company, Battery D, crossed the Rhine on a roll and pushed on through Germany.

Gradually I made my way back to Eupen, where Annie and I returned to our cherished routine. Had there not been a war we might have stayed together indefinitely—I truly loved her—but on the other hand it was only because of the war that we'd met. This time around, I stayed in uniform like a soldier coming off the line on pass. I was AWOL, but with the Allies stampeding across Deutschland, I figured the German war machine was kaput.

I painted stage sets and bandstands for visiting USO performers—Dietrich, Ray McKinley's Glenn Miller Band, Mickey Rooney, and the Jimmy McPartland jazz group—along with the remnants of European cabaret and circus acts. I sketched the Donut Dugout GI scene, sometimes giving away the drawings, sometimes throwing them away. In my self-taught apprenticeship everyone and everywhere was a subject, everyone a model in a life class.

But just as Annie and I had settled down again in our make-believe life, officials from the German government appeared and ordered all citizens to return to their hometowns, even though Annie's hometown had been obliterated, her house demolished, and her family killed. She was ordered back to Aachen, about fifteen miles north. And like that, she was gone. I was devastated. I hitched a ride across the border on a British truck in search of her.

What I found in Aachen was dismal. The majestic, ancient city, once known as Aix-la-Chapelle, coronation site of centuries of German kings and burial place

of the Emperor Charlemagne, was flattened. Its homeless citizens were huddled in whatever shelter they could find, scattered across the battered, desolate city, its medieval cathedral one of the lone surviving landmarks. I wandered from group to group, desperately in search of my wartime soulmate.

Finally, after frantically searching an endless ration line, I found her. We reunited with an embrace of such joy and passion, but mingled with inconsolable sadness, knowing that this time our farewell would be final. I had to go back. We pledged undying love, promised to write, and parted. With war-hardened resignation, I knew Annie's courage would pull her through and that the British occupiers would take care of her. She went on to marry a British officer and live happily in the south of England. We kept in touch until Annie died, well into her nineties, in 2003.

Back in Eupen, I had time to wallow in my misery. Since I had been unattached to a unit for several months, I was technically AWOL, which qualified me for a general court-martial. The army placed me under arrest, and I was whisked away by military escort. From the backseat of the command car, speeding over the endless autobahn route, I couldn't help but notice that I had never before merited such official attention. Foolishly I said to myself, "You're finally somebody of importance!" But for the wrong reasons. As I surveyed the desolation at the hands of the Allies and the Nazis, it all seemed so pointless and hopeless.

My indifferent MP retainers took me to Pilsen, Czechoslovakia, where I awaited trial for desertion. But from what I understood of my situation, it wasn't quite as dire as it might have been. There had been a wave of desertion cases and even cases of self-inflicted wounds—relative to all this the army cut me some slack. The charge against me was stricken from the record, and my arrest never appeared on my discharge.

Annie was gone from my life, and now that the war was over and combat behind me, I knew what my next move would be. I figured that since I was in Europe, I might as well see what we were fighting for. Having served three years qualified me on points alone for discharge, but I signed up for the Army of Occupation as an artist anyway.

I requested to be sent to Frankfurt and made a side trip to Würzburg to view the work of sixteenth-century German wood sculptor Tilman Riemenschneider. In books illustrating sculpture, I had never seen such fine craftsmanship as his. But when you see these carved wooden statues up close, you realize he applied this technical virtuosity purely to convey an overwhelming emotional expressiveness. His *Saint Barbara* in the Bayerisches Nationalmuseum is so incredibly poignant,

a late Gothic face drenched in melancholy. When I saw his *Mary with Child* in the Pfarrkirche St. Bernhard in Würzburg, I was overcome with emotion. The Madonna had a heartrending, inward-looking expression, her face and body alive with inconsolable grief. Even the folds of her drapery were rife with anxiety, as if her psychic turmoil was so intense it had begun to infect her clothing.

She reminded me of Annie, and tears streamed down my face. It's such an incredibly affecting image that it inspired Hermann Hesse to write of the Madonna: "Dreamily she gazes out from her glass case, far away from our world . . . in her gracefulness and distinction she is refined to a degree of perfection far above that of mankind today." As I stood before it I thought, How could such a spiritual, soul-searching image come from these brutal, barbaric people whose atrocities I'd witnessed during the war? But I learned that Riemanschneider himself had been savagely treated during the German Peasants War, which ended in 1525 with the massacre of eight thousand Würzburg citizens. He was tortured and his hands broken so he could never carve again. Riemanschneider's self-portrait, made long before the war, seems to project all the sorrow and resignation of his later sufferings.

I had also been moved by Albrecht Dürer's woodcuts of the Passion, which contained all the cruelty that humans can inflict on each other as well as a vision of redemption. After seeing countless reproductions in books, the physical reality of Dürer's original woodblock prints—the swirling compositions and infinite detail—blew me away. I couldn't get over that what I was looking at was the actual thing—centuries-old prints on paper that I was holding in my hands.

Loaned to Freiburg Special Services, my own subject matter took a turn to the profane. After stenciling army symbols on helmet liners came the fun stuff—one-of-a-kind VD posters. My cautionary images may have bordered on pornography, but they got the soldiers' attention. By then penicillin, Captain Marvel of the clap, had come along, but I was not in a hurry to try it out. The army during the occupation, of course, had no end of VD. We had to put up a list of guys who had VD, embarrassing everybody. They had to go get their penicillin shots. I don't know what they did before penicillin, I don't even want to think about it! I took my own propaganda seriously and exercised caution while fraternizing with the local Fräuleins.

With the war over, I thought I'd try a game that big shots and gangsters played: golf. Enlisted men were allowed to play on the Bad Nauheim Club golf course so off I headed. Just my luck, the day I decided to play a round, General Patton showed up, and a bunch of busybodies were running around the course shouting,

"Everyone off! Everyone off the golf course—now!" What the hell? No matter what tee, green, or fairway you were on, when Old Blood and Guts teed off, the entire course had to be cleared. This seemed like a lot of hooey to me, but I figured anyone who had thrown a full-blown army through the insurmountable odds of the German Wehrmacht at the Battle of the Bulge ought to be allowed to do what the hell he wanted. As it happened, General Patton would soon be the indirect cause of my final dressing down by the army.

It came about one sunny afternoon in Frankfurt as I strolled down the street arm-in-arm with a local charmer. We'd stopped at an antiques shop window to view the hodge-podge of broken lamps and dusty figurines, when the specter of General Patton's sedan suddenly appeared behind us, reflected in the glass. With regimental reflex I smartly turned about-face to the street, ready to salute the general, but when I saw the standard was covered, I realized there was no need. If the general wasn't in the car, what was the use of ceremony? We continued down the street, the car ominously following us and eventually pulling up alongside the curb.

"You didn't salute the general's vehicle, soldier!" an MP shouted out.

I knew from long experience not to question the army's pretzel logic, so I answered, "The driver was alone at the wheel, sir, sans the general."

Like some *Sad Sack* cartoon sergeant, the MP snarled back, "You will salute the general's vehicle whenever, sergeant!"

Apparently the car itself had magically acquired a general's rank—like the overcoat in the story by Nikolai Gogol. Did this logic now apply to his chair, his bed, his . . . Never mind.

Something went off in my head at that moment—the army had disrupted my social life once too often. European combat concluded, I had more than enough points to qualify for immediate discharge. Enough of army chicken-shit. I had no idea how I would pursue life as an artist, but it was time to stop stalling.

On the way to Rotterdam to ship out, I made a detour to see Peter Paul Rubens's crucifixion altarpiece, *Raising the Cross,* at the Cathedral of Our Lady in Antwerp. After viewing so many reproductions of Rubens's work, I had to see this live too, in that majestic Gothic cathedral unharmed by bombing. I was overwhelmed—it's huge and dramatic. The dynamics of the painting are so viscerally compelling that you are swept into the action. A surging triangle in the central panel brings the crucifixion to roiling life as soldiers try to raise the cross, which seems to be overwhelmingly heavy, the wood of the cross itself turning into a tree bursting with foliage. On the right hand panel is the alarmingly foreshortened muzzle of a horse that

seems to project threateningly out of the picture at you. The horse bears its rider, a sinister tyrant ordering the death of two other Jewish martyrs.

I may not have prayed that day, but whatever I had unconsciously wished over the last four years was calling to me big time. I was on my way to an uncertain but all-consuming future.

Throughout the years I'd spent in the war, I'd had plenty of time to think about what might be in store for me back home. But what was that, really? I had left nothing behind and had less to return to. How do you define a life that had no definition to begin with? I was running amok. In the army, if you did something wrong, you'd get punished. So the army was perfect for me in a way (not that I didn't manage to bend the rules, plenty). Most of the time, it was downright boring now that I think about it, but it was also the first big adventure of my life. The army had given me a sense of identity, separated me from the throng. Army life had primed me to exploit my artistic skills to my own advantage. Would I get a chance to use these skills in civvies?

The question had actually answered itself one day during the campaign in eastern France along the Belgian border. As I read the lead story in the army magazine *Stars and Stripes,* a sentence jumped out at me: A full year of college would be

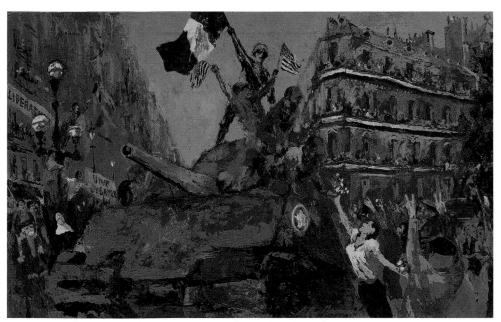

Liberation *by LeRoy Neiman. Enamel and Acrylic on Canvas, 1993.* © LeRoy Neiman

awarded for each year spent in wartime service. I had four years coming. There it was. I would put in four years at art school and carry on my act.

But I still had to get home in one piece. The first night out, while in the North Sea, the liberty troop ship I'd boarded in Rotterdam collided with a freighter and was ripped right down the middle. As the boat sank ingloriously, we trod hastily across the army blankets spread on the floor from our interrupted craps game, scrambled up the clogged stairs, and abandoned ship for a rescue vessel, to the blare of an Army-Navy game over the public address system.

We were welcomed in Boston by a military brass band indifferently tooting on the dock, as anticlimactic a reception as Uncle Sam could have mustered. I was carted on a troop train to Camp McCoy, Wisconsin, where my mother collected me in that same 1941 Ford two-door I had left behind. I got behind the wheel and drove back to St. Paul. Lydia had cooked up a batch of her Polish-style pierogies for dinner. Devouring those lovingly prepared fresh dough treats filled with sweet cottage cheese, deep-fried and sprinkled with sugar, I knew there was no better taste than that—it was the taste of home.

I left the army with an honorable discharge and five battle stars—Normandy, northern France, Ardennes, Rhineland, and central Europe. I'd winged it, seen a world beyond my imagination, and learned a little more about a lot of things—including myself. But there was no time to look back. The most significant designation on those discharge papers of November 20, 1945, was Army T/4 Artist. I was ready to see where it would take me.

3

Chicago Boho, or How I Went from Eating Pierogies at My Mother's Kitchen Table to Becoming a Crazy Artist

Picture this: Summer 1946, an old jalopy careening along the Mississippi bluffs, stuffed to the brim with easels, canvases, paint-encrusted palettes, boxes of oil paints, batches of paintbrushes, and sketchbook pages flying out the windows. It's the artmobile running on old master fumes with Clement Haupers, a wild and wooly artist, at the wheel and me leaning out the window surveying the lay of the land for any eminently paintable landscape. We were a veritable caricature of bohemian artists on a mission to search out the sublime vista.

In the wilderness painting department, the nineteenth-century Hudson River school was the high-water mark—Thomas Cole, Frederic Edwin Church, John Frederick Kensett. Those were the guys. Beetling crags, teetering promontories, tumbling cataracts, endless forests, blinding sunsets, and the occasional volcano (available on demand). We seasoned their style with liberal sprinklings of impressionist, post-impressionist, and fauve flavors. We'd have settled for a more serene type of river view—like George Caleb Bingham's *Fur Traders Descending the Missouri*—if it had been available, but fur traders were in short supply in our day.

Clement Haupers was the genuine article, your classic, old-school goateed Parnassian artist—the paint-splattered, possessed painter, rumpled as an unmade bed, with a manic gleam in his eye. The way artists were meant to be, not like some artists today, who look like businessmen. Clement was my idea of what an artist should look like. He was my idol, mentor, and roguish role model—he lived the full-bore *vie bohème*.

Those were the days when any artist worth his linseed oil went to Paris to study, preferably with some hair-raising maniac of modernism—which is just what Haupers had done. He'd gotten out of St. Paul as quickly as he could and studied in Paris with André Lhote, a founder of the cubist movement. Cubism! Jesus, this

In a straw hat, late 1940s. Author's Collection

was like getting lessons from one of the guys who split the atom. Cubism was the Big Bang of modern art.

When he wasn't wearing his trademark paint-splattered smock, he dressed like a Left Bank dandy in the purple tux he kept for soirees and salons. He had a sweet living arrangement too. He cohabited with one of his former students, Clara Mairs, twenty years older than he, with the money to keep this sacred monster in true haute bohemian style, indulging his excesses and not prying too closely into his sexual preferences.

I'd gotten hooked up with Haupers through my old art teacher at Washington High, Betsy Mulholland. She'd encouraged me to use the GI Bill to go to art school, and in that first winter after the Battle of the Bulge, I attended Haupers's classes at the St. Paul School of Art three nights a week, studying life drawing and figure painting, working on cheap beaver board and cotton canvas.

I thought I'd stay around St. Paul just long enough for my hair to grow out, and meantime soak up as much art as I could in the city's collections. Art is an addiction, a little like sex, the more you get the more you want. I searched out everything, everywhere and anywhere. The higher the octane the better. There were treasures to be discovered in the Minneapolis Institute of Arts, like the seventeenth-century neoclassic French painter, Poussin. Not his freeze-dried gods and goddesses

posing in well-behaved landscapes, but how he dramatized these figures in space. The geometry he used to make those ancient statues come to life was like waking the dead. I would later recognize this technique in Cézanne, whose alchemical compositions made even rocks and trees come to life. There were other revelations in St. Paul: Franz Marc's famous blue horses prancing at the top of the main stairway of the Minneapolis Walker Art Center, and prolific local painters Paul Manship and Adoph Dehn.

I perused art books at the St. Paul Public Library and checked them out to study at home. The artists who appealed to me were the Renaissance painters. The Renaissance was not very popular at that time because de Kooning and Pollock had just taken over the game—and they deserved to—but there were things that I still wanted to achieve in my art, things I wasn't satisfied with, and I knew the old masters had the answers to these things. There were painters like Frans Hals and Rembrandt—boy, they could really paint, and I would swipe different techniques from them.

Haupers had found an eager student. I wanted to learn. And this guy could talk. He had endless theories about Cézanne and cubism. Space organization! Color modulation! Volume and thrust! His palette was as organized as Mondrian's sock drawer, the colors fastidiously mixed with a palette knife. He was a cunning colorist who disdained using color straight out of the tube. Ah, that was considered barbarous! Artists ought to be hanged for perpetrating stuff like that on an unknowing public. He could hold forth on color temperature until your very brain cells started to turn to burnt umber.

In the winter he had the quaint old French habit of sticking to still life and figure painting—nudes and flower vases. In the summer he painted his lively, whimsical landscapes filled with space and light, materializing trees and hills with his impulsive brushwork, dipping his brush into the paint and blending skies and clouds out of cobalt blues and zinc whites.

We played our roles to the hilt, the wide-eyed twenty-five-year-old ex-GI student sitting at the feet of the forty-five-year-old master as he indoctrinated me into the mysteries of color and the cold architecture of anatomy. He gave me a list of books to read; he'd plunge into offbeat tangents of art history at the drop of a hat. Was I aware that Titian's revelers and drunken female nudes predated Poussin's wanton, erotic Bacchanals? These were things apparently every self-respecting artist should know. He encouraged my interest in Poussin and Cézanne, and disdained Dufy and Lautrec, two artists I admired, but who Haupers had absolutely no time

A letter about me from Clement Haupers. Author's Collection

for. Dufy? "A mere magazine illustrator of sailboats and hotels." Lautrec? "A slick debaser of Japanese woodcuts in the service of whorehouses!" But I had my own ideas about them. I saw Dufy as a sophisticated diarist of social scenes, and in Lautrec I recognized a graphic punch that could stand up to the most effective advertising around. We closed many a bar arguing about this stuff.

Haupers may have had qualms about artists who muddied the great river of art by fraternizing with glittering high society, but he loved F. Scott Fitzgerald. Flashy flappers! Elegant playboys! Haupers introduced me to the novels of Fitzgerald, tales of dazzling extravagance as if spied through a peephole. Like Fitzgerald, I was secretly drawn to the high life from an early age, and like Fitzgerald I lacked the credentials that would get me in the door. And Fitzgerald didn't give a damn whether he was portrayed as a shrewd observer of life or a glorified pulp novelist. That was the way he saw it and that's the way he told it, a lesson I would have to learn the hard way: No matter what yobs or snobs say about you, never doubt your own vision.

Ars longa, vita brevis is the old saying. Art takes a long time to master, but life, alas, is short. What they don't tell you is that an artist's life is for the most part solitary and lonely. The first time this sunk into me was when I encountered a fellow student lugging an instrument case on his way to a French horn class. He was an outstanding student of Haupers, so I asked him, "What do you prefer doing, painting or music?"

"I think I prefer painting," he said, "except for the solitary aspect, and that's what attracts me to music, the camaraderie of an orchestra."

Well, I had no other talent to frustrate my commitment to painting, and I felt oddly relieved by that. Perhaps the wild social scenes I would soon pursue would be an antidote to the solitary life of the artist. I was not going to spend my time alone in a loft—I wanted to be out in the world of glamour and beautiful women. It wouldn't take long.

My favorite memory of Haupers took place on a landscape-painting foray one peak autumn afternoon. If you're a landscape painter, autumn is your prime time. You stand in front of a maple tree that looks like it has caught fire right before your eyes, and it's as if Mother Nature is throwing down the gauntlet: Okay, wise guy, try and top that with your crimson and cadmium orange!

As we drove along Minnesota's fertile rolling farmland, Haupers related the passing landscapes to paintings by Segonzac, Pissarro, and Renoir. Then spying a wooded glen along a sweeping hillside, he yelled, "Hell, LeRoy, at nine o'clock, if that isn't the most sublime sight I've seen all day. Let's pull over and catch that sultry beauty." We were big game hunters out to bag the scenic trophy, to catch the wild, noble, leafy life intact.

Haupers leaped from the car to retrieve his painting gear. "Damn it, Lee!" he exclaimed, rummaging in the trunk. "I brought canvas, paints, and easel and forgot my damn brushes!" When I offered mine he would have none of it, but gathered his gear and disappeared down the hill.

About an hour later, immersed in my own painting, I heard, "Lee, come take a look!" Following his voice, I found Haupers at his easel, swiping the final touches on a vibrant autumn composition with a large oak leaf. He'd bagged the burning bush before him with great swatches of brilliant inflamed color streaked across the canvas in Van Gogh vermillion and Pissarro pinks. And he'd painted the damn thing entirely with branches and leaves! What a stroke of genius, he'd painted nature with nature. How many artists can claim to have done that? "Vincent would've loved that move—too bad he never thought of it," he guffawed. When we were packing up the car, there in the trunk, behind the spare where Haupers had tucked them away, were his brushes. "Just think, LeRoy, if you'd found them, a great opportunity would've been lost to art." Van Gogh had said, "God is Nature." Jackson Pollock had said, "I am Nature." But neither of these guys had thought of actually enlisting her in painting a canvas.

Time to get serious about art schools. To qualify, I took my high school equivalency exam and got my diploma. I assembled a portfolio of classroom studies and salvaged army drawings, and sent it to the top half-dozen art schools. The replies

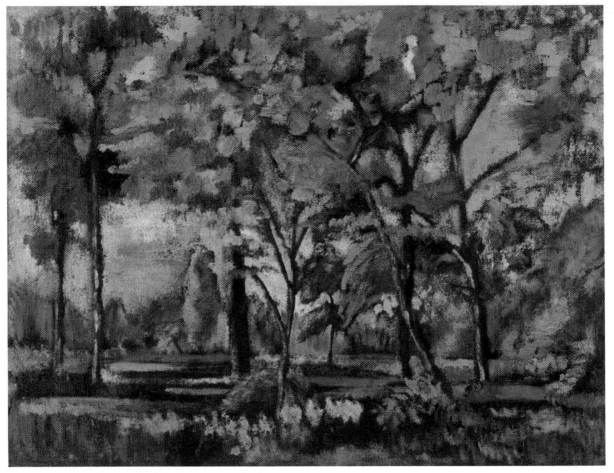

Landscape II *by LeRoy Neiman. Oil on Board, 1946.* Author's Collection

were all positive. Now it was a matter of where, not if. On Haupers's recommendation, I chose the School of the Art Institute of Chicago, the SAIC.

I was heading into the unknown again, but now armed with easel and art supplies, it felt less precarious. I piled everything into my flashy red, used Ford convertible, top down, and vaulted into the driver's seat next to Mickey. Did I mention Mickey? We'd been seeing a lot of each other, especially since she lived midway between the Minneapolis Institute of Arts and the Walker Art Center, an ideal address for a matinee after the old masters.

I'd come by and say, "You know that painting by Rubens in the museum, *The Rape of the Daughters of Leucippus*? Do you think you could pose for that so I could sketch it?"

Mickey would say, "If you want to get laid, just say so." Mickey was always game for adventure, so I had no trouble persuading her to take off with me to Chicago.

Leaving St. Paul behind, Mickey cozied up beside me, I felt like Kaa, the big rock python from Rudyard Kipling's *Jungle Book*. The wily snake changes his skin maybe two hundred times in a lifetime, and is moody and depressed until the new skin takes on its glossy shine. I was shedding my army uniform for a new life.

Two flat tires later, we blew into the Windy City. Of the two and one half million students attending college that autumn of 1947, I was one of a million former servicemen on the GI Bill. The war had changed everything. College, which had been the preserve of the privileged, was now open to everyone. I was almost ten years older than the high school kids entering art school, and a war-tested vet. But unlike them, I knew this was my big chance.

Chicago was an entire city of museums, galleries, and libraries, filled with purloined, pilfered, and purchased great works of art. The Museum, the Ryerson Library, the Print Collection, the Goodman Theatre of Drama—and all within reach of the Art Institute.

First-year curriculum meant painting, drawing, design, perspective, anatomy, as well as the technical stuff: stretching and priming canvas, rabbit glue, gesso, egg tempera, oils. I had such an insatiable appetite that I took classes on Saturdays and three nights a week, seeking out instructors with different slants, styles, and attitudes.

I was no longer a loner on some eccentric mission—art schools are magnets for freaks. Outsiders. Wild and feral types. A lot of kids who don't know what they want to do (but know what they don't want to do). Even John Lennon gravitated to art school. There were plenty of these outsiders at the Institute. There was Leon Golub, future provocateur of the Chicago Monster Roster; Robert Clark, who would morph into the *LOVE* poster artist Robert Indiana; and Red Grooms, who would go on to make frenetic urban paintings and constructions. Hyper-realists (Richard Estes), sculptors (Joe Goto and Richard Hunt), Eugene Bennett from Oregon, and from Boise realist Robert Addison, who would become my roommate and cohort. Also Irving Petlin, John Bageris, Robert Natkin, Nathan Goldstein, and future *Ebony* art

director, Herb Temple. Not to mention Seymour Rosofsky and Ted Frano, who both died too young.

You're meant to get laid in art school. But I was such an avid artnik I didn't even pursue the good-looking existentialist girls with their Juliette Greco look, or the healthy farm girls and beatnik broads straddling the drawing benches in class. Anyway, I had my main squeeze, "Mrs." Mickey Neiman, to come home to. The GI Bill subsidized married couples, so Mickey and I played the part of happily married newlyweds in a studio on Chicago's northwest side. But there was trouble in paradise. When Mickey got home from her salesgirl job at Robert Hall, she no longer found it flattering that I wanted her to pose as nymph or sultry sprite. "Screw Rubens, I want to go out dancing. I'm sick of being holed up in this little room night after night with an art junky."

My obsessive behavior was getting to me too. I was overstimulated, overtired, and overwhelmed, on top of which I hadn't really ever dealt with the postwar shock that was still eating away at me. It all piled up and landed me at the Hines Veterans Hospital in Chicago (supposedly for exhaustion), where I was subjected to a battery of tests. Like all shrinks, the doctors there had nutty theories, but when the psychiatrist insisted I shave off my mustache, I said, "No way!" How would I recognize myself without it? These were the kind of people who'd tell Santa Claus to shave off his beard. When the social workers wheeled in a cart of paint tubes, watercolor pads, and brushes, you'd think I would have jumped for joy. But I was on to their little tricks. I could see a "psychiatric evaluation" coming a mile away. They wanted me to make some Rorschach doodles so they could slap a label on me, but I wasn't going to play along with these psychiatric philistines. They wanted to detain me. I wanted out.

One evening I sketched a buddy of mine, flat on his back in pain, breathing heavily in the bed next to mine. When I woke up the next morning, the nurses were changing the sheets. He had died during the night. That afternoon I called Mickey. She smuggled me out in hospital-issue gown and slippers, sketchbook under my arm. I left my street clothes, shoes, everything at the hospital, knowing it was worth replacing them with the little money I had. No one ever followed up on my whereabouts.

Back home things only got worse as Mickey and I continued to unravel. Women may be attracted to wild and crazy artists, but in the end they want to be married to some guy who'll bring home the bacon, and Mickey had serious doubts about my ever making it as an artist. But I wasn't about to settle down and get a job even

for true love (and that was wearing thin too). Aspiring artists are not good candidates for bourgeois family life. Mickey knew me pretty well. When we parted ways a few months later, she gave me Reginald Marsh's *Anatomy for Artists.* In his social protest paintings of bars, strippers, and street scenes, Marsh projected a love of wild living, a milieu I'd soon plunge into with equal gusto, the demimonde of gamblers, pimps, hookers, and con artists.

With Mickey gone, my shacking-up arrangements deteriorated. I relocated to a third-floor walk-up in a rundown brownstone on Erie Street, where amenities included a bathroom down the hall. I soon learned that the empty Blatz Beer case parked under the sink had been placed there by my vertically challenged fellow lodgers, six midgets who worked as strippers at a nude club on South Wabash. The sextet slept nude, lengthwise, three to a bed on a set of twins. I sketched them languorously posing on their bedspreads, and at the strip joint, grinding in their teeny beaded G-strings. Better yet, the apartment next door became an unofficial life-drawing studio where fellow students and I man-

In studio, drawing Louise O'Connell. Author's Collection

aged to convince the flight attendants who came and went to strip and pose for the sake of art.

My landlady, a fleshy hulk of a woman, saw it as her duty to crash into my room at any time on a campaign to stomp out invading cockroaches with her bare feet. The scavengers were a force to contend with. In my second-year apartment, shared with schoolmates on Chicago's Southside, the roaches dined on the milk-based casein color on our canvases, an act of such chutzpah that it inspired Joe Goto to weld a giant insect sculpture in their honor.

While sketching and painting, I devoted some time to my other creation, my artist-in-progress persona, a task I enthusiastically embraced. I adopted a uniform consisting of two paint-splattered beige overalls (colorfully decorated since they doubled as a paint rag), one to wear to class while the other was in the wash. The artist-immersed-in-his-art was also displayed daily at the Walgreens' lunch counter across from the Art Institute on Michigan Avenue, where Cliff Westermann, Ed Fisher, Bob Addison, and I commandeered a booth, though to the ire of the management we brought in our own sandwiches.

Food money was scarce for an artist on a GI Bill stipend. The only ones getting fat were the bugs eating the paint on our canvases. Art supplies, especially cadmiums, were expensive, so it was common practice among students to scoop off the pricey globs of slow-drying reds, oranges, and yellows from palettes stored in classroom racks, and it was considered fair game to lift the occasional tube of cad from the art store.

But if food and art supplies were few and far between, the great instructors at SAIC, whose teaching I remember to this day, more than compensated. There was the creative composition instructor, Ed Rupprecht, a dapper gentleman with a Robert Delaunay demeanor who had studied with Hans Hoffmann. "Ed," as he allowed students to call him, stressed space and narrative elements. He said of subject matter that a bowling alley was as valid as any more elevated scene.

At SAIC you could learn to draw or paint in just about any manner or style from the fifteenth century to the present. John Rogers Cox taught scratchboard rendering in litho crayon and razor blade, and Allen Philbrick's pen and ink class à la Joseph Pennell included instruction in how to draw like the masters: the black and sepia reed-pen sketches of Rembrandt, Rowlandson's rowdy crowd scenes, and Van Gogh's intense cross-hatched drawings.

Drawing instructor Briggs Dyer used to take his classes outdoors to the Near North Side, Riverview Amusement Park, and the lakefront. One day during a class along the Chicago River, I was sitting with Bob Addison sketching the Wrigley building from below when Dyer came by. He looked at Addison's painting and said,

"You've painted a postcard blue sky, okay, but remember, every color that exists is in the sky from sunset to sundown. In the sky, anything goes." From there I deduced that if any color goes in the sky, then any color goes with anything. Picasso used to say that Gauguin invented modern art when he chose to paint his Tahitian skies any color that came into his head—or what was left on his palette that afternoon.

Of all my instructors, no one stands out more than the intimidating, inimitable Russian, Boris Israilevich Anisfeld. Painter, graphic designer, and set designer, Anisfeld first came to the States with Leon Bakst while working on sets and costumes for Sergei Diaghilev's legendary Ballets Russes. When he visited Chicago in 1921 to do the sets for Prokofiev's opera, *Love for Three Oranges,* he stayed and taught there for the next forty years.

Like his paintings, Anisfeld was theatrical and mystical. He was in his seventies when I attended his classes. With his gray beard and pageboy haircut, he was looked upon as a wizardly ancient. But he was also a tough taskmaster. "You must *vork*! You must *stoody*!" he'd berate us. "You must trust vat you see! You must trust vat you feel!" His mantra was, "You must see things virst in color!" His lectures on coloration were charged with emotional drama. Colors had characters—of course! Heady blue-greens and smoldering oranges butted up against edgy greens, and then swooned into sensuous rose-violets and golds. He mixed deep transparent glazes like alizarin crimson and ultramarine to achieve a rich, potent black. Never use black straight out of the tube! Black is its own world, where things appear out of the darkness.

Gatherings at Anisfeld's Old World studio on Goethe Street were like a séance. Surrounded by half-burned candles and roped-up bundles of costume sketches from his Ballets Russes days, we'd talk far into the night about beauty and drama. I was convinced he was a true mystic straight out of Dostoyevsky.

With a model, student of Boris Anisfeld, 1948. Author's Collection

But the best thing I learned from Anisfeld was his common sense. I remember one morning in class when he singled me out for one of his personal tutorials.

With his piercing gaze trained on me, he brought his left hand to my eye level, his forefinger pointing upward. "Look!" he commanded. He then circled his right forefinger around the left. "You see how round the finger? Both fingers are round! Every part of body is round! When you paint, you must know this! *Everything* in the body is round! You must use straight lines only for style!" The concept may have previously occurred to me—or maybe not—but I realized it was a simple observation that every artist should know. There are no straight lines in nature. Nature is as voluptuous and busty as a Rubens Venus.

Another morning, as we were squeezing color on palettes in preparation for the day's classes, a white-haired woman, easily eighty, in a floor-length skirt and shawl, began slowly weaving her way through our easels. Carefully stepping up on the model stand, she settled into position, hands folded in her lap. It was a first. We had never had a costumed octogenarian as a model before.

Mitzie *by LeRoy Neiman. Litho Pen on Scratchboard, 1948.*
Author's Collection

Her presence and sense of style suggested a nineteenth-century favorite of mine, Adolphe Monticelli, who had died of absinthe consumption, possibly explaining the thick, crushed jewel-like surfaces he favored. Intoxicated with the green poisonous alcohol, he saw life encrusted with amethysts like a Byzantine painting. I'd just seen Monticelli's portrait of his mother upstairs in the museum. Now here she sat before me. Confident of my interpretation, I was on a roll when I noticed Anisfeld making straight for my easel. Eyes twinkling, he said, "Ha! Ya! You try to be Monticelli, but it still turns out to be *you!*"

Well, then you have to ask, who am I? I didn't always know who that was, but I knew who I wasn't. You find out who you are through the paintings you're obsessed with. I gained my own awareness through the Art Institute exhibitions, from the 1948 Van Gogh retrospective, to the US Army's blockbuster of rescued Nazi art plunder, the Berlin Masterpieces, to

a stunning display of French tapestries. But the real TNT was the Abstract Expressionist Exhibition.

Jackson Pollock, Willem de Kooning, Marca Relli, Franz Kline, and Philip Guston sent shock waves through the school. The paint surfaces writhed. Space expanded and contracted instantaneously. I was particularly struck by the way Pollock and de Kooning metamorphosed paint. The jolt it gave me was both frustrating and invigorating, like witnessing a powerful switch from one way of seeing the world to another. Even if I would never paint like Pollock or de Kooning, I was still psyched.

Art history since the Renaissance has been the history of toppling the statues of former gods of art. Violent arguments erupted over what mattered and what was irrelevant, and factions formed among the students, each side claiming superiority, demonstrating its claim to a recently canonized past genius. It was considered mandatory to stay vigilant about who was in and who was out.

Seated Nude *by LeRoy Neiman. Charcoal on Paper, 1947.* Author's Collection

I stayed out of it. Instead, I pored over the Renaissance drawing books in the Ryerson Library. I examined Bonnard's scintillating use of vibrating colors and Cézanne's subtle compositions. I'd not previously had any interest in caricature, satire, or even English painting for that matter, but I was instinctively drawn to the eighteenth-century English satirists. I loved the ribald gusto of Thomas Rowlandson, a great draftsman who drenched his social commentary in his fluid watercolors. I was crazy about William Hogarth, an engraver by trade, who worked out his ideas on canvas before making an engraving and impaled hypocritical English society on his spiky prints. And then there was Daumier, whose wry narratives and teeming cast of characters plain blew me away. I wanted to figure out how to transpose their satirical barbs to our own contemporary follies.

I could appreciate the breakthrough excitement of abstract expressionism and still identify with artists like Dufy, Delaunay, and Demuth. I found myself gravitating to less current and more controversial second-tier artists. Kees van Dongen was out of favor with the art establishment, but I liked his garish, graphic portraits of high-society women. "The essential thing," he said of these playful but cynical fauve portraits, "is to elongate the women and especially to make them slim. After that it just remains to enlarge their jewels." I also liked his refreshing candor. "Painting," he claimed, "is the most beautiful of lies."

I could see how Matisse's subtle intelligence had guided him in works like *Woman Before an Aquarium,* how he put down what he saw in his mind with an elegant economy of line and form. I compared the way two artists dealt with similar subjects, like Matisse's *A Woman Sitting before the Window* and Dufy's *Open Window.*

I was equally attracted to the boisterousness and blunt style of Dutch genre painter Adrian van Ostade, a pupil of Frans Hals. His tavern scenes of rowdy peasants, hags, and lowlifes brawling, feasting, and drinking, stirred memories of the regulars at my Frogtown saloons. When my instructor John Rogers Cox pointed out my resemblance to an Ostade alehouse character, I checked the Institute's collection, and looking at it, there I was. I could also easily have been the earnest young painter in another Ostade, with a mahlstick in a drafty attic in the throes of painting a new batch of reprobates. It was uncanny, I felt as if I had just walked out of one of his paintings. Ostade's influence found its way into my later bar paintings. Aside from replacing his pewter and earthenware jugs with fancy stemware, the scenes were pretty much the same only my patrons at the bar were twentieth-century versions of Ostade's patrons. Some things never change.

When I learned that Oskar Kokoschka would be a guest instructor at the Minneapolis Institute School of Art, I made a pilgrimage there. I tracked him down at the museum where he was shepherding a group of followers through a Monet exhibit, and fell in with them as Kokoschka sallied forth through the galleries. Suddenly he stopped short in a doorway. On the far wall of the room was a landscape. He paused to take it in, then charged at the painting, bounding across the room until his nose was pressed against the canvas. Another pause. Without taking his eyes off the painting, he began to retreat, glacially, until finally he stopped about fifteen feet away. The gallery stood stock-still. Oskar Kokoschka bent over and tied a shoelace. At last he turned to the gathering and, face flushed, intoned in a slow, grave monotone: "First! . . . you must look at a painting close-up to see only color . . .

only paint! No image! Then! . . . you must back away . . . back away . . . one step at a time . . . and watch it become something more! That's when it becomes clear to you . . . yes . . . that's the way the artist sees!"

What a performance! It notched up my appreciation of Kokoschka to the hilt. Unfortunately it would be my only contact with the great artist because his tenure involved only critique and discussion sessions. Unbelievably, studio classes with Oskar Kokoschka had been cancelled due to insufficient response! So just as I was getting hooked on expressionism, it was on the way out.

I became an eager student of high and low culture. I discovered the ballet, opera, symphony, and foreign films thanks to my friend Bob Addison's long-hair leanings. Sketching the Chicago Symphony Orchestra from high up in the nosebleed section of Orchestra Hall was an impossibility. From that height we'd watch a minuscule Fritz Reiner conducting far below. I'd have to become far more solvent before I would be able to sketch among the elite first-row orchestra seats, and even then I'd have to put up with the lethal glances of concertgoers propped up in corpse-like stillness.

Cool jazz was as close as Chicago's South Side, and there you could see Charlie "Bird" Parker, Dizzy Gillespie, Miles Davis, and Max Roach. I loved jazz for its intimacy and idiosyncratic performers. Listeners and music were crammed together cheek by jowl. You could sit up close, your eardrums pounding with the jarring vibes.

My habit of playing with words and images when I paint may have been planted in my head by Chicago's

Charlie "Bird" Parker *by LeRoy Neiman. Enamel and Oil on Board, 1964.*
© LeRoy Neiman

Miles Davis *by LeRoy Neiman. Enamel and Acrylic on Board, 1985.* © LeRoy Neiman/George Wein's Collection

poetry scene. I'd show up early at poetry readings by e.e. cummings, T. S. Eliot, Stephen Spender, and Edith Sitwell to find the best spot for sketching them up close. One rainy afternoon, after he'd spoken at a reading, Spender stopped by my studio. He took in the series of bar studies I was working on at the time, then tactfully let me know, "It isn't quite my thing, you see." He was a Sam Francis man.

By the late '40s, the Cold War had begun. Now we not only had to deal with aesthetic theories and battling schools of painting, but also the actual end of the world. The atomic bomb, like some nefarious egg, hatched an entire era of anxiety and paranoia. Existentialism had taught us that man was alone in the universe, now he was about to be vaporized by a nuclear bomb. "A-bomb" threats gave rise to ferocious intellectual debates. The University of Chicago was a hotbed of social theories. I squeezed into lectures there and took classes at DePaul University and the University of Illinois.

At art school there was a period when I liberated myself from everything I'd seen and been taught—broke away from it all and decided I would paint things the way I wanted—give a character a green nose or orange hair, anything that made the person or the situation interesting.

Going to art school after the war gave me new strength. I knew what it was to be a nonentity, and if I was going to make anything of myself, I knew I had to do it myself. Once you get caught up with people who are more informed and knowledgeable, more sophisticated and worldly, you're driven to keep up with them as best you can.

I was a kid whose literary resources had been limited to Depression-era comic books. Now I had some catching up to do. I knew I needed to read the weighty works of the modernist masters—Hemingway, Fitzgerald, Dostoyevsky, Gogol, and Baudelaire. Jean-Paul Sartre's *Being and Nothingness* was clearly the essential work of gloom-and-doom literature, along with the bleak and paranoid visions of Franz Kafka and Samuel Beckett. I've read them all by the way, and not because they were part of some required curriculum, but out of the sheer pleasure of experiencing the art of words.

The end-of-the-world party was only just getting started. By the '60s it would really get rolling. Parties, even end-of-the-world parties, were serious business, as I would soon find out when I started working with *Playboy*. My whole career has basically been built on taking man-at-his-leisure seriously! And the seeds of that got planted when I came upon the theories of leisure and man at play, themes that would fuel my work, inspire my style, and resonate throughout my life.

There I was, great piles of books stacked around me, theories and philosophies buzzing around my head like pesky intellectual flies. I began with that old Victorian social mechanic's clockwork utopia, Jeremy Bentham's *Pleasure Principle,* and read Thorstein Veblen's chilling assessment of society, *Theory of the Leisure Class.* I knew this guy was onto something deep and troubling, so I next plunged into

David Riesman's thesis on urban culture, *The Lonely Crowd,* which lead me to poet Reuel Denney's *The Astonished Muse.* The masterpiece of play theory is the Dutch medievalist Johan Huizinga's erudite and whimsical treatise, *Homo Ludens,* which defines man as the playful animal. I read and reread it, delighting in his idea of play as culture.

Everyone has a theory, even Swedes do it. And I was Swedish. Based on my experiences on the family farm, I always felt that Swedish culture was lagging compared to the great achievements of Western Europe, but wending my way through the thickets of philosophy, I came upon the eighteenth-century genius and cultural dilettante, Emanuel Swedenborg. The man was an entire culture packed into one prickly package: economist, mathematician, physiologist, paleontologist, crystologist, and anatomist. He turned out verse and theological treatises in his spare time, claimed to be conversant with spirits and angels, and shocked his followers with the erotic, rhapsodic transports inspired by these exchanges. Was it Swedenborg's talent for rattling cages that drew me to him?

My discovery of Swedenborg inspired a trip back home to explore my St. Paul roots. Every great artist has to paint his mother, and Lydia at fifty, bursting with buoyant energy and feisty spirit, was an ideal subject. I knew I had a knack for capturing a likeness. I sat my mom down in a chair and began to work diligently on her portrait. When I was finished, I unveiled it with a certain cockiness. Was she amazed at my stunning technique? Did she coo with motherly pride? Not Lydia's style. Snatching the portrait off the easel, she headed up the stairs.

"So, Mom," I said (now reduced to fishing for a compliment), "What do you think of it?"

As soon as the words were out of my mouth, I knew it was a mistake.

"You made me look old," she said, as she spirited it out of sight.

The painting lived in the attic for years, and I never dared inquire about it. It was banished so that no neighbor or visiting relative would cast their eyes on it. It was as if I had committed a crime. Then one Christmas twenty-five years later, to my astonishment, I found it framed in the living room. I asked what had provoked her to bring it out of hiding. "Why, it makes me look so young!" she said, as if the answer was obvious.

Back in Chicago, prowling the galleries of the Art Institute Museum, I found my true master: Henri de Toulouse-Lautrec, in the Chester Dale Collection. The Institute owned a Lautrec sketchbook and hundreds of prints, among them his incredible study in asymmetry, the Moulin Rouge. I became fascinated with his

graphic magic. I was astonished at the way he could throw a line around a character and effortlessly capture the foolish vanity of a Moulin Rouge star, the pathos of an aging performer, the brittle nobility of the petite coquette. He seamlessly blended his own graphic personality onto that of his subjects with those flashy, whiplash lines. How did he create these fantastic and grotesque scenes out of sheer line and color? And how could I learn to do it too?

I hounded the curator of prints and drawings, Carl Schniewind, and his assistant, Hugh Edwards. I needed to gorge myself on the work of this sacred monster!

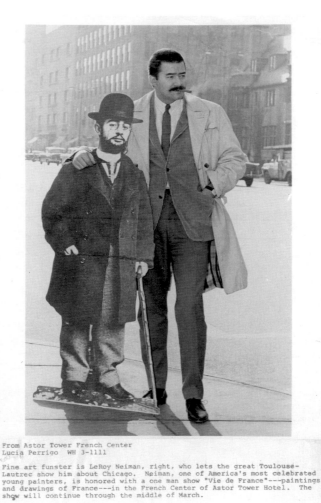

From Astor Tower French Center
Lucia Perrigo WH 3-1111

Fine art funster is LeRoy Neiman, right, who lets the great Toulouse-Lautrec show him about Chicago. Neiman, one of America's most celebrated young painters, is honored with a one man show "Vie de France"---paintings and drawings of France---in the French Center of Astor Tower Hotel. The show will continue through the middle of March.

With a Lautrec cut-out on the Rive Droit. Chicago, 1963. Author's Collection

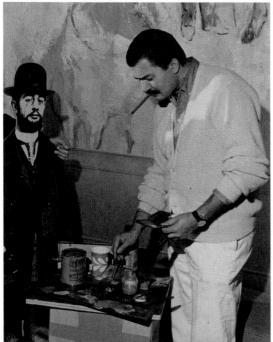

Painting with a Lautrec cut-out. Chicago, 1963.
Author's Collection

And they would dutifully tote out the precious boxes of Lautrec lithographs and prints and let me examine them in white cotton gloves.

Most drawing classes emphasize the weight of the subject, defining mass through shading, delineating muscles, busts, and buttocks. Only fashion illustration encouraged the loose and fluid line of a Lautrec drawing. As I sketched models in class, the example of Lautrec's lithographs was always in the back of my mind.

Lautrec's drawings were essentially graphic telegraphy. What I needed to learn next was how to couture my creations. They needed to go shopping and get dressed up, and this I learned from the elegant wash drawings of Constantin Guys. He taught me how to use costumes as social commentary, to capture the character and atmosphere of the subject in the folds of a gown or the tilt of a hat. One day it dawned on me

Painting en plein air *in Chicago.* Author's Collection

that what I really wanted to learn was how to capture the mood of people in groups, how they act and react together to create a kind of impromptu social drama. In color reproductions of Veronese's *Marriage at Cana,* I was impressed by his use of posturing to communicate emotion, and his ability to create dramatic composition out of social gatherings.

The influence of Japanese art on van Gogh, Lautrec, and Gauguin helped set modern art in motion, but its most long-lasting influence has been on fashion illustration, where the line defines the style. Fashion illustration fed my fascination with the exquisite economy of Japanese prints—Utamaro's graceful women and the erotic picture books of the Ukiyo-e artists.

One day near the end of my third year, Dean Hubert Ropp called me out of class to his office. He wanted to talk one-on-one about my painting. Straight off, Ropp lit into me. "You can't take raw, primary colors at full strength, LeRoy, and jam them up against strong, contrasting values!" I was caught off guard but was typically unrepentant and uncapitulating.

"That's the way I paint," I shot back. Ropp looked at me, one eyebrow raised, then slowly nodded. His response caught me totally by surprise. "I'd like you to teach a class in summer school."

So in the summer of '49 I became an instructor to many of my fellow students, teaching fashion illustration. Upon Ropp's suggestion, I'd tested the waters doing fashion drawings for some retail accounts, along with moonlighting in children's book publishing, my first step into the commercial arena, ironically initiated through my foray into fine art. And I felt the part. I was somehow comfortable in the role of a flashy high-fashion man. I counted on my natural flair for drama and throwing unconventional ideas around to back me up. A successful stint at fashion illustration segued into teaching a life-drawing course that fall. Beyond that, I had a plan. I'd teach for five more years, then combine my SAIC income and freelance proceeds and relocate to New York City.

What made me think my life would suddenly go according to plan? Hadn't I read all

Me in 1948. Author's Collection

the books about the fickleness of Fate, the unpredictability of man's well-laid plans? My carefully thought-out strategies would once again be scrambled. I would end up teaching at SAIC for another ten years, and my long dreamed-of arrival in New York would take a detour via London and Paris. The culprit this time was a creature yet to be incarnated. She had rabbit ears . . . along with other endowments.

Receipt from one of my first painting sales. Author's Collection

4

Underground Artist

They call it the art world, but it's a very small world, after all. I'd been used to surviving in the larger one by my wits and the seat of my pants, but now I was part of the beau monde of art. In 1950 I became an instructor at the SAIC and thus made my entrée into this rarified environment. But the scrappy world I'd come from was my natural habitat—there you could still find gangsters, cops on the take, and babes galore. I loved the raw bravado and rough-and-tumble of the streets, where you had to rely on your instincts. And I wanted to paint that rude, roiling, teeming world and bring it into the well-behaved art galleries and fancy living rooms of Chicago's elite.

My basement apartment on Wabash Avenue was a minimalist environment: a mattress on the floor, ceiling pipes above (convenient for hanging clothes), a table, chairs, a TV on a crate, brick walls, and a floor treatment of wall-to-wall cement. The building's boiler rumbled and squealed like a drunken organ. There were canvases on stretchers—some painted, some raw—paint cans, props, and paraphernalia.

For an easel, I hauled a rickety upright piano down the stairs with the help of my GI Bill army buddy, Cliff Westerman. It came in handy at my BYOB parties until

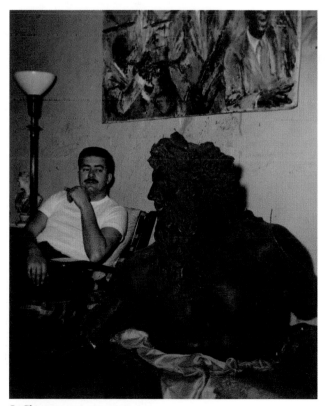

In Chicago, 1955. Author's Collection

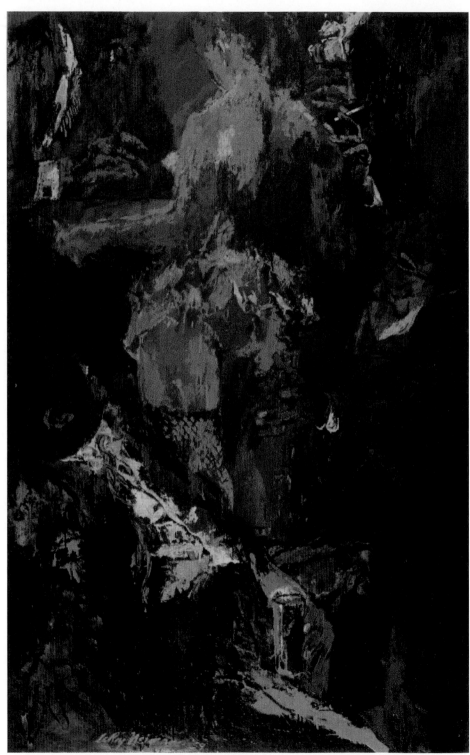

Cigarette Girl *by LeRoy Neiman. Enamel and Oil on Canvas, 1959.* © LeRoy Neiman

the keys got so encrusted with enamel drippings that it could barely play Bartok. Cliff, the poor SOB, left for Korea soon afterward and missed our raucous parties featuring my favorite model, Mattie, who served drinks in a skimpy maid's apron and stilettos. If I was lucky, a temporary live-in would occasionally take pity on me, straighten up the place, and cook a few meals before drifting off. Then I'd be back to eating at lunch counters and Spam in a can.

On nights when the moon was full and the neon flashing, I'd venture out of my subterranean sanctuary like a werewolf to sniff out suitably raunchy subjects in strip joints, gin palaces, and derelict dives on Clark Street. I'd also hit the posh clubs, cabarets, and slick singles bars on Rush Street, where corporate types hung out with conventioneer whoopee-makers in their desperate lunge at merry-making. These scenes were my inspiration for paintings like *Expense Account, New Year's Eve,* and *Cigarette Girl.* The nights were filled with longing, booze, despair, and the eternal search for babes in a landscape of bars and pickup joints, like the mob-run Hickory House, the original Gaslight Club, the Tradewinds, where a young Buddy Hackett packed them in, and Club Alabam, where at Christmas time, the forlorn parking attendant dressed up as Santa.

At the Gigi Club on Clark Street, energetic strippers with bored eyes gyrated on an elevated stage above an oval bar while horny guys ran fantasy scenarios in their heads. It was a fluorescent jungle where the males of the species, six deep, stared through clouds of smoke at a female artificially in heat. Hulking floor men moved threateningly through the crowd, intimidating any patron who had an empty glass in his hand by shining a flashlight at the back of his head.

My North Clark sketchbooks were filled with raw pen and ink tableaux of the lower depths, featuring vice squad dicks collaborating with prostitutes, derelicts, and johns, and beefy cops, their pickup wagons throbbing at the curb for the night's catch. By the end of my crawl, this disturbing brew of corruption, the spiritually desolate, the lost, and the despondent all in pursuit of soulless joy left me emotionally drained, my eyes smarting from the continuous assault of one sordid scene after another—the undertow of humanity in pursuit of frantic fun. It would take me twenty years to venture back into these squalid scenes, this time around for *Playboy,* to illustrate New York's 42nd Street massage parlors. (I was so revolted by this frothy corner of hell that I walked away without making a single mark in my sketchbook.)

In contrast to the seedy nighttime pleasures of the lower depths, Chicago's lakefront district with its five-star restaurants, lavish, glamorous social fetes, and

big-time sports events was a relief—the kind of scenarios I could depict just the way I saw them.

The uptown scene may have looked more reputable, but in reality the criminal element was just more organized. In Chicago, the Cicero mob began courting me—hoodlums and their kids on luxury yachts docked along Lake Shore Drive, boxers in action at the Marigold Gardens. Their commissions were the kind you couldn't exactly refuse, and they always paid in green. In the early '50s, viewers were glued to their TV sets watching the Estes Kefauver senate subcommittee hearings on organized crime, and some of these local gangsters would have fit right in there. When one of these guys would come to my studio, they'd act just like gangsters in the movies, making straight for the window to scope out the street below. They had the readies, but they'd bargain you down, and you weren't about to haggle with them. After they'd negotiated the price down to, say, $500, they'd take their portrait, grab a couple more paintings, pull out a roll of bills, peel off a half-dozen C-notes, tuck the canvases under their arm, and scram.

One bitterly cold Chicago morning, a treacherous-looking guy showed up at my door in a gray Borsalino, navy overcoat, white silk scarf, foulard cravat, and cigar. You knew this guy was an upper echelon gangster. He wanted his mug painted. After casing the joint, he took a long look at me and asked gruffly, "Wheredya want me to sit?"

"Well, I was going to paint you standing. And how about if you keep your coat and hat on too?"

"Aw, sure, whatever ya think—you're the artist, cuz. But make it quick, huh?"

I threw myself into it and then presented the portrait to him. But something was off, and I knew it. It was the eyes. This guy was no common hood, he was a stone-cold killer and it showed—he exuded a chilling aura of cruelty. The portrait needed an icy cobalt blue glint in the eyes. I made the alteration—I'd nailed it! But what would he think? Would he be pissed off at my interpretation?

No way! He peeled off a few bills, grabbed the painting, and headed for the street to his waiting Cadillac. Looking out the window, watching the curls of exhaust spiral up into the frigid air, I wondered how many slugs to the back of the head he'd delivered in his time.

Even when you were on their good side, you had to watch your back with this sort. Be civil, but never get too close. I remember the time Edward G. Robinson came to my first one-man show at Hammer Gallery in New York. I went up to greet the "Little Caesar," a well-known art connoisseur with a great collection of paintings—

Eugène Delacroix, Renoir, Gauguin, Degas, van Gogh, Lautrec, Matisse, and Picasso. It was an honor that he'd come to see my show at all. He took me by the hand and led me around until we came upon a monoprint. He stopped in his tracks, pulled out his glasses, and examined it closely.

"It's Capone!" he said, with that oily smile of his.

I waited. By now a crowd had gathered.

"You know, I never met the big fellah," he said. "Just as well. They treat you good, generous and all that, but you gotta be careful not to cozy up to these gangster guys."

Along with local mobsters, I was drawn to the city's glad-handing local politicos. They were a shifty species, becoming someone else at every turn. For the cover of a controversial political rag, I did a puffed-up Mayor Daley, like he was a tarnished saint, the medallion of the City of Chicago

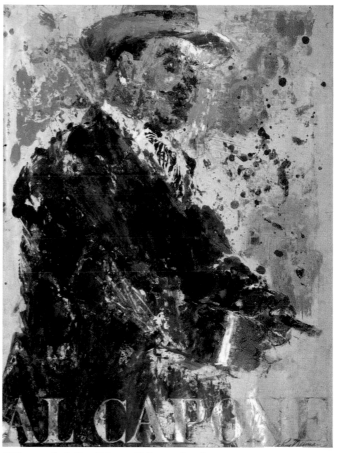

Al Capone by LeRoy Neiman. Lithograph, 1965. Author's Collection

hovering halo-like behind his enormous head. I also caught Daley and Germany's Chancellor Conrad Adenauer—prune face and melon head—in an open car parading down State Street.

Another source of income came from executives who wanted soft-core paintings of their mistresses—interchangeable long-legged blondes.

I pulled out Reginald Marsh's *Anatomy for Artists,* which Mickey had given me when we split up. Out of boredom, I began experimenting with different mediums and techniques. For an odd, unaccountable six months, I passed through a surrealistic, black painting phase possibly related to Baudelaire's poetry, which I was reading at the time. Ruminations like "Evil is committed without effort, naturally, fatally" will make you see the world darkly.

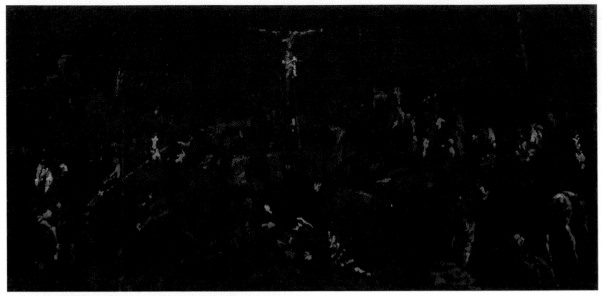

Crucifixion *by LeRoy Neiman. Oil on Board, 1955.* Author's Collection

Or maybe it was instigated by Lina, a girlfriend from Rome, who fed me stories about living under Mussolini's fascism in wartime Italy and praised the futurist painters. She would come out with things like *"Futurismo è l'avenire!"* (Futurism is the coming thing). Through her, I developed a liking for Scipione, Severini, and especially Boccioni, whose wild horses I admired.

Next I went through a brief religious phase in my art—religious art being a niche that had been scandalously neglected since the seventeenth century. I started by imitating the old masters. I made a copy of Tintoretto's *Crucifixion* as well as the two crucifixions from Rubens's Antwerp altarpiece, which I'd seen when I was in the army. To these, I added my own contribution, of Christ being nailed to the cross in Obit, which drew attention at the Chicago Artists and Vicinity Show. One day during Holy Week, I ran into Father Regan from Holy Name Cathedral across from my studio, dragging on a cigarette outside the sacristy. Oh, I thought, just the guy to get a reaction to my work. Who better? I invited him to view my religious oeuvre. We descended into my studio, and I stopped expectantly in front of my version of Titian's *The Entombment,* awaiting his astonishment and benediction. But he didn't pause—not even a glance! No, the good father passed right by the body of Christ and grieving mourners, and made a beeline for the jazz artists and nudes. So much for ecclesiastical assessments—and my career as a religious painter.

I had no problem abandoning the sacred for the profane, but also no intention of spending too much time in my next genre: retail advertising for a commercial art studio. I was all too aware of the drudgery involved in a lifetime doomed to laboring over drawing boards—tense, overworked, and mindless illustration, excruciatingly detailed. I was an arrogant upstart on his way, well, to something better. I had nothing but contempt for the lifers, like the diligent and dedicated Marcella with her meticulously rendered tableware, pots, pans, and toasters. I couldn't resist pointing out that she'd missed something in the drawing she had made of a pot. "Take another look," I said. As we leaned into the shiny metal surface, our distorted reflections peered back, like leering fish-eye demons. Marcella was mortified. After making my point, I felt ashamed—I'd embarrassed an earnest and hard-working artist over a petty point of view.

What was going to become of me? What was I going to do with my life? When I met the saucy, raven-haired copywriter, Janet Byrne, I didn't actually think, "This is the woman I'm going to spend the rest of my life with." Her reaction to me wasn't exactly a revelation either. As I approached the desk where she was working, she murmured to an assistant, "Check out the one with the built-in smirk, here comes trouble." And she can't say, after fifty-plus years of marriage, that I didn't live up to her first take on me.

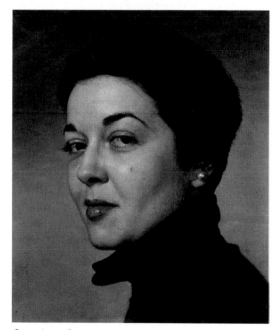

Janet in 1958. Author's Collection

Janet soon became the creative director of a fashion agency specializing in hats designed by the likes of Lilly Dache and Walter Florell. One of these millinery mavens designed the "Mac Hat" as a tribute for Douglas MacArthur's parade down State Street after President Truman recalled him from the Philippines. I put my version of MacArthur's hat cocked at a rakish angle on Janet and put his corncob pipe in her mouth. That was my last job for that client, which was just fine with me. Despite my orneriness I got a Chicago Art Directors award—but I'd had it with this nonsense.

My most ambitious campaign involved persuading Janet that I was the one for her—not an easy undertaking, to prove that an unknown, penniless artist was a better

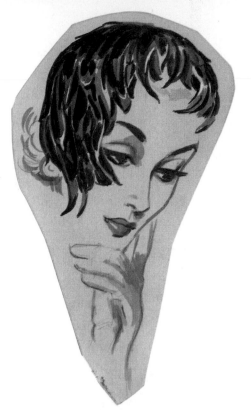

Fashion illustrations of Janet.
Ink on Paper. Author's Collection

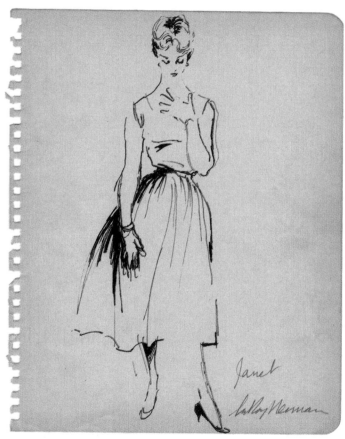

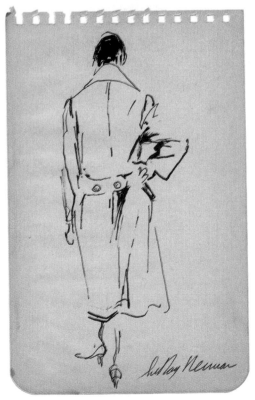

catch than some rising executive. And my methods weren't exactly conventional either; they consisted of getting her to model in my evening fashion illustration class followed by dinner and the Friday Night Fights on TV. But for reasons still a mystery, it worked, and eventually she capitulated to my half-assed charms.

The war had changed American culture. In the '50s the notion of "lifestyle" was taking hold, and a fresh batch of savvy monthlies was feeding into it, seeking out adventurous, unconventional types to create their editorial. I began taking assignments from *Chicago* magazine, first of the city-life publications, which featured Claes Oldenburg, a young Swedish art director and the future pop artist, who would put outrageous sculptures in public spaces: a huge clothespin, an enormous smashed ice cream cone on top of an office building, and a giant spoon with a cherry on it. "I am for an art that is political-erotical-mystical," he declaimed, "that does something other than sit on its ass in a museum." And he wasn't kidding.

Chicago magazine sent me on a junket to Cody, Wyoming, to cover the promo of a recently published book on Buffalo Bill. It was my first taste of the art of media freeloading. They put me on a United Airlines Mainliner with an entourage of heavy-drinking, skeptical, acerbic TV news editors and journalists. These guys were a new species to me, the most outrageous being the flamboyant top-hatted gourmand and pundit, Lucius Beebe, correspondent for the *New York Herald Tribune* and the *New Yorker*. He said his function was "that of a connoisseur of the preposterous. . . . I did have a fabulous time. I did drink more champagne and get to more dinner parties and general jollification than I would have in almost any other profession." A man after my own heart.

Part of the new lifestyle of the '50s was getting rid of the old prewar prudishness, and lo and behold along came a new batch of skin magazines to fulfill the libidinous itch lurking in the minds of men. *Esquire* had pioneered risqué illustration with the infamously erotic Vargas girls—considered so outrageous that the government had threatened to take away the magazine's second-class mailing privileges. But that was back in the '40s. Times had changed even further—now the public demanded less censorship and more skin. And while he was working at *Esquire,* the first inklings of a new kind of girlie magazine had occurred to my friend Hugh Hefner. It would be more provocative and sophisticated than anything the world had yet seen: porn with cachet. His *Playboy* magazine would be billed as "Entertainment for Men,"

introducing a new generation of postwar professional males to the pleasures of life and fleshy delights.

I liked Hef from the minute I met him, which, coincidentally, goes back to the same day I met my future wife, Janet, up at Carson Pirie Scott department store where they were both working and I was dabbling with fashion illustration on the side. Janet was writing copy for the women's advertising. Hef was writing copy for the men's. An ambitious young kid from Chicago's South Side, he had written, illustrated, designed, and self-marketed a book called *Toddling Town*.

With our shared graphic interest, it was inevitable that Hef and I would cross paths among the maze of cubicles that housed the beehive of workers in the marketing department. Mostly we carried on water cooler conversation, but enough to be aware of each other's work and know that we clicked. Then one day Janet and I were walking down the street, and here comes Hef in the other direction. Without missing a step as we passed each other, he shouted out, "Hey LeRoy, I'm starting a magazine. Will you do something for it?" No standing on ceremony. No chance to let him talk me into it. But that random passing would lead to a future neither of us was ready to imagine.

Playboy would include intellectual subjects, serious fiction, avant-garde art, hip graphics, racy humor, full-page cartoons, and a Playmate of the Month amply displayed on the now immortal *Playboy* centerfold. The idea was made for me, and I jumped in. The first thing I did for *Playboy* was to illustrate a short story called "Black Country" by Charles Beaumont, about a jazz musician who blows his brains out. It got *Playboy* its first prestigious prize, a Gold at the Chicago Art Directors Awards. After that, Hef gave me a bunch of assignments, working on special features. Meanwhile, I was getting overtures from *Chicago* magazine to work for them exclusively, and Time-Life's newly launched weekly, *Sports Illustrated,* was putting out feelers. Hef insisted I choose my loyalties.

I soon took on the label of *Playboy* artist in residence. Was there really a choice? At that time, *Playboy* was mainly Hef's heady daydream, but there were major perks: girls, parties, and seriously good times. It was no contest. I'd go exclusively with *Playboy.* It's easy enough in retrospect to say, "Well, that couldn't have been too hard a decision," but that move was to have significant unforeseen consequences for my future. Was it the best decision I've made in my life? The worst? Or just the next in a long series of choices based solely on instinct? My art friends warned, "Watch out, LeRoy, that's the first step down the slippery slope. You have to decide if you want to be a serious artist or associated with tits and ass." I didn't see it that way, and

in any case, I was irresistibly drawn to the subject matter and scene. A life of following my intuition and jumping in the deep end (to hell with the consequences) had taught me to go for it. If you don't, you might end up painting your reflection in the latest brand of toaster. And often when you go for the conventional choice, it evaporates. Who would guess that Hef's girls-next-door would flourish and *Chicago* magazine fold in six months?

To get from my Wabash basement to *Playboy*'s brownstone offices at 11 East Superior Street and avoid the gale-force arctic blasts of the Windy City, I'd duck through Holy Name Cathedral—which was ironic seeing as the Roman Catholic Diocese of Chicago would join the wave of contention that soon arose over *Playboy*'s explicit content.

On June 22, 1957, I paused at that altar to marry Janet Byrne, having successfully worn her down to say, "I do." We split our honeymoon between Miami Beach and Saugatuck, Michigan, where I was a painting instructor at the Art Institute's Ox Bow Summer School—then we headed back to Chicago.

I wanted my new bride to meet my father, and what better excuse than to celebrate Father's Day with him. On the way, we stopped in St. Paul to visit my mother before continuing on to Duluth, where we found Charlie in a rundown bar at the Holland Hotel on Water Street. We drove north together to the latest SRO he called home in Two Harbors, Minnesota. Halfway along the thirty-five-mile drive, he spotted a familiar filling station. "Pull over," he shouted excitedly and jumped from the car.

"What's up, Dad?" I asked.

He pointed to a graveyard across the highway.

"Gunda is buried there," he announced forlornly. Gunda was his

A photograph of Janet and me while we were dating. Author's Collection

fifth wife. "When she passed on I was beside myself," he sighed, "for darn near two weeks!"

When we reached Two Harbors, Charlie led us to a ramshackle boarding-house long in need of a paint job, rocking chairs strewn along a wraparound porch. We followed him up the stairs, down a creaking narrow corridor, and past a communal toilet to his single sleeping room. He unlocked the door, and a mangy dog bolted from the dark interior, tail wagging desperately.

The happy mutt pranced around him as he switched on a naked bulb hanging from a cord in the center of the room. It shed a halo of light on a dismal, lonely life: a corner sink and mirror with straight-edge razor, shaving soap and cup, bar of Borax laundry soap, and a ragged towel. A clothes rack on wheels stood between an unpainted Chippendale highboy and a single unmade bed. Next to the bed a night table held an alarm clock, ashtray, and two framed photographs. We looked at the pictures—two boys with faces beaming. "These are my two sons," he said proudly, pointing to half brothers I'd never met. "Kermit, he's aged fourteen, and this is Earl, sixteen." Even back then, he was so far gone he'd forgotten that Earl was also the name of my older brother.

We didn't stay long. We hugged. Charlie gave Janet a wet smack, and we drove away. He stood at the curb waving good-bye. As I watched his figure recede into the distance, I could feel he knew I loved him, but I knew it was the last time I'd ever see him.

Back in Chicago, Janet and I settled into our bohemian lifestyle. We now had a brand-new appliance, for Hef had contributed a new-fangled electric coffee percolator to the wedding loot.

My next mission for *Playboy* would involve market research, and I didn't have a clue about any of it. But that's been true of many things I've gotten involved in during my life. This project was for the magazine's second year inaugural issue. Hef asked me to define the *Playboy* audience in a black-and-white illustration to be used in a double-page spread asking, "What Kind of Man Reads *Playboy*?" The ad would face the magazine's first fashion piece, "The Well-Dressed Playboy," and also run in the industry bible, *Ad Age*.

Without marketing gurus or stats on demographics to distract me, I set to work concocting the Playboy Man. After hours of trying to define this guy, I realized it wasn't going to be easy. To begin with, how the hell could I materialize Hef's daydream? In other words, I had to create the ultimate hip, sexy, sophisticated, immaculately tailored man of the hour. Hef was obsessed with the image of this zeitgeist gent—the late '50s fantasy male—completely identifying with the man. Even if Hef wasn't exactly the spitting image of this guy, he considered himself the

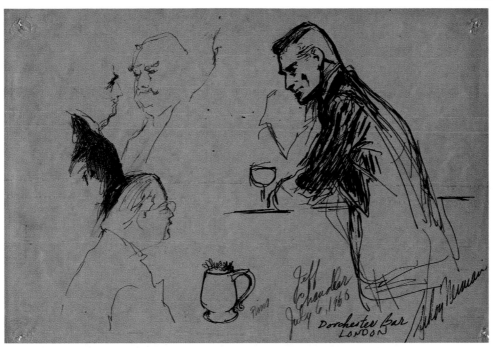

Jeff Chandler at the Dorchester Bar *by LeRoy Neiman. Ink on Paper, 1960.* Author's Collection

embodiment of the Playboy image. So now I had two problems: create a new, red-hot male to symbolize the magazine's essence, but make him an homage to Hugh M. Hefner.

How do you concoct a highball mixing, cool-looking, impossibly handsome Frankenstein? It finally dawned on me: Select two current heartthrobs and mix them. Take one part the ruggedly handsome Jeff Chandler and one part the darkly debonair Cary Grant—shake and stir into the perfect Playboy cocktail. The result was the epitome of cool—a full-length, elegant standing figure, the new Renaissance man posing in late '50s contrapposto—right foot casually crossed over left, right arm leaning on an umbrella. Behold the Hip Urban Male incarnated: button-down collar, ample cuffs, and wingtip brogues (the executive shoes of the day). Standing out against the high-rise city skyline of Chicago's Gold Coast, radiating the supernatural vitality, confidence, and successful stance of the postwar American male, he was It. New! Improved! The all-American Playboy Man. When I presented him to Hef and the promotion director, Victor Lownes III, they whooped in unison, "He's our guy!"

I'd thrown in my lot with *Playboy*'s irresistible distractions, but I was still teaching art and trying to figure out how to paint like myself. The style of the hour was abstract expressionism—Jackson Pollock, de Kooning, Franz Kline—but as hard as I tried, faces and figures would poke out at me from the surface of the canvas, saying, "Hey, look who's in here, LeRoy, why are you trying to cover us up?" To hell with surrealism, futurism, or ab-exism! Even when I'd start a painting in abstract, there was a subject lurking: a face, a place, a scenario would seductively emerge. I'd slap on paint, covering the surface, and out of the chaos, fragments of insolent images demanding to be materialized would present themselves. What the hell is that, I'd ask myself. By God, that looks like a hotshot at a baccarat table! Put a babe at his back and I've got a bang-up Vegas painting.

But neither wind nor hail nor dark of night, nor *Playboy*'s seductive enticements, kept me from my pursuit of Art, which involved submitting my paintings to exhibitions and group shows judged by busybody jurists. When I set out to paint realistically, I thought, "Now this really works!" I couldn't wait to show my underworld paintings, my original take on the lower depths. The art world, I thought, will be stunned. Figures materializing out of pools of color—who'd ever done that before? I contributed my grotesque *Laughing in a Bar* series to a sociological exhibit at Chicago's Sherman Hotel in '51, held one-man shows at the short-lived 750 Gallery and at Lincoln College, and showed regularly at Detroit's Anna Werbe Gallery, where young Chicago artists were featured. I also showed at a Marshall Field's exhibition, displaying my work in the store's galleries with South Side black sculptor Marion Perkins. I even managed to sell some Dufyesque oils.

I was moving up, getting into the elite gallery scene. The Oehlschlaeger Gallery on Oak Street was the first established gallery to take my work—on consignment, but still. The Beard Gallery, a nondescript operation on South 10th Street in

People Laughing in a Bar *by LeRoy Neiman. Charcoal on Paper, 1952.*
Author's Collection

Minneapolis, also took consignment pieces from me. There a gay, world-weary, somewhat sweaty but well-meaning dealer examined my work, made an assessment of my talent, then leaned in toward me and conspiratorially whispered: "Go to Paris and paint. [beat] I learned everything about making love in Paris." In a few years I would be on my way there, but under entirely different circumstances—by then I wasn't trying to become an avant-garde artist and I no longer needed lessons in making love.

The first art dealer who expressed serious interest in my work was Myrtle Todes. Her gallery was in Glencoe, one of the exclusive North Shore suburbs of Chicago on Lake Michigan. Myrtle said she'd admired my painting, *Canyon,* at the 1955 Carnegie International in Pittsburgh, and wanted to hold a one-man show of my work at her upmarket gallery in moneyed suburbia. I eagerly accepted. Her one condition was that there would be no mention of my association with *Playboy,* a condition that should have been a red flag right there and then as to my fate in the art world—but I paid no notice.

Janet and I, fully pleased with ourselves, cruised up Lake Shore Drive for our first meeting with Myrtle in my new red Ford convertible loaded up with my paintings. We were greeted by a gushing Mrs. Todes as we leaned the paintings up against the gallery walls. She loved the work, but when she'd finished examining them she paused and said, "Is that all of them?" I gathered from her remark that something was wrong, but I had no idea what it could be. "Where are the Western landscapes?" she asked in a troubled voice. "Where is the one from Pittsburgh?" Western landscapes? Who did she think I was, Frederic Remington? She seemed to be under the mistaken impression that I was a painter of mesas and Navajo. What was she talking about? Increasingly agitated she said, "They didn't return *Canyon* at the close of the Carnegie?" Now it dawned on me. Oh, that canyon. *Canyon* wasn't a ravine in Utah—it was a bird's-eye view looking down at Wall Street from a skyscraper forty-five stories up. Myrtle clearly knew

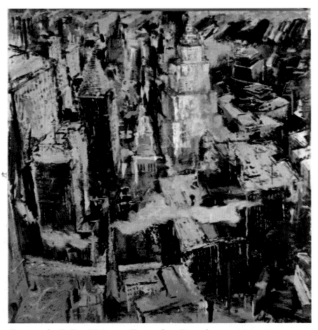

Canyon by LeRoy Neiman. Enamel on Board, 1953. © LeRoy Neiman

the difference between Monument Valley and Wall Street. Obviously, she hadn't actually seen the painting, she'd just read the Carnegie International catalog that listed my work, with no reproduction of it.

Despite my art's lack of sagebrush and cantinas, Myrtle had nothing to worry about. My paintings were reasonably priced and sold well. The best thing about the show was the reviews. In the *Milwaukee Journal,* Frank Getlein wrote that Neiman "has for several years been regarded as one of the most promising young Americans . . . at the Todes Gallery, he redeems the promise." This guy really got me. About my bar series he said, "He has staked out a certain area of American urban life as his own personal field of operation . . . evolved a painting style perfectly suited to say what he has to say. . . . Neiman is a man who goes to the saloon to sketch, to look, to penetrate." In the *Chicago American,* Meyer Levin came up with a review I might have written myself: "It is still a mystery how any one painter can seize your eye, make himself known. One young man who has that ability is LeRoy Neiman of Chicago. . . . His recent one-man show confirmed the impression that this artist has something of his own to say." Levin had hit on my natural inclination. Bars and nightlife were my chosen sublunar landscapes. I wasn't a tourist in these milieus. I'd brought that seedy melancholy of two o'clock in the morning revelry alive and breathing into the white-walled sanctuary of the art world. Without really thinking about it, I had hit on subject matter that combined both my lifestyle and my art—social life high and low would be my turf and shape my future.

I was still teaching full time at the School of the Art Institute of Chicago and getting into group and solo shows—but truth be told, I hadn't yet figured out who I was as a painter. In every artist's life there's an epiphany, the turning point that crystallizes everything that came before. I remember my turning point as if it were yesterday. One Saturday afternoon in '52, Louie, the janitor for the apartment building next to my studio, was carting wheelbarrows of quart and gallon paint cans to a dump truck. When I asked what he was up to, he shrugged. "Gotta get rid of all these half-empty cans left over from painting the apartments!" I looked at the labels. All high-gloss enamels. "Can I take them off your hands?" I asked. Louie was more than happy to let me have the lot. Back in my basement I lost no time pouring and dripping straight from the can, the paint dribbling and splattering, puddling and meandering like multicolored snakes. Then with artist's palette knife and basic plastering tools I began spreading and swiping the thick, lustrous fluids. Since that day, liquid enamel paint and later adding in liquid acrylics have been my chosen mediums.

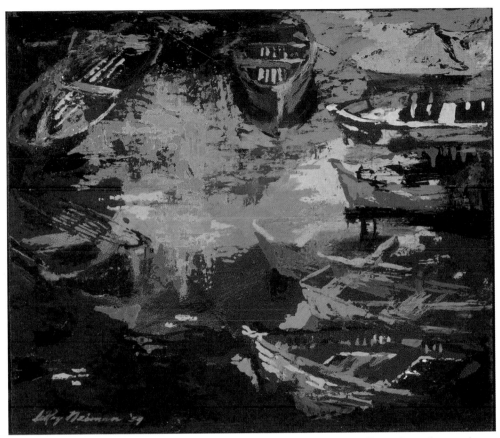

Idle Boats II *by LeRoy Neiman. Enamel on Board, 1959.* Idle Boats II *is stylistically similar to the award-winning 1953* Idle Boats. © LeRoy Neiman

When I showed Janet the first painting in my new fluid style, she named it *Idle Boats*. It was a breakthrough, and museums were the first to see it for what it was. They began throwing awards at me and acquiring my paintings: a first prize at the annual juried Twin City Shows in '53, which the Minneapolis Institute of the Arts bought on the spot. That accidentally-on-purpose trickle-and-dribble style was getting me a lot of traction. I picked up a second prize for *Men, Boats and the Sea* at the Minnesota State Show in '54, and was included in the Collectors exhibition at the Walker Art Center in Minneapolis. My new technique became so successful that I began shipping the oils to my mother in St. Paul so she could enter them in local exhibitions, lugging them to the shows and collecting them after, proud as a peacock when they picked up an award.

I was hardly a kid, but whatever worked. Confusion about my age was something I'd profited from more than once. I'd developed a habit of lying about my age from when I was a teenage punk, cadging drinks from a distracted bartender. I probably hadn't been all that convincing, but it was the Depression, times were tough, and they just looked the other way.

When it was convenient, I practiced the art of deception in the other direction. At age thirty, I was invited to participate in a national exhibition of young, emerging artists but when I gave my age, I was disqualified—the age limit being twenty-five. It was easy for me as a skilled draftsman to add a line to my birthdate—1921—and turn it into 1927.

That graphic sleight of hand worked to my benefit except during the Vietnam War years—I'd made myself too young to have fought in World War II. It annoyed the hell out of me to hear comments like "What do you know about war?" or "Your generation lucked out!" Finally, in 2001 I came clean on my eightieth birthday, taking advantage of the dubious honor of being an octogenarian, and the opportunity to brag about having "shit on the battlefield" in WWII.

My lifelong involvement in the sports arena began that day on the football field at the Bears' game. I realized then that if I was going to capture the energy and thrill of sports, I had to get into the thick of it and not just be a distant observer. These were the early days—no media-driven events, TV extravaganzas, players' agents, or cheerleaders in skimpy costumes. Just a dozen pro teams with a bunch of animal names. Back then I had no idea where my involvement in sports would lead me.

I'd hung out at racetracks since my student days, heading out to Cicero's back-to-back proletarian tracks, Hawthorne and Sportsman's Park. I now set my eyes on the elegant clubhouses at Arlington Park, north of Chicago, and Washington Park on the South Side.

I loved flat racing. In vivid contrast to the racetracks of my youth, the social spectrum was on grand display here. It was some scene: millionaire breeders, owners and syndicate investors, horse trainers and race strategists gathered in the paddock along with the jockeys holding the race in their reins, the grooms who lived and sometimes slept with the animals, and the hot walkers and stable hands who, after rooting their champions home, waited along the rail at the finish line to return the sweating horses back to the barns. And as always the rabid fans screamed from the stands, the bettors with furrowed brow and stubby pencil figuring the odds, and the in-the-know kibitzers touting Midnight Dancer over Mr. Miami in the second or cogitating whether Tea Biscuit really had the goods to outsprint Trixie

in the fourth. All encircled the paddock, assessing the status and style like insiders, making studied picks, and heading for the betting windows.

It was a light operetta going on right in front of my eyes, with all the characters straight out of central casting—star players and thoroughbreds, man and beast alike. I wanted to communicate that heart-pounding excitement of a day at the races and the colorful crew these events attracted. And track presidents, devotees, handicappers, turf writers, and members of the betting gentry all accepted me as one of them.

I never got tired of witnessing the near mythological fusion of jockey and steed, that centaur-like man-horse fusion, where the one becomes inseparable from the other in the headlong rush toward the finish line. The horsey set could tell I loved the sport, and owners and fanciers snapped up my work, hanging my canvases in their clubhouses alongside master painters of the horse, like George Stubbs, Sir Alfred Munnings, and Degas. By the late '50s, track presidents began to sponsor exhibitions of my equine work. Forget the fancy galleries—I had exhibitions at Belmont, the Big A (Aquaduct), Saratoga, Monmouth Park and Atlantic City in the New York area, and the snazzy tracks in the L.A. area like Santa Anita and Hollywood Park. At Churchill Downs there's a nine-by-sixteen-foot canvas of mine, *Stretch Stampede,* in the entrance to the president's office. By the '70s they were naming races after me.

You meet an interesting breed of person at the track. In '76 I was in the President's Box at Sportsman's Park sitting next to the legendary big band leader Cab Calloway the afternoon they named the fifth race, "The LeRoy Neiman." As the horses thundered by, Cab reminisced about the days when his band played Capone's club in Cicero. Pointing to a set of seats below us, he said, "See that box? That was Big Al's box." He stared silently at the box for a minute, then looked back at me, eyes moistening, and said, "This was Big Al's track."

At Arlington in '59, I made my first sketch of a jockey, the controversial Bill Hartack, known for his frequent run-ins with racing officials, trainers, owners, and the press. I was sketching Hartack from the respectful distance of the spectator side of the paddock rail when he strode over, curious about what I was up to. We talked, and I showed him my sketch. He liked what I'd done and volunteered to pose in the silk room, showing up in fresh silks and reappearing to be sketched between races for the rest of the afternoon. After that we became fast friends.

The jockey is a breed apart—you can't just decide you want to be one—you're either born that way or you're not. Being short, compact, and high-strung instills a kind of built-in swagger, and I loved catching that cocky, preening jockey stance.

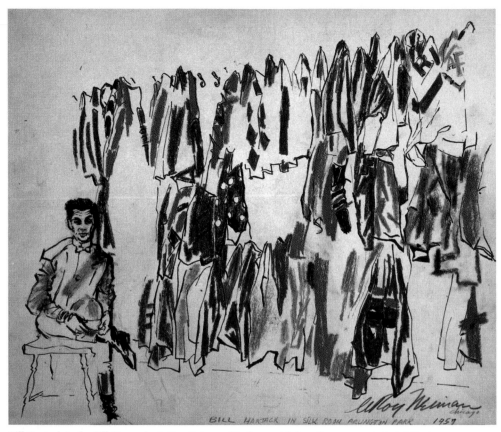

Bill Hartack in the Silk Room *by LeRoy Neiman. Marker and Ink on Paper, 1957.* Author's Collection

In time I got their body language down so you could read it from any angle. "Neiman's painting of a jockey from the back, with arms akimbo, was best in show," a critic wrote about my exhibition racing paintings in the Chicago Public Library Art Room. I got up close and personal with a bunch of these stakes-winning jocks, like Hartack, Bill Shoemaker, Angel Cordero, Lafitte Pincay, Eddie Arcaro, and Cash Asmussen (a tall drink of water), and I eventually became friends with most of them.

I sketched Eddie Arcaro in the tack room during the Flamingo Stakes at Hialeah. "Banana Nose," as he was known, was a classic picture rider, the best. He always behaved like the reigning king of the track he was. As we headed for the paddock, Eddie turned to me as he was slipping his armband on his sleeve. "Young man!" he said, with a voice of such regal authority I at first didn't realize he was

talking to me. I looked round for the rookie jock he was addressing, but it was just me and Eddie. "Whatever pictures you do around the track," he continued, "make sure they're good for horse racing." He didn't need to remind me of that—I had been track mad since I was a teenager.

I became such a fixture at Hialeah that the owners put a stone cottage at my disposal just off the fence at the turn for the home stretch. It was the perfect vantage point for taking in the action—and a perfect setting to do nude studies on the roof between races until I got word from management: "Neiman, stick with the four-legged creatures! We don't want you distracting the jockeys with your hijinks."

What could be better than stabling at the horse track? I loved watching the horses gather, cantering and milling around before being led to the starting gate. Suddenly they're off at such speed they seem like they're airborne. In the heat of the race, they'd round the clubhouse and storm into the home stretch, hoofs pounding down the straightaway toward the finish line, the roar of the fans reaching a supersonic chorus of excitement, anticipation, their whole being fused with the galloping horses, man and horse overcoming the limits of the physically possible. That all-enveloping sound rattled your bones and stunned your mind in one ecstatic moment. It became so addictive I often climbed to the roof of the stands to feel the vibrations from below. Then, almost eerily, as the race ended, the noise would subside to a murmuring hush.

After the races, hot jocks like Guistines and Hartack, and their apprentice "bug boys," would gather for happy hour at my makeshift studio, with pretty women in their wake. As the sun slipped behind my flower-covered cottage (dubbed "The Belvedere" after Marie Antoinette's music pavilion at Versailles), I saw my future unfolding before my eyes. Work and play were beginning to blend seamlessly.

Hef, me, and Macbeth at the Playboy mansion. Author's Collection

5

Me, Hef, the Femlin, Lenny Bruce's Laundry, and the Bunny Dorm

The Femlin leaped fully formed one Thursday night in '56 after a chat with Hef. She was a little erotic goddess you could (almost) put in your pocket, weighing five pounds and measuring just two hands high. More than half a century later, she still looks as fetching as the day she was born.

Hef fell for her right away. "What is it, though?" he wanted to know.

"It's a gremlin." I said. "But it's female." (British pilots in World War II had blamed engine trouble on gremlins—definitely male mechanical menaces.)

"Oh," he said. "Then it's a Femlin," a combination of "feminine" and "gremlin" that came straight out of Hef's fevered brain. He was always thinking, always cogitating. You could tell by the pipe. Pipes are philosophical; deep, ruminating thinkers smoke pipes. The pipe was an ideal prop for Hef to enhance his image and attract girls. He's a movie freak, and famous movie stars smoked pipes. The great fictional deductive thinker Sherlock Holmes smoked a pipe. The first time Hef came out with a pipe was on the TV show *Playboy After Dark.* He was holding it the way you hold a cigarette, so I went over to him and said, "Hef, you don't hold a pipe like that, hold it by the bowl." The devil's in the details.

Here's how the Femlin happened: Hef wanted to liven up the Party Jokes page.

"Draw something, LeRoy," he said.

"What do you suggest?"

"I don't know . . . a symbol, a sexy something." Hef was always fomenting. "We've got to do something," he'd say. Time was rushing by and the Playboy moment couldn't wait. Then a few minutes later, "LeRoy you know you are the guy to do it." He kept after me, and finally I came up with this frisky creature. Hef might have thought I'd just whipped it out. But I never just whip anything out; I

Even then Hef was work obsessed and woman crazy—exactly the combination that made the magazine a success. He loved the idea of working and playing at the same (frenetic) pace. In fact, Hef thought work and play *were* the same thing, which was one of the secret formulas of the magazine—the Playboy Philosophy in a nutshell. It didn't take me long to adjust to that scene, and pretty soon they were flying me here and there, and that was my life. For years I lived between the Playboy mansion and the *Playboy* office, along with painting in my studio, traveling, and navigating the art world.

Playboy Bunny *by LeRoy Neiman. Marker and Ink on Paper, 1965.* Author's Collection

When I started contributing to *Playboy,* I was somewhat of a prima donna, but I loved being in the magazine; it gave my work visibility. In the beginning some of my work was pretty abstract, but I never heard any criticism about it. Later, when I had more time, it got to be more fun. Like the origin of the Bunny. *Playboy* needed a mascot. A sexed-up monkey? Then Hef said maybe it should be a rabbit, or better yet, "The Bunny," and we all lit up at that. It just felt right: "The Bunny."

The first Playboy mansion was a gracefully aging house at 1340 North State Parkway in one of Chicago's grand old patrician neighborhoods. A few months into the mansion's career, Shel Silverstein and I walked in on an important meeting in its grand ballroom. Silverstein, cartoonist, songwriter, playwright, author of children's books, all-around genius, was my partner-in-crime. He had been in the Korean War and was working as a reporter, still an unknown, when Hef wooed him over to *Playboy.* Hef's antennae were always out to recruit hot new finds, and as soon as Shel started contributing, *Playboy* snatched him up. The two of us became fast friends, always horsing around like a couple of kids, and whenever we showed up, Hef knew it was best not to encourage us. So when we crashed the ballroom meeting,

we were promptly ignored. No problem, there was plenty to view. A young designer was presenting her first fitting of the Playboy Bunny costume on a shapely, in-the-flesh model for Hef and his brother, Keith. Bunny ears were already in place,

and with a few revisions—a pinch here, a hoist there, the installation of bunny tail on derriere—the Playboy Bunny was born, all accomplished without a single suggestion or endorsement from Shel or me. Hef added the bow tie, collar, and cuffs to the bunny costume to give it a touch of sophistication. Who knows where the bunny costume would be today if we'd been allowed to weigh in?

Shel Silverstein drawing me, 1960. Author's Collection

The first Playboy Club opened in 1960, on Walton Street just off Chicago's Magnificent Mile, and was an instant hit. The new bevy of Bunnies wore scanty costumes with hiked-up bosoms, fishnet stockings and stiletto heels, formal starched collars, bow ties and cuffs, and improbable rabbit ears and tails. They were Western-style geishas that keyholders could ogle but not touch, according to rules upheld with vigorous vigilance by the Bunny Mother. Adding to the Bunny guidelines, Keith Hefner formulated the "Bunny Dip," a courtesan-style pose performed when proffering a customer's drink, more a sort of curtsy while balancing a generous exposure of ample cleavage.

The sophisticated indoor playground of the Playboy Clubs offered men adult entertainment that was acceptably sinful. The goings-on all took place in the dubious parenthesis of the "Playboy Philosophy," forged by Hef with memos that flew out of his lair daily. Other CEO's correspondence might have had headings like, "From the desk of . . ." Hef's should have been, "From the bed of . . ." since his bed in the round would eventually become his standard place of business. The Playboy Philosophy became the new swingers' credo, the tract for a hedonist cult whose main tenets involved erasing rather than creating rules. It would be defined and proselytized with messianic zeal by Hef in the years to come.

I, too, was captivated by the heady new enterprise—not that I paid much heed to the slippery metaphysics—I'd simply found an extremely enticing place to hang out. Would I like to commute between the *Playboy* building and the Playboy

mansion, bursting with Bunnies, Playmates, and celebrities? Hot-and-cold-running scantily clad young women to sketch—and ogle—night and day? You bet!

I was the *Playboy* artist in residence, and that, I rationalized, necessitated my logging time at the Playboy mansion. I needed to be there fairly often, didn't I, in order to expand my body of work and keep up with any new developments? In my capacity as court painter to the Bunny kingdom, I'd slip upstairs to the Bunny dorms during these sabbaticals and do a few odd charcoal studies of the girls, languishing nude over rumpled white sheets, their tanned bottoms draped over frilly pillows. I'd unexpectedly created a new genre of art known as "bedscapes." (It's true that François Boucher and Jean-Honoré Fragonard had dabbled in this risqué style centuries before me, but that was long ago and the babes were mainly mythological.) In this case the subjects were the real McCoy, and I usually gave them my drawings in appreciation of their anatomical offerings.

Did my wandering paintbrush take its toll on life at home? Here's where Janet demonstrated virtues where mine were lacking. She was the classic artist's wife, sacrificing her own artistic ambitions to support my career and putting up with the nonsense it entailed. Did she ever want to throw in the towel? Hell yes! But I always managed to convince her that life with this unpredictable, insensitive artist was

18th Century Nudes after Boucher *by LeRoy Neiman. Conte Crayon on Paper, 1956.* Author's Collection

All Told

more to her taste than not. Hef had a special affection for her too, so she never felt like an outsider. Not that she had any desire to mingle in the Playboy scene anyway. And I never desired another woman to be my wife. When you look at the glue that holds most marriages together, we've had a good go of it all these years.

There were never more than four or five guests in the mansion, and more than a few wanted to take home a memento of their visit to Hef's sultry seraglio. They had a habit of snatching my Femlin drawings off the club's walls as fast as they could be replaced. Finally, like Wily E. Coyote, Hef hired the Acme Art Security Service and had them screw the frisky creatures to the wall—and they'd still disappear, proving that larceny is the sincerest form of flattery.

Hef was an original. He was a thinker, a ponderer, but didn't claim to be an intellectual by any stretch of the imagination. Still, he was a lot more complicated than people think. In issue after issue of *Playboy,* he was busy writing about a man living the kind of life he was aspiring to. Good wine, fine books, a paneled den, willing tarts. A devout hedonist, a man devoid of inhibitions, and without a

Nude Torso on Phone by LeRoy Neiman. Conte Crayon on Paper, early 1980s. Author's Collection

care in the world. This wasn't exactly what Hef was really like—it was something of a caricature—but like all caricatures, it contained more than a grain of truth. *Playboy* was the work of Hef's imagination; the pictorials were his projections. At heart he was a utopian, promoting a middle American fantasy of the good life.

Hef kept records of everything in his scrapbooks. If you wrote him a note or sent him a sketch, he put it in his scrapbooks. Everything to do with the magazine was history to Hef. Because of this you had to be somewhat careful, but his meticulous record keeping wasn't meant to embarrass you. Everything was done as part of the "evolution of the new man." If you walked into a museum of natural history, where it showed *Homo habilis, Homo erectus,* and *Homo sapiens,* the

last exhibit in Hef's diorama would be "Homo ludens hefnerensis"—a gent in a fancy dressing gown, slippers with crests on them, holding a glass of scotch in one hand and a pipe in the other, while a luscious blonde awaits his pleasure on an expensive plush couch. This was Hef's all-consuming dream, and he was going to live it fully.

He was more circumspect about what went on at *Playboy* and at the Playboy mansion than you might imagine, maybe because his family was intimately involved. His brother Keith worked there and his father was the original bookkeeper, taking care of all the finances—a CPA and played the part well. Hef had come from a religious background; his mother was a strict Calvinist, so the mix of hedonism, sex, and consumerism in the Playboy Philosophy were at odds with his background. Hef's daughter, Christie (I remember holding her in my arms when she was a baby), eventually became the CEO of the company—and was a success at it.

Femlin with Playboy Bunny Head *by LeRoy Neiman. Graphite on Paper, undated.* Author's Collection

I'm not sure I'm really qualified to detail the Playboy Philosophy, although it's not that hard to grasp when you get down to it. When Hef was developing it, he was on his big round bed, filled with piles of books with markers in them: Ibsen, Nietzsche, the Kinsey Reports, Rollo May's *Man's Search for Himself,* R. D. Laing's *The Divided Self,* Thorstein Veblen's *The Theory of the Leisure Class,* John Kenneth Galbraith's *The Affluent Society,* and something by Johan Huizinga—probably my influence.

The Playboy Philosophy was his magnum opus. It was published in *Playboy* in eighteen installments from December 1962 through September 1964. If his radical magazine dared to include literate editorial content, it could also hold forth on the cerebral side of sex. Maybe the tome was no competition for the centerfold, but it made for meaty reading. The idea of Playboy was always more than a magazine anyway. It was a mindset, spun out through the clubs, Bunnies, patrons, even *Playboy After Dark,* Hef's late-night lounge lizard

syndicated TV show that brought the Playboy ethos into every American home. And the Playboy Philosophy was its lynchpin.

He'd work on it all night long. There he was—underlining sentences, picking out words, a mad scholar hard at work—in his pajamas. Sometimes I'd find Hef cross-legged on the bedroom floor, what there was of it (the room was mostly that round bed).

Augie Spectorsky, *Playboy*'s editorial director, would often come by at night and work with him. Hef would dictate passages from his ongoing investigation to Spectorsky, who was a smart guy and a contemporary. He had started a men's magazine in New York similar to the *New Yorker,* except more raunchy, but it never got going—folded after two issues!

Everybody who worked for *Playboy* had an opinion about the magazine. Meanwhile Hef was writing this philosophy every night in his windowless pod. It was like those paintings of Saint Jerome in his study with his tame lion and his lectern—but painted by Francis Bacon.

Whatever else it was, the Playboy Philosophy was a lot more fun than existentialism and Marxism. And *Playboy* had pictures. Whenever you went into his office, Hef would have photographs piled up everywhere, and he'd be leaning over, looking at contact sheets through a loop, peering at slides on a light box. Very studious, except you've got to remember what the subject of these photographs was: fetching naked women.

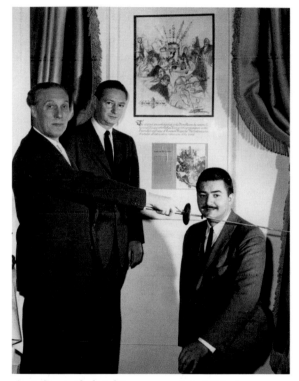

Augie Spectorsky knighting me, 1957. Author's Collection

Hef would talk to Vince Tajiri, the Japanese art director, without even looking up, just talking all the time, going from one image to another and then back to the first one. But with such distracting subject matter, can you blame him?

Hef existed completely in another world. That magazine was his creation, his kingdom, his future legacy. A turn of the ankle or a turn of phrase—these discussions could go on for hours. The good life was serious business.

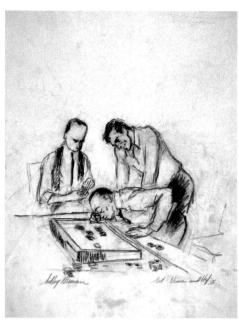

Art, Vince, and Hef *by LeRoy Neiman. Charcoal on Paper, 1955.* Author's Collection

The round bed was where all the action took place. Hef and I would sit there and look at my drawings. He would question everything. "Why is the sky pink in this painting?" To which I would say, "Well, you might as well ask why is the sky blue?"

"Yes, why is it, LeRoy, have you ever asked yourself that?"

"Well, Hef, I'd have to say, because it goes so well with green."

Hef scrutinized every page of the magazine and was on top of all the editorial content in *Playboy*, but he cared most about the pictorials. The word "pictorial" might be defined as "a generously airbrushed photograph of a well-endowed young woman with no clothes on." Nobody ever expected Hef to read all the articles that were written for the magazine. And yet he knew that these pieces, by their weightiness, and by the renown of the authors or the seriousness of the subjects, were the very thing that made his magazine more than another rag with smutty pictures.

Hef had a voyeuristic, almost Kinseyian, curiosity about the sex act, even going so far as to study his own participation in it. He once showed Shel and me the blue movies that he had made (I understand he just recently had them all destroyed). A nurses' residence was two blocks down on Michigan Avenue, and that's where Hef would get the girls for his films. His friend Eldon Sellars acted as the cameraman for Hef's home movies—art films they were not.

But as enthusiastic as Hef was about proselytizing his new lifestyle and demolishing puritanical inhibitions, he also harbored some reservations about what he was doing. Because of his religious upbringing, he was somewhat sensitive about the new sexual liberation he so enthusiastically championed as the auteur of a sophisticated skin magazine that was essentially soft-core porn.

I was doing Hef's portrait one time, and he wanted me to model his hair on Tony Curtis's curl, a characteristic example of his image honing. Curtis used to stay at the mansion—always marveled at himself in the mirror, and it's true that he was a glamorous man.

I decided I would paint Hef from life with a Bunny on each side (I put them in later). Hef wore loafers in the office, but for his official portrait, the question came up: "Do you think we want the loafers in there? Or slippers?" Another of those trying ontological questions. I was painting him from the other end of his office, separated from Hef by an archway, and he was shouting to me, like an Italian domestic conversation. I love how an Italian always has something to say, but waits until he is about to leave the room, then hollers it over his shoulder into the room behind him and waits for the answer.

Hef, for all his grandstanding, was a modest guy, so I was surprised to find that the entire time I was drawing him, he'd been looking in the mirror. "You know what we really need in this portrait, LeRoy? I'd like to have a lock of hair like Tony Curtis falling over my brow." Just like that. And I did put that curl on his face. I always drew from life, and took great stubborn pride in that. I followed a long tradition of plein air, Folies Bergère painters: Toulouse-Lautrec, Monet, van Gogh. I have always been a sketchbook maniac.

Part of the fun of working on *Playboy* was the eccentric characters who worked for the magazine, the craziest genius being Shel Silverstein.

Early on when we first met, Shel and I were sitting outside on the steps of my Wabash Avenue studio. There was a Catholic church opposite, and the priests were playing softball with some kids in the street. Shel turned to me and asked, "Have you got some watercolors handy?" I went into my studio, got some

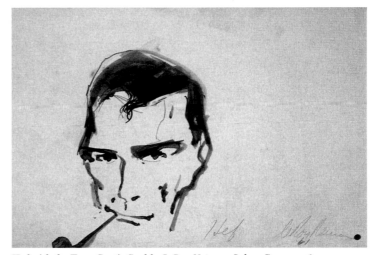

Hef with the Tony Curtis Curl *by LeRoy Neiman. Ink on Paper, 1961.*
Author's Collection

brushes, a watercolor tray, and some paper, and gave them to him. He started working on a drawing—holding it away from me. You know the way people who are drawing cover the paper so you can't see what they're up to? He was always pulling shit like that. He finished the drawing and showed it to me. The priest was playing

ball, wearing a big pair of glasses, but instead of the lenses Shel painted stained-glass windows. I knew he was brilliant from that one drawing—and he proved that over and over again.

Shel was a complete con man, and I say that with real appreciation. He would say, "I'm going to call this broad, a Chicago girl." He would get on the phone, "Hey, sweetie, I just blew into town." Meanwhile, he'd been in Chicago for three weeks already. "Honey, I've got to see you; we really need to get together." Just bullshit. "But, jeez, I'm leaving town tomorrow. Maybe next time, sweetie." No purpose to any of this. The girl probably didn't particularly want to see him, but that's the way he was. Always had to have something going on.

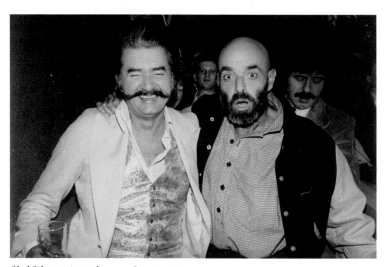

Shel Silverstein and me, 1978. Author's Collection

We had a routine, Shel and I. We'd run into some shapely babe on the street, and I'd have a tape measure in my pocket. Shel would say, "Miss, we need to take your breast measurement." He'd put the tape measure around her chest. "Thirty-six inches? Incredible. Put that down, LeRoy." Then he'd say, "We've got to measure you around the waist. Ah, she's twenty-two inches. Excellent." I'd pretend to write it down, all along explaining to the girl that we were official repre-sentatives of *Playboy* magazine assigned to select the Playmate of the Month. You know, "Hef wants us to blah, blah, blah. If we discover you're the right girl, *you* might be the Playmate of the Month." Utter bullshit. It was all inspired nonsense and it was pure fun.

We had another routine we'd do at parties, an act with three chairs. I'd lie down and put my feet on the middle chair, Shel would put his head next to my feet and put his feet on the third chair, and then we'd cover ourselves with a blanket. When you looked at us, you'd see a nine-foot person with my grinning face peeking out from the blanket. Shel, old friend. When you died in '99, and didn't even make it to seventy, it was tough to accept.

When *Penthouse* launched in London, they tried to copy *Playboy*'s "Man at His Leisure" feature, my jet-setters' guide to the world's hot spots, using an artist who imitated my style. He didn't do a bad job, but I complained, and after a few months they junked it.

I used to go to parties over at Bob Guccione's mansion in New York (the guy behind *Penthouse*). But I'd never tell Hef. Guccione was a painter, and he traveled to Italy to paint nudes, nymphs, and shepherdesses. That's why he was so obsessed, supposedly, with the photographs. The *Penthouse* pictorials were far more explicit than those of *Playboy,* and the girls more honky-tonk. Guccione had a good eye, and a big collection of old masters. He loved women and he used them, just like any of these guys did—whoever got involved with Guccione got laid. *Penthouse* and *Hustler,* the girlie magazines that came after *Playboy,* had no philosophy, and their brazen approach to sex ultimately made *Playboy*'s attempt to rationalize explicit sex seem coy by comparison.

Shel Silverstein *by LeRoy Neiman. Charcoal on Paper, 1999.*
Author's Collection

Bob Guccione: always three gold chains around his neck, his shirt open, and black curly hair spilling out. He always had a few girls around him in spiked heels, too—sitting in a big chair like a throne. What a weird time that was. He was a strange bird, Guccione, but I liked him. He was a sensitive guy underneath it all. One Sunday afternoon he called me up, and I went downtown with him to see his paintings at this makeshift gallery. Previous to this revelation, he'd never shown them to anyone—he was a reclusive kind of a guy. They weren't great paintings, but I was surprised at how strong they were. A little like the Swiss painter Hans Erni—when men were men and women were sexy blondes.

In those days every guy who started a skin magazine would get in touch with me eventually and ask me to do something for them. I never did—which is one of the reasons Hef and I are still tight. *Hustler*'s Larry Flynt contacted me. I was having an exhibition in Honolulu, and one day in walked Larry Flynt and invited

me to lunch. He told me the story of how *Hustler* got started. He explained that he was a rough guy and had a bar in a small town in Indiana called The Hustler, a lot of action going on, hot girls hanging around, strippers and all that. People started saying, "Larry, why dontcha start your own stroke magazine, like *Playboy* and *Penthouse*—ever think of that?"

Larry always agreed: "Yeah, that's a real good idea."

He was going to create a new magazine that would be a real challenger to *Playboy* and *Penthouse,* but first he had to find the secret ingredient. So he hired a company to do market research. He wanted them to do a survey to find out what would sell more magazines: legs, tits, or ass? They did their research and came back to him.

"Mr. Flynt, we've done our survey and we've arrived at what would really sell in a magazine and it isn't legs, tits, or ass."

"Well, what is it?"

"Cunt!"

They advised him to show pussy in the centerfold, and hence *Hustler*'s dubious rise to fame and fortune.

~

There were times when Hef was on his good behavior and times when he wasn't. But even then, he was still a gentleman. He seldom swore and he never really drank. He didn't even like dirty jokes! And, of course, people were always telling him dirty jokes.

In the beginning there were the Playboy parties, and pretty soon they developed into the Playboy Club, where comedians like Mort Sahl, Lenny Bruce, and Buddy Hackett performed. The Bunny dormitory was in the mansion and it was officially off-limits. There was an unstated rule that if you were sleeping with one of the girls, you had to be discreet about it.

The Playboy mansion had the Blue Room, which was usually occupied by the upcoming Playmate of the Month, and the Red Room, where favored guests would stay. Live-in stays meant sharing the bathroom connecting the suites—a very agreeable, communal arrangement. Nobody minded sharing a bathroom with the Playmate of the Month. She enjoyed a form of honored guest quarantine, her room strictly off-limits to male visitors. Shel Silverstein, and sometimes Lenny Bruce or myself, were also frequently put in the Blue Room, if it was available.

Buddy Hackett was always there—and always on. The comedians were always cooking, and their brains seemed to be reserved for specific subjects. Buddy Hack-

ett was the saloon comic; the fat Jack E. Leonard was aggressive, abusive, the godfather of insult humor; and then there was the in-house humorist, Jackie Gayle, who started out as the drummer for stripper Sally Marr, Lenny Bruce's mother.

Mort Sahl had newspapers from every city in the United States sent to him; he was constantly sniffing out material for his improvisational riffs—stuff to inspire his scrutiny of the ridiculous behavior of humans, especially cultural and political figures—always ready to be outraged, but in his genial manner. He brilliantly affected the sweet, reasonable response of the common man faced with absurd behavior, and he found it everywhere. He kept his stack of current papers and magazines piled up beside him on the roof of the Playboy mansion, and one day when the wind picked up, they flew off the roof, blowing everywhere.

The Playboy circuit also helped launch comic talents like Dick Gregory, Richard Pryor, George Carlin, and Steve Martin, all of whom often popped in at mansion parties. Ballroom to bedroom, the mansion was filled with interesting characters partaking of the scene. I loved hanging out with the guys who drew the *Playboy* cartoons, like Shel, Jules Feiffer, Harvey Kurtzman, Gahan Wilson, and Arnold Roth.

We had TV cowboys, cutting-edge satirists, and Hollywood dreamboats in full-time residence. In the breakfast nook, along with your Eggs Benedict, you could share a booth with Bill Cosby, *Roots* author Alex Haley, the Reverend Jesse Jackson, or Hugh O'Brien, television's Wyatt Earp.

Once the mansion was in full swing, Hef abandoned the *Playboy* offices and shed his business uniform—black loafers, white sweat socks, white shirt, black trousers, and Pepsi bottle dangling from an index finger hooked into its opening—for his official silk pj's look. From

Buddy Hackett *by LeRoy Neiman. Enamel on Board, 1965.* © LeRoy Neiman

Mort Sahl *by LeRoy Neiman. Ink on Paper, 1960.* Author's Collection

Lenny Bruce *by LeRoy Neiman. Felt Pen on Paper, 1962.*
Author's Collection

then on he hunkered down in the mansion, rarely bothering with office appearances. All work was shuttled over to him *en lit.*

I was especially fond of the brilliant, surly, shocking, handsomely vain Lenny Bruce. Lenny was so outrageous as a performer that you forgot that he was handsome. He wasn't even much of a womanizer; he was too much into his own head. He was like a live electrical wire on stage and off. He would come on stage all wound up. Hef loved him, and his showcases at the Playboy Club are essentially what made him. Hef commissioned Lenny to write his autobiography, *How to Talk Dirty and Influence People,* with the help of Paul Krassner, and serialized it in *Playboy* in '64 and '65. Hef further helped Lenny's career by featuring him in the television debut of *Playboy's Penthouse* in October '59.

One morning, soon after Lenny changed his cabaret performance image from tuxedo to army fatigues, the houseman brought our laundry to the breakfast table—my shirts crisply ironed and carefully folded, Lenny's fatigues laundered but casually folded up. Lenny hit the ceiling. He lost no time pointing out to the hapless houseman that army issue deserved the same respect as civilian clothes. "Where's your fucking patriotism, man?" For Lenny there was always something wrong with everything. He was forever blowing up about stuff—and he was generally right.

Lenny dragged a big oversize suitcase around with him, a cross between a valise and a trunk, which served as his traveling business office—and War Room—the center of operations from which he waged an endless battle with various police departments, DA's offices, and other agencies of the US government over obscenity. Inside were legal books and contracts, and the lid served as a bulletin board littered with clippings and appointment reminders. I was honored that in this seething shrine of contention and rebuttal was my drawing, a sketch I'd done of him performing at Shelly Kasten's Cloisters, where there was always a front table for our group, madly applauding at Lenny's blue comic routines.

It was far from nonstop orgies at the mansion. What you'd find in the lounges and corridors of Hef's frothy kingdom wasn't, at least on the surface, so much about rampant sex as the company we kept: comedians doing shtick, writers expounding, social agitators, dropout clergy, politicians, and movie stars holding forth on the issues of the day.

Everyone was in top form—and why not? Surrounded by a bevy of hot beauties naturally made for a heightened atmosphere. What better place to hang out? You could take it the way you wanted. If you were just there to get laid, the ambiance was a bonus. If you were there for the metaphysics and the one-liners—getting laid was the icing on the cake. You could make up a good story when you got home about how this Nobel prize winner explained to you the difference between a quark and Joan of Arc.

I had never been any more of a stud than the next guy, though I'd encountered my share of women. But the Playboy mansion was something beyond my wildest dreams. Bunnies and Playmates scampered around the house in panties, teddies, and little fluffy slippers; hot girls hovered at every turn, ready to flirt, flatter, compliment, cajole, and reconnoiter. The environment was daunting. I don't want to ruin your fantasies about the Playboy mansion as a den of debauchery, with grottoes and cabanas and lacy boudoirs conveniently placed around the grounds for nonstop fornication, frolic, and . . . here, supply whatever reveries you've nurtured about the Playboy mansion to this point. But by no means was it a wanton scene of sex and drugs. Hef's house rules were firmly upheld. I'm not claiming "nothing happened," but any randy encounters remained more-or-less confidential. And the sacred rule of the house held firm: Hef had first dibs, very earnestly explaining to the candidates why he had to bed them down. If they were going to be in his magazine, he needed to get to know them.

And how did all these dolls get into the Playboy mansion in the first place? If you were as hot as most of these girls were, you didn't exactly need to knock down the door to get in. They all knew each other. One girl would work her way in through a date or something, and the game was on. Once she was in the door, she'd go straight downstairs, jump on the fire pole, slide down to the swimming pool, and change clothes, and within five minutes it would be like she'd been there forever.

The layout of the Playboy mansion was as well known as Seinfeld's apartment would be later on. Art Buchwald, one of the classic *Playboy* contributors, wrote a story about how these future Bunnies knew the plans of the whole house like the back of their hands long before they arrived.

Bunny Twisters *by LeRoy Neiman. Enamel on Board, 1962.*
© LeRoy Neiman

When the Bunnies were being trained, you couldn't fool around with them. Fondling Bunnies, especially in the Playboy Clubs, was absolutely taboo. Look but don't touch—but believe me there was plenty of touchy-feely stuff outside the clubs. Most of these girls knew what they were doing. Some of them were manipulative, some wanted guys with money, some just wanted a modicum of independence. They were savvy. The guys trying to come on to them were pretty naive in comparison. The girls knew just how to handle them, and they knew every trick in the book.

You would never imagine some of the girls who wore Bunny ears. Gloria Steinem, who started *MS* magazine, was a Bunny. Steinem was conspicuous around the Playboy Club, and there was a good reason: She was working as an undercover journalist for *Show* magazine. The piece, which came out in '63, was an exposé of life at the Playboy Clubs. The Bunnies lead a dog's life, she wrote, working long, grueling shifts for poor pay. In the end she concluded that the Bunny life is a metaphor for women's plight in general: "All women are Bunnies, but it doesn't have to be that way." In '83 the piece was made into an ABC TV movie called *A Bunny's Tale,* with Kirstie Alley playing Steinem.

Steinem's put-down of the Playboy Clubs didn't affect their popularity—they were multiplying like rabbits, causing Hef's brother Keith to institute periodic Bunny hunts to keep up with the need for new recruits. For the Miami Playboy Club opening, club manager Arnold Morton booked my old wartime friend, Marlene Dietrich, now in the latest, most imperious stage of her career, to perform in the Playboy Penthouse. Arnold was beside himself that he had snagged the aging *Blue Angel* star and legendary diva. In the '50s Marlene had been the highest paid

entertainer in Vegas, just as she had once been the highest paid actress in Hollywood. She had each of her legs insured for a million bucks back when a million bucks meant something.

She had been a goddess long ago. "But, dahling, life is so cruel, no? They forget that the King of Somewhere or Other strewed roses in my path. . . ." Just in case there were no besotted fans there that night, she bought two dozen roses at her own expense to have presented to her onstage after the performance (knowing *Playboy* wouldn't pop for it). And she even had arranged with the executive chef to have them stored in the kitchen refrigerator for reuse the next night. Upon discovering the roses in storage, Arnold went ballistic. He ordered them thrown out, saying it was against restaurant hygiene, and stomped off.

Femlin with a Cottontail by LeRoy Neiman. Ink on Paper, undated. Author's Collection

⌖

So was *Playboy* an advance in civilization or the work of the devil wrapped up in fancy packaging? That was the question of the hour. The Chicago archdiocese was making serious noise about how disgusting the magazine was and how it was corrupting the youth of America. But *Playboy* was just as serious about its position. There was sociological commentary in the magazine too, so wasn't the church basically competition? The original *Playboy* office was right across the damn street from the Catholic Church. They were outraged. *Playboy* moved its offices, but as far as the church was concerned, the smell of sulphur still hung in the air.

The church had ancient medieval manuals as reference, the *Malleus Maleficarum* (*Hammer of Witches*) and the *Examen of Witches*. They must have missed the good old days of the Spanish Inquisition when you could burn sinners at the stake or put them on the rack. The shameless whores of Babylon at *Playboy* were flaunting their pudendas in broad daylight, for God's sake! Wait, hadn't they read Hef's philosophical musings on man and society? But the philosophy was part of the problem. Hadn't they burned Giordano Bruno at the stake for his philosophical theories? And hadn't Galileo come within an inch of his life for expounding

dangerous new ideas? To the custodians of morality, the most galling thing about *Playboy* was that its brand of slick eroticism had become almost socially acceptable among the middle class. *Playboy* was being sold openly in magazine racks, people left copies of *Playboy* lying about at their country houses, modern couples found it acceptably naughty. Such alleged filth, we all knew, had since time immemorial been bought from under the counter to be savored furtively, hidden beneath the bed or in the garage.

Now an angry mob of outraged citizens was demanding that *Playboy,* brazen purveyor of smut, be called to account and Hefner, its chief diabolist, be brought to justice. There was to be an obscenity trial to quash this abomination once and for all. *The City of Chicago vs.* Playboy.

Early on December 7, 1963, Hef, Shel, and I exited through the gates of the Playboy mansion on genteel North State Parkway, where a limo idled at curbside, puffing exhaust in the frigid morning air, waited to transport us to the Cook County Courthouse.

Hef had been secluded in his windowless bedroom for months, refining his philosophy. He had been in there on the round bed for sixty days, never leaving the room. He had his girls come in and see him. Now his philosophy was to be put to the test. He emerged into the low, glaring winter sun, sans shades, without a blink. I got in the limo; the atmosphere was electric. Hef sat in the front seat. He was ready for whatever they would throw at him. When the trial first came up, Hef had picked a black lawyer. He was always trying to stick it to the powers that be.

The city had long tried to nail him, and now they thought they had their shot. The hearing lasted long hours, as back issues of *Playboy* were insultingly compared with other sleazy skin magazines. Imagine! How dare you compare *Playboy* to these lascivious stroke mags, your honor, filthy periodicals hawking bare-naked ladies without even the fig-leaf of a philosophical undergarment to justify them. Hadn't they noticed that *Playboy* had a cultural agenda? It had a philosophy, for God's sake.

When we got into the courtroom, I made a couple of drawings. I'd never done a courtroom drawing in my life before that case. At that time artists in the courtroom were drawing from life. It's pretty much gone by the wayside now. This was before cameras or even videotaping was allowed. As I sketched the proceedings, I recall the jury retiring gleefully to examine the evidence. Like the Vatican, which has the biggest collection of pornography in the world, all moral watchdogs have the best collections of smut.

We imagined what was going on in the judge's chambers: "Uh, judge, take a peek at Exhibit X. What do you think of Miss December, a nice college girl, recently graduated cum laude from Northwestern in social studies? You have to admit that the fur rug, the Christmas tree, the stack of presents, and the mistletoe in the pictorial were done tastefully, yes?"

"But, counselor, why does the girl have no clothes on?"

"That roaring fire, your honor; she was hot, just burning up."

The judge, taking up his magnifying glass: "Do I see Santa's sack and boots in this picture? Are you implying Santa is rewarding this little trollop? Or worse, having sexual congress with the girl?"

"Well, your honor, Santa is still there, it's true. He can't make up his mind, you see, because Miss December is naughty and nice. As to whether they're about to do the wild thing, we leave that to our readers' imagination."

But the trial wasn't really about Miss December, it was about Jayne Mansfield's T&A. In the 1963 film *Promises! Promises!* Jayne Mansfield, the ultimate blonde bombshell—and looking very hot—was the first American movie star to go totally topless in a major motion picture (since the Hayes Code was established in 1930). The film caused an uproar and was banned in a number of cities. *Playboy* featured some stills from the film, which caused more hue and cry since it was obvious from the photos that Mansfield had been totally nude on the set. This pictorial provided the excuse for the obscenity trial. As with most censorship, it only helped *Playboy*— and made *Promises! Promises!* a hit. "Banned in Boston" never fails at the box office.

The jury returned with their verdict: hung jury. No pun intended. When we got back to the house, Hef asked if he could have my drawings of the trial for his scrapbooks. I surrendered them, knowing Hef's sentimental commitment to posterity.

It was a victory for the liberal—and libidinous—imagination. But, to be candid, I never went for the more vulgar aspects of *Playboy*. I had discussions with Hef about it, about the way the magazine represented women. Hef was such a believer in his freethinking theories about "sex and society" and so on, but you just can't get around the fact that it appealed to horny men who wanted to get their rocks off to the pictorials—that word! Calling them "pictorials" only made the steamy photographs seem more lurid, however much philosophy you laid on top of it. And I say that while admitting I've been as guilty as anyone of not treating women so great myself.

Hypocrisy is the engine of society, the very thing *Playboy* claimed it was skewering. But, let's face it, nooky was the main draw for the mansion crowd—the politicians,

the comedians, the movie stars. Hef had so many girls there; I had never seen anything like it in my life. He had created an environment, which to him was legitimate—it was an evolution in the history of mankind, "man" being the operative word—that freed him from inhibitions and social restraints. We talked about it for hours on end, mixing sex with culture and philosophy . . . and who could argue with the Playboy Philosophy? Except who wanted to examine its premise too closely? What most people wanted to examine closely was the intimate parts of the Playmate of the Month. That was the elephant in the room.

I look back on my history, I think about all the things I went through because I was so naive. I never thought much about what I was getting involved in. I went into scenes willy-nilly, and the only reason I could pull them off was because I always had a girl on my arm—that made me acceptable anywhere. You go to Vegas, Hong Kong, or wherever, and you'll find that people like to talk to the girls you're with more than they want to talk to you. To the girls I might have seemed to be their entrée, but it was really the other way around. Any time a young guy comes around and tells me he's going to wing it as a painter, a writer, or whatever, I tell

Hef with the Mixologist *painting.* Author's Collection

him, "Wherever you go, bring a woman with you." That's the best advice I can give them. I owe a good deal of what I have in life to women, and yet my whole life I've essentially exploited them—that's my cross, it's where I came from. Like most guys I feel like I'm a victim and perpetrator, and I don't know where one begins and the other ends.

The thing about Hef is that he never was about the vulgarity of *Playboy* either, and he looked askance at the guys around the Playboy Club who were only there for the sex. He didn't want to think about it, but that was the secret of *Playboy:* It was an all-American blend of pornography and Puritanism. The girl next door gets laid.

<center>⌐⌐</center>

As the '60s advanced and sexual boundaries began to blur, I rashly agreed to be interviewed by syndicated newspaper columnist Phyllis Battelle for the *New York Journal-American.* The interview started out pleasantly enough. We talked about *Playboy* and my role there as the magazine's artist. Then I began to prognosticate (interviews with prudish journalists tend to provoke that in me). I forecasted that porno art would one day hang on the walls of art galleries and in museums. And that has come as true as much as anyone could have imagined, with the explicitly sexual paintings of David Salle and artworks made by Jeff Koons with porn star (and member of the Italian parliament) Ilona Staller. La Cicciolina (her stage name) also appeared nude in various editions of *Playboy.*

I predicted that depictions of sex would become more and more ubiquitous in the next few years. It began to get under her skin. "The pornography movement is on its way," I concluded brashly. "And when it comes the world will simply accept it. It's a circus we live in. It may seem to you a curiosity, an abomination, but it's not going to slow down. . . . If you can get adjusted to chaos, you may find it exciting."

I was trying to provoke her, but it was true that the once forbidden was going public—and fast. Celebrity, sex, sports, and violence were now the bitch's brew of popular entertainment, driven first by television, then by porn on video tape in the '70s and now on the Internet. And *Playboy* had been at the very beginning of this risqué revolution.

The timing of my involvement with *Playboy* had been perfect. At their swanky watering holes, the elite were beginning to rub shoulders with the nouveau riche, a generation of educated, young professionals who felt they'd earned the right to enjoy what, up to that time, had been primarily the domain of the rich and privileged.

ASSIGNMENT: AMERICA

Thriving in World of Chaos

By PHYLLIS BATTELLE

"IT'S KIND of important to keep losing—to keep yourself exposed to shock and disappointment," says Leroy Nieman. "You have to plunge into chaos occasionally, and get yourself completely beat up in the process. It's the way to stay alive.

BATTELLE

"I mean, if life goes on beautifully all the time, you get not to really care about anything. But the emergency disasters, the bad stuff — you learn from it. Of course, you can't go out on the street and just expect to run into these things. You can't get disaster from people you love. You have to stick your neck out and ask for it.

"We're living in a wonderful time for put-downs and setbacks. This animal-nature thing everybody's talking about is really here. It's all true. It's all good. It's downhill all the way . . ."

Nieman is an artist. Although he is a highly successful artist, it is unnecessary to add that he is unconventional. When he was a hungry artist, living in a basement and teaching at the Chicago Art Institute to earn money for paints and palettes, he found it easier to run into those little emergency disasters which he finds all-important to make one learn, feel and live.

Now he has to go out and look for them. (Recently, while sketching Sonny Liston at the latter's training camp, Nieman purposely blew a cloud of cigar smoke into the ex-heavyweight's face. When Liston glowered, the artist remarked, "Gee, you look beautiful when you're mad." He was thrown out, bodily. "You can't buy experiences like that," reminisces Nieman happily.)

In the near future, Nieman, a good-looking young man with a gentle voice and a mustache the length of a baby's bottle brush, will join a Yugoslavian nudist colony and an African lion hunt, to paint his impressions for Playboy magazine. He trusts there'll be some trouble.

Besides roving the world on a lavish expense account, Nieman sells his paintings through chic galleries such as the Hammer Gallery in New York and the Salon D'Arte Moderne in Paris. He has a "not unbeautiful" life, and a wife, but he "can't go respectable, because I don't believe in it. It is not interesting to be 'respectable.'" And in these times, it is not easy, either.

"We are living in times when there is a general breakdown of morality and breakthrough into the age of illumination. There are no taboos anymore.

"The discotheque may be symbolic of the trend. In a discotheque, the crowds and noise and frenzy are so great, you have the feeling the lid can blow off any minute. Old people, who once lived in quiet clothes and wisdom, now submit to the indignity of trying to look young.

"In art, the pornography movement is on its way, and when it comes, the world will accept it. It's a circus we live in, a curiosity. And it's not going to slow down.

"But as I said, if you can get adjusted to chaos, you'll find it exciting. And you may as well . . ."

Hearst Headline Service

Phyllis Battelle article about "Leroy Nieman" (with misspelled name). Author's Collection

My *Playboy* connection forever sealed my fate as an artist who would not be accepted by the art establishment. Early on I'd found myself on the wrong side of the art scene, but, being born on the wrong side of the tracks, that was just fine with me. I loved *Playboy;* it connected me with a crowd I could relate to. I'd rather be a folk hero to forty million *Playboy* readers, any day, than an icon among the airless art elite.

Though never an employee of the magazine, from then on my fate would be inextricably linked with *Playboy.* I loved working with Hef, and he always treated me well. I was told by many people not to get involved with *Playboy,* and that it would ruin my career. But *Playboy* was liberating; I was drawn to it, and went for it full throttle. If I was marginalized because of it, I didn't care. I've lived my life as I wanted to live it, and screw what happens. I always stayed in tune with my own ambitions and attitudes, and I'm still my intractable old self, for better or worse.

Our Guy *by LeRoy Neiman. Ink on Paper.* Author's Collection

*Budd Schulberg with Joe Oppenheim by LeRoy Neiman. Sepia Marker
on Paper, 1968.* Author's Collection

My Playboy *business card.* Author's Collection

I was in heaven—what artist wouldn't want to illustrate an excerpt from Jack Kerouac's *On the Road,* pieces by Budd Schulberg, or articles by *Beat* writer Herb Gold. I also did fashion spreads, with many of the male models suspiciously similar in appearance to Hef. Get yourself a silk bathrobe and you could be Hugh Hefner. As for me, I was now the card-carrying *Playboy* artist in residence, an official entrée to all kinds of wild and crazy affairs.

Before the war, sophisticated pleasures were the preserve of the Café Society elite. By assuming the role as guide for the emerging class of nouveau young professionals who now felt entitled to indulge in those pleasures, *Playboy* was in the ideal position to take the lead. My new feature, "Man at His Leisure," would show our readers where to go and what to wear. In the beginning I didn't have any more clue than the average reader did about these rare terrains, but as a poor boy in a rich man's world, I was the man for the job, no question about that. I may have been a novice to the haunts of the privileged, but that had never stopped me before. I had confidence, insatiable curiosity, and a box full of paints and pastels—plus an almost bottomless expense account—and I soon learned to wrangle my way into these new social scenes.

Bernard Shaw once said, "There is no sincerer love than the love of food." Now Hef was no gourmet—his number one item on any menu was roast chicken—but he decided that the first installment of "Man at His Leisure" would investigate the local five-star restaurants. This was a daunting prospect. I wasn't much more savvy about haute cuisine than most Americans, whose gastronomic knowledge came from that sturdy household bible, the *Joy of Cooking*. I was about to get a crash course in vintage wines, *plat de résistance,* and hand-rolled Havana cigars. But more intimidating was how to deal with the scorn of the snobbish maitre d', or the master chef who would immediately detect my ignorance. Nevertheless, in May 1958, I set off for the elegantly ostentatious Pump Room, Chicago's top restaurant, located in the staid Ambassador East Hotel—famous for scenes between Cary Grant and Eva Marie Saint in *North by Northwest.* I entered its sunken, carpeted dining room lined with white booths. Waiters scurried about, busboys in plumed white turbans flamboyantly filled your coffee cup in a long sweeping pour. I chose the Pump Room, with its curved bar, as the scene of my first major bar painting, *The Pump Room Bar,* which depicted the bartender as an isolated figure, detached and barricaded behind the bar, observing the extravagant show swirling around him, like the affectless barmaid in Manet's *Bar at the Folies Bergère.*

The paint had barely dried on my work when Hef showed up at my studio on Chicago Avenue to take possession of it. We maneuvered the six-by-four-foot framed painting around the narrow landing and down the stairs Laurel and Hardy–style, strapped it to the roof of his black Lincoln limo, and took it over to his new quarters at the St. Claire Street *Playboy* building. That's the way we did things in those days. Hef kept the painting until it was handed down to his daughter, Christie, for her office when she became chairman and CEO.

My next assignment was to paint an illustrious old hoofer in his natural habitat. It happened one night at the grand old Palmer House in Chicago's downtown Loop—so-named for its suspended maze of clattering "El" trains—where I encountered a magnificent relic from a bygone age, the world-weary Maurice Chevalier. Back then the Palmer House, with its fading luster, was a fitting backdrop for Chevalier's poignant show biz razzmatazz. He was the very image of an aging crooner—a character out of another age, almost his own ghost by now. He was performing at the hotel's Empire Room, and as we were leaving his suite where I'd sketched him, Chevalier handed me his signature straw boater, as if he were too feeble to even carry it. Or was it the mock act of an opera buffa monarch proffering his crown to a lackey?

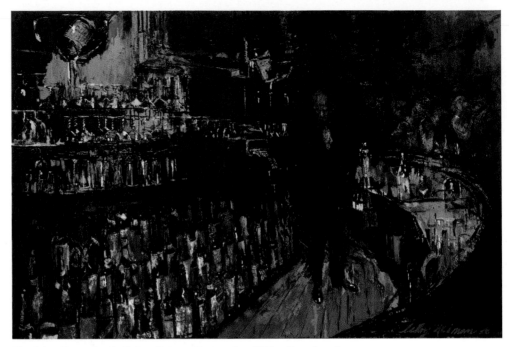

The Pump Room Bar *by LeRoy Neiman. Eanamel and Oil on Board, 1958.* © LeRoy Neiman

Maurice Chevalier at the Palmer House *by LeRoy Neiman. Ink on Paper, 1959.* Author's Collection

Holding the iconic hat, I walked alongside him as he slowly made his way to the elevator; he seemed so frail, I wondered whether he would make it to the lobby. Once down there I had to steer him like an old vessel on its last voyage around a gaggle of blue-haired, autograph-seeking Chevalier fans—one too many bony hands clutching at him and he would be pulled apart like an antique doll. At the top of the grand carpeted staircase to the Empire Room, he turned to me. "Merci, Monsieur LeRoi," he said, puffing lightly from the climb. Then something remarkable happened.

As the satin-toned MC announced, "And now the Empire Room proudly presents the

one and only . . ." I watched as a fantastic metamorphosis took place before my eyes. Rising up as if miraculously inflated by an invisible air pump, he snatched the straw hat from my hand and, waving it above his head, bounded into the room like a jackrabbit. I watched in astonishment as the spotlight tracked him—this magical transformation from the old trooper who moments before seemed on the brink of the grave into this overwound marionette—as he hopped and pranced around the tables of the packed dining room and leaped onto the stage.

As I continued my culinary explorations, I soon learned something about haute cuisine restaurants that had never occurred to me: It's not all about the food. Gourmet restaurants are theater—bona fide high drama with almost everyone overplaying their roles—including the customers. Ernie's in San Francisco, for example, was such a perfect stage set that Hitchcock replicated its dining room for the restaurant scenes in *Vertigo.*

Ernie's *by LeRoy Neiman. Marker and Pen on Sketchbook Paper, 1967.* Author's Collection

The show often revolves around the restaurant owner; a classic example of this was Romanoff's, run by a "professional impostor" and self-styled aristocrat straight out of a farce, "Prince" Michael Romanoff of Lithuania. His true coronation came about when Frank Sinatra—whom he'd helped bail out in his bad years—anointed him as an honorary member of the Rat Pack.

Sardi's in Manhattan's theater district became such a classic spot for Broadway actors and actresses to hang out that it also got used in a number of movies. Stars inevitably become parodies of themselves—they're often easy to draw for that reason, they're readymades— just a few lines and you know it's Woody Allen, Humphrey Bogart, or Cary Grant in a nutshell—which explains why Sardi's walls are covered with caricatures.

The Colony at 61st and Madison had been a swanky speakeasy in the '20s but was now just plain swanky. Jet-set high society, Wall Street tycoons, Park

Woody Allen *by LeRoy Neiman. Charcoal on Paper,*
1970. Author's Collection

Sirio at Le Cirque *by LeRoy Neiman. Sepia and Black*
Ink on Paper, 1979. Author's Collection

Avenue swells, and the ladies who lunch patron-ized the joint—not only to eat the great food but also to see and be seen. Even the waiters became celebrities—Le Cirque's owner, Sirio Maccioni, got his start there waiting tables. *Playboy* was by now famous—or infamous—enough that we got seated in the blue-and-white-stripe-tented Bar Room at the Colony—also favored by the Duke of Windsor to avoid such social riffraff as Truman Capote, Sinatra, and Onassis and Jackie O, who were consigned to the formal dining room.

If you had the wherewithal, fancy restaurants offered you the opportunity to cast yourself in an informal play. At the very exclusive Chambord on Third Avenue, for instance, you might get a walk-on with Orson Welles as he tucked into his pressed duck or petite marmite. If you listened closely, you might catch the name of a rare vintage wine he was regularly ordering from their legend-ary wine cellar. Still, back then, a meal for two that pulled out all the stops would only set you back about fifty bucks.

But neither haute cuisine nor Broadway show would survive for a minute without the support-ing roles of car park attendant, unctuous door-man, curvaceous coat-check girl, and officious maitre d'. And then there was the backstage crew: busboys, sous chef, sauciers, pastry chefs, sink men—all the performances orchestrated by the arias of the imperious chef, a toqued tyrant in his sweaty kingdom. Like a well-tuned orchestra, this company not only mounted the production but also set the tone for the performance the audience at the table had better measure up to.

Le Cirque Menu *by LeRoy Neiman. Colored Markers on Paper, 1982.* Author's Collection

Cut to the *Playboy* offices, early evening, some months later. Hef, as always, is wreathed in a haze of smoke.

"LeRoy, I have a brand-new mission for you . . ."

"And what would that be?"

"Europe!"

"Europe? Kings and saints, mad artists, the Renaissance, Shakespeare? I've been there, Hef. The last time I saw it, it was crumbling and falling down, but I'll give it another go. Great museums, great cathedrals . . ."

"Not that Europe, LeRoy, the sexy new Europe—jet-set Euro babes, Left Bank broads, Monte Carlo, Ascot, St. Moritz, St. Tropez, nude beaches."

I'd go for that too, and Hef was right. Postwar Europe would be something else again. From that night on, we looked at Europe through new eyes.

"Hell, it's a goddamned unexplored playground."

Hef frowned. He wasn't into profanity.

+Janet
1968

ITINERARY - LEROY NEIMAN

Thursday March 21	Depart Kennedy via Pan Am # 90 at 6: 15 pm
Friday March 22	Arrive Brussels at 7: 35 am Stay until Sunday at Hotel Residence 319 Avenue Louise
Sunday March 24	Depart Brussels via Iberian 772 at 12:45 pm Arrive Copenhagen at 2: 15 pm Depart Copenhagen via Scandinavian 768 at 3: 15 p, Arrive Moscow at 9:30pm
March 24 to March 31	Stay in Moscow at National Hotel 1/17 Gorky Street tel: B 9 -99-17
Sunday March 31	Depart Moscow via Aeroflot 1151 at ######## 8 am Arrive Leningrad at 9: 15 am
March 31 to April 3	Stay in Leningrad at Astoria Hotel
Wednesday April 3	Depart Leningrad via Aeroflot 075 at 10:05 am Arrive Copenhagen at 11:30 am Depart Copenhagen via Pan Am 103 at 1:30 pm Arrive London at 3: 10 pm Stay at Dorchester HOTEL
Thursday April 4	Depart London via Pan Am 1 at 6:30 pm Arrive Kennedy at 8: 10 pm

American Embassy
19/21 Chaikovsky St.
Moscow

tel: 52-00-11

Here we go!
Don't worry! LeRoy's health is O.K.
the doctor gave us the go-ahead —
will talk to you when we return
Love —
Janet

— In case of emergency —
contact Earl first and
he can contact the
embassy —

LeRoy says he's feeling very good!

Travel itinerary, 1968. Author's Collection

"Okay, I get it," I went on. "It's the happening spot for randy, upwardly mobile young professionals in search of adventure, gourmet restaurants, luxurious spas, Alpine ski slopes, and hot flesh."

We spent the next few hours on the floor riffling through a litter of maps and charting ports of pleasure like a couple of kids tearing open presents under the Christmas tree. And, like Santa, we made a list.

Playboy would raid Europe, not like the Vandals and the Visigoths exactly, but like apprentice bon vivants. Back in those days, Americans were clueless about Europe, and intimidated to go there. They didn't speak the languages and thought they'd get treated like rubes. But they had the money to spend, and *Playboy* was going to tell them how, with my feature paving the way.

"That's it!" Hef said. "When can you leave?"

"I'm packed."

Now all I had to do was convince Janet. With my traditional finesse, I burst the news on her that night at dinner, giving her a Chicago Minute to acquiesce. Argument one: She'd have to vacate her job as a high school art teacher. Rebuttal: No

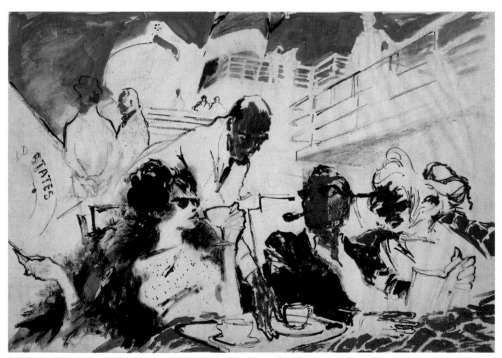

S.S. United States *by LeRoy Neiman. Ink, Marker and Pencil on Paper, 1961.* © LeRoy Neiman

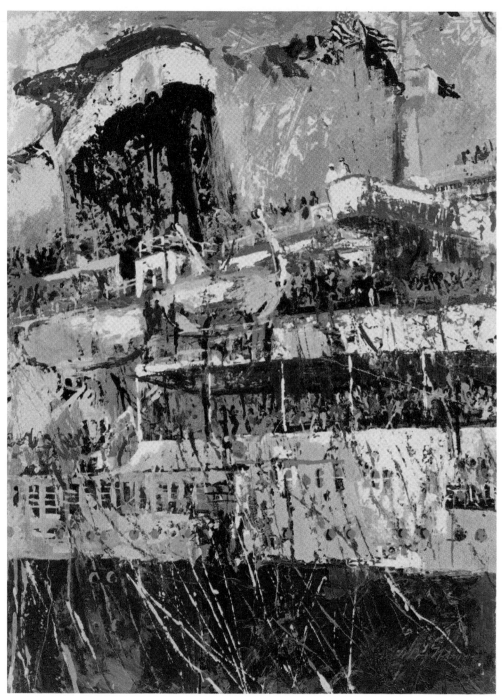

S.S. United States *by LeRoy Neiman. Enamel on Board, 1961.* © LeRoy Neiman

contest. Argument two: She'd have to leave her close-knit Irish family. Rebuttal: In her heart, hadn't she always known she'd signed up for a life of adventure? By the last bite of Salisbury steak, Janet was onboard, literally.

We decided to take the luxury liner route to Europe—a gracious interlude between our familiar life in the States and the Europe I had only known from my wartime experiences. On a March day in 1960 we boarded the SS *United States* bound for Southampton.

From years of experience sketching, I'd acquired a kind of X-ray vision about the personalities I drew. I'm quick to identify types, so who did I spy the first day at sea but a passenger I immediately recognized as the "Self-Satisfied Self-Made Man." These guys always exude a kind of unearned arrogance from their prowess at shady high-level shenanigans. Meanwhile, as I was checking him out, he was studying my wife. By the third day at sea, his attentions had developed into open flirtation—dancing with Janet and backing her bets with his chips at the gaming table, the way high rollers do with their floozies.

By the fifth night I'd had enough. When I ran into the lout in a narrow ship's passageway, I said, "I don't know what you think you're up to with all this nonsense you're carrying on with my wife, but if you don't stop it pronto, I'm telling you . . ."

With a courtly wave of his hand he interrupted me.

"My dear fellow, let me explain," he said in a mellow voice. "I make this tedious crossing ad nauseam, so I'm sure you can understand that it is far more congenial when one can enjoy the temporary pleasures of delightful female company."

He was some character, all right, but I wasn't falling for this smooth patter.

"That's all very well and good," I said, "but we're not on this voyage for your entertainment, especially not my wife. You better find another way to entertain yourself, buddy."

He stood there for a minute with an amused look on his face, as if trying to take in what I'd just said.

"I'll tell you what, good man," he began. I waited to see what this operator would come up with next. "If I'm not mistaken, I've seen you sketching onboard, haven't I? What do you say to a wager between gentlemen?"

"Over what, 'my good man'?"

"How about a drawing contest with your lovely wife as judge?"

Now how could I resist that?

But, who was this guy? A secret dabbler in oils? An unknown master out to humiliate me in front of my wife? Not his game. At breakfast the next morning,

I found out. He was just another businessman making a deal—and he'd already secured his wildcard. Descending to the bowels of third class, he'd procured a young artist—a kid on his way to France on a Fulbright. The showdown was to take place at our table after dinner.

About ten o'clock that night, a shy young man toting a sketch pad and charcoal pencils showed up along with his smug backer. I could see how nervous he was, so I told him to sit down and have a drink, and we'd talk about our favorite painters. At one point he leaned over to me and confided, "I'm an abstract painter, you know. I only agreed to this for a taste of first class, and some extra cash for the trip."

All right! He was the genuine article—an artist getting by on his wits. Let the games begin.

We were each to pick a subject, and the kid picked a guy at our table—a retired chiropractor on holiday with his wife—not the most inspired choice, but what the hell. My eyes, by contrast, fell on a satirical scene: three German gourmands, Goering types, polishing off Linzer torte *mit schlag*. I can only imagine what George Grosz would have done with these grotesques.

Janet gave the signal and we were off and running. Within minutes I could see the poor kid was sweating, and I felt for him. I saw him erasing, making another stab, then wiping it off. He was panicking—it was painfully obvious that figure drawing was not his thing.

Meantime, my tableau was taking shape. A keen student of the classic English satirists like James Gillray, I knew I could beat this kid hands down, but I didn't want to show anybody up. I just wanted to humiliate the arrogant prick who'd set up the contest. Right then I had a brainstorm. I turned to Janet. "You're an artist, dear, how about you having a go?" The jury approved. I withdrew to my cognac. Janet's drawing was a knockout, and she was voted the winner unanimously.

The kid beamed. "You beat me, hands down," he said, grateful the ordeal was over and he could collect his money, and after shaking hands all around he took his leave. As for the gent who'd issued the challenge, he was nowhere to be seen, but for the rest of the voyage, he had not a word or a wink for my better half.

The first onshore sightseeing didn't even have to wait until London. On our transport from Le Havre to Southampton, we noticed a curious passenger seated across the aisle. Though he was dressed somewhat shabbily, or well traveled anyway, in a rumpled trench coat and threadbare cashmere sweater, there was a presence about him that spoke of more than a vagabond. When the customs agent began thumbing through the equally worn pages of his passport, Janet's sharp eyes caught

the name, John Paul Getty. Our planets would cross again under less benign circumstances, but that story's still to come.

⌒

Once in Europe I set up two studios: one at Passy in Paris and one on Brompton Place in London. This time Europe would be a theater of my own operations.

Over the next two years, I would come to know Paris, London, and Rome almost as well as I would later come to know New York. I would discover that there was something downright fascinating and exotic about functioning in a foreign city. With no command of the languages, the experience would be visual—amusing, confusing, mysterious, and emanating from the senses.

Hef's first European assignment for "Man at His Leisure" was to search out Paris nightlife—the meat of Paris: cafes, clubs, showgirls, and the best restaurants in the world. As I tucked into the numbered *canard à la presse* at the three-star La Tour d'Argent, I imagined guys in Milwaukee and Omaha reading this stuff, eyes popping out of their heads. I also had to report on that citadel of French cuisine, Le Grand Véfour in the Palais Royal, where Napoleon, Hugo, Cocteau, and Colette once feasted. Realizing that if the *Playboy* audience showed up there, they weren't likely to catch a glimpse of these luminaries except as a ghostly clatter of embossed silverware on Limoges china, I also recommended Maxim's, the kind of place where you might catch a glimpse of international roués like Aristotle Onassis and Porfirio Rubirosa, if that was your thing.

When I visited Maxim's with Hef years later, he had an assistant call ahead to arrange for a roast chicken dish—not normally a Maxim's offering. Hef may have set me off in search of the finest haute cuisine in the world, but his was strictly a down-home, Midwestern palate, and whether he was in a fancy Paris restaurant

Maxim's *by LeRoy Neiman. Enamel and Oil on Board, 1970.* © LeRoy Neiman

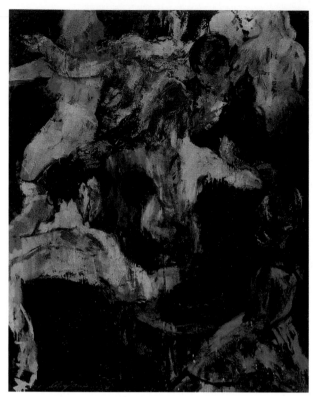

Twist a la Chez Régine *by LeRoy Neiman. Enamel and Oil on Board, 1961.* © LeRoy Neiman

or a Chicago steak joint, he wanted his chicken. The entrée was presented under glass with great fanfare, and after the meal the chef emerged to sit down with his celebrated guest, a glass of brandy in hand— as was his custom—and he leaned back waiting to bask in high praise for his specially concocted dish. "And did you enjoy your *poulet,* Monsieur?" Hef's answer: "I've had better."

If you were looking for something friskier than Maxim's, the haute discotheque Chez Régine's was the place to watch hot women swiveling their hips to a Sixties worldwide dance craze. The Twist had hit Paris, and it attracted a glossy crowd ranging from Premier Georges Pompidou to Nureyev and my Passy neighbor, Brigitte Bardot. The velvet rope at Régine's could be daunting to any man, but since I'd just contributed a piece with Art Buchwald for *Paris Match,* I had solid Parisian cred. That first entrée to Régine's world would be the beginning of a lifelong friendship with the diva of disco, a friendship that traveled back across the pond.

Enough of pâtés and sorbets and famous guys you've never heard of doing the Watusi. It's Paris, gentlemen, time to check out *les* girls. The women of Paris were openly erotic and seductive. Stripped of American puritanism, they flaunted their sexuality. The streets and avenues were hot. Everywhere you looked there were petite shop girls striking poses in cafes, bohemian madonnas reading thick tomes on the metro, sultry gamines smoking Gauloises under bridges, or elegant women in couture dresses sashaying down the Champs Élysées. They flirted with you openly, and they expected you to stare back. What would be the point of getting dressed up to show off your assets if men didn't ogle you? I didn't need to be convinced—I was a professional, certified gawker with gawker credentials. I had my sketch pad to prove it—and concealed behind its pages I could prolong my voyeurism as long as I wished.

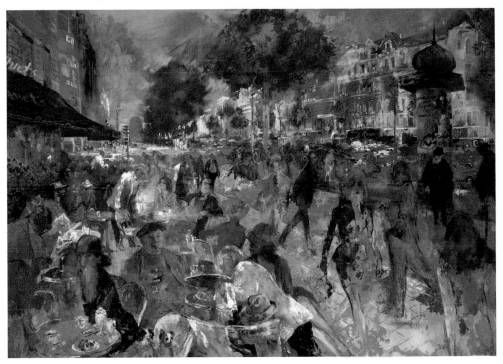

Fouquet's by LeRoy Neiman. Enamel and Acrylic on Canvas, 1991. Author's Collection

The place to go to see high-gloss girlie extravaganzas—and what red-blooded, *Playboy*-reading American male wouldn't want to—were the Lido, the Crazy Horse, and the most famous of all, the Folies Bergère where Manet's *belle époque demi-mondaines* had strutted and flaunted their stuff, and their modern counterparts still titillated blushing tourists with indecent displays of flesh and feathers. My imagination still sweetly stirs whenever I recall those kicky, long-legged showgirls strutting like swans backstage.

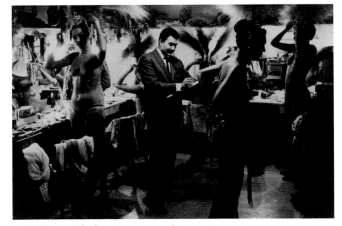

At the Paris Lido dressing room, 1960. Author's Collection

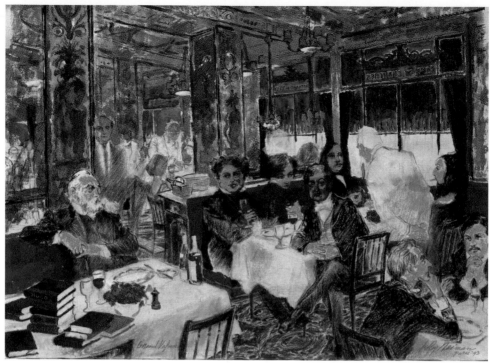

Le Grand Véfour *by LeRoy Neiman. Charcoal, Pastel, Marker, and Gouache on Paper, 1993.* © LeRoy Neiman

If the slick playboy image of the Right Bank wasn't to your taste, you could try the Left Bank, where metaphysics and noir movies were all the rage. Existentialism had been invented in Paris—man alone in the universe—and in the clubs of St. Germain's Left Bank, they celebrated nothingness nightly. It's the end of the world, so let's dress for it—basic black was the essential wardrobe—and let's hang out with Jean-Paul Sartre and Juliette Greco. For the men the Capone tough-guy look was de rigueur. Jean Gabin, who specialized in droll gangster roles and disaffected *policiers,* was a saint in this crowd. After reading Camus's *The Myth of Sisyphus*—the theme of which, as I recall, was that it was all downhill from here—the only music you wanted to listen to was jazz, whether it was the birth of cool with Miles Davis or le jazz hot with Louis Armstrong and Count Basie wailing at the Olympia.

Paris was the city American expats couldn't get enough of, and my Passy studio soon became the place for Yanks to gather after hours. Basie's band would stop by after their last set, and James Baldwin showed up on occasion to rattle cages—fueled with *The Fire Next Time* rage and the bitter psychology of racism. One night after

he'd stoked everybody to fever pitch, he retreated to my studio where I was holed up finishing a commission—he knew I was a sympathetic ear and didn't take his diatribes personally. We continued the conversation whenever I'd run into him in Montparnasse or at the Deux Magots, and after he went back to the States to become involved in the Civil Rights movement, I missed his rants and philosophical reflections on everybody from Plato to Hegel.

Jackson Pollock and de Kooning may have hijacked the avant-garde art world by this point, but until then every modernism there was had come out of Paris—impressionism, fauvism, cubism: the geniuses of implausible

James Baldwin by LeRoy Neiman. Marker on Paper, 1964.
Author's Collection

acts of avant-garde audacity—Picasso, Matisse, and Duchamp started the whole thing. After women and food, that's what Paris stood for: Art with a capital A. It was everywhere: on the street, and in the art galleries, ateliers, artist haunts, and monumental museums. The Louvre was a city of art in and of itself.

There was a sizable contingent of American artists living in Paris too. If you wanted to talk art American-style or wax nostalgic about the Windy City, you could find plenty of company among SAIC alumni who were living there. I often got together with my old classmate Leon Golub, of the monster art movement, at his studio near the Bois de Boulogne; spent time with Seymour Rosofsky, who painted unsettling pictures in a surreal primitive style; and knocked around town with the promising young African American painter, Bob Thompson, who lived in the so-called Beat Hotel and made bold fauvist-type paintings in the bright primary colors that I also loved to paint with. (Unfortunately, heroin got him, and he died way too young, in his early forties.)

One day Bob and I took a visiting SAIC sculpture student to the studio of Alberto Giacometti, near the flower market. We met the kid at the classic bohemian hangout, Deux Magots on the Boulevard St. Germain, a portfolio clutched under his arm. "Let's take a look," I said. Photos of healthy girls, bordering on obese and

Café Deux Magots *by LeRoy Neiman. Enamel on Board, 1962.* © LeRoy Neiman

full-buttocked, along with robust-looking voluminous male figures in the Gaston Lachaise/Botero manner were his thing. Why he was so eager to show these plump figures to the Swiss sculptor of ethereal mantis-like entities I don't know, but he was beside himself to meet the master.

We made our way to Giacometti's address and rang the buzzer. After several minutes (did he forget we were coming?) he answered the door, disheveled and dragging on a cigarette. Introductions were made all around. He welcomed us into his studio and said, *"S'il vous plait s'asseoir, mes amis."* But it wasn't that easy to find a place to sit in his dusty, cluttered atelier. I perched myself on a wobbly stool and was checking out the place when I realized the kid had already opened up his portfolio and was foisting photos of his work on Giacometti. In his nervous enthusiasm he was spilling them out onto the floor, and as he gathered one batch up, another batch slipped out.

Giacometti appeared to be taking it all in with great amusement, puffing on a Gitanes while examining the kid's sculptures, but ominously saying nothing as he turned over the images one by one. The kid started to sweat—perhaps it had occurred to him that showing these corpulent creations to Giacometti, the master of scrawny, elongated sculptures, was like bringing steak to a vegetarian dinner party. But just at that moment, Giacometti reared back in his chair and sprang to his feet. "Volume! Form!" he exclaimed, wildly waving his hands around invisible buxom outlines. "It is this that I have always struggled to achieve! Me, I do only these beanstalks! These puny matchstick figures!" Was he putting us on? We waited anxiously, uncertain how to react until he broke into ecstatic laughter. Giacometti was utterly unpretentious and compassionate, and his reaction was typical of his generous nature. Maybe too much postwar existentialism had starved the imaginative creatures he made, and he delighted in seeing the kid's figures as ripe and bulbous as melons.

All this feasting and ogling and traipsing to the ateliers of exalted artists was exhilarating, but after a while I needed to get out of Dodge. I picked up a tiny red Austin Healey Innocenti and, weaving through the crazy Paris traffic, headed south.

If the French were uninhibited in Paris, St. Tropez was a shameless playground of sea, sand, and sex. A blur of hot and topless barefooted beachniks, bellybuttons, and bottoms. The whole place was erotically charged, a pickup plage. If you didn't score on the beach, there was always the clubs—discothèques going strong, wild, and boisterous at three in the morning.

Monte Carlo, the capital of Monaco, a postage-stamp kingdom on the Côte d'Azur, was a 568-acre country barely the size of a Texas

Chemin de Fer *by LeRoy Neiman. Enamel on Board, 1966.* © LeRoy Neiman

Buses and Bowlers, London *by LeRoy Neiman. Ink and Watercolor on Paper, 1964.* © LeRoy Neiman

circulation of any paper in the world, until it screwed itself hacking phone messages, ending its inglorious career.

The English find seamy private clubs irresistible—upper-crust Brits love to slum at tony after-hours dens where the elite can rub shoulders with eccentric painters, tarty working girls, and underworld thugs. The two most infamous of these clubs were owned by Polish émigrés. Siegi Sessler, who could have been an Al Capone understudy, ran the show at Siegi's Club, a favorite late-night stop for Sinatra on Charles Street in Mayfair, where the regulars were a saucy mix of aristocrats, fashionistas, arrivistes, upstarts, and underworld mobsters—and, after I had featured it in *Playboy*—adventurous Americans looking for sport in the early hours of the morning.

At six feet four inches and 250 pounds, the beefy, jowled, and cigar-smoking John Mills was impresario at Les Ambassadeurs, a darkly brocaded and wood-carved Edwardian retreat off Hyde Park, with a membership roster featuring the Duke of Edinburgh, Sir Winston Churchill, the Sheikh of Kuwait, and Cary Grant.

The Polish mafia had also infiltrated London's emerging film scene. One night in '64 at a party at *Playboy* vice president Vic Lowndes's flat, I drew the portrait of an up-and-coming director—a little guy who was getting a lot of attention. This was Roman Polanski, whose chilling film, *Knife in the Water,* had come out two years earlier and made him famous. That night, they screened what was touted as his first film, a surrealistic twenty-minute movie about two men in the snow pulling a sled. The snow keeps falling and eventually covers them both, and they end up looking like mummies.

Polanski lived in Paris, but he'd brought a screenplay with him called *Cul-de-sac,* a black comedy he was trying to pitch to Vic to get backing. We later went

to the film's premiere, described by one critic, Ivan Butler, as the "grimmest of comedies, most hilarious of tragedies." Who could have imagined how Polanski's macabre view and unsettling freakishness would eventually spill over into his private life?

My night-shift explorations in London's underworld also led me to the Raymond Revue Bar, where full-frontal displays of nudity snuck past the censors due to its clever status as a members-only club. I caught the prime minister, Sir Alec Douglas-Home and his son, David, in the audience one night, and included them in a panoramic sketch, politely watching the panoply of bumping and grinding.

Sketching the highly visible had its occupational hazards. I once saw the monocled, eccentric oil magnate Nubar Gulbenkian, who, if not the world's richest man, was damn close, lunching with J. Paul Getty. A few weeks later I

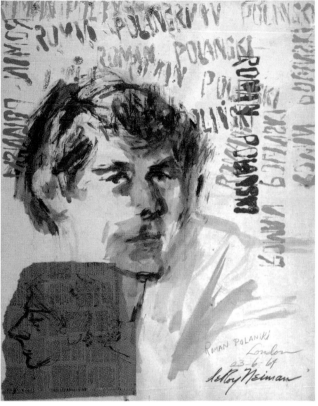

Roman Polanski *by LeRoy Neiman. Ink and Acrylic with Collaged Newspaper, 1964.* Author's Collection

got a call from Spectorsky at *Playboy*. He was unusually tense. "Getty's contacted the office from London, LeRoy," he told me. "In no way are we to reproduce those Dorchester images you did of Getty and Gulbenkian."

"No problem," I assured Spec, "consider the case closed." Or not. Several days later the phone rings again. It's Getty. Reminding me—as if he had to—of his vast fortune. Then he hisses, "If you ever try to use any of the sketches in any way, I'll sue you for everything you're worth."

William Faulkner said, "The past is never dead. It isn't even past," and this was never more true than in England. On Sundays London shut down, the one exception being the pewter bar of the Grenadier Arms on Wilton Row. It dated back to the Napoleonic Wars, and as far as the customers gathered there to celebrate the victory over Napoleon were concerned, it could've been yesterday. Seeing a frail Duke

of Windsor there among the rowdy mods and trendies made you wonder if you hadn't just caught a glimpse of a royal ghost. The place was said to be haunted—and I sure as hell believed there were spirits abroad—what with sightings of shadows gliding across the room, objects moving in the night, and footsteps heard pacing back and forth. But I figured these were spirits inspired more by an overindulgence of Pimm's Cups and Black Widows than any unhallowed ghost.

You can't always believe what you read in the papers—and you can't always take as literally what you see in the pages of the glossy skin magazines. Yugoslavia's nude beaches, for instance. What could be more stimulating than the idea of dozens of bare-naked ladies sunbathing along the Adriatic? For "Man at His Leisure," I painted a very rosy picture of this scene. The main illustration showed a group of beautiful young women ecstatically emerging from the surf.

For an artist, as I've said, a nudist beach provides a wonderful variety of living forms in shades of curry and apricot. But when the random boat drifts shoreward with leering tourists bearing binoculars, they might be greeted with a shower of rocks and unpleasantries. On the other hand, this can turn the nudeniks on to start striking provocative poses. It's not true that no one gets a lift at a nude beach. It happens. But when someone becomes visibly sexually aroused, they aren't given more than a passing notice.

The nude beach where I worked, called Sveti Stefan, was a mixture of jet-set modern and Yugoslavian medieval. Parading in the buff has never been my style—nothing to hide, nothing to flaunt—so my sketchbook served as both drawing surface and shield. I did a saucy drawing of a sybaritic Slav emerging from a snorkeling session in the waters off Red Island, like Venus rising from the sea foam. And there's a photograph of me "in the altogether," smoking a cigar and sketching a babe posing on a rock.

But when I said it's a delight to the eye in every way, that was a bit of a fib. Full disclosure: put away all fantasies of the body beautiful. The place was filled with sun-worshipping Germans who strictly enforced an "undress" code with scant physical prerequisites. At the beach, children played while their parents, definitely past primetime viewing, looked on languidly. The minority of buff bodies hardly atoned for the rest who were grossly overweight and out of shape. High-noon perspiration poured off dimly, oiled bodies. I wedged myself at a picnic table for *déjeuner* alfresco between two fleshy carnivores. Soon a naked waitress, no *Playboy* centerfold, came by to take my order. I looked up to see sweat dripping from the thicket of her armpits. Time to check out.

Yugoslavia spread from "Man at His Leisure" in Playboy. Reproduced by Special Permission of *Playboy* magazine © *Playboy*

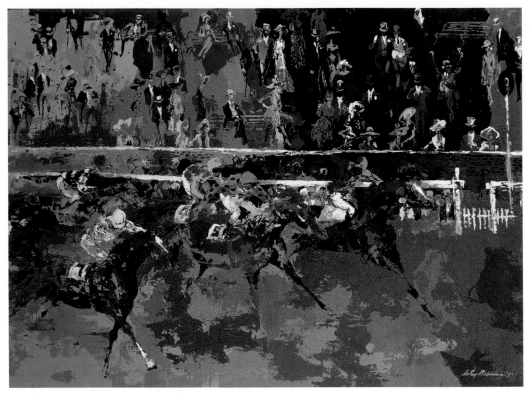

Ascot Finish *by LeRoy Neiman. Enamel and Acrylic on Board, 1973.* © LeRoy Neiman

Nobody was nude at Royal Ascot. Everyone from royalty to rogues decked out to the hilt for the occasion. I wore a top hat and morning coat. Ascot is a pageant, a fashion show, a Victorian lawn party, a cotillion ball, and an opportunity to show off hats so extreme they eclipse the faces of their wearers. I half expected Rex Harrison and Julie Andrews to burst out singing, as a hive of choreographed courtiers exchanged ceremonial bows and genteel pleasantries in front of the Royal Box. And there was horse racing too.

As bloodlines of man and beast preened between royal enclosure and paddock, the British social ladder in all its gradations was on parade. If lucky you might even get a leg up to the next rung. "I stye in rycing," one cockney hot walker told me, "because you get next to the rich. If you rub shoulders with them, some of it 'as to rub off."

Horses and stunning women have inspired artists for decades. Degas and Dufy found these events a colorist's paradise at Longchamp. Flirtatious mademoiselles mingled with uniformed members of the French army—a mix of fashionably dressed

femmes in the latest haute couture, prancing steeds, and jockeys in their harlequin colors.

Longchamp, which takes place the first weekend in October, is where the British pit their finest thoroughbreds against the French crème de la crème in flat racing for the Prix de l'Arc de Triomphe, an event first viewed in 1857 by Napoleon III from his yacht on the Seine. Weaving through the Bois de Boulogne in a taxi, watching Frenchmen and their women riding in horse-drawn carriages or relaxing in the grass with the ever-present picnic lunch (complete with fresh fruit and bottle of wine), it seems unlikely that the activity of a racetrack could be harbored within the park.

There were aristocrat rounds of polo at Bagatelle, whose ranks read like a roll call of the royal, noble, and super rich. Or for a more rural horsey event, there was Auteuil, a rugged cross-country run over creeks, down banks, and over stone walls, known as steeplechase racing, named for the church steeple that served as orientation for the riders.

On the right, facing the camera. Longchamp, 1962. Author's Collection

Study for La Plage a Deauville *by LeRoy Neiman. Watercolor on Paper, 1986.* Author's Collection

At Deauville during the August social season, you could take your pick of horses galloping around the track, the click-clack of high heels across the marbled lobbies of the Royal and Normandy hotels, or the intoxicating spin of the roulette

wheels at night in the casino, where high rollers would nonchalantly drop sums of money at gaming tables equivalent to a small country's GNP.

They say a proper initiation into the upper classes involves killing something. Ancient blood sports are among the more savage forms of aristocratic folly, like the Elizabethan pastime of riding to hounds at Hertfordshire, initiated in the seventeenth century, they'll tell you, to control the fox population. Oscar Wilde more accurately described it as "the unspeakable in pursuit of the inedible." My introduction to this grand old pageant had kicked off in Southern Pines, North Carolina, where I witnessed the blessing of the hounds, as close to religion as I'd been since my wedding day. Considering these exquisite but high-strung creatures were born and bred to kill, I wondered if the blessing was an act of absolution.

But for pure savagery nothing can quite equal the Rallye Vallières stag hunt near Chantilly. Jaunty bereted gents in black cloaks blithely sipped from hip flasks while women in tight-quilted vests gossiped and flirted, and then set off to watch the hounds bring down a stag and rip it to pieces in a bloody primal climax.

Here I was on location, experiencing a contemporary reenactment on those very heaths and woods that had inspired artists to paint the hunt for hundreds of years. Elizabethans and Renaissance artists glorified these rituals with their flamboyant pageantry and dark fables. From the fifteenth cen-

At Chantilly, 1962. Author's Collection

tury there was Uccello's masterpiece, *The Hunt by Night,* at Oxford; the sixteenth-century unicorn tapestries at the Musée de Cluny in Paris and at the Cloisters in New York; seventeenth-century allegorical hunt engravings; and finally, the nineteenth-century English sporting prints produced for the fashionable amusements of the gentry.

St. Mark's, Venice *by LeRoy Neiman. Acrylic on Paper, 1991.* Author's Collection

In Florence the enormous tapestries—ten feet high by twenty feet across— by the eighteenth-century French artist Oudry, depicting the royal hunt and featuring Louis XV with attendants, horsemen, and hounds, were the finest I'd ever seen. They inspired me to make a series of tapestries that I called *Hunt of the Unicorn,* done on six-by-four-foot horizontal burlap panels. I used the Chateau Raray, site of Cocteau's *Beauty and the Beast,* as the location for my *Rendezvous de Chasse,* a romantic image with horses, huntsmen, branded hounds—the full treatment.

When I open my sketchbooks from that period, I'm amazed at the number of scenes I covered. It's a visual history of an era at play. Hanging out with the glitterati of London, Paris, and beyond, I hurtled through those years on high-octane enthusiasm. It's exhausting now even to list the events I covered: the Cambridge-Oxford Boat Race, cricket at Lord's, boxing at Wembley, the Tour de France in Paris, soccer at the Stade de France, boxing at Wagram and the Palais des Sports, the Grand Prix de Monaco Formula One, the Cannes Film Festival, and the Garaglia Regatta along the Riviera from San Remo to Toulon. There was a tasting tour through the Champagne country, discovering Magritte murals in Belgium's Knokke-le-zoute casino, finding a *Time* magazine cover in Moscow's Lenin Library with my painting of Bobby Hull on it, sketching rehearsals of the Bolshoi Ballet, watching the Kirov from the prompter's box in St. Petersburg, camel racing in the dust of Morocco (I lost the sketches in a hotel in Casablanca, but found comfort from a belly dancer in Tangiers). Did I leave anything out? Ah, yes, the Royal Dublin Horse Show, and

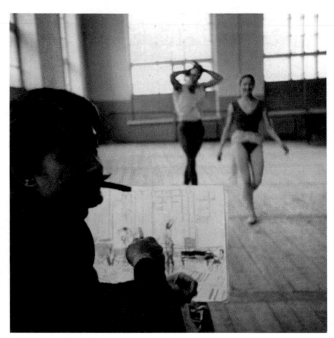

Drawing the Kirov Ballet, 1968. Author's Collection

thoroughbred racing at the Curragh Racecourse in County Kildare and Phoenix Park, where the best part was mixing with the ruddy and loquacious racing crowd in the Horseshoe Bar at the elegant old Shelbourne Hotel in Dublin. Here politicians, bookmakers, writers, and actors from the legendary Abbey Theatre all mingled and held forth—like so many voices from Finnegan's Wake.

And I'm not even going into the more leisurely adventures, like the time Janet and I traveled through the Riviera. We slept in a chateau near Toulon, then headed for Marseille, birthplace of Monticelli, for some classic bouillabaisse, and indulged our palates at the famous Moulin de Mougins, sampling Chef Roger Vergé's simple and fresh Cuisine de Soleil. Provence was a moveable feast: van Gogh's Arles, Cézanne's Mont Sainte-Victoire in Aix-en-Provence, and aromatic Grasse, center of the French fragrance industry, with its fields of lavender and jasmine, and its annual battle of flowers where women in diaphanous dresses throw flowers to the crowds.

And on top of this, while on my quest for "Man at His Leisure," I discovered the Beatles. Well, a few others had discovered them first—but I did see them in the primal cave from which they hatched: the Cavern in Liverpool, where I'd last set foot as a soldier in '43.

The evening began over a few pints with a couple of steeplechase jockeys at the Bears Paw Pub on Lord Street, then moved to the fights at Liverpool Stadium to sketch the soon-to-be world middleweight champion, Terry Downes. Whenever I'd ask about the nightlife of Liverpool—I wasn't expecting much—I'd hear (in thick Liverpudlian accents), "You've got to see these lads down at the Cavern—they make a lovely row in there."

So down a warren of rain-swept streets I went in search of the "grotty" and swinging joint, when suddenly out of the mist loomed the Cavern Club at 10

Mathew Street in the fruit-market area. I entered a vaulted brick-ceiling space crammed with a writhing mass of young Liverpudlians. In my all-American '50s crew cut, I shouldered my way past neo-Edwardian Teddy Boys in pointed shoes and long sideburns, and rockers in leather and chains in the dim, smoke-choked room, to the foot of a minimal stage. No ventilation, no fancy lighting, and the walls ran with sweat.

There they were, four lads, cheeky and irreverent, playing guitars and drums surrounded by frenzied fans. They wore leather jackets and stovepipe pants. They turned their backs on the audience when they felt like it, told dirty jokes, laughed, ate sandwiches, and played the loudest, most ear-splitting rock I'd ever heard. A few years later, in '66, after their dizzying rise to wealth and fame, I'd portray them in the uniforms of successful city business types, with bowlers and walking sticks, in a painting for the London Playboy Club. But that was all to come. For now they were just a band of working-class heroes called the Beatles.

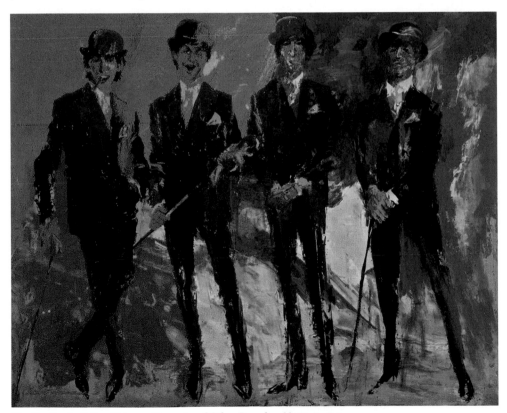

The Beatles *by LeRoy Neiman. Enamel and Oil on Board, 1966.* © LeRoy Neiman

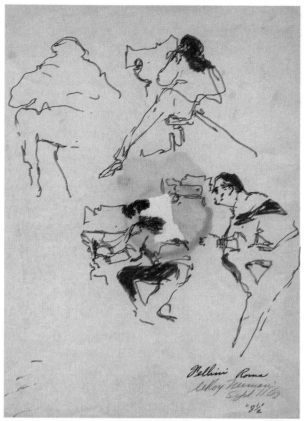

Fellini Shooting 8½ in Rome by LeRoy Neiman. Felt Pen on Paper, 1962. Author's Collection

Talking with Fellini in 1962. Author's Collection

This was the great age of European movies, the French New Wave, Italian *neorealismo,* dark Swedish visions, and gritty Brit social dramas, and no one was more the rage than Federico Fellini. I met him when he was shooting *8½,* starring his cinematic alter ego, Marcello Mastroianni, who always thought it was a big joke that Americans called him a Latin lover. The Italian original soon found a source of amusement in the wise-cracking American who'd crashed his set, which led to our discovering a common bond in art. When I asked Fellini where he had come up with his bizarre cast of carnival characters, he told me he saw the world satirically because he'd started out as a cartoonist, apprenticing under Saul Steinberg—evidence that Steinberg's iconic depiction of New York as the center of the world bears serious consideration.

The Holy Grail of Italian filmmaking was Cinecittà, a vast studio complex that resembled a small town devoted to film. At the time I was there, the most bloated Hollywood-style movie extravaganza was being filmed—a movie so costly it would contribute to the demise of the big-time studio system even as it depicted the fall of the Roman Empire. Elizabeth Taylor and Richard Burton were shooting *Cleopatra* there, and their off-screen romance was the real subject of tabloid frenzy. But I was more interested in another star on an adjacent set—Gina Lollobrigida—as were the Italian paparazzi who swarmed around

her like she was a queen bee in mating season. Between takes she sat in a director's chair, and I sidled over under the cover of my sketchbook to make some three-quarter studies of her face. She gestured for me to pull up a chair. A beautiful

woman rarely misses the smitten admirer—especially one with pencil in hand recording her gorgeousness. On the screen she looked like a voluptuous Roman goddess, but in person she was tiny and had the vulnerability petite women possess that inspires men to protect them.

Like all Romans she loved to talk: the movie industry in Rome, "a petty nest of vipers"; her nemesis Sophia Loren, "You know what they say about her early profession, yes?"; Italy's art scene and her photography. But how do you focus when you're in the presence of an international stunner? I got distracted, and by the time she was called for her next scene, *Cleopatra* had finished shooting for the day, and the incendiary Taylor-Burton duo had left to carry on their improvised scenes off-camera. I wouldn't meet up with Lollobrigida again until her photography show in New York in the '80s. We exchanged addresses and swore to keep in touch, but that was the last time I saw her. Ciao bella!

Gina Lollobrigida *by LeRoy Neiman. Felt Pen on Paper, 1962.*
Author's Collection

Fellini didn't have to put in casting calls for extras; the teeming life on the streets of Rome was there doing its evening *passeggiata*: Sports cars, bikers, starlets and oglers, Roman revelers, continental playboys both genuine and bogus, touristas, stray royals, could-be film moguls, and would-be Sophia Lorens milled nightly around the Café de Paris on the Via Veneto, or Rosati's in the shadow of twin baroque churches. Those churches inspired me to use Rosati's for my feature on Roman nights, which ran in *Playboy*'s January '68 issue. It was such an action-packed scene, and there were so many fantastic types that it took a foldout beyond the usual double-page spread to fit them all in.

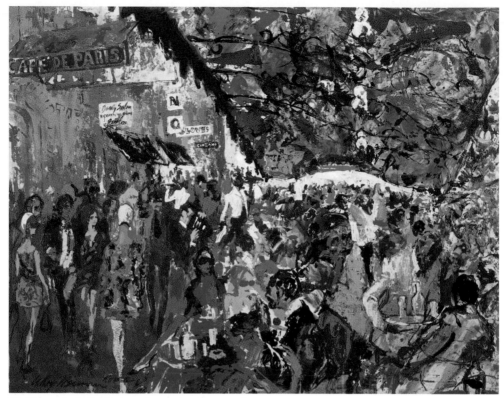

Via Veneto *by LeRoy Neiman. Enamel on Paper, 1962.* Author's Collection

One of the problems I tried to solve in my "Man at His Leisure" feature was how to show a panoramic view of the scene I was trying to convey. Solution: a third- or fourth-floor suite at the hotels where I stayed. Setting up at a window—preferably a balcony—gave me a vantage point from which to depict the passing throngs against a colorful background. If you're thinking of trying this out, here's a list of haute perches: London's Dorchester (panoramic views of Hyde Park and the Thames), the Savoy (distant vista of Westminster Abbey), the Paris Ritz (facing the Place Vendôme), Rome's Excelsior (the Via Veneto), and the Hassler (the Spanish Steps—a classic meeting place). From the Danieli or Gritti Palace you are virtually hovering over Venice's Grand Canal; the Amigo in Brussels overlooks Grand Place; and from Brenners Park in the Black Forest you can check out Baden-Baden's spa crowd.

Living like royalty in these grand hotels from another time, I saw them as courts, with their retinues of unassuming, conspicuously inconspicuous function-

aries from young journeymen to proud lifers, these tip-dependent wage earners all intermingling with the well-to-do.

꙼

Cocktail hour in Monte Carlo Harbor: A group of jet-setters gather on the deck of a yacht that is more like a floating boutique hotel. Among the elite crowd onboard is polo player and Dominican diplomat Porfirio Rubirosa—his reputation was that his maneuvers between the sheets were as skillful as his statecraft. The brutal Dominican dictator "El Jefe" (the Boss) Rafael Trujillo once described Rubirosa's assets as: "He is good at his job, because women like him and he is a wonderful liar."

So I figured I'd ask him a question that had long been bothering me: "In your vast experience, Mr. Rubirosa, is it better to give a woman flowers or perfume?" He reflected on this as if he were pondering a deep question of world politics while contessas, heiresses, debutantes, and starlets danced across his mind. "I think it is not flowers that a woman desires the most. No!" He raised himself up. "It is perfume. You see . . ." The setting sun appeared to pause as I waited for the maestro's explanation. ". . . the fragrance," he says with a twinge of nostalgia, "it will endure longer than the affair."

There'd always be someone in these scenes who couldn't resist twitting me about my magazine affiliation. To Rubirosa: "And what do you think of *Playboy* magazine?" With a flicker of a glance at me, Rubi replied, "I've read it, but why bother with photos? I prefer my women live." That's one critique of the magazine I can't dispute.

Trujillo was assassinated in 1961, and four years later the playboy diplomat died as he had lived. After a night of celebrating the Coupe de France polo cup win, his Ferrari 250 GT crashed into a tree in the Bois de Boulogne.

I watched the passing tableau from behind my sketchbook—both entrée and shield to that world. Neither a complete outsider nor one of them, I was content to be a fly on the wall. I was a scout reconnoitering pleasures unknown to most Americans.

I watched how these people chose to spend their inexhaustible time and money. Marriage vows were tested and monkey business was accepted. As Evelyn Waugh put it: "Manners are especially the need of the plain. The pretty can get away with anything."

The trappings of affluence and luxury fascinated me, as did the decadent dance of the dolce vita. But I was living in a parallel world. Meanwhile, back in the States

things were falling apart. JFK had been assassinated; there were race riots in Watts and Detroit; cities were burning; and the Vietnam War spurred violent clashes.

Aside from the odd artist and musician, most Americans I met abroad were pleasure-seeking CEOs and power brokers living it up in a Euro playground. But even in those pre-digital times, they were never out of touch with what was happening in the real world. Hanging out with them while their guard was down, I often felt more informed about what was really going on than if I'd been back in the States.

Despite all this traveling and observing, I still sought respect as a fine artist and entered some of my paintings at the Salon d'Art Moderne in '61, where I won a Gold Medal. This led to talks with the Galerie Paul Pétridès on the exclusive rue du Faubourg Saint-Honoré. But just as negotiations were looking good, the *Playboy* curse raised its head. No one can be snootier than a French art dealer, and when Paul Pétridès heard about my involvement with the magazine, he sneered, "*Jamais!*" How was *Playboy,* promoter of sensuality and well-endowed young women, such a moral slur to him? Especially since it was rumored that during the occupation, Pétridès sold paintings to Goering and outed Jewish collectors. I should have snapped back, "*J'accuse!*" but it blew over too quickly.

After much equivocating and splitting hairs *en francais,* it was agreed that I'd exhibit with Madame Pétridès at her Galerie O. Bosc. *Fini?* Not so fast. The afternoon before the opening, I suggested an oil of a French paddock scene for the window. Madame dissented. "The painting, it will not be suitable there. It is better to consider one or two aquarelles, *non?*" I pushed for the oil. "But Monsieur," she countered, "it is the image on the affiche! Avenue Matignon! Faubourg Saint Honore! This painting is everywhere!" French logic. In my opinion, the fact that the poster was all over Paris was all the more reason to put the oil painting in the window.

Ah, but I was an ignorant American. I didn't understand the subtleties of the French art market. With a great Gallic sigh and a look of patient condescension she said, "Monsieur Neiman. The French do not buy the large oils, especially not from *des artistes Américains inconnus.*" *Très bien,* Madame. Now it was a case of her obstinacy versus my tenacity. After much back and forth, we settled on a compromise. We'd display the oil in the window—*mais!*—only for the preview—to humor the ignorant American.

No sooner had we begun to position the painting in the window than a Mercedes limo pulled up in front of the gallery. A chauffeur jumped out and opened

the door for a stout, expensively dressed gentleman. After gazing at the painting for a moment, he strode into the gallery. "The oil in the window!" he barked in a thick German accent, "I would like it. Can you ship it to Berlin for me please?"

The peevish Madame Pétridès was now all unctuous charm. "But of course, Monsieur!" she said, sashaying over to him, "And may I offer you a café as we take the details?"

"I'm on my way to the airport, Madame," he replied, handing her his card and turning to leave, adding over his shoulder, "You may ship it to that address."

I looked over at Madame. Unfazed she looked at me triumphantly, as if she'd aced the sale, and said, "Ah, those German industrialists, they collect their art with such bravado!"

As a postscript to this story, it turned out that the supercilious Paul Pétridès lived to the ripe age of ninety-two after making a bundle on the American and Japanese markets. In '79, after a cache of stolen paintings was found in his possession, he was sentenced to three years in prison, but beat the rap by pleading old age.

The following year, in March of '62, I had a show in London at the O'Hana Gallery on Carlos Place, owned by the charming and quirky Jacques O'Hana, who talked the Honourable Gerald Lascelles, cousin of Queen Elizabeth, into performing the opening honors. Even a naughty old lord showed up for it, the thirteenth Duke of Bedford. He'd got himself in the tabloids for allowing a film about a nudist colony to be shot on his manor, Woburn Abbey. But his lordship was quite unrepentant, saying, "I wouldn't mind going nude myself." The Duke showed up with his third Duchess, French film producer Nicole Milinaire, and party-girl step-daughter, Catherine Milinaire, the Paris Hilton of her day.

We twisted the night away, and the next day Roger Beardwood reported in his column in the *Evening Standard,* "Artist Neiman Dances as the Cash Rolls In." But the main event for me came when I spotted a diminutive woman threading her way through the crowd. Though I hadn't seen her for twenty years, I recognized her purposeful gait and steadfast smile immediately. Not a baroness but a true lady, she had traveled from her home in Uckfield, Sussex, for the opening. It was my wartime sweetheart, Annie.

With Shel Silverstein and Louis "Satchmo" Armstrong in 1962. Author's Collection

Artist Photo at Mr. Chow's: from top to bottom (left to right)
1. Michael Heizer 2. David Hockney 3. LeRoy Neiman 4. Dennis
Oppenheim 5. Stefano 6. William Wegman 7. John Lurie
8. Unidentified 9. John Chamberlain 10. Andy Warhol 11. Arman
12. Alex Katz 13. Keith Haring 14. Kenny Scharf 15. Tony Shafrazi
16. Red Grooms 17. Julian Schnabel 18. Jean-Michel Basquiat
19. Francesco Clemente 20. Robert Mapplethorpe 21. Ronnie
Cutrone 22. Unidentified 23. Sandro Chia 24. Chris Goode 25. Darius
Azari 26. Bernard Zette 27. Shawn Hausman 28. Eric Goode Michael
Halsband/Landov

With Nelson Mandela and my painting on the flag of South
Africa, Nelson Mandela, in 1997. Author's Collection

San Francisco *by **LeRoy Neiman**. Enamel and Acrylic on Board, 1991.* © LeRoy Neiman

Orange Sky Sailing *by **LeRoy Neiman**. Enamel and Acrylic on Board, undated.* © LeRoy Neiman

Cafe de la Paix by LeRoy Neiman. Enamel and Oil on Board, 1961. Author's Collection

Stretch Stampede *by LeRoy Neiman. Enamel and Acrylic on Canvas, 1975.* © LeRoy Neiman

Basketball Superstars *by LeRoy Neiman. Enamel and Acrylic on Board, 1977.* © LeRoy Neiman

1972 LeRoy at the Knicks vs. Lakers game at Madison Square Garden.

Author's Collection/Photo by Barton Silverman

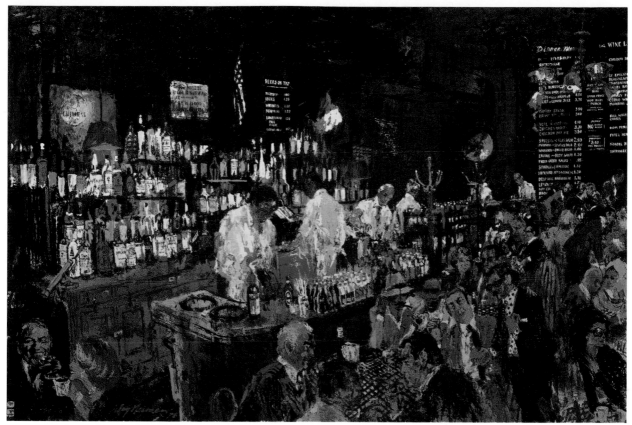

P.J. Clarke's *by LeRoy Neiman. Enamel and Acrylic on Board, 1978.* © LeRoy Neiman

With Muhammad Ali at Gracie Mansion in 1991.

Author's Collection/Photo by Howard L. Bingham

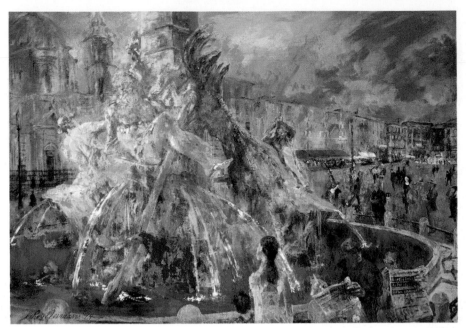

Piazza Navona *by LeRoy Neiman. Enamel and Acrylic on Canvas, 1994.* Author's Collection

April at Augusta *by LeRoy Neiman. Enamel and Acrylic on Board, 1990.* © LeRoy Neiman

At the 1984 Los Angeles Olympics. Author's Collection
/ Photo by Lynn Quayle

Painting Opening Ceremonies XXIII Olympiad *at the Playboy mansion in 1984.* Author's Collection / Photo by Lynn Quayle

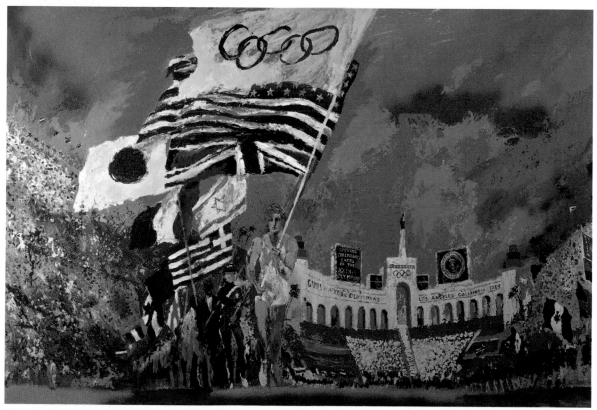

Opening Ceremonies XXIII Olympiad *by LeRoy Neiman. Enamel and Acrylic on Board, 1984.* © LeRoy Neiman

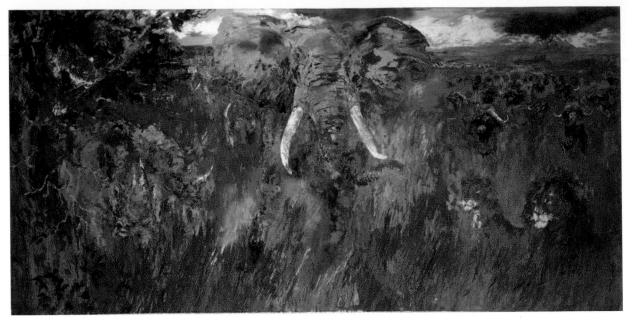

Big Five *by LeRoy Neiman. Enamel and Acrylic on Canvas, 1994.* © LeRoy Neiman

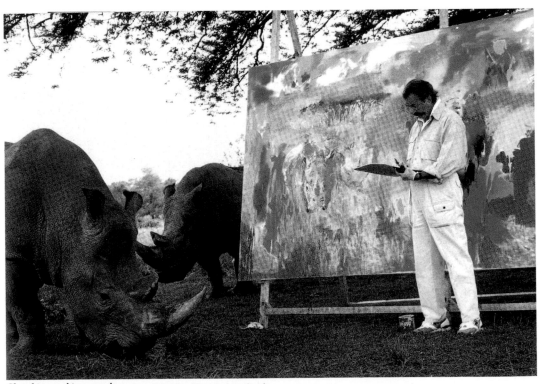

Sketching a rhino couple. Author's Collection / Photo by Lynn Quayle

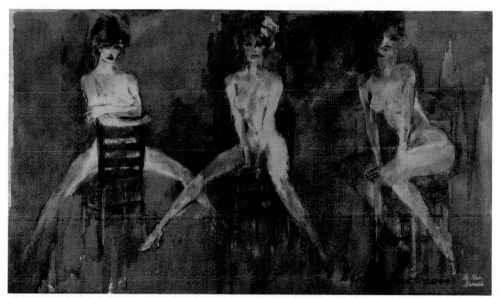

Three Graces *by LeRoy Neiman. Enamel and Shellac on Board, 2000.* © LeRoy Neiman

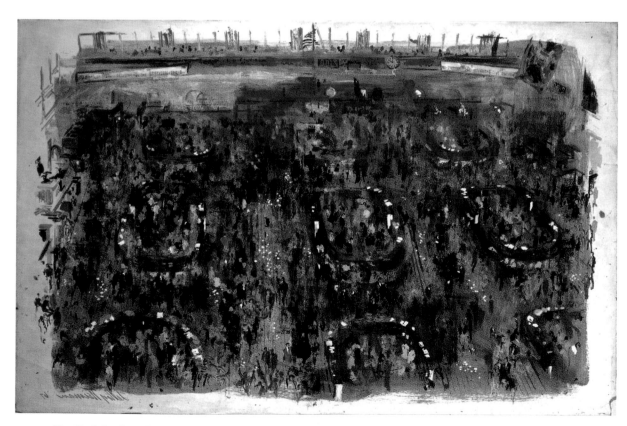

New York Stock Exchange *by LeRoy Neiman. Monotype on Paper, 1967.* © LeRoy Neiman

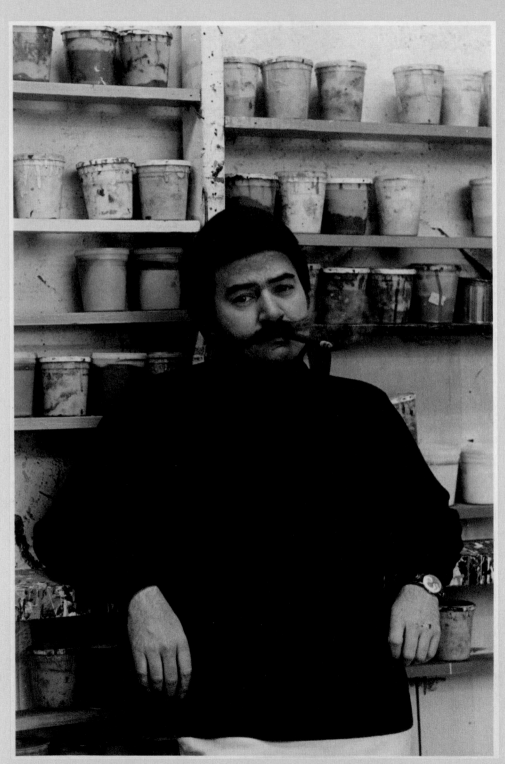

In the New York studio, 1969. Author's Collection

7

The Artist in Residence

There were no more mountains to climb, plats du jour to consume, horses to sketch, roulette wheels to spin, games of chemin de fer or *cherchez les femmes* to play. My Euro-walkabout had created a splashy record of an entire era—the goings and loiterings of the nouveau riche. It was time for me to relocate to New York City. In '63 my brother, Earl, found me an apartment in a grand old building on the west side, with double-height artists' studios. I moved in and have been there ever since.

I came back from my long sojourn in Europe, sketchbooks crammed with drawings, and as many paintings, to find that the feckless goddess of the art world had upended everything. When I left on my travels, abstract expressionism was still the dominant art movement. I understood abstract expressionism. I had started out painting like the splashy ab-ex guys, but by the time I got back to New York and got into the swing of things, pop art was all the rage. Warhol soup cans had made their debut, rolling off the supermarket aisle into the prestigious galleries and glossy magazines.

Because of the way I paint, people often think that the latest trends art movements would make me cantankerous and crabby—but not at all, art is about the only thing that's never made me ornery. I've always liked seeing what new artists were up to. You march to your drummer, I'll march to mine.

And the inspiration for my beat was all practically next door to me: the Metropolitan Opera, the NY Philharmonic, the Juilliard School, and the New York City Ballet at the newly constructed Lincoln Center for the Performing Arts with its cutout arcades, looking like a set from a Menotti opera. Lincoln Center wasn't exactly *son et lumière* in Arles, but on summer nights with the whole area lit up for the evening's events, and the splash and sparkle of the fountain in the center of the plaza, it was a magical place.

The new Metropolitan Opera House opened with a splash on September 16, 1966, three years after I'd settled in. It was (and still is) the largest opera house in

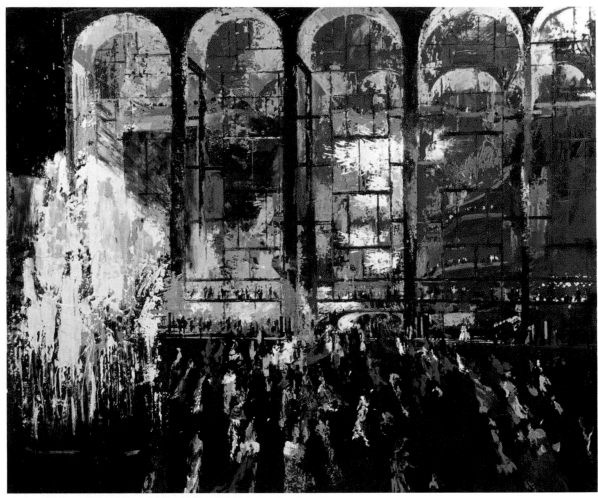

Metropolitan Opera *by LeRoy Neiman. Oil and Enamel on Board, 1966.* © LeRoy Neiman

North America. I love these super-gala events. You know what I think of when I see them? An occasion for a painting! A 160-foot-long, 9-foot-wide red carpet rolled out for the so-called Diamond Brigade makes a great ribbon of paint on which to place these bejeweled socialites. You've never seen so many dowagers and tycoons in one place at one time.

When the Met puts on *Aida,* it's a magnificent Egyptian cinemascope production—and always a great opportunity for bringing livestock on stage. That night there were five live horses, three goats, and a camel. It was such a flashy, flashbulby

occasion that I did two paintings of that night. Crowds of fancy people in fancy dress and candelabras are my forte. My specialty is a mob of haute-coutured dames and fat cats striking a pose—like the *Grand Escalier* painting I did at the opera during my stay in Paris, and my drawings of the six-deep chic intermission crowd at the Met's mezzanine bar.

In his ballet dancers, Degas caught the kind of grace you don't see anywhere else in life, a defiance of gravity that's the closest thing a body in motion can get to in performance. On off-performance days, I'd wander into an empty Avery Fisher Hall or the Metropolitan and choose my vantage point in the curve of empty seats next to the stage. At rehearsals I sketched Leonard Bernstein, Beverly Sills, ballet master George Balanchine, choreographer Jerome Robbins, and many young dancers such as Suzanne Farrell, Peter Martins, and Edward Villella. I used Villella as the model for my *Harlequin* painting. He was perfect. From the first moment I saw Harlequin in a performance by the Comedia del Arte players on Paris's Left Bank, I loved this sly, nimble character in his tatterdemalion finery. He represents for me life in all its irony and wit.

I was lucky to be living right next to Central Park. Now there was a landscape worthy of Claude Lorrain, the

Grand Escalier de L'Opera **by LeRoy Neiman. Enamel and Oil on Board,** *1969.* © LeRoy Neiman

Leonard Bernstein *by LeRoy Neiman. Sepia and Brown Ink on Paper,* *1967.* Author's Collection

Harlequin *by LeRoy Neiman. Enamel and Acrylic on Map of Bergamo, 1982.* Author's Collection

great baroque landscape painter. The park is in itself a work of art. Its brilliant artifice is to pretend that what you are walking through is unadulterated nature, relocated to the center of New York City. It was ingeniously laid out by two master designers, Frederick Law Olmsted and Calvert Vaux, who used great lawns, pathways, ponds, trees, and rock formations as their palette. Not everyone can create a masterpiece like Central Park where people of every ilk can congregate and wander about. When I first moved into my studio, the building across the way was a riding stable, and, as if you lived in another century, you could hear the clippity-clop of horses as they walked into the park from the stable. I can never get enough of Central Park with its green shade and patches of open grass, arbors, and playing fields.

You look up past the park's leafy green trees to a city of walls. Like canyons—which might be a come down, but it all depends on

New York Skyline *by LeRoy Neiman. Ink on Paper, 1955.* Author's Collection

how you look at it. When I first got to New York, I saw a city of walls and doors—walls for hanging pictures on and doors to get my foot in.

One of those doors belonged to the Hammer brothers' gallery on 57th Street. The Hammer brothers, who didn't have the greatest reputation in the art world but sold paintings galore, had recently approached me about representation. Dilemma. So one night at dinner with my old friend Jean Shepherd, his wife, and the playwright Herb Gardner, I asked for their advice about getting involved with the brothers. Jean put it to me bluntly: "You have two choices here, LeRoy. Sell out, or hold out. Let me give you some advice. Most people in New York end up selling out. If you do too, you're going to find that it's really savage out there. On the other hand, you've got a good shot at making it, faster and easier, if you hold out. Few people try, so you'll have less competition." All heads wisely nodded in agreement.

As I've never been one for following the counsel of others, including sometimes, my own, I showed up the next day at Hammer Galleries like a lamb to the slaughter. There to greet me were the three Russian Bears. Harry was the oldest and the gallery's accountant; Victor was the youngest, the gallery director and man-about-town storyteller, all dapper with a carnation kept fresh in a water vial concealed behind his lapel; and Armand was the outrageous entrepreneur and international hustler. It's the one and only time I've ever auditioned for a gallery. I pretty much felt it was a shoo-in—either that or they hated my work, because the interview ended so abruptly. I'd only shown them four transparencies and unwrapped a small drawing before they interrupted the meeting, saying, "Thank you for bringing in your work, Mr. Neiman. We'll be in touch." That was it.

The following day I got a call from Victor. He welcomed me to the Hammer Galleries. No art discussed.

I'd really wanted to be in a top New York gallery, but instead impatiently went with the first big gallery that showed interest. I guess my work looked sellable, and that was the one and only criterion for the Hammers. Everything about them was out of step with the art world. When they moved their gallery from East to West 57th, it was on street level with a big front window where they showcased the art like in a department store. The more prestigious dealers had their galleries on the upper floors and looked down, literally, on the Hammer Gallery, like a snobbish old gent with a monocle examining a bug on his shoe. Hammer was either just clueless about the art scene, or else they didn't give a damn. I couldn't have chosen a more irreverent bunch of dealers than these fellows.

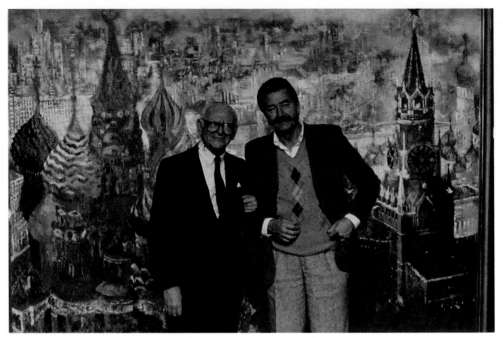

With Armand Hammer in front of my Red Square Panorama *painting in 1987.* Author's Collection

And they'd set up shop on the wrong side of the street. All the other galleries were on the downtown side, so what did Hammer do? Go north. On the other side of the street were galleries that held contemporary, critically reviewed shows where gallery goers rode elevators floor-to-floor, artist-to-artist, like in an exclusive arcade, flushing out top-notch exhibits and meeting or ogling art lovers and collectors. Hammer Galleries was famous all right and well bankrolled, but carried a controversial reputation. Victor Hammer was labeled an art merchant, more interested in sales than in the quality of the paintings (show me a dealer who isn't). So many dealers love to pretend that their main focus is the sacred work of art, knowing this aloofness only ups the price.

Victor made another cardinal sin in the art world by pandering to his celebrity and society pals, exhibiting the work of cafe society painters like Fleur Cowles, creator of the chic *Flair* magazine, the precious watercolors of a well-known Parisian couturier, and the oil paintings of front-page lawyer Louis Nizer. But shows at Hammer Galleries were always a party, I have to grant them that. Exhibitions centered around the whirligig contraptions of Rube Goldberg, the witty paintings of Ludwig Bemelmans, best known for his *Madeline* children's books, the costume

design sketches of Marcel Vertès, and when times were tough, the inexhaustible sleighs-in-the-snow paintings from the Grandma Moses estate.

One day I was at the gallery while they were hanging the show by the Dutch fauvist Kees van Dongen, one of my idols, an erotic colorist, a painter of sensuous, brilliantly garish portraits—one of the supreme fauvist artists. Just then Victor sweeps into the gallery and says, "Take all that stuff down, we're canceling the show." Van Dongen had come over from Monaco for the show and was devastated. When art wasn't moving, Victor could be heartless. He also cut short a show of Phillip Evergood's, whose fantastically grotesque paintings of American life are a disturbing record of our national schizophrenia. And he rejected Abraham Rattner, a kind of twentieth-century icon maker—a luminous, brilliantly colored religious painter. These guys may have been in the twilight of their careers, but they were great artists. When I asked Victor why, he just snapped, "They don't sell."

The Hammer brothers were an anachronism. If you were to start a business with your brothers today, you probably wouldn't identify it that way. But at one point in history, and not that long ago, brothers in business were all the rage. The shaggy-bearded Smith brothers peddled cough drops, and in show biz there were the Marx brothers, the Ritz brothers, and the formidable Warner brothers in Hollywood, four guys who, when they finished screwing everybody else, turned on each other.

The first one-man show in history took place in Paris in 1855 when Gustave Courbet pitched a tent outside the exhibition he'd been kicked out of, to show his work. My first solo show at Hammer took place in October of '63. Fortunately for me it was a sales success, otherwise I would have been out on my ass like all those other painters—in very good company, but without a gallery. Victor was Mr. Show Biz, a dapper, witty guy who came on like his favorite jolly song-and-dance men—in fact he thought he was Al Jolson. One

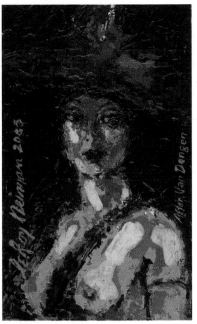

Homage to Van Dongen *by LeRoy Neiman.*
Enamel and Acrylic on Board, 2003.
Lynn Quayle's Collection

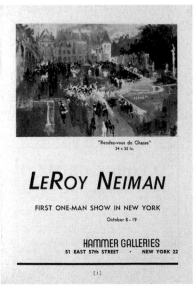

LeRoy Neiman—First One Man Show Card, 1963. Author's Collection

Friday after I'd had several sellout shows, Victor invited me to lunch at the Dutch Treat, in the Regency Hotel, one of his favorite men's clubs. In the middle of the meal the shameless hoofer went off, this time into his Eddie Cantor routine, telling jokes and singing (they didn't put the "ham" in Hammer for nothing). When he settled down he said, "LeRoy, let's go sit over there with Gene Tunney," which I was thrilled to do, Tunney being the great retired heavyweight champion. We were all laughing and talking and telling great old boxing yarns when Victor switched to his Jekyll and Hyde routine. One minute he was a jovial drinking buddy, the next minute he was snarling in my ear, "LeRoy, whaddya think you're doing?"

Before I could ask him what he meant, he said, "I'm hearing bad things, LeRoy. I hear you're selling paintings out of your studio. That's got to stop—or else."

I told him I had no intention of stopping, "And Victor," I said. "What the hell do you mean 'or else'?"

He got red in the face, and was working up to a nasty blowout, but none of that impressed me. I'd handled worse than Victor in my day, and I wasn't giving an inch.

"What I sell in the studio are paintings you won't hang in your gallery."

"Yeah, like what?"

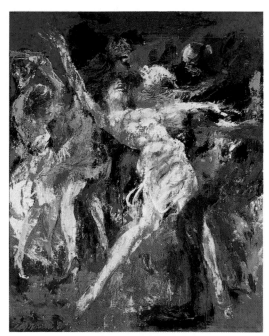

Club St. Germain *by LeRoy Neiman. Enamel and Oil on Canvas, 1961.* © LeRoy Neiman

"Oh, you know, paintings of blacks and whites socializing, prizefights, erotic nudes—subjects you say you don't want to sell."

"Ah, that stuff," he said with a disapproving smirk, but after that I never heard any more about my private sales.

They weren't exactly liberals, the Hammer brothers, and you could practically see the smoke coming out of Victor's ears when he got worked up about such subjects. While hanging my first one-man show at Hammer, Victor suddenly grabbed my arm and hissed, "Don't even bother hanging it. This one's not going in the exhibition." It was a painting of a Paris discothèque, the Club St. Germain, in which I'd shown a black man dancing with a comely young white girl.

"What are you talking about?" I asked him.

"Well, look at it . . . what do you think I'm talking about?"

"I'm looking, spell it out for me."

"Our clientele are not up to this sort of provocative subject."

"Who are these people?" I heard myself blurt out. "It stays or no show."

He could see I wasn't going to budge, so he shrugged his shoulders and said, "Okay, well, if you feel so strongly I'll hang it around the corner, where only the adventurous will discover it."

Guess what? The painting was the first to sell that night at the opening.

The press release for the show, written by CBS newswriter Merv Block, was better than anything I could have written myself. This is the extravagant way he described my first Hammer show: "Neiman builds his figures with flickering dabs, daubs, and rapid veils of paint, with an intelligently fauvist practice in color—light, vivid, and gay . . . he has a sharp eye for stance, posture and bodily tensions, plus an ability to set them down, as well as a gift for catching and conveying movement. Neiman's own background among the unwashed, unwatched and unwanted accounts for his fascination with both the underprivileged and the overprivileged."

Let me give you an idea of the Hammer brothers' approach to fine art. You walk in the gallery, and there are two salesmen, sitting at identical desks, hustling art— that's the only way I can put it. They were like two stock market short traders who'd lost their way and ended up in an art gallery, both jabbering away, competing as to who could sell the most Neimans over the phone to their clients—sight unseen. And when I say sight unseen, I mean they probably had no idea what painting they were talking about themselves. They had a catalog and a price list. These guys could sell art to the blind.

Armand Hammer had a unique approach to making himself prestigious in the art world. If he couldn't create a high-class gallery, he'd buy one. So in the early '70s, Armand Hammer bought the much revered Knoedler & Co., the first gallery ever to open doors in New York City, back in 1846.

Salvador Dalí was a perfect match for the Hammer brothers. He was a genius, but with an out-of-control mercenary streak. It was widely rumored that he would sign stacks of blank lithographic paper if he needed some extra cash. I was at an opening of his one-man show at Knoedler when the photographer, Ken Zeran, asked Dalí and me to pose together for a photo in front of a Dalí painting. Dalí had his ubiquitous cane, and I had my cigar. Victor, ever the control freak, came charging over and shouted, "LeRoy, get rid of the cigar!"

Dalí quickly intervened. "No, LeRoy, keep cigar—good prop."

Dalí was someone who understood the value of an indelible image. By the mid-'60s, art was part of pop culture, and you needed some sort of image to identify yourself when your picture got in the paper. In fact, I owe the extravagant length of my mustache to Dalí's wife, Gala.

"LeRoy, never do anything in half measures," she told me. That was something she and Dalí knew only too well.

"Either grow your mustache wider like Salvador or cut it to mouth width like Omar Sharif."

Well, you know which direction I went in.

Victor Hammer was a menace, a fussy, bean-counting man who knew little about art. But he wasn't the only difficult Hammer brother I had to deal with. Armand was always up to something tricky—how else did he acquire all his millions? I got a taste of his maneuverings firsthand in the early '80s. Armand was in his eighties himself, he had an impressive art collection, and he had decided it was time to add a Neiman to his holdings. I was flattered, seeing as the only other living American painter in his collection was Andrew Wyeth.

With Salvador Dalí, 1972. © Kenneth Michael Zeran

Armand had a grand manner and knew how to charm people he was about to fleece. "LeRoy," he announced, "I believe you are the Daumier of our time."

Well, that got to me (Honoré Daumier is one of my favorite social satirists, and I knew Armand was proud of his Daumiers). I waited for his next line. "Therefore I would like to select a work of yours to add to my collection."

No problem. I consulted with gallery director Richard Lynch and Maury Leibovitz, president of Knoedler Publishing, and we agreed on the three works we'd show him. Armand arrived punctually at the gallery with great flourish to make his choice.

"Okay, let's see what you've got."

We brought out a large roulette painting.

"Aw, no, much too big! Next!"

We showed him a smaller oil of a nude.

"Subject matter unsuitable!"

Finally we brought out a twenty-four-by-thirty-inch watercolor titled *Homage to Constantin Guys*—Baudelaire called Guys "the painter of modern life"—in which I had juxtaposed details of Guys's compositions, including carriage and ballroom scenes. We scanned Armand's face, anticipating his reaction. He was beaming.

"Okay, so what's the price tag?"

"$25,000," I quoted.

"Nonsense!" Armand snapped.

"Okay, we can let you have it for $15,000." Maury said, thinking he was offering him a great deal.

"I'm not going with that figure!"

Appealing to Armand's business acumen, Dick Lynch said, "Dr. Hammer, you don't expect a Neiman, one of your own artists, to go under that figure, do you?"

I'd dealt with self-made titans before, and I could see at this point it was pretty hopeless reasoning with a guy like that.

Finally he said, "What the hell, this is my gallery, isn't it? Why should I have to pay for it in the first place? Dick, send the watercolor to my home in Brentwood! I like it!"

Done deal.

Armand's favorite axiom was "There is no such thing as a deal that can't be made," and he knew what he was talking about.

Armand was an irrepressible self-promoter and a master at manipulating people. He was at his happiest when he was able to accomplish both simultaneously. I'm a sucker for madcap characters, so he found me an easy accomplice in his off-the-top-of-his-head schemes. Out of the blue I'd get these crazy summonses. The phone would ring, and it was Armand calling from his private jet: "LeRoy, you must come with me to Holmby Hills, California, the sooner the better."

"And why is that, Armand?"

In his imperial manner, he'd reply, "To see my new Daumiers, of course."

Another call from the jet. (Armand had a penchant for high-altitude calls.) "LeRoy, you must come with me and view the Hammer Codex."

The "Hammer Codex" had been known throughout its long history as the Codex Leicester until Hammer bought it. Its creator, Leonardo da Vinci, had been too modest to attach his own name to this collection of his scientific writings, but not so Armand (after he sold it, though, it reverted to its original name).

'92 at well over ninety years of age. But the Mephisthophelean charm of Dr. Hammer—his fiendish laugh, his stingy dealings—were excused by those near him, who enjoyed his ribald and rabid storytelling. He relished the Redd Foxx or Don Rickles brand of filthy joke. The rougher and more off-color, the better.

Why did I stick with Hammer Gallery all these years? Because we were in the same boat, the Hammers and myself—especially Armand and I. We'd both been savagely maligned and vilified by "official" circles. We were both thought of as beyond the pale by the art police (and other busybodies), and neither of us showed any intention of changing our ways to suit their high-falutin' opinions. Armand was slippery as an eel, so it was always an entertaining challenge doing business with him and our in-house dealings were as mysterious as the art game itself. The cast of characters at Hammer Gallery was straight out of vaudeville and enjoyed a prolonged fifty-year run off-Broadway.

⌒

The setting: the Hammer Gallery, just off Park Avenue. It's a Saturday afternoon in the early '60s. The curtain rises. Enter an affluent Park Avenue gent strolling into the gallery with a recently plucked girlfriend on his arm (his wife estranged or conveniently out of town). He parades her around the gallery with exquisite care and selects, say, a Renoir or a Pissarro, and maybe a small Neiman.

"Have these sent over to my residence this afternoon, my good man," he commands with the entitlement of the well-heeled.

"Certainly, sir," says the obsequious salesman.

On his way out, he pauses dramatically at the front entrance. The staff stop what they're doing and wait to hear what he is about to say.

"Just a minute, darling, forgive me," he says in a plummy voice to the pretty young thing on his arm. "But is there anything that you saw here that you liked?"

She nods coyly, demurely hiding her excitement. With great ceremony the two of them make another turn around the galleries. She pauses in front of a delicate, modestly priced Degas pastel. Now both are smiling, holding hands as they exit the gallery.

The silver-tongued devil calls back over his shoulder to the salesman, "Send the Degas along this afternoon with the rest."

Monday he calls and cancels. The painting served perfectly for the weekend, including the Saturday night soiree he was throwing.

No artist ever depicted these denizens of urban Park Avenue, the Hamptons, and Newport like Peter Arno, the *New Yorker* magazine cartoonist (and talented

lithographer) who could skewer an entire self-satisfied class in a few graphic lines and a witty caption—one of my favorite artists. He was the true social historian of this milieu, and an exquisite caricaturist. His treatment of bars, restaurants, private clubs, and their patrons—rich inebriated gourmands, self-important males and their festooned wives and floozies—interacting with the jaded waiters, doormen, and taxi and limo drivers who attended them, was a wry commentary on the relationship between the smart set and the functionaries that swirled around them.

~

There was the opera buffa of the Hammer Gallery, and the light comedy of New York high society's hijinx. And then there was the real theater of Broadway—on and off. My first theatrical commission was a painting of Sammy Davis Jr. for the program cover of Clifford Odets's play *Golden Boy* in '63. Sammy Davis Jr. was a totally manic character. He would do three shows a night at the Copa while in rehearsal for the musical, hang out at Jilly's with Sinatra, and then spend the night with a couple of showgirls. Nothing slowed Sammy down. He propelled himself toward the opening of the show like an overwound toy. I painted Sammy at the premiere making his entrance like a Las Vegas princeling, mounted police guarding the formal limo-and-taxi first night *arrivées* under the blinking Majestic Theatre marquee.

Hilliard "Hilly" Elkins, the same guy who had produced Sammy's show, went on to *Oh! Calcutta!* downtown in '69, with skits by writers like Samuel Beckett, John Lennon, Sam Shepard, and Kenneth Tynan, and he asked me to do the art for the program. The big scandal at the time was that *Oh! Calcutta!* featured an all-nude cast. I'd been drawing naked models, Playboy Bunnies, and

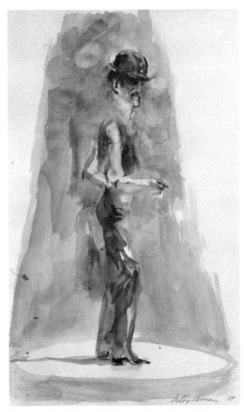

Sammy Davis Jr. as Bojangles *by LeRoy Neiman.*
Ink on Paper, 1984. Author's Collection

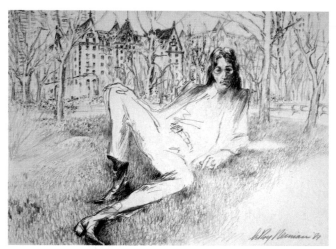

John Lennon in the Park *by LeRoy Neiman. Brown and Black Felt Pen on Paper, 1989.* Author's Collection

Beckett *by LeRoy Neiman. Enamel and Acrylic on Board, 2008.* Author's Collection

Femlins most of my life, so the bare bottoms, breasts, and other anatomical paraphernalia were no more outré to me than figure drawing an overweight model at art school. Although skirts were hiked up and trousers pulled down, none of this was supposedly designed to titillate—although that's what sold tickets. It became the fifth longest running play in New York's theatrical history. This was theatre, not burlesque, with characters who just happened to be in a state of undress, and no one turned a hair. The actors didn't exactly have the gym-toned bodies of today, and from three or four rows back in the house seats, even a sex-crazed sailor would have had a hard time getting excited.

I did so much art for the theatre that it's hard for me to remember all the productions. I know I did the poster for a Kurt Weill/Bertolt Brecht Off-Broadway revue, and a giant stage-height blowup of Brendan Behan's head for *Borstal Boy* that was displayed on the drop curtain before each act (made from the sketch I'd done of him at the Algonquin Bar before he died in '64). Later, Janet and I flew to Ireland with the cast of the Abbey Theatre production, where they put my sketches on view in the lobby. After the drawings got favorable mention in the Dublin press, they mysteriously disappeared. The Abbey

186 *All Told*

Theatre management pleaded innocent, or should I say ignorance, and I chalked it up to an overzealous fan. Years later a similar thing took place at the Ibsen Theatre in Oslo, where I did an ink-wash drawing for the promotion of an Ibsen play. My slant was cross-country skiers circling the statue of Ibsen on a pedestal in front of the Ibsen Theatre. The original was never returned.

Theater managers, actors, and producers were used to the idea of artists sketching, but outside of horse racing an artist hadn't been seen around the athletic field or sports arena since artists like George Bellows ventured out in the '30s. But every artist eventually finds his special subject, and I was soon to find mine. When I first got into it, no one else was sketching sports events live and on the spot—there was no tradition to relate to

Brendan Behan *by LeRoy Neiman. Felt Pen on Paper, 1970.*
Author's Collection

in the kind of art I was doing at these events. Nineteenth-century sports art had focused for the most part on prizefighting and horse racing prints, and in the early twentieth century had consisted mainly of social sports. So with no set standard to fall back on but my own way of seeing, I had to rely on what was taking place live before my eyes. Almost immediately I became immersed in the spectacle of big-time sports, and the hysteria and adrenaline of the spectators.

My presence there was so unusual, I myself often became the subject. "Hey, there's some guy out there with a pencil, a pad, and a big cigar." People would come out to look at me like they would a two-headed chicken. What I was doing was considered peculiar by the sports crowd, and even by the sportswriters, team owners, and players. The players had never, for the most part, seen an artist sketching anything, never mind on the field right in the middle of a pre-game practice. In the beginning, the very oddity of what I was doing got me noticed in the media. I'd be picked up by a local TV station as a curiosity—an artist sketching live on location! I'm no shrinking violet, and as the cameras moved in for close-ups, I

Drawing Swoboda, 1969. Author's Collection

played it up for all it was worth. I would flourish my pencil like a wand and splash color on the page with abandon. I knew how to be dramatic. As I drew and carried on, the cameras caught the captivating process of a sketch coming to life. I was good at capturing on-the-spot action and making it jump off the page, and before the days of periscopic zooming lenses, I could catch dramatic moments far from the sidelines.

Soon columnists began to pick up on "this Neiman guy." Writers always like scoops—anything unusual that comes in their line of sight—and scribes like Irv "Kup" Kupcinet from the *Chicago Sun-Times,* Larry Merchant of the *New York Post,* Herb Caen of the *San Francisco Chronicle,* and Nick Seitz of the *Christian Science Monitor* began dubbing me the "first ever sports artist." Forget about Bellows, Degas, and the rest. Then they went a little nuts. *Newsday*'s Stan Isaacs started it with a description of me as "the sportsman's Van Gogh." Jim Benagh in the *Detroit Free Press* followed with "Sports has its 'Van Gogh' in artist-painter Neiman." I got called the "Rembrandt of the ring" by the *New York Post*'s Lester Bromberg. One of my favorite quotes was "the Howard Cosell of contemporary art"—that was

Charles Shere of the *Oakland Tribune*. But these guys' familiarity with art was not exactly vast—for them it was Michelangelo, Rembrandt, or Van Gogh, and if it involved anything a little kooky, Picasso. Well, after you've been called Rembrandt and Van Gogh, your mere appearance becomes an art historical event in the sports world. At the third Muhammad Ali vs. Ken Norton fight at Yankee Stadium in September '76, Ali's corner was overrun with his supporters, due to a police strike, and I had circled the ring and was standing ringside at Norton's corner. As Norton mounted the ring steps, he glanced down at me and remarked, "This must be a big fight. LeRoy's here."

Well, I knew all these comparisons to the great masters in the press wasn't going to endear me to the art contingent—never mind an artist getting mixed up in something with such mass appeal as sports. Why is he doing this stuff? Did you know that Neiman's artwork is appearing on magazine and sports event program covers? And that his gouaches have been picked up on-camera and reproductions hung in bars, barbershops, and store windows? And, worse still, the art was selling nationally like candy. That was proof enough that I didn't belong in the insular world of the art elite. I was popular, too popular.

Art, since it went public in the nineteenth century, has been a cliquish scene. I'm not putting it down, I'm just saying. Art movements depend on a sort of insider trading mentality. Everybody isn't supposed to get it—if they did, where would the art market be? As George Bernard Shaw said, "If more than ten percent of the people get it, it isn't art." In the games of chance the art game is no exception, and I was responding to the cards I'd been dealt.

If I wasn't making friends among art connoisseurs, I had a whole new group of pals, the hearty, hard-drinking camaraderie of sports columnists. It isn't everybody's career that benefits from a chance encounter in the men's room—but that's where I first met the immortal Red Smith. I can remember it like it was yesterday. I was at the Hialeah Race Track in '64 and had just come down from Fred Capossela's race-calling booth (up at the highest level of the grandstands) for a quick pit stop before the running of the Flamingo Stakes. As I was washing my hands, I glanced into the mirror, and there reflected behind me, in a doorless stall reading the *Journal American,* sat the man himself. I had never met Red Smith, nor ever seen him in person for that matter—never mind in such an intimate situation—but I heard myself say, "Reading your own stuff, eh Red?"

He raised his head, looked my reflection in the eye, and said, "Makes darn good reading in a setting such as this."

happened to them in their lives. Just the memories they provide for us fight freaks should qualify them for a comfortable retirement.

⌐

From the beginning, surfing was practically a religious cult, then the Beach Boys wrote a couple of songs. Then there was the Bruce Brown movie *Endless Summer,* and it turned into a national craze. People were curious about this new sport, so *Playboy* sent me to check it out. I headed down the California coast from Malibu to San Onofre, to join in the lifestyle along the beach—the onshore dropouts, beach bunnies, land sharks, hipsters, and celebrity beach boys and girls. The archetypal surfer was tall, sandy-haired, and lean. The scar under his kneecap was his badge of honor—a calcium deposit formed from kneeling on the boards and paddling out to countless lineups—much like the ballet dancer's venerable, calloused, disfigured feet. Some surfers wore wet suits plastered with surfing pins and Maltese crosses, talking that surf talk, trying to "please fear" by riding the "big guns" and getting "locked in the curl." For the true surfboard freaks, it wasn't just a fad. For them surfing had always been a passion sport, a lifestyle unto itself. Forty years later you can still find

Hawaiian Surfing *by LeRoy Neiman. Enamel and Oil on Board, 1966.* © LeRoy Neiman

them there, now elder statesmen, surfboard designers, and the like. I still hear from some of them, contacting me for sketches I made during those halcyon days.

Right up there with the wave-catchers are the zealots who spend dawn to dusk swinging, slicing, and chipping away at their handicaps in the exasperating and exhilarating game of golf. All the time I was growing up, I thought golf was no more than a local sport because Bobby Jones had won the US Open at Interlachen in Minneapolis in '30, and Minneapolis-born Patty Berg dominated women's golf. At the annual Greater St. Paul Open you could watch major players of the day like "Light Horse" Harry Cooper swat golf balls while the gallery swatted at the unofficial Minnesota state bird, the mosquito.

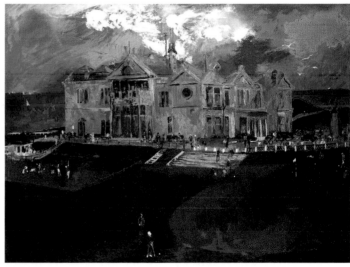

Clubhouse at Old St. Andrews *by LeRoy Neiman. Enamel and Acrylic on Board, 1987.* © LeRoy Neiman

So I never imagined the miles I'd log for golf art patrons the world over, sketching and painting spectacular courses like Gavea in Rio, Shek O in Hong Kong, Kawana in Japan, Le Royal in Belgium, and golf's birthplace, Old St. Andrews in Scotland, along with stateside courses like Pebble Beach, Seminole, Winged Foot, Hilton Head, Baltusrol, Bethpage, and Pinehurst.

Painting the grand landscape sport—manicured greens, curving ponds, sculpted sand, and rocky hillocks—was a satisfaction in itself. Sometimes it served as backdrop, like the watercolor I did of Mike Tyson chugging around the Vegas Dunes' course to the beat of his headset; or Liston and Clay training pre-fight in Miami in '64, Sonny jogging a public course in combat boots and Cassius in weighted paratroopers at a course nearby.

But the main event was the great masters. One summer morning in '72, on a commission to sketch Jack Nicklaus for *Golf Digest,* I followed a practice round with Nicklaus and Doug Sanders at the Westchester Country Club. We were at the ninth tee and Nicklaus was preparing to drive—pin-drop silence—when suddenly a gust of wind lifts a paper off my sketchpad. I watched horrified as it fluttered

toward Jack's ball, wondering if I should dive for it or invent some lame apology. In one smooth stroke, Nicklaus plucked the sheet out of the air with his club head and pinned it to the ground. Then he looked over at me, unruffled, and said, "Hey, sorry there, LeRoy, hope I didn't damage your sketch." I snatched up the paper and was getting the hell out of the way when I heard the crack of club to ball and the familiar Nicklaus grunt of satisfaction. He won that tournament too.

In '83 I did a private commission of the US Open at Oakmont Country Club for a Pittsburgh art dealer that combined recent winners Palmer, Nicklaus, and Calvin Peete with Open legends like Ben Hogan, Bobby Jones, Tommy Armour, and Sammy Snead. When the serigraph edition was being produced, the dealer had one revision: '82 US Open winner Calvin Peete had to be scrapped. Peete was red hot at the time and prominent in the composition, but it didn't matter. The dealer was convinced the presence of an African American would hurt sales. I said, "No way," and the silk screens sold like hotcakes.

I never had the opportunity to paint Pete Brown, the first black American to win a PGA tournament back in '64, but I did get other notable frontrunners like Lee Elder, Jim Thorpe, Jim Dent, and a favorite of mine, Charlie Sifford, who sat for me at the Doral, chomping on his cigar. Charlie's reception to qualifying on the tour back in '59 was a far cry from the hero worship that later greeted Tiger Woods (more on Woods later).

The real worshippers of the game—the hardcore amateurs—aren't prepared to abandon it after eighteen holes. They'll mount paintings in their offices and game rooms of golf courses they've played and players they've followed. And those who can afford it dream of a spread bordering the course, its groomed lawns blending seamlessly with the beckoning fairways. Short of that, the country club becomes a second home, the more exclusive the better, wherever in the world you want to find it.

Take the St. Cloud Country Club just northwest of Paris. Spreading out from the Seine, it evokes scenes of Raoul Dufy's 1924 oil, *St. Cloud Park*. (With his organization of landscape and space, I wish I could have seen the golf course a la Dufy.) Before the town of St. Cloud became a golf mecca, it was the home of the splendiferous court of Louis XIV—when the king was in residence. For me it stirred memories of St. Cloud, Minnesota, northwest of St. Paul, where the state reformatory courted delinquents from my neighborhood—its name pronounced "cloud" to the natives, as opposed to the frogs' "clue."

In '90, I decided to include the St. Cloud course in my *Big Time Golf* book, which meant a trip was in order. I'd made my base the Ritz in Paris, so what could

be easier than getting the solicitous staff to handle the arrangements? But when I asked the concierge to reserve a table for lunch at the country club that afternoon, he looked at me in shock and feigned bewilderment. "*Mais,* monsieur is a member?" he asked.

"*Non,*" I replied in perfect French.

"But St. Cloud, it is a *club privé,* monsieur."

"Yes, but I won't be golfing, I'll only be sketching."

The Gallic pause. The shrug of shoulders. The icy rejoinder. "Of course, Monsieur Neiman." He made the call. Or maybe he called his mistress, for all I could tell from the conversation, which went something like, "*Non? Désolé! Merci!*" followed by a self-satisfied, "So sorry, Mr. Neiman, it is im-poh-seeble."

Time for Yankee ingenuity. Grabbing my assistant, Lynn Quayle, and a taxi, I said, "Saint Clue! Vite!" In no time, we pulled up in front of the clubhouse and fell in behind a foursome heading for the first tee. I set up near the ball wash and began sketching.

Well into it, a distinguished French gentleman strolled over. "And why is it that you are making the art here, Monsieur?" he inquired politely.

Was this curtains? "I'm planning to include St. Cloud in a book on grand golf courses of the world," I explained.

Surprisingly delighted, he replied, "And so when you have completed your work, I would be *enchanté* if you and your lovely lady friend would join me at the clubhouse."

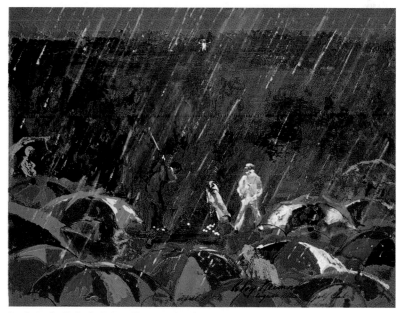

Arnie in the Rain *by LeRoy Neiman. Acrylic, Pen, and Pastel on Paper, 1973.*
© LeRoy Neiman

It turned out that the curious monsieur was on St. Cloud's board of directors. During a fine tour of the clubhouse, he told us that the course had been built by Americans. "And now you must be the guests of myself and my wife for dinner!"

he concluded. The day ended over cocktails at his Île St. Louis apartment and an evening stroll along the Left Bank for dinner at the Tour d'Argent.

Reservations not made by the Ritz.

Don't think you're at the nineteenth hole yet. St. Cloud offers another memory from the early '90s—the afternoon when I was struck by the game of a coffee-colored kid, a teenager but so gracious and comfortable, with an attitude and carriage that belied his tender years. It was Tiger Woods. I would later do a raft of work on him, including a feature in *Playboy*. But that's the end of another story.

⟋

We're a country that craves stars. We fired George III, and ever since we blew off the aristocrats, we've had to manufacture our own version in the form of movie stars, pop singers, baseball home run heroes, golf idols, and football players. I'm thinking about one football icon in particular—this fantastic quarterback, Joe Namath. I first heard about him from Joe Hirsch, the *Daily Racing Form*'s top writer, in the Gulfstream paddock—the paddock is where you get the inside scoop (whether it's true or not is another matter).

Namath's star was clearly on the rise, so I figured I'd better go and check him out. This guy was as famous for being a handsome stud as he was on the playing field.

Tad Dowd *by LeRoy Neiman. Marker on Paper, undated.* Author's Collection

Tom Jones *by LeRoy Neiman. Marker, Felt Pen, and Pencil on Paper, 1965.* Author's Collection

Guys like Joe Namath worked on their image almost as hard as they worked on their game. I met him at an Upper East Side singles hangout called Dudes and Dolls, where I found him strategically positioned at the bar chatting with Tom Jones and Tad Dowd.

I had a vested interest in learning about Namath; he was the New York Jets' new high-priced star, and Sonny Werblin, co-owner of the Jets, had recently bestowed the Jets' artist-in-residence status on me. I'd become a fixture, sketching at Shea Stadium, traveling with the team, the whole nine yards. I stayed with the Jets from '67 through the next two years, until they got around to winning the AFL, then followed the team to the showdown with the NFL Baltimore Colts in Miami at Super Bowl III. At practice and drills I hung with young maverick writer Eleanor Kain, who published a weekly football diary, *Line Back.* But this

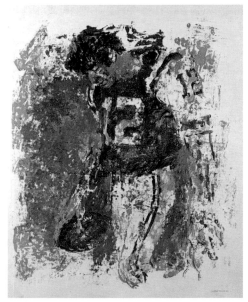

Namath by LeRoy Neiman. Enamel and Acrylic on Paper, 1981. Author's Collection

1972 Namath and me at Shea Stadium. Author's Collection

was still the dark ages in sports reporting. Would you believe as late as '69, women reporters weren't even allowed on the field during practice, let alone in the press box at games?

In January '69 I went down to Miami to cover Super Bowl III (the first AFL-NFL championship to be called a Super Bowl). On game day, January 12, I had breakfast with the team, and then we all piled into a bus. Despite the motorcycle escort, the driver got lost between our Ft. Lauderdale hotel and the Orange Bowl, so we drifted around seeking the right directions. We arrived late to find ourselves confronted by a loud, hostile crowd of Colts supporters who began violently rocking the bus. A couple of linemen ran interference for Joe as he bolted out the bus door and made for the team entrance. The rest of the team and their artist filed out, and we made our way through the crowd of Baltimorians, who had by now settled down, satisfied they had done a good job intimidating the enemy. As the annals of football have chronicled, the Jets won as a result of an early game handoff from Namath to Matt Snell. The final score was Jets 16-Colts 7, and Joe was carried off the field, raising his forefinger to the heavens in the since oft-repeated "#1" victory sign, then a first. I painted that image for the jacket of a book by Dave Anderson called *Countdown to Super Bowl,* for which I also did the inside artwork.

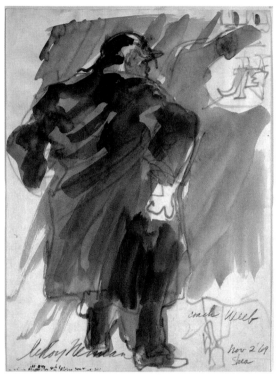

Weeb Ewbank *by LeRoy Neiman. Watercolor and Sepia Pen on Paper, 1969.* Author's Collection

It was the team's first and only Super Bowl victory, and my first Super Bowl, and despite the dozens I've worked since, it will forever remain the touchstone. Joe was nominated Most Valuable Player, and his whole life thereafter has been a memorial to that one game.

The players liked the idea of my traveling with the team and all, but Jets' Coach Weeb Ewbank never fully took to my presence on the bench as the Jets' artist in residence. In fact, he'd worked up a routine of his own, bitching about me whenever he could.

One wet October Sunday at Shea Stadium, my assistant Linda and I were kneeling on Jets towels at the forty-yard line. On a sloppy field, running back Bill Mathis got hit by a monolithic defenseman and came sliding out of bounds, practically knocking me over. My sheet of drawing paper went flying into the mud. As Coach Ewbank came roaring over, loudly complaining about some infraction or other to the head lineman, his cleated shoe pierced my drawing. When he saw the drawing under his foot, half-buried in the mud, he looked down at it, and a broad grin spread across his face.

"You know something, LeRoy, I think your work's actually improving."

During the years that led up to that Super Bowl, Joe Namath had managed to get himself in the papers a lot—he'd become a celebrity on and off the field. Everything he did got in somebody's column. He had a TV installed in his shower, he was dating a movie star, he was going to be in a movie . . . When he opened the Bachelors III bar on Lexington Avenue, the league was furious, but what could they do? He was a football hero and now he'd turned into Broadway Joe. It was fun while it lasted—I held court in the LeRoy Booth while Namath's buddy Ray Abrusie tended bar. Namath's flirtation with the singles bar trade was short lived, but the nonsense continued with his venture as a pantyhose-clad advertising spokesperson. Joe's teammates often partied at Namath's East 76th Street bachelor pad with its highly publicized white llama rug. Occasionally a football would spiral across the room and Namath would holler, "Hey you guys, careful when you're passin' that football, you're gonna hit my chandelier!"

I've observed that owning a chandelier is a dramatic way that the recently arrived certify that they've made it—it's the nouveau riche crown jewel. Ali wasn't content with just one—his Chicago mansion had a bunch of them. While he was away training for the first Frazier fight, he repeatedly called his wife about the delivery of a certain chandelier with the same concern as if she was about to deliver a baby. *Playboy* probably aided and abetted this arriviste obsession with chandeliers. I could see Hef writing somewhere in the Playboy Philosophy decorating manual that "Every exclusive bachelor pad needs a well-hung chandelier." Hef was addicted to them. He insisted that a chandelier be displayed prominently in the foyer of the first Chicago Playboy Club. As for me, I admit that I too succumbed. I bought an eighteen-branch crystal behemoth from a razed hotel ballroom and installed it in the study off my studio.

One of my last dealings with Sonny Werblin, the "Get It Done" team owner and stadium builder, was in the '70s, when he called one day to arrange a meeting.

He'd been chosen to head the renovation of Madison Square Garden—at that time not yet ten years old, but it needed a facelift. Sonny had a vision and I was going to be part of that vision.

"LeRoy, here's what I see: a panoramic series of Neiman paintings, encircling the corridors of the Garden's main arena."

"Sonny, that's a pretty big undertaking, I gotta think about it."

"Money's no object, LeRoy. No matter the cost, I want a big statement, I want the finest sports art available, whatever it takes—and that's you, Neiman."

Was this how Michelangelo felt when Pope Julius II commissioned him to paint the Sistine Chapel? No comparisons between me and one of the greatest artists who ever lived, but we both had to figure out what to do with a huge amount of wall space. It was pretty overwhelming—but what a challenge! I went back to my studio and began kicking around design ideas. Unlike Michelangelo, I didn't have to figure out where to put the Sybils, Moses, and God, but still. Weeks went by. No word from Sonny. Due to the immensity of the undertaking, I began to get concerned. Then out of the blue, Werblin called. A lot of preamble, convivial chat and jokes. Unable to curb my anxiety, I blurted out, "Where are we on the project, Sonny?"

"Oh, that . . .Well, here's where we're at, LeRoy!" he replied lightheartedly. "We've decided instead of installing original art, we'll put advertising on the walls. Why should we pay you when somebody else can pay us?"

I was sorely disappointed. But what did I expect? Sonny wasn't Pope Julius II and, let's face it, I wasn't Michelangelo. And come to think of it, Julius tried to stiff Michelangelo on payment too.

Muhammad Ali and the Voodoo Doodles

One day in the late '90s I pulled out a seldom-opened studio drawer and found the two old sketchbooks in which I'd made drawings and notes on two big fights: Liston vs. Clay in '64 and Ali vs. Liston in '65. I blew the dust off the first sketchbook, and when I opened it up, out jumped a fantastic creature, like a genii out of a bottle, jabbing, rapping, rhyming, taunting, joking, making himself up as he went along—just like he was in those days. Ali! Muhammad Ali, the mercurial boxer-poet-king and prankster himself, in all his contrary glory. Or, Cassius Clay, as he was known in the first of those fights.

I remember when I first heard the name Cassius Clay. You knew this was someone you'd want to meet just from the way people talked about him: "LeRoy, you gotta see this guy to believe it, he's incredible!" And, of course, you were fascinated by the way he talked about himself. He spoke the kind of inspired jive you never heard from a boxer—and not that often from a hipster poet either: "Only last week I murdered a rock, I injured a stone, hospitalized a brick! Hey, I'm so mean I can make medicine sick."

Many people didn't take him seriously at first because he was such a loudmouth. They thought he was all talk. Thought he was saying all this stuff because he couldn't fight. I was new in town myself. It was May '63. I'd finagled my way into the press section at the St. Nicholas Arena right in my neighborhood. The talk before the fight

Drawing Ali sparring at the 5th Street Gym in Miami, 1964. Author's Collection

that night was all about this undefeated new kid on the block, Cassius Clay, who was facing the unbeaten "Harlem Barber," Billy Daniels. They called him the Harlem Barber because that's what he did—he cut hair. People were saying Clay was unbeatable. He'd won thirteen previous fights in a row, ten of them knockouts.

When I was taken back to the dressing room pre-fight, up-close he was everything people said he was: a big (six-foot three-inch), healthy-looking, bronze-toned young kid talking a blue streak. "Man, I can rhyme so bad it oughta be a crime." Right off, I started drawing him. Ali would examine everything. Seeing me drawing, he said, "What you doin' there? How do you do that? I can do that, gimme that thing, man. What is that thing anyway? A Rapidograph. Outta sight! Lemme have it."

I gave him my pad and Rapidograph pen. Hands bandaged, he drew an airplane, an automobile, and a profile of himself on the lower right portion of my drawing of him. He wrote, CASSIUS CLAY, NEXT HEAVY-WEIGHT CHAMP BY 1963. As he was signing it, a commissioner stuck his head in the door. "Time to get in the ring, kid!"

Without looking up, Cassius mumbled, "Soon as I finish!" Finally pleased with himself, he passed the book back to me and had his gloves laced by his trainer, Angelo Dundee, who then ushered him out to meet his opponent. The bout was stopped in the seventh round, leaving Daniels busted up with cuts.

Next, Dundee took Clay to London to knock out the chipper British Empire heavyweight champion Henry Cooper—now Sir Henry. When Ali & Co. got back to the States, they invited me down to Miami Beach for the forthcoming Liston/Clay title fight. The fight was being co-promoted by Angelo's brother Chris, who managed the

Angelo Dundee and Ali *by LeRoy Neiman. Pen and Marker on Paper, 1975.*
Author's Collection

Dundee boxing enterprise at the famed 5th Street Gym, where Angelo trained a stable of contenders and a couple of champions. Chris was the textbook hands-on prizefight matchmaker-operator. He had a way of holding his audience captive, his arms around two guys octopus-like while talking to a third in front of him and a fourth out of the corner of his mouth, for the benefit of a fifth, about an absent sixth.

The Dundee camp adopted me, and I was soon folded into the Cassius Clay road show. I saw myself as a foot soldier on the battlefields of boxing. My two sketchbooks from those years are filled with drawings I made at the training camps, and notes jotted down in the fighters' humid and sweaty changing rooms, ringside, and at Clay's zany press conferences, immersed in the bedlam of it all and, later on, quietly at his rented home in a poor district of Miami.

Ali was noisy all the time. He pronounced, prophesied, and boasta-sized his victories. Now, watching me drawing, a lightbulb had gone off in his head: Drawing could be a weapon. He could make fight prediction drawings, and, like visual voodoo, these fiendish doodles would fly off the page and make his forecasts come true. He made the first of these drawings when he was in training for the first Liston fight in Miami in February '64, and another one in November '64, just before the scheduled rematch. And hadn't the drawings both come true?

At first the only drawings he did were of himself KO-ing his oppo-nent—Ali punching someone, the guy falling down flat on the canvas. His idea of art was something you could knock people out with. Later on, he

5th Street Gym Miami *by LeRoy Neiman. Marker and Pen on Paper, 1962.* Author's Collection

would do landscapes with the sun and the moon—and within them the usual pic-ture of him knocking a guy out!

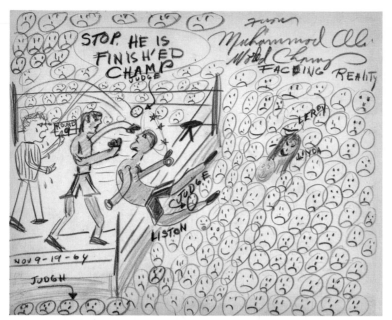

Prediction Drawing *by Muhammad Ali. Litho Pencil on Paper, 1965.*
Author's Collection, Courtesy of Muhammad Ali Enterprises LLC

Ali had always held that if you said, rhymed, chanted, or shouted something loud enough, it would come true.

Now he'd convinced himself that if you made a drawing of an opponent lying face down on the canvas, that would also come true. Pure Rapidographic logic.

I'd been a follower since the first time I squeezed a robin's egg blue crayon in my pint-sized fist in kindergarten. That's when the demonic spirit of painting first took possession of me, as color crayons and drawing paper were passed out. At school I scribbled on walls, at home I crayoned all over the kitchen linoleum. That was fun enough, but now I was hanging with Muhammad Ali in his suite at the Midtown Motor Inn—across the street from Madison Square Garden—where he would defend his title against Zora Folley the next night, March 22, 1967.

—

"Sonny Liston will go in eight," it said on the side of his tour bus, which also carried the slogan: "The world's most colorful fighter," colorful spelled out in blue, red, yellow, orange, and purple. He was so amazing that journalists couldn't resist quoting him. I just had to write down everything he said: "Pop-pop-pop! No one can whup me!" "You're no champ, you're a chump! Chump! Chump! Jailbird! Bear you're too Ugly, I'm gonna eat you alive. I'm gonna whup you so baaad!"

When I arrived in Miami Beach with my *Playboy* magazine press card on February 3, several weeks before the first fight, the atmosphere was like a high-tension wire. Florida was a Jim Crow state, and as if to pour gasoline on an already smoldering fire, there were rumors that Cassius Clay was having talks with Malcolm X of the Nation of Islam.

The fiery, charismatic Malcolm X had just returned from the Middle East, where he'd visited Mecca. He would drop by to talk to his potential convert, and I'd sketch him. He was a daunting presence: wiry, copper-colored hair, freckled skin, rimless glasses, and an unnerving stare. Unlike Clay, he didn't seem to have much of a sense of humor. He would lean over, his hand cupped to Cassius's ear, communicating secret messages to him. As George Foreman said of Ali's indoctrination, "Malcolm X told Ali many truths and a few untruths along with it."

"Allah has given you the strength to beat Liston," I heard Malcolm tell Clay. "You can show the world what a true believer can do. You can win; you can do this. You are going to be the greatest of all time. The fight will show the whole world that a true believer will always come out on top."

Cassius Clay and Malcolm X *by LeRoy Neiman. Ink on Paper, 1964.* Author's Collection

The promoter, Bill MacDonald Jr., threatened to cancel the fight unless Clay denied his affiliation with the Nation of Islam/Black Muslims. "No," he said, "I won't fight under your condition." The promoter backed down.

Everyone was on edge. The FBI and Secret Service, detectives, local cops, the pickpocket detail, and plainclothes officers were on the lookout for recognizable hoodlums and gamblers. Rumors were spreading that the Klan was out to get Clay for his Muslim interests, while dark-suited Muslims were scattered among the celebrities ringside.

Liston, irritated at Clay's taunting and raillery, considered Clay's harassment shtick, figuring him to be some sort of galoot—an eccentric, foolish individual with a personality problem. "Clay's goadin' don't get to me. He's just a loudmouth punk. I'm a man!" Liston shouted, beaming his death-ray look, holding up two fingers, indicating Clay would go down in the second round.

Sonny Liston *by LeRoy Neiman. Enamel on Board, undated.* Author's Collection

Clay always liked having me around, and he enjoyed being sketched anytime. Liston was far more wary, even hostile, and artlessly uncontrived. I'd watched him scowling, circling backward as he shadowboxed around the ring. One afternoon Liston noticed me standing there sketching next to the ropes, and gave me the baleful, intimidating, double-whammy Liston glare. A really ill-tempered Svengali.

"Get rid of the cigar!" he growled.

"It's not lit," I shot back at him. He stopped, turned around, and shuttled forward.

"I said, 'Get rid of the cigar.' I don't care if it's cold!"

I was considering the request to surrender my precious prop when Liston stopped abruptly in front of me and gestured to his timekeeper, Teddy King.

"Throw the artist off the stage!" he said.

Okay, so I backed off, nixed the cigar—and continued to draw.

One night Liston was skipping rope to "Night Train." After his workout, he approached me and said matter-of-factly, "Artist, I don't like you doin' me only boxin'. Come over to my house this evening and I'll show you how I want to be painted."

Around five o'clock I showed up at his front door. Sonny answered the bell, all spruced up in a freshly laundered, open-collared white shirt, impeccable with dark slacks and shined loafers, as spotless and immaculate as the expansive living quarters.

We entered the main room. Joe Louis, the grand old heavyweight champ, was sprawled on an overstuffed sofa, staring at a TV. He gave me a lazy nod. Liston then led me on a tour, showing me elaborately framed photos of himself hung all over the place. He always dressed well—iridescent suits and silk cravats. "That's the way I want you to paint me, not as a fighter, but as a gentleman."

Too bad I never got around to doing it.

Liston avoided fraternizing with the sycophants who milled around him, bottom-feeders who only wanted to share in his visibility and money—he knew they really didn't care about him anymore than the riffraff out of his past did.

At 218 pounds Liston was heavy; his physical appearance didn't inspire confidence. Since '61 he had fought only four times, all knockouts. During the same time Clay had had seventeen fights with fourteen knockouts. Liston was as sluggish as Cassius was sharp. Clay was prepared, studied films of his fights, always working on his footwork.

1964, me (far right, standing next to Joe Louis) at a Liston workout. Author's Collection

Clay had this buddy—Drew "Bundini" Brown—with him all the time. They'd chant together: "Float like a butterfly, sting like a bee. Whoo-ahh!" They had a routine. They'd show off. Bundini was 100 percent an operator. He claimed he was Clay's trainer, but he was really just his straight man. He was a Cassius Clay impersonator, essentially—he imitated everything Clay did. But Bundini did introduce the weighted paratrooper boots, which added three pounds of weight to each foot for Clay's roadwork, so when he got in the ring he seemed like he was floating.

Clay always had a great trainer in Angelo Dundee. Angelo had known this kid was really something from the very beginning, and he never meddled with him. They'd have three-minute sparring rounds where Angelo would yell out, "Time!" but Clay would ignore him and just keep on going. He'd spar for five minutes if he felt like it, at top speed.

Day of the fight: February 25, 1964. A scowling Sonny Liston stands menacingly in his corner. At the bell for round one, Liston lurches forward, tries to decapitate Clay with a right hook, but the punch misses, and Clay slides gracefully

Brothers Dundee *by LeRoy Neiman. Black Felt Pen with Collaged Paper on Paper, undated.* Author's Collection

away. Clay has the edge in round one. Round two Clay opens a tiny cut under Liston's eye, evidence of blood, but it's Liston's round. In round three Clay lands a right uppercut, Liston's cheek spurts blood. By this time Clay has established his momentum, he goes in with a brazen two-fisted assault and then moves away. Cassius punches fast, fleet-footed, stinging left hits and razor-like rights. He circles, dances, feints, pops, prances, snipes, pecks, and cuffs. Sonny Liston sticks to his MO—left hooks, pulverizing rights, stalking, bashing, slugging. Clay breaks the rules of boxing, takes chances, backs up, but he has blinding speed, hits hard, and can take Liston's relentless punches. After five rounds Liston is getting tired, and as the fight wears on, it becomes clear that he is a lot older than he claims to be. By round six Clay goes at him, punching away at his left eye. Next he lands three rights and three lefts; he's taking charge. Clay's heavy left smack on his opponent's left shoulder is probably what does Liston in. He remains sullenly on his stool at the bell for the seventh round, then spits out his mouthpiece and quits.

Cassius immediately springs to his feet. "I am the King! I am the King! I am the King!" Pandemonium breaks out. Liston is subdued, outdone, done in, vanquished. His unsalvageable reputation matched his image as a brutal prizefighter. No one wanted him to be respectable, and he wasn't about to try to convince them otherwise. They start calling him, "Sit down Charley."

Clay is cock-a-doodle-dooing at the top of his lungs: "I made the big Ugly Bear look like an amateur. I just played with him and I whupped him so bad, like I said I would." But with the fight ending so unexpectedly—that unsettling image of Liston quitting on his stool at the beginning of the seventh round—there were going to be questions about what had happened. Because of the disputed events and the "unsatisfying" conclusion of that first fight, there obviously had to be a rematch.

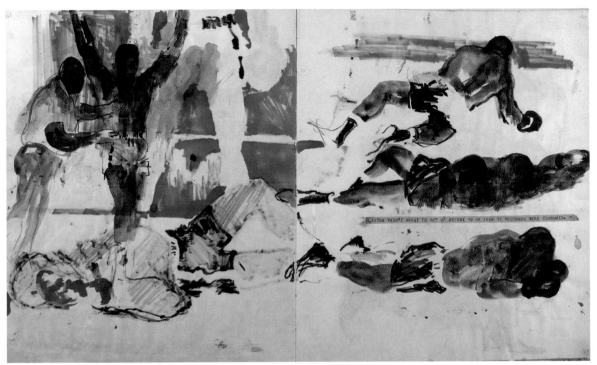

Clay–Liston at St. Dominic's Arena *by LeRoy Neiman. Watercolor and Marker on Paper.* Author's Collection

But before it could be announced, there was a bombshell at the following morning's press conference. Cassius got up and told the press: "I know the truth. I don't have to be what you want me to be. I'm free to be what I want." Right then and there he got my attention—and my heart. Nobody was quite ready to hear what he said next. He had joined the Nation of Islam and taken the name Cassius X (he changed it again on March 6, to Muhammad Ali). But, as serious as he was about his conversion, all the dizzying change was complicated by the fact that he was always messing with everybody's head. You never knew if he was putting you on or what. He said he was a Muslim, but he never for one minute stopped being a prankster.

When Clay became a Muslim and changed his name, overnight the roles of good guy and bad guy in the upcoming Ali/Liston fight shifted. The sullen, thuggish Sonny Liston improbably became the champion of fundamental American values, and Ali's popularity with White America evaporated. The hostility to Ali's conversion was so extreme that the mainstream press, including the *New York Times,* refused to

acknowledge his name change while Ali refused to answer to his given name. Angelo Dundee's solution was to refer to him as "Champ."

"For Christ's sake," he said, "my family name isn't Dundee, it's Mirena!"

The rematch was initially scheduled for the Boston Garden, November 16, 1964. But three days before the fight Ali had a hernia attack, requiring emergency surgery. Liston put it down to, "If he'd stop all that hollerin' in the street and carrying on the way he does, he wouldn't have hurt hisself." Meanwhile, Liston was under arrest for drunk driving in Las Vegas. On February 1, 1965, Ali joined seventy-eight-year-old Marianne Moore in a booth at Toots Shor's for an afternoon of poetry reading. "Ali, he fights and he writes," she said, mimicking him.

In Sherry Biltmore room 612, I hung out with Ali and Angelo, watching films of the first fight. "Angie," Ali said, "I shook up the world, I got the world watching this time. I see what Liston positively cannot do at his age. I'm workin' on my piston drive punch" (aka his anchor punch). Ali once boasted that it was timed at 4/100ths of a second: "That's an eye blink."

The rambunctious Ali continued to caricature and demean Liston. A flurry of put-downs, mockery, and disdain were embroidered with declarations of his own beauty, talent, and prowess. Al Braverman, Liston's PR guy, said, "As for fighter's dimensions, Clay's mouth is ten inches, Liston's is five."

Liston was barred from fighting in New York and Las Vegas. The rematch was in limbo, it was said, because of the rumors of violence and actual threats. Due to all of the above, the fight was moved to Lewiston, Maine, for May 26, 1965. Although far from the criminal interference of the big cities, nobody was taking any chances. The town was busy with beat-walkers, state troopers, Lewiston police, specialists in black religious cults, and police checking women's purses.

Before the second fight, Ali was a different character, somewhat subdued. But that did nothing to subdue the ambiance of heightened theatricality. At the weigh-in, Ali's wife, Sonji Roi, showed up dressed to the nines and done up in a beehive hairdo, as was Ali's mother, Odessa Clay. Light-skinned like her son—she was a quarter Irish—she called Cassius "G-G," which she said were Ali's first words as a baby, though he later claimed he was trying to say, "Golden Gloves."

Talk, talk, and more talk swirled about the upcoming fight. The Ali legend had attracted literati as well as sportswriters. George Plimpton was there, as was Murray Kempton. The famous sportswriter, Red Smith, was saying, "I take the Louisville Bard facetiously," while Jack Cuddy from UPI was predicting, "It will be lights out for the Bear." Norman Mailer, storyteller, anecdoter, word-painter, was hold-

ing court at a bar. Mailer might have thought he knew everything, but what he wrote about boxing was not so much on the button. I knew what went down because I'd been there. Mailer's principal subject was always Mailer.

After being introduced for the first time in the ring as Muhammad Ali, the champ makes the traditional gesture of being ready to receive what Allah gives. Ali is bigger than Liston, he's also younger, taller, quicker, and in better shape. An early right hook hurts Liston, and he veers off-balance. Ali's circling hit-and-run tactics disorient him. Ali backs away from a Liston straight left, returns with a short right cross, and, bizarrely, Liston falls, hits the canvas—and doesn't get up. It's only the second time Liston's been on the floor. Ali stands over Liston shouting, "Get up! Get up!"

That punch was what Ali had called his anchor punch, the piston drive he had learned from Jack Johnson years ago. But because of the implausible end to the fight, people started to refer to it as "Ali's phantom punch." The time in the ring was one minute flat, some say one minute, forty-five seconds, but still—it was unbelievable. Half an hour after the finish, people began chanting, "Fake! Fake! Fix! Fix!"

At the Clay/Liston, Ali/Liston fights, the Mob was there and the Muslims were there, and you got the feeling nobody wanted either of the contenders to win decisively. Something was not quite right with those fights. Then there were the writers who despised Ali, and those who liked him, really liked him. He was playing the game with most of the writers, playing dumb, entertaining as always, and whatever they wrote, that's what he wanted them to think. Nobody ever really found out what went on with that fight—and nobody wanted the truth. I never believed that Ali pulled his punch. If

George Plimpton *by LeRoy Neiman.* **Black Marker on Paper,** *1964.* Author's Collection

Norman Mailer *by LeRoy Neiman.* **Charcoal and Pastel on Paper,** *1982.* Author's Collection

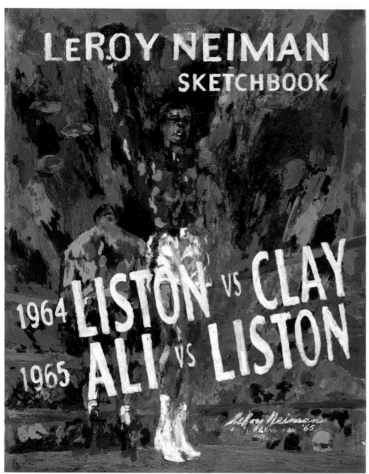

The cover of my Ali/Liston Sketchbook. Author's Collection

anything, had Liston fixed the fight himself? Did he even want to beat Ali? Enough said!

And then six years later . . . On a cold January morning in '71, Angelo Dundee, Hassan, a Chicago Muslim, and I wound our way through Central Park in a limo following the Champ, Jimmy Ellis, and another sparring partner in their Lincoln. It was just above ten degrees with a bone-chilling wind. A bright early light was glancing off the high-rise buildings. At the reservoir we piled out. Ali and his two sparring partners were off and running, leaving clouds of vapor behind as they jogged around the reservoir's chain-link fence. The rest of us stayed huddled along the warm grill of our car, shivering. As they circled the reservoir the first time and were coming around the bend, Jimmy called out, "Come on, LeRoy, fall in and run with us, man." Chugging by, Ali quipped over his shoulder, "LeRoy's nose is running already." That sense of the ridiculous endeared Ali to everyone around him.

After the run we went to a midtown coffee shop, where everyone in the place seemed glued to their morning paper. We slipped into a booth, and Angelo swiped a *New York Times* late edition left behind on an unoccupied table. It shouted the news in bold print: LISTON FOUND DEAD. As Angie read aloud the sketchy details of Sonny's death, Ali sat there in stony silence, his eyes staring straight ahead. For the rest of the meal, he didn't say a word.

The Ali/Liston bouts would never be counted among the truly great fights, but they were pivotal and historic. The two fights were already shadowed in mystery, and Liston's inexplicable death added to it. On the night of January 5, 1971, his body was found at his luxurious country club home in Las Vegas by his wife, Geraldine. He had been dead for a week. All sorts of rumors arose. Was it suicide? Murder? A heroin overdose? There were no needle punctures found on his body. His death was determined to be of natural causes. Sadly, as Harold Conrad said of him, "Liston died the day he was born."

Then came Vietnam, and Ali refused to go. "I ain't got no quarrel with the Vietcong." "No Vietcong ever called me Nigger." "I ain't goin' no ten thousand miles to murder innocent brown people."

All that stuff. Amazing. He enraged people with that, but none of the hostility that came at him made him change his mind for one minute. Ali was playful and mischievous, but when it got real, he got real. He was unbelievably courageous when it came to sticking to his convictions—what athlete in any sport has ever done what he did, give up his championship for his beliefs? They said he violated the Selective Service Act. They took away his title for three years. They wouldn't let him fight because he refused to go to Vietnam. But he wouldn't agree to go to college to avoid the draft either; he wouldn't do any dodges. Ali didn't care what they did to him.

The boxing commissioner who denied him his title was a cigar-chomping World War II bombardier, a self-proclaimed patriot. When he threatened to throw Ali in jail, the Champ said, "What's five years? I've been in jail for the last four hundred years."

He was so unpopular with mainstream America that he was booed when he entered the ring at fights in the '60s.

Ali came over to my studio often during those years—he was kind of lost. When he came back to the ring, he won a lot of fights, but his life never really got under control until after he stopped fighting and met "Lonnie," a longtime family friend whom he married in '86. She'd gone to UCLA, had some hutzpah. She took him in hand and policed his affairs, engineered his public comeback, made sure he got paid plenty for his appearances.

Lonnie was the best thing that ever happened to Ali because she got rid of all those guys hanging around him—the stud entourage who would get him women,

and if Ali wasn't available, well, they'd help themselves. Lonnie had had enough of those guys; she cleaned house on the whole thing.

My friend Gene Kilroy was the king stud of this crowd; he was a football star in college and later worked with the Philadelphia Eagles before he ran the Catskills boxing camp when Ali was the champion. I did a life-size portrait of Ali there on the wooden wall—used a knothole for one of his eyes. Kilroy used to let paying customers watch Ali shadowbox in front of that painting instead of a mirror. He eventually developed into a Vegas honcho—a great contact man there. He always had girls around him and could arrange anything for anybody in Vegas. He was a good friend of Ali's, but Lonnie limited his access.

When you come right down to it, maybe Ali didn't always have the best judgment. He'd pick on guys that didn't deserve to be picked on and let other guys—the hustlers around him—do anything. Weird people would attach themselves to his entourage. There was a big bruiser of a black guy who carried a chair with him and set it down by the door to protect Ali. You could always find him camped outside Ali's door, and every once in a while he'd say, "Muhammad Ali is not available, no one's coming in."

You'd ask, "Why?"

"Ali is busy."

"What's he doing?"

Pointless conversations. He wasn't going to stop you. He had no authority at all. It was a circus, really—but fun.

━

One night we were sitting around the kitchen table in Ali's rented bungalow outside Atlanta: Angelo, Ali, myself, and a few sportswriters—and Cash, as Ali's father, Cassius Sr. was called, handsome dandy, bellicose, pugnacious, and a real fast talker, just like Ali. After watching me sketch for a few minutes, he threw out a loud boast: "This LeRoy thinks he's so damn special, but I can sketch just as good as him if I want to."

Ali loved a challenge, his whole life was all about contests and pouncing on the opportunity to start a fight, or just create a fuss. He jumped in: "We gonna have a drawin' showdown. The opponents: Cassius Clay Sr. vs. LeRoy Neiman."

Clay Sr. insisted we do landscapes. I chose a backyard scene through the kitchen window, featuring a couple of garbage cans and a clothesline. Cash wasn't going to limit himself to trash and laundry. No, he was going to work strictly from

his imagination. Ali solemnly officiated. Only minutes into the contest, Cash was clearly struggling with his ambitious subject. Ali jumped up, raised my arm, and declared, "No contest! LeRoy is the Heavyweight Champion of Art!"

Then, pointing to his father, he dismissed him ignominiously: "You have gone down to defeat!"

Ali's father was a sign and billboard painter, so he was an artist of sorts. When Ali first started painting, his father was envious of him, like a jealous colleague. Suddenly they were all painters—the father, the brother—and Ali knew they weren't. He'd insult them. He'd insult anybody, no matter who you were. People, listening to his dazzling raps, often thought he was entertaining them, not realizing he was really putting them down. He was an original, no question, brazen as they come, but everybody close to him liked him. And, of course, he could fight.

Joe Frazier, who was the heavyweight champion during Ali's exile, petitioned President Nixon to give Ali his title back, which he did in '70. After four years of

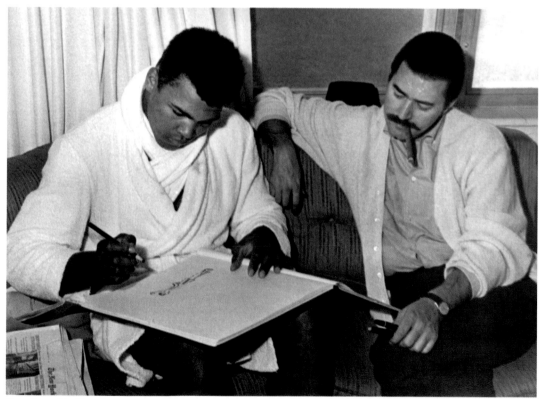

Drawing with Ali, 1964. Author's Collection

wandering in the wilderness—and mouthing off about it—Ali was reinstated and began preparing for his first comeback fight against Jerry Quarry that October in Atlanta.

Ali was a provocateur, he could stir things up in an instant, and that's what made it fun to be around him. Things that had been fixtures since the dawn of boxing could get a new spin with Ali in the mix. The Round Card Girl, for example, was born in Atlanta just before the Jerry Quarry fight.

Chris Dundee was beside himself in the Ali corner, upset and hollering, "Where the hell is the round card guy?!" followed by a number of colorful expletives. I was there with my current assistant, Linda, a curvaceous, energetic Mexican brunette, dressed to the nines in a nifty designer suit. I immediately had the solution.

"Hey, Chris!" I hollered. "How about using Linda as a substitute?"

The crowd was getting really loud, and Ali was coming down the aisle.

"C'mon, Chris," I said. "She loves Ali, it would be historic: the first Round Card Girl!"

He got it right away. "You can do it, Linda," he told her. "Come on sweetie."

And the two of them started looking through the numbered cards stacked against the ring steps. The crowd hooted and hollered every time Linda, sashaying, circled the ring. She peeked into Ali's corner whenever she passed, and I swear Ali winked at her one time. Linda was there in the ring, round cards in hand, when the fight stopped and Ali did his dance.

Linda chummed around with me for fourteen years. I cared about her, but she got on the wrong side of drugs for a while, and then there was no communicating with her. Ali loved her too. They used to talk together—all absorbed over something. I would ask, "What are you talking about?"

"None of your business."

You didn't need any special qualifications for Ali to like you or to hang around with him. He was also celebrity crazy—actors, singers—he loved to have them around. The Beatles (he pretended to KO George Harrison), anybody like that. For Ali, the more cameras the better.

And he was a contradiction—almost always happy, but an unhappy guy in many ways. And he could be obstinate as hell. One day, Ali was helping carry my emblem-embossed sketchbook case down the street. It's a big, heavy, antique-looking thing—a water bearer's bag I picked up in Morocco—that looks like it might have belonged to Don Quixote. As we were walking, I decided to tell him about the time Joe Louis rescued my drawing case.

I'd left it back in the rubdown room, and Louis caught up with me, saying, "LeRoy, you forgot your case." As soon as I finished telling the story, Ali dropped the case.

"I don't carry nothin' for no white boy," he said. Then, pointing at the ground, "LeRoy, you pick that up right now!"

One time, we were driving down a street in Atlanta when Ali said, "Stop the car!" There was a restaurant he'd seen, Pascal's, which had a lunch counter, and so we all piled out of the car and went in. The place was busy, and Ali looked around and saw that all the booths and tables were filled. He sat on the stool at the counter. Ali wanted to be there—he was reenacting the historic anti-segregation lunch counter protests in Greensboro, North Carolina, in 1960, when four black students sat on white-only stools at a Woolworth's lunch counter and refused to move.

"I want the stool," Ali said.

There were a bunch of black people in the restaurant and Ali would speak an exaggerated black dialect when he was around blacks. "I wants to sit at the counter," he said. "I don't wants to sit at no booth or no table."

Now that he saw all eyes were on him, he added, "I wanna speak and when I speak I want my chair to be swivelin' around so I can talk to the whole room." Another event-filled afternoon traveling with Ali.

My Drawing Case *by LeRoy Neiman. Watercolor and Pen on Paper, 2010.* Author's Collection

As an artist, Ali had a narrow range, but I was astonished by his nonstop approach. He did all his drawings with a free hand—no correction, coaching, or opinions. The overweening self-confidence was standard Ali. He'd draw until he had covered every inch, edge to edge, of my Strathmore paper, cut to my 14¾-by-13½-inch sketchbook size.

The morning of the Quarry fight, we were drawing together in the corner of the room, a big suite. He was drawing in his own style: the knockout drawings, then the moonscapes and sunscapes, mountains and trees.

Ten minutes into the drawing session, he raised his head from his project and stared across the room to where Jimmy Ellis and another sparring partner sat on a well-worn naugahyde couch. Ali's sparring partners were always big bruisers—he had to spar with tough guys to maintain his superiority. They'd been all over the world, but still had very little sophistication to them. Ali looked over at them and said, "Hey, look at those couple of monkeys over there, Pussy One and Pussy Two with their crayons."

They were sitting shoulder to shoulder, immersed in coloring a pulp paper comic book. Ali mumbled, "I wanna work in color like that."

He'd messed with crayons and colored pencils with me previously, but now I had a better idea.

"Champ, my studio is just a few minutes away. I'll run back and get you some watercolors. That's what you're ready for."

"I'll be waiting, LeRoy," he said in his get-your-ass-back-here voice.

Within half an hour I returned with watercolor cakes, a pan for water, rags, a Strathmore pad, and brushes. I said, "You gotta put color where the color wants to be. You gotta paint the sun yellow, the grass green, the sky blue—or pink . . . or purple . . . or . . ." If you suggested anything to him when he was drawing, he might do it.

Ali settled right down to work. He was a natural. After a few minutes, I excused myself, saying I had somewhere to be.

"Come up before the weigh-in tomorrow morning," said Ali. "I'll finish this painting tonight."

I showed up the next morning around eleven o'clock, and he presented it proudly. The ring, the fighters, the encircling crowd in Ali-color. From then on Ali worked in color, his compositions always filling the surface edge to edge. He'd get a kick out of portraying the fight crowd as a sea of oval heads with down-turned mouths—whites unhappy that he was the winner—interspersed with blacks and myself smiling broadly. He liked many of these paintings so much that he kept them for himself, partly because everyone (including me) told him how great they were. I never wanted to interfere with his expression. He'd take a white sheet of paper, standard-size watercolor paper, draw the ring, and then put all the people

in it. He'd draw and draw and draw, and then draw sideways when he couldn't fit anymore people in.

He was amazed by his drawings and paintings. He kept showing them off to his hangers-on, who would take off with them and sell them. His drawings were just like his poetry—immediate and simple and funny and clever.

Ali's wife, Lonnie, confided in me recently that he was painting again, nearly every day, and that he'd started after I'd sent him the LeRoy Neiman Sketchbook: Liston vs. Clay 1964/Ali vs. Liston 1965, with reproductions of his prediction art for both fights. Now that the fight game is behind him, he's into landscapes.

<center>⌒</center>

Although Frazier had been instrumental in lifting boxing's ban on Ali, as soon as Ali got his title back he began viciously taunting Frazier, mugging on TV, mimicking Frazier's squashed-in nose, and worse. He said terrible stuff to Frazier, calling him an Uncle Tom, which he was not, not at all. Frazier was very black. He started working in the cotton fields when he was six years old, and later he worked in a slaughterhouse, where he'd hit the cattle on the head to knock them out. He was bitter at how he was treated by Ali—but they eventually reconciled.

In '71 on a commission I sketched firsthand, and then painted, the official poster for the first Ali-Frazier fight at the Garden. Everyone who was anyone showed up for the "Fight of the Century." Sinatra was in the press section as a ringside photographer for *Life* magazine. Burt Lancaster was the announcer. And then there was the flashy wildlife contingent. Ali's fame, his outrageousness, his unrepentant outlaw code had endeared him to a teeming world of *Sporting Life* dandies, hustlers, plumed cockatoos from the pimpocracy with their women, extravagantly outfitted and Afro'd casino gamblers—a fantastic underworld of glamour and glitz—all mixed in with black leaders, businessmen, politicians, Muslims, and ministers. I titled a sketch from that fight, *Blacks Blackin' It,* as a tribute to those colorful followers of Ali who'd come downtown to the Garden by subway from Harlem, by Amtrak from nearby Philadelphia and Washington, by air from the ghettos of Detroit, Chicago's South Side, and as far away as L.A. to support their man. Ali had drawn that entire black audience from the upper balcony of the arena down to ringside.

Then the fight's over. Frazier and Ali are waiting for the decision. Frazier thinks he won the fight because he knocked Ali down in the last round. That was the only time he ever got a clean shot at Ali. Hit him right in the jaw. Sure, Ali

Blacks Blackin' It *by LeRoy Neiman. Marker and Pen on Paper, 1970/71.*
Author's Collection

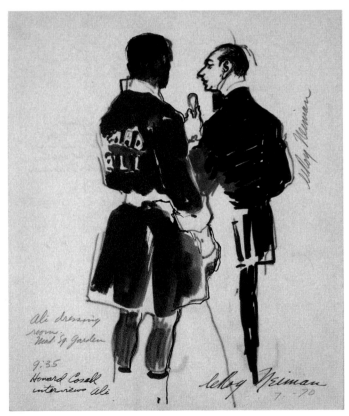

Howard Cosell with Ali *by LeRoy Neiman. Marker on Paper, 1970.* Author's
Collection

hit the canvas, but he came right back up like a jack-in-the-box. He wasn't used to getting knocked down. This was one of Ali's toughest fights—fifteen rounds back-and-forth fighting. Ali took his defeat with good humor, knowing he could take Joe's measure at anytime. They fought twice after that, and Ali beat him both times.

The next day I was with Ali and Howard Cosell on *Wide World of Sports* at an ABC studio, located in the basement of the studio building where I live. Due to a technical hitch, no film of the fight was readily available, so they showed my round-by-round sketches during our discussion, one drawing for each round. I got a lot of exposure that day and found an unexpected untapped audience—as new to art as they were to Neiman, an audience that would soon take to me as I would to them.

Before the second Ali/Frazier bout in January '74, the fighters did an interview with Howard Cosell. Joe was wearing elevator shoes, which were very fashionable in those days. Ali was popping off, and my good friend Cosell, a blustery, obnoxious character himself, was sitting between them. I was minding my own business in the first row. Whenever Joe would say some-

thing that he thought was clever, Ali would come back with something really nasty. Suddenly Ali jumped to his feet, stepped over Cosell, stood over Frazier, and started making fun of his elevator shoes. Joe jumped up and they went at each other, down on the floor, rolling around, both wearing suits. Ali's jacket got all torn up. Ali kept shouting like he does, and Joe finally got really mad and walked out—like there'd be no fight. (There was, and Ali won the rematch in twelve rounds.)

One time I was in Philadelphia with Frazier, and Joe ordered champagne to show off (these guys were always ordering champagne). When the champagne came, Joe took the bottle, grabbed the wire, and in one stroke ripped the cork off. What a fierce hombre he was, really tough and basic.

At the Thrilla in Manila—the third and final fight between Ali and Frazier, in the Philippines, October '75—I was in Ali's corner. It was a brutal fight; it was sickening, it was so hard. Ali said it was the closest he came to death. But when Frazier came back to his corner at the end of the fourteenth round his corner suddenly stopped the fight. It's over! I jumped into Ali's corner. He got up to celebrate, then just collapsed, flat on his back, out cold on the canvas. "My God, he's had a heart attack!" someone said. But then he jumped up and started yelling, ecstatic that they'd stopped the fight and he was the heavyweight champion of the world.

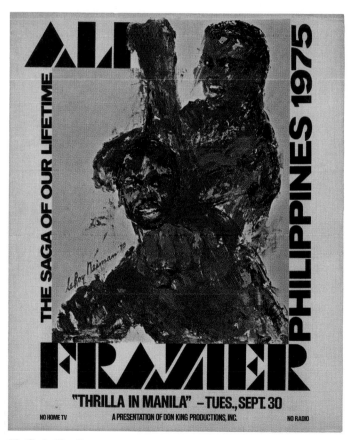

Thrilla in Manila poster, 1975. Author's Collection

If you have enough mojo, the world becomes fluid. In Ali's universe, nothing was fixed, everything was susceptible to change to the power of Ali. Whatever Ali came across, he made into his sparring partner—including the speed of light. "Fast! Fast!

Last night I cut the light off in my bedroom, hit the switch, and was in the bed before the room was dark."

Ali didn't believe in the distinctions other people believed in. Categories weren't something you wanted to be put in, even big, impressive categories like "World Heavyweight Champion." You could be a boxer, a poet, a painter, a philosopher, a cultural leader, a joker. They were all the same—only different. He'd say things with such conviction that even if they at first sounded like absolute BS, you'd start to believe them. Then he'd hype himself up to the point where they actually would come true.

I've made paintings of Ali and paintings of Harlequin. The similarity between the two of them is amazing. Ali really was Harlequin—mischievous, sly, funny—a trickster. Always showing off, grandstanding. Dramatizing. Like Harlequin, he'd take people out of their own situations and make them into actors in his own show.

Everything was a performance with Ali—even in the ring, taking massive hits from his opponent. Ali would have the same look on his face whether he was winning or not. If he missed, he'd make a face like, "I meant to do that!" If George Foreman landed a punch, he'd say, "That the best you can do, George? George, you're fighting popcorn."

The fight game was full of characters, especially the promoters, and in particular, Don King, the most infamous of all fight promoters. I went with him to Rumble in the Jungle—the world championship fight between Ali and George Foreman in Kinshasa, Zaire, in '74. Ali met us at the plane. There they were: Ali, the King of Zaire, the president, and every other functionary with him. The people there idolized Ali, they were already chanting, "Ali Boombaye! Ali Boombaye!" (Ali kill him! Ali kill him!) Meaning George Foreman.

In Zaire I went with Ali to visit the Pygmies. He loved the Pygmies. George Plimpton wrote that Ali went to see a shaman in Zaire, who summoned up a woman with trembling hands to get to Foreman and make him lose the fight. Ali was a great believer in magic, from his fight predic-

Harlekin *by LeRoy Neiman. Marker and Ink on Paper, undated.* Author's Collection

tion drawings to verbal prophecies, so I don't doubt that Ali would have visited a witch doctor in the Congo. He'd use any means to win.

Don King was really something. There was nobody like him, always running his mouth off, just like Ali. Both had limited education, both had a large vocabulary. But Ali liked King because he was a blowhard too. One afternoon George Foreman, Angelo, a couple of other fighters, and I were sitting around, and Ali was shooting off his mouth as usual, shaking his fist, shaping everybody up in his head. Don King came in with his outlandish vocabulary, saying things that Ali didn't quite know what to make of. Ali came back at him with some of his crazy material, and pretty soon things got rough and tempers flared. We were all sitting there hoping there wasn't going to be a fight, but for a minute there it looked like they meant it. They might have been acting but if so, it was convincing. Who knew with these guys?

Don King said, "I will fight you right now!"

Ali was sitting on the sofa next to me. He got up. Now, Don King was pretty big but not all

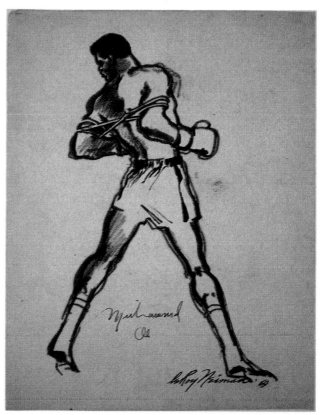

Ali All Tied Up *by LeRoy Neiman. Sepia and Black Pen on Paper, 1969.* Author's Collection

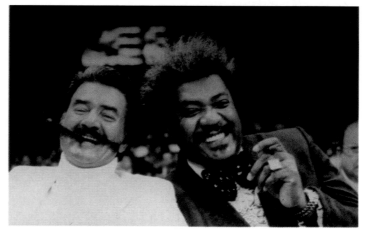

With Don King. Author's Collection

that threatening. Ali said, "You wanna fight? I will fight you. I will take you out right away."

Both of them stood there face to face, glaring at each other. Then Ali turned to Jimmy Ellis, one of his sparring partners, sitting over in the corner. "Come on over here, this man wants to fight me. You fight him."

Then he sat down like nothing ever happened. Don King walked out in a rage. Ali shouted, "Coward!" There was Don promoting his fight, but Ali showed no respect for him whatsoever.

I knew Don King when he first came out of prison and that man was cold. His background was in the numbers racket, that kind of game, in Cleveland. HBO announcer and analyst Larry Merchant, another friend for many years, once said to me, "Don King was an evil genius." Don made every effort to become a model citizen and finally got himself pardoned by the mayor of Cleveland, got himself declared innocent after he had served time. He didn't want it on his record.

<p style="text-align:center">❧</p>

Ali was a boon to sportswriters—they loved him for the volumes of Ali-isms. There's a quote from Oscar Wilde. He said he didn't mind if a poet was a drunk, but when the drunk was a poet . . . Sportswriters were both in those days.

Liquor was the coin of the realm. Jimmy Cannon stopped drinking outright because all his colleagues were always sending him booze and he'd drink it. He'd get so sozzled, he had to stop accepting gifts. Jimmy was a character known for his tough-guy aphorisms. He famously said of Joe Louis that he was "a credit to his race, the human race." When he had no specific sports event to write about in his column, he'd hold forth on whatever crossed his mind, opening with the phrase: "Nobody asked me, but . . ."

In sports, as in a number of other aspects of life—horse racing, women, and so on—hanging out is the main event. That's why I always wanted to be in the thick of it, soaking up the clammy air, the perspiration, the charged atmosphere. I wanted the viewers of my art to be able to visualize themselves inside my paintings, at the scene of the spectacle, and feel like they were actually in the painting itself, so they could say, "It's like I'm part of the action!"

I paint all that's around me, and I put all that human contact in my paintings, all the information—it's all there. In the twentieth century, fine artists boycotted sports events. In the late nineteenth century, horse racing and boxing were considered worthy subjects, and great paintings came out of that. The French were break-

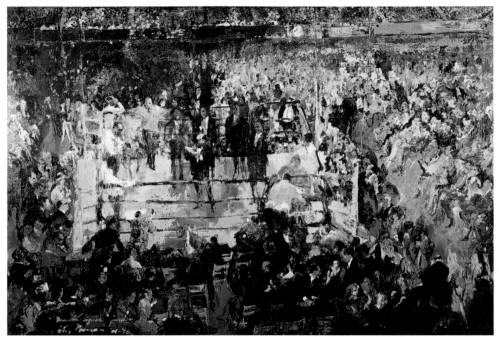

Introduction of the Champions at Madison Square Garden by LeRoy Neiman.
Enamel and Oil on Canvas, 1965. © LeRoy Neiman

ing the ice—they often worked from photographs, copying images and doing some amazing things with them.

My boxing memories from the '60s might best be summed up in a commission I did for Madison Square Garden in '65, *Introduction of the Champions,* an eight-by-twelve-foot canvas that still hangs there today. Joe Louis is in the ring with Jack Dempsey, Archie Moore, and Sugar Ray Robinson. They are being introduced pre-fight by announcer Johnny Adee. Meanwhile, back in the seats, a standing Cassius Clay raves and shakes his fist. At ringside are 125 recognizable figures: captains of industry and entertainment, press and celebrities, the political world and under-world with their expensive companions. You will never see a bad set of legs in the front row.

Fighters come in many shapes and sizes, but they're mainly big, bad-tempered, and sullen. I once went to see Mike Tyson in jail when I was in Indianapolis for the Indy 500. He didn't mind being in jail—it played to his self-destructive nature. Tyson

was in jail this time on a claim of rape, but he had been incarcerated a few times before that. At least that's what he told me. A genuinely brutal guy, he didn't trust anybody, but he would do anything Don King asked him to do.

In the art world, dealers will bullshit you. They think it's part of the game, and it is. Same bullshit with the fight game. Hurricane Carter was mean to the core. He would look at you with a penetrating, nasty gaze that could bore a hole in your soul. He hated everybody back then. But he was a great fighter.

On the other end of the spectrum was Beau Jack. In '67, while sketching on the Miami set of *Tony Rome* with Frank Sinatra, I learned that the great ex–welterweight champion had started out as a shoeshine boy in Georgia. He got some backers, became a lightweight champion, and fought all over the world—in Paris, in Hong Kong. Now he was back to shining shoes in the basement men's room of the Hotel Fontainebleau. I had to stop by and pay my respects. I found Beau Jack sitting on a stool, just like a fighter between rounds. After I introduced myself, he went on to tell me about how he'd started as a shoeshine in Georgia before he became a fighter and then a world champion. "I went through millions," he boasted nostalgically, "and saw the world. But you know, it ain't that bad to wind up full circle, right back to where you started. Now I'm shining the shoes of 'the Voice' himself, Mr. Frank Sinatra. I got my memories and I got my fans like you, who stop by and say hello."

Later that evening I was up in Sinatra's suite with actor Richard Conte; Joe Fischetti, aka "Joe Fish" (he was Al Capone's cousin); and a few other cronies. Frank always had his posse—that's why they called it the Rat Pack. There was a soft knock at the door. One of the bodyguards answered. He went back to Frank and leaned in, "It's Beau Jack personally delivering your shoes." Sinatra jumped out of his chair, dashed to the door, pulled Beau Jack into the room, and announced, "Gentlemen, your attention!" With one arm holding up the shoes, the other around the old champ's shoulders, he said, "I'm proud to say that one of the greatest champions of all time, Beau Jack, has just shined my kicks."

Gene Tunney was the first great boxer I met, a real good-looking man. Catholic, he married a socialite and went on to make a lot of money. Every Friday night at the fights, he'd be ringside with Dempsey. They'd announce "Former Heavyweight Champion of the World Jack Dempsey!" and a big roar would go up. But when they announced Gene Tunney, there'd be minor applause.

The impression was that Dempsey was a regular guy, a guy who would take a drink now and then, while Tunney was pegged an elitist, an intellectual. It

was a caricature but it stuck. That's what fame does to people, makes them into caricatures—and eventually you end up a cartoon drawing on the wall at Sardi's or some hash house.

Where did the idea that Tunney was brainy come from? Well, one time Tunney was on his rubbing table, and a sportswriter interviewing him left a copy of one of Shakespeare's plays behind. Tunney was curious about any book lying around, so he picked it up, flipped through it. Another writer in the dressing room saw the book in his hand and said, "My god, this guy Tunney reads Shakespeare in his dressing room!" And they built everything out of that.

Dempsey was a different kind of guy. He just looked right, a charismatic type. He knew he was Dempsey, that's all. Dempsey would say, "Shake the hand of Jack Dempsey" every time you'd see him. Everybody, whoever you were, whether he'd met you before or not. At least with me, he called me by my name. "LeRoy, you wanna say hello to Jack Dempsey?"

Joe Louis was something else. If you had a woman with you, he'd make a pass, like all those old movie stars did. The "Brown Bomber"—that's what they called him.

But women love fighters too. I think there's an enticing level of mystery that boxers project—and nerve. Fighters love to punch somebody out and don't mind taking a punch themselves. You're meant to avoid punches for your own protection, but you can't be afraid of taking a hit. Fighters love it when somebody picks a fight with them, in the ring or in the streets.

⌇

Ali fought Oscar Bonavena in '70. Oscar Natalio "Ringo" Bonavena was a big name, an Argentinean contender. He was a good puncher, but he had seriously provoked Ali by calling him a "black kangaroo." Ali hit him in the body and knocked him out and it was over—first time Bonavena had ever lost by KO.

There is something terrible about when a champion, a big shot like Bonavena, gets knocked out—it's so definitive. You get two guys who love to fight— both in really good shape. They train and train. They constantly think about the weaknesses of their opponent. How are they going to beat this guy? Then one guy turns around and puts out the other's lights. Devastating. Like Ali used to say, "No one knows what to say in the loser's dressing room."

Bonavena eventually came to a bad end, shot to death at the Mustang Ranch whorehouse near Reno, Nevada. He was having an affair with Sally, the wife of the

Bonavena *by LeRoy Neiman. Enamel on Board, 1966.*
© LeRoy Neiman

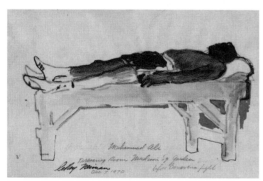

Ali before the Bonavena Fight *by LeRoy Neiman. Marker and Pen on Paper, 1970.* Author's Collection

owner, Joe Conforte. Not a good idea. It was dramatized in a movie, *Love Ranch,* starring Joe Pesci and Helen Mirren.

There's nothing like two fighters meeting each other for the first time in the ring. It takes a lot of guts to walk in there cold. They don't talk about it, but they're human beings and the same things apply like to anyone else—but at a heavyweight championship fight it's all multiplied ten times. Ali never showed his insecurities, but he had them. Football players, tennis players, basketball players, they all go out to destroy their opponents, but they have to persuade themselves first—and that all happens in the mind and heart.

I guess I go through a similar mind game whenever someone commissions a painting from me. They want a Neiman painting and I have to convince them that they are going to get a Neiman—whoever that is. You need to do that in order to get to the point where you can create not so much what they expect of you, but what you expect of yourself.

I remember walking into an arena with Ingemar Johansson and a nineteen-year-old Cassius Clay. Angelo Dundee's brother, Chris, had arranged for an afternoon workout between him and Johansson. Once they were in the ring, Ali played with him. This big Swede was a handsome, really impressive-looking guy, a real fighter, a knockout puncher. He called his right fist "toonder and lightning" and the "Hammer of Thor." Ali just kept on bad-mouthing him. Johansson was the heavyweight champion of the world. But none of that fazed Ali. He kept shooting his mouth off.

"I'm going to knock you out in the fourth round."

Ali so confounded and confused him, Johansson refused to fight him. He was very vain, and didn't want to be humiliated. Ali just psyched him out. "You

won't be able to lay a glove on me. I'll show you!" The workout was over before it started.

Ali was always going on two tracks at warp speed, the physical and the psychological, and opponents couldn't handle that. They'd think about what he was saying, and it would drive them nuts. He'd keep up the dialogue until it curdled their brains or made them so mad they lost control, forgot all sense of pacing themselves, just laid into him and burned themselves out—at which point Ali would come back, fresh as if he were in round one, and take them out.

In November '66 Ali was going to fight Cleveland "Big Cat" Williams down in Houston. Cat had a .357 Magnum slug in him—shot "for no reason" at a traffic light by a cop. He was a glamorous character but unpopular because he devastated his opponents. He'd been in jail, was as big as the Alamo. In his cowboy boots and hat, Big Cat was taller than Ali—who was six feet three inches himself. Ali would harass him and Big Cat would say, "Leave me alone! Keep your mouth shut! Shut up!"

But Ali would keep hammering at him. He accused Williams of being a coward, afraid of him, all kinds of absurd accusations. Big Cat Williams was a bad dude with a bad attitude, but Ali just looked at him and said, "You think you're so big, but I'm bigger than you are." The guy didn't know what to say, he's thinking, "Who the hell is this? What the fuck is he talking about?" Cat was a neighborhood hero, a tough son of bitch. Couldn't believe how Ali was playing him.

They stood together at the weigh-in. Ali was smaller than him, but he looked up and said, "I'm going to knock you out, chump!" Cat's thinking, "You can't do stuff like that!" And then Ali knocked the hell out of him in the ring. He beat him up, cruelly. If Ali had a thing with somebody, he would torment them, bad-mouth them, and then he would punish them. Keep it up all through the fight.

I would often ask fighters, "What did Ali say in the ring, during the fight?" and nobody would answer. The referees wouldn't tell you either. The losers never complained about Ali bad-mouthing them. Well, maybe Joe Frazier did, but then Ali really did a number on him.

I've never picked a fight in my life. There have been plenty of people who wanted to fight with me, but I always defused it. A lot of athletes get into a jam because they're too ready for action all the time; they react without thinking. Too strong, too fast. They don't think about what's happening to them because that's the way they play the game. The social game can be pretty much the same thing if you're not paying attention. Women can be goddamned inscrutable. You don't know what they're talking about, but you know there's an undercurrent there that

you're never going to understand. You really never know what they're thinking. Good-looking women are dangerous, really dangerous. They are a mystery, but I've always wanted them around—what can you do?

◠

Ali never stopped talking. Going down the street from one place to another, even a short drive, wherever you were, he'd talk. I would ride around with him a lot, he was always going someplace—it could be ten miles, could be six blocks—and I'd be sitting in the backseat with him. He'd be talking away, just rambling on or dropping off to sleep, one or the other.

We'd be in Atlanta or some big city with a lot of billboards, and every time he'd pass one, Ali would riff on it, pulling stuff out of the air. When you paused at a stoplight, he'd do a couple of billboards for you—turn them into manic sentences. Brilliant. He'd grab words off billboards and turn them around. He'd come up with these profound rants, and I'd wonder, where did he pick that up? I'd look out the window in the direction where he'd been looking, and there on a billboard would be the words that he'd scrambled. He'd borrow anything from anywhere and add

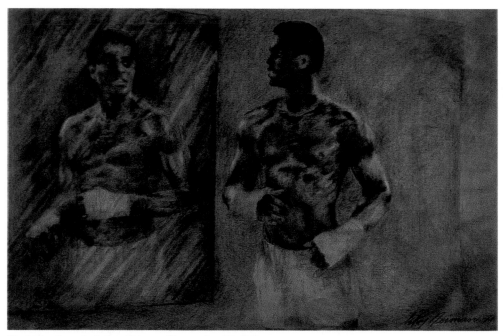

Black Narcissus *by LeRoy Neiman. Charcoal on Kraft Paper, 1974.* Author's Collection

it to his material. Just weave it in. He could make words do things they weren't intended to do, make them dance, give them personalities. He could see the energy in things and use it.

He'd swipe advertising jingles and recycle them. He was a great scrape man. Guys would give Ali poems to write, or they'd write poems themselves, give them to him, and he'd take credit for them. With Ali, if he read it, it was his. That's what's so tragic now; he's lost that, he can't really speak like he used to.

He looked at everything too. He was always looking out the window of the limo, waving to his fans, spread out as if he were on his own planet. Or he'd look around the arena, see an empty seat, and make up a story about it. Verbal virtuosity was not new to the Black culture, but Ali's raps were new to boxing. He was fast and wicked. I've met a lot of fighters, but I've never met anybody who had that way of bullshitting and saying the truth at the same time. Putting you on and trying to convince you simultaneously. He started saying he was the greatest fighter of all time, and then he began to insist on it. MUHAMMAD ALI, GREATEST FIGHTER OF ALL TIME, like it was carved in granite. He'd write it out for sportswriters. Megalo-maniacal—that was his style. Ali claims he picked up the saying, "I'm the greatest!" from Little Richard.

I went to lunch at Ali's house in Louisville about five years before finishing this book. It was the morning of the Kentucky Derby, and the last time I saw him in person. He mainly lives in Phoenix, Arizona, because he likes the weather. But in Louisville he can maintain his privacy because there's not the traffic of a big city. Ali sits there at the head of the table with that certain smile he gives visitors. If somebody he knows well shows up, a flash comes over his face. His eyes still sparkle when he recognizes you, a warm thing he always did, which he'll only turn on for old friends, children—and celebrities.

When I went over to greet Ali that day, he lit right up. That felt good after all the crazy years we logged together. Lennox Lewis was there too—these former heavyweight champs maintained great respect for each other. Lewis reminded me of the time at Sylvester Stallone's *Rocky* party at the Hard Rock Café when I told

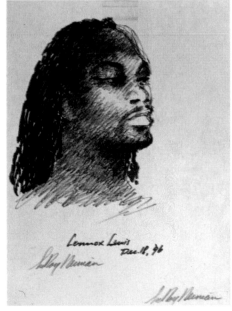

Lennox Lewis *by LeRoy Neiman. Black and Brown Marker on Paper, 1996.* © LeRoy Neiman

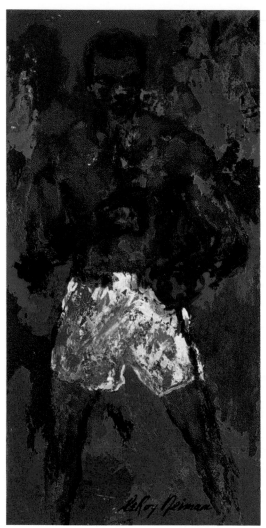

Golden Ali *by LeRoy Neiman. Enamel and Acrylic on Board, 1990s.* Author's Collection

him I'd paint him if he took the title. I never got to the painting, but I sketched Lewis plenty of times.

In the old days, you'd be at a party with Ali, let's say you'd come with some girl. Maybe you've even been with her for a while, but she wants to see Ali. His standard line to women was, "Some chickbox you got there!" Then, when you'd move away, he'd grin and whisper in the girl's ear, "You can do better than him."

After his last fight with Frazier, everyone was asking Ali, "When are you going to retire?" Never! He wasn't going to hang it up, he wouldn't stop. Nothing to do with money. It's crazy—they're crazy, boxers. All the champions I've known had the same urge. Ali fought ten or twelve fights after the last bout with Frazier. One after the other, at least ten or twelve more than he should have.

Why didn't he quit? How could he? He had to win. He did that as a kid, did it his whole life. He'd go in to fight Patterson to beat him up, knock him out. Unbelievable. That's when he was really happy. He had no professional-level skill at anything but boxing, and that he did brilliantly. He had a basketball court but never used it, he didn't care about anything but boxing. The fight. That's what he enjoyed. He had an angelic, beautiful face, but he was a fighter to the core.

Who knows what goes on in his head now? He's always flying off someplace. He likes to be seen, likes to be with people. Everybody is moved when they see him.

Ali never should have fought again after losing to Larry Holmes, but the Muslims wanted him to go on, the world wanted him to go on. He was a god by this time, an absolute god. He was an amazing phenomenon. Who would want to see him stop?

As Seen on TV (and Everywhere Else)

I'm a storyteller—only I tell my stories in a riot of color. Painters have always told stories—martyrdoms, murders, battles, saints, and sinners—and that's still what I do. I paint battle scenes like the baccarat tables at Monte Carlo, matador vs. bull, Ali vs. Frazier. I paint scenes where the underdog triumphs, like Superbowl III where a Jets quarterback overturned the team's losing streak, or the day a horse with odds of 20-1 won the Kentucky Derby. I paint superheroes, like the Olympians who daily perform supernatural feats, things we could never do, even with years of practice.

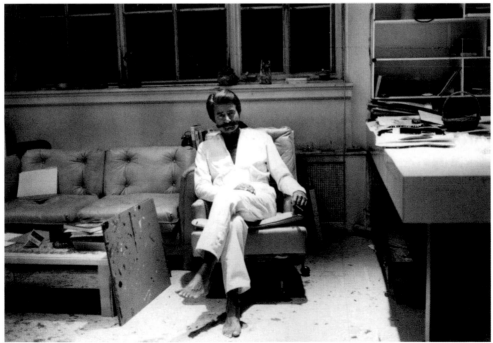

In my New York City studio, 1979. Author's Collection / Photo by Maria Del Greco

Super athletes are genetically different from other people. However hard you or I may try—not that I ever wanted to—we could never hope to be a professional or Olympic athlete. Great athletes are built differently. In physical comparison to the normal run of people, they're freaks: They're stronger and bigger—able to jump twenty-five feet where we couldn't jump ten. And there's a mental drive, a conviction involved in being a star athlete—few are born with that kind of mettle.

In '72 I flew to Iceland to witness one of these exotics in action. Touching down in Reykjavik was like landing on the surface of the moon—mournful, relentless winds swept across a vast, treeless, volcano-pocked landscape. I was on an ABC assignment to sketch Bobby Fischer and Boris Spassky battle it out for the world chess championship.

Bobby Fischer was crazy obsessed! He carried a pocket chess set around; he was always playing. He was a player, like anybody else, like any athlete of that caliber who is focused on his game, but he was not normal—if there is such a thing. He was like Lenny Bruce in that way. Eccentrics! Intense! You might as well get into your game all the way, because who the hell knows what the point of life is or how we got here or what is going on.

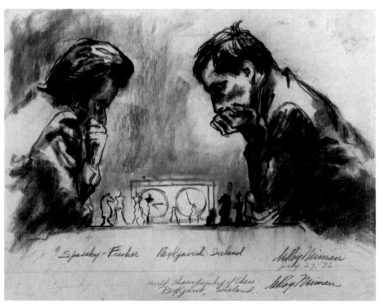

Spassky and Fischer *by LeRoy Neiman. Litho Pen and Charcoal on Paper, 1972.*
Author's Collection

How I came to be in Iceland covering a chess tournament happened like this: I was at a tennis match at Madison Square Garden sketching Pancho Gonzalez as he performed his between-sets ritual. He'd methodically change his shirt and socks and replace corn plasters on the court—to the crowd's great amusement. As I was sketching, I sensed someone looking over my shoulder with more than routine curiosity. The beady eyes of ABC kahuna Roone Arledge were upon me. He nodded appreciatively. Apparently he liked what I was up to—flattering, but how would that

ever translate into anything other than a compliment? Except for Tex Antoine's weather doodles and courtroom sketches, they didn't use artists on TV. But then he addressed me with the solemnity of the powerful, saying, "LeRoy, you know, I think I might be able to find a place for you on the new series I'm producing, *Wide World of Sports.*" How that would work, I had no idea, but who was I to question Roone Arledge? Capturing athletes in play—that was one of my passions. But an artist on TV? Now that would be something! Game on.

Of course this game would be played by Roone's set of rules. Day or night I was to be on call, ready to act at a moment's notice. My first call came from Iceland. I looked at the clock, it was two in the morning.

"LeRoy, we need you here, pronto," Arledge fired into the phone. "Get yourself on the next plane to Reykjavik. Fischer's just banned the crew from the match. No cameras. No glaring lights. We need to get you over here to document the damn thing."

Roone Arledge *by LeRoy Neiman. Graphite on Paper, 1972.* Author's Collection

Soon my plane was skidding along a landing strip just short of the Arctic Circle. Next morning I woke up in the Holiday Inn-ish Hotel Loftleidir and tracked down the dining room. Breakfast was an ascetic affair, hardy Icelandic helpings of fish, eels, and a side order of kelp. As I slid my tray past the steaming metal containers, I nearly collided with the guy in front of me absentmindedly nudging his tray forward, completely engrossed in a pocket chessboard. It was Bobby Fischer. I could see right away he was a rare bird.

I'd done a bit of research on the two contestants. Any similarities between the twenty-nine-year-old American, Fischer, and the thirty-five-year-old Russian, Spassky, ended with their Jewish heritage—and even there Bobby Fischer would turn on his own people, later spewing anti-Semitic rants. The tightly wound Fischer was a nonsmoker, Spassky a chain-smoker. Boris was outgoing, a tennis player, while Bobby was hermetically holed up in his room, listening to the pounding of

rock music, studying his opponent's game, or it was said, reading the Bible and *Playboy.*

My first day at the match, I positioned myself as close to the chessboard as I could, with my chin at the edge of stage. I knew how to be unobtrusive. That's the other talent I've developed: being there and not being there at the same time. Above me, the two competitors entered and took their places, poised head-to-head. I set to work using my favorite medium, a rapidograph. Not thirty seconds had passed when Fischer suddenly sat bolt upright. I was shocked to see he was sending a venomous look in my direction. Apparently he possessed the ultrasonic hearing of a bat. The faint scratching of my pen had gotten to him—it was disturbing his brainwaves!

I screwed the top on my Rapidograph, pocketed it, and chose something that wouldn't make any noise—a silent, felt-tip marker—and continued drawing. Again Fischer froze. Like a predatory creature in the wilds, he began furiously sniffing the air. The scent of the ink was distracting him! He was neurotic as hell. All eyes were on me, the offending presence, the ongoing cause of Fischer's unease. In a match as tense as this one, I had unwittingly become the determining factor in the game. I could see the headline: "Insensitive Artist Loses Title for American Chess Champ." I tenderly capped the marker and reached for a soft graphite pencil—soundless, squeakless, odorless. To my relief, the play continued without consequence. Later

At the Munich Olympic Stadium, 1972. Author's Collection / Photo by Neil Leifer

on, out of Fischer's range, I added touches of ink and watercolor, and the drawings appeared the following Saturday on *Wide World of Sports.* Despite the nerve-racking beginning and the minimal action involved, it was thrilling to watch and compelling to draw, with the stress of their minds expressing itself in contorted body language.

Roone was pleased with the outcome, so

pleased that he decided I was ready to qualify for the Olympics. But not just any Olympics—the soon-to-be tragic 1972 Munich Summer Olympics. I was anointed an announcer, fitted in an official ABC green jacket, and positioned alongside Peter Jennings for the opening ceremonies. Sitting there in the moat encircling the track, watching as wave after wave of the greatest athletes on the planet marched by, I became concerned. How was I going to translate all that energy and grace onto paper? But I'd brought with me my tray of aquarelle colors and water-soluble crayons—what better medium than one that uses water to catch the flowing thrust and momentum of the athletes?

Roone initially had me on camera with Jennings, but that idea was junked. Instead I was given my own evening segment, doing live commentary on sketches I'd made at the various events during the day. I'd show my renderings and talk about the games. I'd done this sort of thing before, but not with eighty million people watching around the world. The exposure was mind-boggling.

I even got interested in some of the less-promoted events, such as fencing, though it wasn't covered by ABC. Fencing matches were conducted in all-white costumes devoid of national identification except for the numbered medallion on each mask. I got so into it that I made a field trip to Ludwig-Maximilians University one afternoon to watch the Das Corps Suevia Fraternity engage in old-guard fencing. The organization had originally been formed in 1803 to fight against Napoleon—but rivalry was now limited to neighboring universities. Like Heidelberg, membership in the fraternities had three main requirements: Candidates had to participate in five matches over two years, face masks were verboten, and because of this—the third and steepest stipulation—a member's credentials would be indelibly registered through facial scars.

Back at the Games, the Israeli team, fired up, flags furling, were in exquisite form. I sketched their wrestling team weighing in for the opening-round competition, so spirited, clear-eyed, and conditioned. It made the horrific attack at dawn on September 5 by eight Palestinian terrorists all the more poignant for me. When word broke that morning at the Sheridan, where press and network announcers were staying, there was a mad scramble for ABC vehicles to get to the Olympic Village. My driver was ready to go, so Howard Cosell and Jim Murray climbed in with me—two seasoned pros overtaken by anger, grief, anxiety, and disbelief.

We pulled up to the Olympic Village, where athletes had been living together in amity. To avoid an overbearing military presence, security had been kept deliberately thin. Now we were faced with the scene of a massacre. Two Israeli athletes had

been killed within minutes, and nine held hostage. From Jim McKay's outpost, we could see the captors, armed and masked, holding vigil on the balcony as German tanks rolled in. The sense of foreboding was palpable.

With the terrorists demanding the release of two hundred thirty-four Arab prisoners, negotiations crawled on throughout the long day, but we were in no way prepared for the shocking denouement. A rescue attempt and chaotic gun battle at the military airport outside Munich resulted in the death of four hostages in a burning helicopter, and the remaining five hostages were mowed down inside another helicopter by terrorist machine gun fire—those very athletes I had sketched earlier that day. As I looked back at the drawings, I felt a poignant connection with them. Beyond the brutality and senseless loss of life, a fundamental faith in the human spirit had been violated.

Whatever sport I'm covering, I always like to establish a one-on-one connection with the athletes involved. Of all the great athletes I got to know at Munich, two stand out in my mind: "Pre," the distance runner Steve Prefontaine, who would slo-mo past me at practice so I could catch his moves, and the brilliant gold medal

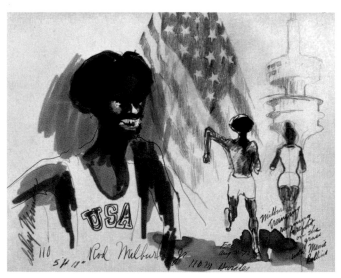

Rod Milburn Jr. *by LeRoy Neiman. Marker, Felt Pen, and Pencil on Paper, 1972.* Author's Collection

hurdler, Rod Milburn, who cheerfully cooperated with my odd request to run barefoot on the grass so I could sketch his pink-soled, green-stained heels as he leaped over the hurdles. Both died before their time. Prefontaine was killed in a car crash three years after Munich at age twenty-four. Milburn died in '97 just shy of fifty, in an accident on the job at a paper plant in Louisiana.

Except for the legendary sports heroes, the fame of an athlete is fleeting. Two years after Munich, I ran across an obit in the *New York Times* announcing the death at twenty-two of Chris Taylor, the great white whale of the US wrestling team, whom I'd become friendly with at the games. A four-hundred-pound colossus, he was unfailingly polite and gentle, yet so massive that it took two teammates to give him

Chris Taylor *by LeRoy Neiman. Marker on Paper, 1972.*
Author's Collection

Ali & Bill Russell *by LeRoy Neiman. Watercolor, Ink, Marker, and Pencil on Paper, 1967.* Author's Collection

a workout. After his excruciating defeat to Wilfried Dietrich of West Germany for the bronze medal, I tried to reason with Chris that he'd get another chance to redeem himself. The normally happy-go-lucky hulk looked at me with unaccustomed gravity and replied, "Aw, LeRoy, I won't live that long." The note on his passing in the *New York Times* was a spare inch-and-a-half long.

In the aftermath of the terrorist attack it was decided, after some delay and much debate, to continue the games. On the last night, a question of propriety created a controversy among Howard Cosell, *Houston Chronicle* sports columnist Mickey Herskowitz, basketball coach Bill Russell, and me. Should we boycott the closing ceremonies out of respect for the slain athletes? Cosell made his mind up on the spot: "No way!" Russell and I were undecided. Deliberations had come to a stalemate, when with his sardonic wit, Herskowitz broke the gravity. "I wouldn't miss it for anything," he said. "I want to see the Germans bring back all those pigeons they released at the opening ceremonies."

And that's more or less how I became the de facto artist-at-large for *Wide World of Sports.* With Frank Gifford, I covered the Bobby Riggs–Billie Jean King—boy vs. girl—tennis showdown at the new Houston Astrodome. Then I got myself a bird's-eye view of the finish line from the roof of the stands at the Kentucky Derby. It didn't take NBC long to catch on, and soon I began appearing on their pre-game World Series shows with Joe Garagiola. I covered the Stanley Cup with Tim Ryan, and pre-game Super Bowl '73 with Curt Gowdy. I liked doing this stuff—quick visual gigs, an exhilarating environment, and unparalleled exposure.

For the '76 Montreal Olympics, Roone decided to assemble my paintings into an ongoing mural, and every night I'd hold forth on this work-in-progress with anchorman Jim McKay, interpreting the day's events.

Modesty, false or otherwise, has never been my thing. I shamelessly basked in this windfall notoriety and the connection with my fans that it offered me. Letters poured in asking when and where I was appearing next. It was wild. People stopped me on the street—cabbies, truck drivers, hardhats. On Columbus Avenue a guy poked his head out of a manhole and shouted, "Hey LeRoy! Draw me!" In Central Park a park worker, trash-collecting spear in hand, came over to tell me he owned five paintings of mine. I didn't have the heart to tell him they were posters. Fans would offer to swap a sweater, blazer, cravat, or watch for a quick sketch. One night at a Rangers game, a little girl shyly sidled up to me. Would I sign this puck for her dad? There's no more immediate way to connect to your public than that.

I'd tapped into a new kind of audience, people who didn't know much about art, and had little interest in it. They watched as I created images of their favorite prizefighters or football players in action on the spot—they could share in the creative process as I splashed on the colors, dashing off a sketch of a quarterback catching a pass on the thirty-yard line. Watching my drawings come to life on TV helped them feel part of the action. They could feel the energy and drama of the game—when I painted, my mind was totally in the moment—and along with feeling a part of the action, they fell in love with the messenger. This was not art tucked away in some exclusive gallery or imposing museum, this was art in real time.

My baroque mustache helped. I had become a character, the way people like their artists to be—colorful, eccentric, unconventional. One balmy autumn New York afternoon I'd just hailed a cab on Park Avenue, when from out of nowhere, a motorcycle cop roared up and got off his bike, ticket book in hand. My mind was racing. What had I done? Was he after the cabbie? No such luck, he was heading straight for me. But he was smiling. "Hey! Yuh're LeRoy Neiman, right?" he said in

his best New York cop accent, handing me the ticket book. "Would ya sign a ticket for my twelve-year-old daughter?"

The following May, on my way to the Kentucky Derby at Churchill Downs for ABC, cruising like a cool breeze in my convertible, I heard a siren wailing over the blare of the radio, then saw flashing lights in my rearview mirror as a cop signaled me to pull over. Here we go again.

"What seems to be the problem, officer?"

"Do you know how fast you were going back there?"

"Well, see, I work for ABC and I was afraid I was going to miss the race I'm covering . . ."

It sounded pretty lame, but what was there to lose? He paused. There was a flicker of recognition—I was the guy on TV. "Hell, why don't I . . ." Next thing I knew I was enjoying a police escort through backed-up Derby traffic to the track.

I got another break the night Reggie Jackson hit three homers to spur the Yankees on to win the '77 World Series. By the time the crowd poured out of Yankee Stadium, it was after midnight, every cab and limo taken, the subway choked, fans

1977, with Reggie Jackson. Author's Collection

going bananas. Like a vision, a Yellow cab appeared. "Ain't you LeRoy Neiman?" the cabbie called to me, leaning out his window. "If yuh'll draw my picture, I'll take yuh wherever yuh wanna go!" Done. I jumped into the front seat, pulled a couple of fourteen-by-seventeen sheets out of my sketchpad, and settled back in the snarled traffic to make good on the deal. Nearly an hour later, when we pulled up to my Manhattan address, I handed him a finished portrait along with the fare. He looked at the sketch, beaming. "Hey, no way yer payin' fer the fare, Mr. Neiman!" he said, and took off.

But with popularity came the backlash—the critical attacks on my art increased—but I paid little heed. I can't blame the art crowd for taking a dim view of my paintings of football players, four-hundred-pound wrestlers, and racehorses, but I don't regret it for a moment. My interest was moving pictures, while most of my contemporaries in the avant-garde—pop artists, minimalists, color field painters—dealt with static images. I'm a populist by nature, and my subject matter has served me well. All told, I related to cops and cabdrivers more than I did to the anointed tastemakers. And I was invulnerable, right?

I hadn't heard from Roone in a while. ABC was playing possum, but there was no slacking off on my end. Was I pushing the cocky quotient a little too hard? I did a piece on soccer idol Pelé for my old friend Sonny Werblin. Since I was taking part in soccer history, surely the most beautiful inflated bladder-ball sport, shouldn't I add some Neiman panache? Alright, I got carried away sometimes. I engaged a curvy assistant and arranged for a midfield picnic along the sideline—a blanket laid out on the grass stocked with champagne, caviar, and fromage.

Sipping, sketching, and snacking, I became absorbed in drawing a large Pelé image when the "Black Pearl" himself caught on to what I was doing and started playing along—dribbling and swerving past us while throwing wisecracks like, "Make me beautiful, LeRoy." It was great fun until word came down from above. It seemed Sonny didn't appreciate the grandstanding. We were pulled off the field and installed in the owner's box where he could keep an eye on me—not a bad outcome since the victuals up there were at least as good as the spread we'd left behind.

The Black Pearl, that was Pelé. What a great soccer player, unequaled today. Of all the athletes I knew, he was right up there on top. He came to the United States from Rio de Janeiro, and when he arrived here he was still married to Rose, a pretty Spanish woman. I knew it wasn't going to last—too many women throwing themselves at him, and he was a woman-chaser, besides. No escaping divorce court for him. He could do things on the playing field that were unheard of—fool around on

Pelé *by LeRoy Neiman. Acrylic and Enamel on Board, 1975.* Author's Collection

the field, execute his famous scissor kick, and then before you even knew what he was doing make a goal! He was outgoing and good company, and seemed to speak every language there was, a really personable guy.

⌐

I've always had to have an assistant with me on my gambits. "Why does she have to come?" people would ask me. "I can't tell you why," I'd say. "I just need her." The girl working with me at this time was Linda, she'd been around for fifteen years and was no pushover. When it came to foisting herself where she didn't belong, Linda was a pro. There was a big football game in New York, and I knew I could get in (I could always get myself in), but to get her past the Mickey Mouse protocol at the gate was another story. "What's she doin' here?" and all that crap. "Linda, our luck's going to turn," I said. "You're going to get in that game." And just then a marching band came by, tooting and banging, and Linda snuck into the middle of the formation and marched into the game—right in step with the band! Everybody

Silverdome Super Bowl *by LeRoy Neiman. Enamel and Acrylic on Board, 1982.*
© LeRoy Neiman

loved that, the people at the fifty-yard line thought it was hilarious. When she got to the bench where I was with our entourage, she dropped out of the formation and everybody cheered. She was funny, it was funny! (You couldn't have done that in London or Paris at that time, they didn't appreciate nonsense like that, or allow it. They'd throw you out of the stadium!)

Now CBS had a compelling proposal for me. Super Bowl '78 was coming up. Could I render play-by-play computer drawings using the new technology of digital art? I grabbed the opportunity to try out a quirky new idea.

With all the intrigue of a covert operation, CBS dispatched me to Palo Alto where the program was being secretly developed. After I got the hang of it, they shipped a computer to the newly completed New Orleans Superdome. The whole thing went without a hitch, the broadcast got a positive response, but that game marked my first and last digital performance before millions. I was never quite sure what went down and nobody would tell me. Network malarkey.

It wasn't only the end of my digital career. That experience was also the last of my dealings with ABC and Roone Arledge, who saw my work with CBS as a defection. But to tell you the truth, I wasn't really cut out for that scene anyway. I hate that kind of politics where they take you in like an old friend, then fight you for every inch of turf, all the while milking you of your best efforts.

During a typical pre-game powwow at the Super Bowl one year, we were discussing my camera time. A blowhard stands up—a tall, imposing guy—and starts talking as if I wasn't in the room: "This Neiman. How many minutes is he going to get?" When no one offered any information, he continued: "You don't even know what this guy's going to do and you're going to take a chance on him? He's biting into my time!" That's what it was like tangling with the announcers. It was their living—but it was only a sideline for me.

In the long run I would have wasted too much energy competing for exposure, and it wouldn't have served my artistic interests. That world wanted all of you or nothing. Still, in those half-dozen years, I had the pleasure of working with a true maverick in the industry. Roone had that rare, possibly now extinct, ability to operate from his gut. His announcers worked without teleprompters, and he gave me carte blanche. I'll never forget the day I walked into his office to review some sketches in the middle of a meeting with a group of officious-looking empty suits. Roone green-lighted everything with a glance while they looked on, stunned.

The door opened for me by Roone Arledge affected my life indelibly. Plugging into the energy of the broadcast environment added a snap to my work and exploded my visibility. I knew things would never be the same when, while passing through customs after the Munich Games, I heard an inspector call out, "Let LeRoy through!"

While I was still with ABC, a commercial sponsor approached me—I can't remember the product—and mapped out a strategy that involved me doing a soft-shoe routine. They hired a guy to come and teach it to me. I had one lesson and I wasn't any good at all, but they were going to go ahead with it anyway. Then Roone found out about it. He said, "What did I hear about you doing something for a commercial?"

I said, "Yeah, what about it?"

"Well, you're not! Our announcers don't do that kind of thing."

And that was the end of that.

When Roone was done with you, it was over, but then again, so was that extraordinary phase in television history. Some twenty years later, I did enjoy a reunion of

Ascot Double Entry *by LeRoy Neiman. Enamel and Oil on Board, undated.* © LeRoy Neiman

on St. James and Annabel's on Berkeley Square. British upper-class gambling joints, like Annabel's and Crockford's, were different from Las Vegas. They were very . . . sedate. You'd go in there with money, and they would politely dispossess you of your last crumpled five-pound note These people catered to an elite. You'd find a certain breed there—an exclusive one. Vegas, on the other hand, was not exclusive, no way.

It was heady to exhibit my work on the same walls that bore great nineteenth- and twentieth-century artists, and more recently the paintings of Sir Winston Churchill. As a painter, Winston Churchill was a problem solver. He didn't just paint a scene, he brought a heightened sense of specificity—adding a particular stairway or a certain period of furniture. There was a table at the Savoy Hotel in London where he often lunched with his cabinet, and he always finished with his favorite cigar—The Churchill—hand-rolled in Cuba. Whenever I was there, I'd make a point to get that table and light up.

Ascot was a powerfully colorful setting to paint. It's the royal family, the Royal Box, society high and low—the jockeys and managers milling about in the paddock, and the Queen and the aristocracy and the big hats. It was fascinating to watch how these people behave.

I'd draw the horses, and there'd always be a trainer and assorted owners, it was big business. I was constantly getting barred from certain areas—not that that ever stopped me. I was younger—I wouldn't do it anymore. Ascot is about wealth and stature—the royal family, rich jockeys—everybody's rich and that's what makes it such a scene.

Now, Jamaican horse racing, that's a rough one, boy. Frightening stuff! I was in Kingston and decided that I was going to the races. It was a real spectacle, all the races were fixed, right out in the open. I was in the jockey room and one of them, he was about eighteen years old, starts bellyaching about how the other jockeys didn't treat him right. "There's one old jockey here and you can't win a race when he's in it, because he'll whip you right across the face while you're riding. He's a dangerous guy!"

Anything goes here! The race starts, there's a brawl! And the jockeys would do anything—hurt the horse, hit the horse across the eyes—anything! The big thing was to get out ahead of the pack. The kid's going on, "When I see on the sheet that he's in the race, I say, 'Oh, hell, might as well pull out.'"

So I think, I'd better go over and draw this guy. He was in the corner of the jockey room, legs up, in front of a television set, watching some soap opera. He's the man! I said, "I saw you talking to that kid over there."

"Let me tell you something," he said. "When I was fifteen years old, I started riding. These kids are sixteen, seventeen. They used to beat me too, all those old guys, whip me. But now I'm in a position where I can do what I want with them!"

⌒

I'll now reveal a well-kept secret that one of the featured oils at my Bond Street show was a hybrid of Hollywood royalty and British monarchy. I ran into Hollywood producer Darryl Zanuck from time to time, him and his girlfriend, a Parisian confection he kept in a high-rise on First Avenue and 57th Street, and through talking to her, I agreed to paint Zanuck on a horse—as a polo player. He was a character.

An L.A. friend told a story about when they were both staying at the Plaza. He was coming down the elevator and it stopped at one of the lower floors. Out came Zanuck with his beach shoes, robe, towel, and shades, and my friend said, "Where're you going, Darryl?"

"I'm going out for a swim, for Christ's sake!"

And the guy said, "I got to tell you, Darryl, we aren't in L.A.!"

Darryl said, "What the hell are you trying to tell me? I know where I am!"

But he didn't! When he got off at the ground floor, he looked around and he said, "Goddamnit, this is not the Beverly Hills Hotel!"

So I did the painting of Zanuck for his woman and then suddenly, Zanuck died. She called me up. She didn't want it. And I said, "I'd like to have the painting." And she said, "I'll give it to you. It's your painting. Keep it." So now I've got

Darryl Zanuck on his polo pony and I thought, it's a pretty good painting, but how the hell can I sell it? So I decided to put somebody else on the horse. How about Prince Charles? I'd drawn Charles and his father, Prince Philip, at Windsor Castle. I made a few changes, put bigger ears in for Charles. A little finessing, and I'd reincarnated the director into the young prince on his polo pony at Windsor. Everybody loved it, and no one ever questioned the painting's provenance. It hangs today in a Mayfair flat.

Prince Charles Polo at Windsor *by LeRoy Neiman. Enamel and Acrylic on Board, 1982.* © LeRoy Neiman

In my life in the picture trade, plenty of criminals have passed my way with their now-you-see-it-now-you-don't schemes. Wall Street types mask their chicanery in obscure money-making formulas and Ponzi schemes, but this animal shows its spots early and often. My standard response is to cut them off and cut my losses. It's a waste of time, energy, and money trying to collect damages, and seeking revenge only ends up further involving you in their head games.

Experience has taught me that continued association with this ilk only results in guaranteeing further misdeeds. They'll reappear anyway, or their sidekicks will, with a new bag of tricks. I don't know why so many otherwise clever people put the deal ahead of everything else. It's a businessman's job to get the better of you, so it's a waste of time to try to outsmart them at their own game. Meantime you could have gotten some work done. Better to just let it go. And while you're at it, forget about appealing to these guys' sentiments. Big-time operators make no exceptions, not for a close friend or a blood relation, alive or dead.

Yet I can't help it, I have an inbred affection for the hucksters. It all goes back to the penny-ante gangsters who swaggered the streets of my youth defending their two-bit piece of turf in cheap suits and shiny shoes. These guys were our Robin Hoods, and they put a whiff of bravado in our glum existence.

Not surprising then, that I hold a special place in my heart for Vegas. From my first foray into that boom-or-bust desert mirage, when I was comped at the fabulous Flamingo in the late '50s, I was hooked. I've never been tempted by the roll of the bones, but I love the hothouse climate that fuels it. I've followed the town through its many mutations, never tiring of its phantasmagorical ambiance and colorful old-school characters. It's the world capital of fantasy and hustle. Is there any other place on earth that attracts more finely tuned wheeler-dealers?

At the top of the list of these rogues was "Wingy" Grober, a midget among men. Wingy began grooming himself for a life of crime early. As a youth, he parlayed his size, small even by jockey standards, into burglary with a gang of safe-cracking cronies. They'd hoist him through transoms so he could unlock the door and get the loot—a talent for which he successfully served time. In Vegas he was one of these guys who kept track of how much gamblers made and how much they owed—it's a worldwide ring because the gambling establishments are all in cahoots. A gambler may run out on a bet and go over to China, but they keep books, make phone calls . . . so Wingy Grober was Caesars Palace's points man. Boy, he knew how to collect. Wingy would follow somebody to Baltimore or Los Angeles or Mexico City if he had to, knock on the door, and introduce himself with, "I want that money!" He'd terrorize people, scare them out of their wits. They knew they could get shot. This was a business where there were consequences! If the house didn't get their money, the guy would disappear. I've always been drawn to these characters as subject matter. It's my weakness. The Depression was something to live through—punks, roughnecks, desperate people—hoodlums were the only heroes we had.

When I met Wingy in Vegas, he was in his late seventies, and paraded around with a towering ex–show girl on his arm. One day a bartender at Caesars drew him aside. "Hey Wingy," he warned, "I think ya might wanna know yer steady squeeze has been pickin' up strays at the bar."

Wingy thought about it for a minute.

"You're gonna keep that one to yourself!" he snapped back. "When she's with me, she's all mine."

Then there was the elegant, smooth-talking Arnold Rothstein—you'd only guess his checkered past when he opened his mouth to speak in the patois of the

street hood. He was a great gambler, but dabbling in mob matters was his downfall. He ended his days shot in the back at the poker table.

My fascination for these guys might have had something to do with their inclination to use guns to solve every problem. I'd had enough of guns in the army. I'd only fired on the rifle range in basic training, never in action. Unlike the second-tier mob gunmen I'd later come across, who knew the guys they shot, in combat you never saw your victim. The mark of success in the mob game was to live to retire, or maybe get exported back to the Old Country—which didn't happen all that often.

Lenny Rosen was a wily hustler, wildcat real estate tycoon, and unlikely dealer in fine art. Flush or busted, Lenny lived in high style. We sometimes shared a suite at Caesars Palace, courtesy of owner Cliff Perlman, which came stocked with mandatory private terrace swimming pool, big white grand piano, and complimentary females. Every parking valet from Vegas to L.A. knew of Lenny's white Rolls—he was a big tipper. When there was no valet's palm to grease, he resorted to his fallback position: handicapped plates.

That was Lenny. He'd engage in any sort of monkey business to turn a trick, the only criteria being it had to be a challenge. Otherwise, why bother? When he owned the Upstairs Gallery in L.A. on La Cienega, he hung an enormous fake Dalí behind his desk, but that didn't prevent him from dealing with original Dalís as well, along with Mirós, Picassos, and Tamayos. He paired me first with Alexander Calder, then Henry Miller's playful erotica, and lastly Henry Fonda's landscapes, portraits, and caricatures. None of these shows were authorized—I doubt if the artists even knew about them, but I got a kick out of hanging alongside these giants.

Polo Lounge *by LeRoy Neiman. Watercolor, Acrylic and Pencil on Paper, 1981.* © LeRoy Neiman

Several years after the Fonda show, I was leaving the Polo Lounge after dinner one night when a voice called out, "LeRoy Neiman, hold on a minute!" I recognized the distinctive twang as belonging to the legendary Henry Fonda. He was on a call at a wall of pay phones in the Beverly Hills Hotel lobby. "Henry Fonda!" I answered. I was a little surprised he'd recognized me since we'd never met. "LeRoy, tell me something," Fonda said, as he headed my way, letting the receiver drop with a clank. "A friend has commissioned me to do a painting and I can't seem to get myself started. How the hell do you get over the fear?"

I resorted to amateur psychology. "You know that unsure feeling you get when you're in front of the camera, Henry?" I asked. "But once you're out there, it all comes naturally, right?" Fonda lit up.

"You've hit it on the nail, LeRoy, thank you!" he replied, shaking my hand firmly. "That's just what I needed to hear." He bounded back to the pay phone and his dangling conversation.

When I first came to Vegas in the late '50s, it was still a raw town—the flashy, neon-drenched strip was spitting distance from the encroaching desert, and cowpokes still gambled in sawdust-floor joints. Whether your occupation was gangster, gambler, or jazz sideman, business suit and tie was the mandatory dress code. Bugsy Siegel had tarted up his casino, introduced plush carpeting to his jazzy new Flamingo Hotel, but it wasn't until Barron Hilton built his luxury behemoth

Barron Hilton with Jim Mahoney in Hong Kong *by LeRoy Neiman.* *Black Felt Pen and Marker on Paper, 1990.* Author's Collection

that the hospitality industry took over and fantasy hotels, with their pyramid and pirate-themed extravaganzas, started popping up. Then sights the world had never dreamed of began to sprout up in the Old West.

I am magnetically drawn to the gilded, mirrored, pulsing atmosphere of the casino—a theater of bright, blinking lights that never dims and time is banished. A joint teeming with players and voyeurs—a never-ending tragicomedy of winners and losers whose lives are subject to the vagaries of chance. Players and

peepers encircle the tables, registering every emotion from elation to desolation, from masklike cool to the contorted body language of desperation. Aware of the cameras above, players posture and preen, while the systems players and shills carry on oblivious to the surroundings. I find it all mesmerizing, from the high rollers with their bulging wallets, to the lesser-stakes players, to the flat-wallet gamblers casting despairing looks as funds evaporate and savings dwindle. Even the losers are survivors in Vegas.

They do things differently on the Continent. The casinos of Deauville and Monte Carlo are stiff, sedate establishments, so quiet you could hear the ball bouncing on a spinning roulette wheel or the eerie chanting of the French croupier all the way across the carpeted and chandeliered rooms. In Vegas, you could stand right at the roulette table and barely hear the dealer's call over the din. My kind of town.

Eventually I'd get to hang out with the pampered high rollers sipping Château Pétrus and Cristal in baccarat salons like the VIP sanctuary at the fabled Sands, Sinatra's house. I watched high rollers, comps, mob investigations, and big-time open-air prizefights at Caesars, Cliff Perlman's full-scale glitzy gilded palace, where

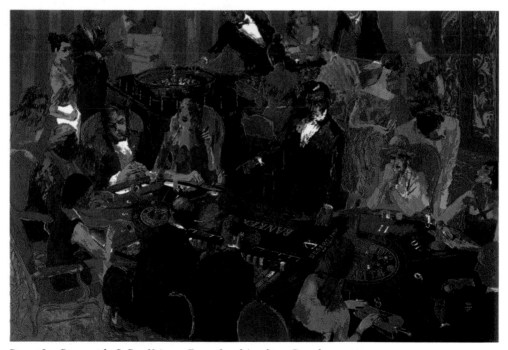

Desert Inn Baccarat *by LeRoy Neiman. Enamel and Acrylic on Board, 1997.* © LeRoy Neiman

mirrors were strategically installed over beds, and an exact replica of Michelangelo's *David,* looking underdressed, stood in an alcove over the bazaar.

Then there were the fabled crusty establishments with Wild West themes, like the Dunes, Desert Inn, Frontier, and Horseshoe. I gravitated to the rough and tumble action there, like a prospector moseying into town. There were craps tables with cowpunchers in ten-gallon Stetsons and stiletto-heeled kicky chicks tossing dice—the yelps at the tables echoed by shouts from the slots was music to my ears.

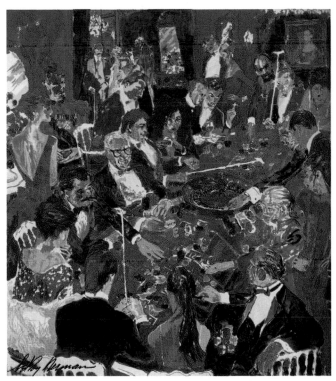

"Even as I approach the gambling hall," Fyodor Dostoyevsky wrote in *The Gambler* back in 1867, "as soon as I hear, two rooms away, the jingle of money poured out on the table, I almost go into convulsions." In Vegas, it's the chips that mesmerize the possessed gambler, sliding and chattering across the table. It's not real money, so the risk is unreal too, and the turn of the card or wheel sends the player into a dreamy ritual.

When the stakes are high, I watch the players as they tense and pose— time is suspended until the cry "Place your bets" breaks the anxiety-charged moment. I watch as the gamblers study the pot with melodramatic eyes. The kibitzers gather around the green felt tables like a gallery around a golf

Baden-Baden *by LeRoy Neiman. Watercolor, Acrylic, and Felt Pen on Paper, 1987.* © LeRoy Neiman

green. As in golf, spectators dress like players, there's no uniform separating oglers from those who are waging bets. Gimlet-eyed onlookers circle around the players in breathless anticipation, captivated by the sweep of the croupier's rake. As he pulls in the napoleons, his expression is as solemn as a church usher passing his collection plate to the faithful.

It's an entire world of freaks, fanatics, operators, suckers, sex, money, and frothy make-believe. No wonder I love to paint it all.

In Sin City in the old days, if you'd hitch a ride in Jimmy "The Greek" Snyder's limo, you'd get a lesson in odds-making. Jimmy took his name from the original great of gamblers, Nick "The Greek," and he caught some flack for it over the years. He'd bet on anything. He'd appraise the real estate we were passing and goad you into challenging his estimate. "What do you think that building is worth?" he'd ask the driver, anybody. "I'll give you a number and you tell me what you think."

Jimmy "The Greek" Snyder *by LeRoy Neiman. Pastel, Marker, and Felt Pen on Paper, 1970.* Author's Collection

Betting all the time, on everything. Between properties, he'd place odds on where and when a fly buzzing about the limo would land.

He'd say, "Where's that fly going to land?"

I'd say, "What do you mean?"

"Front seat? Will he land on the chauffeur's shoulder? These guys can't fly all the time!"

I'd ask him, "What do you think?"

"I asked you!" he answered. There was never money involved. He'd say, "If somebody else was sitting there, I'd challenge him!"

Jimmy the Greek had a show on TV. He'd come on every Saturday night and give his predictions of the sports scores, who'd be the winners, and so on, and he was often right because he had contacts everywhere. He would talk to the coaches and talk to the stars and talk to anybody, and he could get the odds like I could draw a picture. He picked up who and what the favorites were, and he was good. He was a legend, a big figure in gambling because he was the real deal. He became a television sensa-

tion, but then he went too far with a hell-raising racist comment. CBS had to fire him, which essentially destroyed him. Jimmy was a smart guy, very glib (too glib in this case), an attractive personality because he was funny and he never gave a damn about shooting off his mouth. He'd say in a big gruff voice, "I'm an oddsmaker." The Greek! When Jimmy the Greek died, his wife called me and said he died of a broken heart, said they'd broken him. He was a sentimental guy, and that's the way he was with me. I placed my first Ali bet with Jimmy in '71—$1,000 to lay against Frazier. After Ali lost, Jimmy returned the cash, saying he'd forgotten to bet it. That was The Greek.

The high-stakes card players at Binion's Horseshoe World Series of Poker were another attraction. When Benny Binion would invite me to come by, he'd say, "And, LeRoy, feel free to take out your box of paints, cause you never know what kinda colorful characters will show up." With the likes of guys known at the tables as Pug, Tex, and Amarillo Slim, he wasn't kidding. These were poker pros—their eyes were steady and expressionless as they cast chilling glances across the table. The crowd would be spellbound as they sized up the pot and cast a cool gaze on their hands. I watched as their deceptive eye movements flickered and their body language shifted throughout the ritual of card shuffling, bet-placing, chip-stacking—players and onlookers stony-faced, the silence profound.

The pros play poker day and night. They take a nap, get laid, get paid, and get back to the tables. They're poker junkies—doesn't matter how old or young they are, they'll play all night. The women players are the same way—unsparing and canny. They'll do anything to win and don't mind losing, because they know they'll win it back tomorrow.

Those who live by the luck of the draw exist on a magical number-infested plane that can seriously skew their behavior. Imagine this scenario witnessed with my own eyes: A white stretch limo cruises the strip heading for dinner at Caesars Palace Court. Taking up the interior on this balmy summer evening are casino impresario Gene Kilroy, "Fast Freddy," two vivacious airline hostesses, and me. Freddy is superstitious as hell. He's pried himself from the poker tables to experience the good life as lived by other mortals—distractions like food, fun, and sex. We're collecting his date on the way.

The limo pulls up to a modest bungalow. Freddy leaps out and up the walk. (Young inveterate gamblers are always fit.) The front door swings open to reveal a knockout blond, more than equipped for the night's agenda. Freddy takes the ingénue's hand and gives her a twirl. He's Fred Astaire to her Ginger Rogers. But, wait a minute . . . What's happening? Suddenly Freddy's leg jerks spastically, his arms thrash wildly. Is he going down? Nah, not Fast Freddy.

Without missing a beat, he recovers himself and continues promenading his babe down the walk. Then he sees it. The horror. His spit-polished Valentino loafers are smeared with fresh doggy-do.

He turns to Cinderella. "Get back in the house, sweetheart!" he snarls. "You're bad luck!"

With that, Freddy climbs into the limo, slams the door, and orders the driver to pull away, leaving the dolled-up dish at the curb looking totally nonplussed.

Fred Astaire *by LeRoy Neiman. Ink, Acrylic, and Marker on Paper, 1982.* Author's Collection

Before we split Vegas, I want to bring another character back on stage—the joker in the pack—Gene Kilroy, mold-breaker, genuine tough guy, and my good friend. Gene was so good-hearted that he would comp everyone, which meant he was often out of a job until his friend Kirk Kerkorian set him up at another spot in his hotel empire.

When Kilroy was an administrator of sorts at the Ali camp, he had a disagreement with one of Ali's bodyguards—a daunting black dude if you ever saw one. By this time, Gene was bordering on being overweight and a shadow of his glory days, but when Ali suggested they settle the dispute in the camp's training ring with himself acting as ref, Gene didn't hesitate. He got in the ring, and knocked the guy cold.

Another time at a fight at Caesars, Gene and I were heading for our ringside seats when he saw that somebody had taken his place.

"You're sitting in my seat, buddy," he said.

"My seat now," said the doomed bastard. Before he knew what was coming, Gene had picked him up by the tie and slugged him so hard he had to be carried out.

Against this background of card sharks, shysters, heavy hitters, and pleasure-seekers was the Las Vegas femme fatale labor force: comely croupiers, cafe waitresses, car parks, change girls, and the last of the cigarette girls, plus show girls and call girls of all shapes and sizes. These were American beauties groomed to please and tease patrons out of the contents of purse and wallet. Whatever games were being played at the tables, these girls would always beat the odds. Their mantra was, "Wherever there's a winner, there's a gratuity." It was impossible for me to paint a

Caesars Palace Working Girl *by LeRoy Neiman. Enamel and Acrylic on Canvas, 1980.* © LeRoy Neiman

Caesars Palace Working Girl *by LeRoy Neiman. Enamel and Acrylic on Canvas, 1980.* © LeRoy Neiman

Vegas scene without them, often in starring roles, like Baccarat Girl or Change Girl (before they installed thousand-dollar pulls at the slots).

There's no night and no day in the windowless casinos of Las Vegas—it's a nonstop 24/7 glitzy extravaganza. Everything in Vegas is over the top, so naturally you have a parade of larger-than-life performers. Back then stars like Frank Sinatra, Paul Anka, Elvis, Sammy Davis Jr., and Vegas fixture Wayne Newton were always playing in one of the lounges when you wanted some relief from the tables. And none was more outrageous than the flamboyant, jewel-encrusted Liberace. Because I was on the visitors list at the Hilton, I'd occasionally get a call from him when I was in town. "Well, hello LeRoy," he'd say in that campy smiley voice of his. "This is Lee!" As if it could be anyone else. "Are you coming to the show tonight?" His act was always a schmaltzy spectacle with candelabras and rhinestones. He was all honey onstage, but backstage he was not to be toyed with.

One night at the Hilton, after presenting at a beauty pageant, I was hanging around with fellow presenters Barron Hilton, George Hamilton, and assorted pag-

Elvis by LeRoy Neiman. Enamel and Acrylic on Board, 1976.
© LeRoy Neiman

eant personnel when a producer crashed the group. "Wait 'til you hear this one!" he barked. "Seems a sequined automobile has just been delivered to the Liberace set. Seems the gold convertible isn't making enough of an impact! Goldie was already a pain in the ass, now this?" Obviously Barron had been in this movie before. "Oh, God," he said, shaking his head, "just tell him enough is enough," and turned back to our group.

As if on cue, in floated Liberace, all cheery salutations. Seizing his opportunity, the producer shouted in Liberace's direction for all to hear, "It's about the cars! Sequins or gold? One of 'em's gotta go!"

Liberace looked at him, unruffled. Then, oozing his saccharine smile, he replied thoughtfully, "I . . . think . . . not. And I'll tell you why, honey. One gold

Valentine's Day card from Liberace, 1982. Author's Collection

Cadillac is sen-sation-al, two gold Cadillacs are fab-u-lous. They will stay part of the show or I go, go, go."

The backstage bustle fell silent. Not a peep or a protest was heard among the assembled group. Liberace swept away from the red-faced producer to face our group, shook hands all around, and made his exit. Another bravura Liberace performance.

~

Did I say imitation is the sincerest form of flattery? Not when it takes the form of grand larceny. This world of professional poseurs and prima donnas begs time for one more species. You've heard of knock-off Rolexes and Gucci bags? By now there was a flourishing trade in faux LeRoy Neimans. Fame and fortune in the perspiring arts of professional sports had helped create a sorry breed—sports artists whose look, style, and color were all too reminiscent of yours truly.

Some said they studied with me, others said that we had the same teacher, and some jokers half my age even claimed they'd taught me. Aided and abetted by the booming print market, they mimicked me in all formats. A technically advanced copycat in Germany aped my work by juggling colors on a computer. One charac-ter actually happened to have the same last name as me and did a damn good job, putting out his fakes in a brochure that shouted, "Prints by Neiman."

But my favorite has to be the impersonator at the '94 PGA tournament. He toted in a dozen copies of my latest book, *Big Time Golf,* and positioned himself outside the clubhouse with a Neiman-style moustache. He then cajoled players on their way to and from the driving range into signing their featured page. Luckily, several pro tour friends recognized the false moustache and let him know they were on to the hoax.

Mickey Mantle told me about the time he came upon several Neimans hang-ing in a Dallas restaurant and, surprised at the poor workmanship, said to himself, "Wow, LeRoy seems to be in one hell of a slump." Upon closer inspection, he real-ized he'd been bamboozled. "I'll tell you something though, LeRoy," he said. "Your imitators may strike out trying to steal your style, but they've got the LeRoy Nei-man signature down damn good."

One thing I never did was take a break—but I did take the occasional sabbati-cal. That's what landed me at Atelier Weber in Zurich. I'd been fascinated by etch-ing since my student days. Now I took a leave from New York and threw myself into it, toiling into the night on aquatints, mezzotints, and sugarlifts, working on

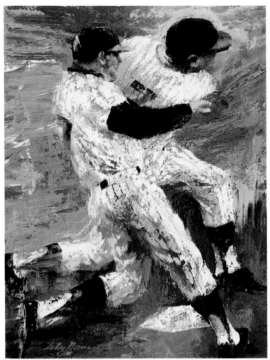

Mickey Mantle Switcher *by LeRoy Neiman. Enamel and Acrylic on Board, undated.* © LeRoy Neiman

spit biting, hand wiping, burnishing plates, and other methodical and obscure processes. It didn't hurt that the studio had offered up a leggy Fräulein as a shop assistant.

During my stay in Zurich, I also delved into lithographs. Jean Schneider, publisher of L'Orangerie Prints, set me up at the Dolder Grand Hotel, with its posh Swiss civilities, including such exotic facilities as a curling court. From there, Jean and I would motor every day to the Mathieu Print Shop in Dielsdorf, where I'd work on stones, which were resolutely lugged about the studio by a limping, Quasimodo-type dwarf. In the room next door was Paul Wunderlich, a graphic artist and master of color lithography from Hamburg. You knew he was there when you saw the Rolls-Royce parked outside and the German police dog standing sentry at the door.

Back in New York, I concentrated on making lithos at Jacques Mulot's West Village studio, the way I'd done in his father's atelier in Paris. I installed an etching press in my studio, and in the course of a few years produced a number of eaux-forte editions. Eventually I moved on to other things, had the press carted out, cleaned up the blackened walls, and hung two sixteenth-century Belgian tapestries in what is now my study. I chalked it all up to expanding my frame of reference.

Next I tried my hand at sculpting and modeling in clay. I cast a half-dozen table pieces—a panther, horses, jockeys, a Harlequin—but it wasn't for me. What stuck was a loyalty to printmaking and multiples.

In '97 I realized my dream of promoting the art of printmaking by creating and funding the LeRoy Neiman Center for Print Studies at Columbia University, where the technique now flourishes in a state-of-the-art environment blessed by academia, offering fellowships to students in the MFA program.

Does the artist ever reach full growth? And if that's possible, does maturity represent the highest point in his or her career? Can it stand up to the freshness

of youth? One afternoon, after a long *déjeuner* in Paris with Nicolas Hélion, who had arranged a private exhibition of my prints in Paris, I met his father, the artist Jean Hélion, at his studio. Post World War II, Hélion père had abruptly switched from abstract painting to representational, so I was interested in exchanging notes. I especially liked the color in his scenes of metro stations and pissoirs, men reading newspapers at sidewalk cafes, and shop window mannequins.

Hélion's studio overlooked the rooftops of Paris near the Luxembourg Gardens. It was brimming with cheerful clutter: a painter's odd assortment of props—umbrellas, ladies' chapeaux, walking sticks, swords, boots, capes, globes, chalices, stuffed parrots, wax fruit, and cavalry helmets. I was in my element—the eclectic chaos of the artist-in-progress. That dusty display of studio bric-a-brac—the still-life elements of Hélion's paintings—spoke, like the rings of a tree, of the generations of change he had spanned.

It was time to mull over the latitude and longitude of my own life. I'd done a good job of revising my age by six years (as documented in public records), but in reality I was a young fifty-something. I had grown up in my work, come of age within it. I'd come to terms with my limitations. My curiosity was seasoned, but not enough to justify acting my age. I still found bowing to convention exceedingly difficult, but I had enough years behind me to appreciate the difference between the life of a starving artist and a thriving one. My art and my career showed no signs of waning. In response to these epiphanies, I shifted into high gear. Maybe it was no coincidence then, that at the end of the '70s, several events presented themselves that made it clear the life I'd actively chosen had also chosen me.

The first was a commission on location in my front yard, Central Park, near one of my favorite restaurants, Tavern on the Green (before it met its demise in a tangle of city bureaucracy). Every November, this familiar spot transforms itself into the finish line for an affair as indigenous to autumn in Manhattan as the falling leaves—the New York City Marathon. It's a perfect intersection of athletic prowess, professional and amateur participation, and an international crowd, all brought to you by the great city of New York.

In '79 its zealous creator, the late Fred Lebow, asked me to paint the marathon's poster. I had a front-row seat at the finish line with assorted New York bigwigs, including Mayor Koch. While Hizzoner might be caught grabbing shut-eye by the fifth inning at Shea or Yankee Stadiums, the adrenaline excitement of the marathon always held his attention.

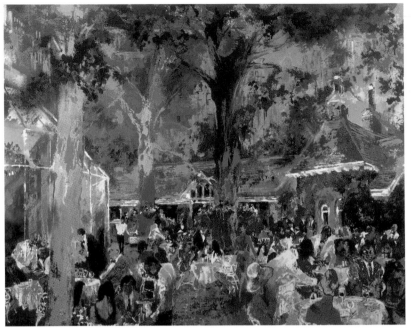

Working on the Tavern on the Green *painting in his studio, 1990.* Author's Collection / Photo by Lynn Quayle

Tavern on the Green *by LeRoy Neiman. Enamel and Acrylic on Board, 1990.* © LeRoy Neiman

New York City Marathon *by LeRoy Neiman. Enamel and Acrylic on Board, 1979.* © LeRoy Neiman

After finishing the painting, I rang Fred up at his office across town and told him he could come by and take a peek. "Can't wait, LeRoy, I'll run right over." When Fred said he was running over, he meant it. Twenty minutes later he was at the door, dripping with sweat in his jogging duds, ready for the viewing.

My next assignment came through my old pal Muhammad Ali. He had been invited to present one of his drawings to UN Secretary General Kurt Waldheim, and Ali asked me to tag along to the press event as his artistic ambassador of sorts. So on January 29, 1979, I found myself being ushered into a semiprivate ceremony at the United Nations.

I felt uneasy around the secretary general. I sketched him throughout the event, studying his sharp features and the arrogant way he carried himself, unable to shake the image of a Nazi storm trooper officer. We'd been in the same war.

That dip into diplomacy was a prelude to event number three, when on a March afternoon on the White House lawn, I would witness the signing of the historic Camp David Accords. I'd been commissioned to paint the three dignitaries involved—President Jimmy Carter, President Anwar al-Sadat of Egypt, and Prime Minister Menachem Begin of Israel.

The day had gone from overcast to optimistic sun. As Carter, Sadat, and Begin made their way to the podium, I got to work. I had just found my drawing momentum when a horde of press photographers and cameramen trampled over me, collapsing and scattering the first row of folding chairs where I was seated and obliterating my view. They were closely followed by a herd of security police fanning out to restore order.

I was considering my next move, when I spotted the First Mom, Lillian Carter, beckoning to me. "Sit here, LeRoy, we'll share," she said, moving to one side of her chair and patting the half-seat she had vacated. Was there a protocol for this kind of offer? As I was pondering the dilemma, the gentleman next to her offered me half of his seat as well. It was Moshe Dayan.

Here were two eminently sketchable subjects flanking me, the white-haired Miss Lillian and the eye-patched Dayan. Thanks to them I got everything I needed for my painting of the signing—and later, a silk screen edition of the work. One hangs in the Carter Presidential Center in Georgia. Two others were hand-delivered on a goodwill trip to Jerusalem and Cairo by Miss Lillian, who presented them to the signatories and reported back to me on how they were received. Sadat said he'd hang it behind his desk. Begin accepted without comment.

White House Signing of the Egyptian-Israeli Peace Treaty *by LeRoy Neiman. Enamel and Acrylic on Board, 1979.* © LeRoy Neiman

With President Carter in the White House, 1980. Courtesy of the Jimmy Carter Library

Subsequently I was invited to a jazz concert at the White House featuring some all-star greats. Before the music started, I'd noticed the ailing Charles Mingus among the crowd. He was known to be a tough and ornery bastard, but he was now too frail to perform. He came over and I grabbed a quick sketch. While we were swapping anecdotes, I became aware that the commander in chief was hovering at my side, watching the progress of the Mingus drawing.

Seizing the opportunity, I turned to sketch Carter, but soon discovered that he was no easy subject. What was it? Not so much his physical characteristics, but something in his demeanor. Then it dawned on me. Unlike the heavy hitters I was used to sketching, the president appeared to have no vanity. I wasn't sure I'd captured him, but handed him the finished work anyway, curious as to how he would respond. Carter examined it and leaned over to me. "I tell you what it needs, LeRoy," he said advisedly. He took the pencil from my hand and drew a straight line from chin to throat. "You gotta get that sag," he said, returning the pencil. I softened the line. It was Jimmy.

I've left my best Miss Lillian tale for last. It took place at a New York fund-raiser luncheon for Walter Mondale, Carter's running mate in his reelection campaign against Reagan. Andy Warhol and I bumped into each other there—Andy snapping, me sketching—and had our customary exchange that included the state of our mothers, the latest developments on the daytime soap, *As the World Turns,* and Andy's wry sizing-up of the gathering.

Charles Mingus *by LeRoy Neiman. Black and Brown Marker on Paper, 1971.* Author's Collection

When we'd had enough of the rubber chicken crowd, it was time to exit under the radar. Andy and I had managed to navigate our way to the elevators without anyone noticing our getaway when we bumped into Miss Lillian. Turned out she had stolen her way to the elevator with the same idea, and, partners-in-crime, we piled in together. As the elevator descended, Lillian asked brightly, "Now where are you boys heading?" After telling her our respective destinations, she said, "Well now, if you don't mind dropping me at my hotel first, I'd be happy to avail my car to you." How could we refuse? Our curious trio piled into her waiting sedan.

Driving with Miss Lillian was not unlike traveling in public with Muhammad Ali. At stoplights, passers-by came up to the car and offered eager greetings. She'd

return their hellos and good wishes, sometimes waving like the Queen Mother, all the while carrying on with us. When our wheels pulled up to the Sheraton, she said, "Now might I interest the both of you in a nip before you're on your way?" By now we were her captive audience. Guarded by two Secret Service hulks, we took the elevator up to her floor, and she led us to her room.

It was a modest single room, dominated by a king-size bed. "I'm not going to tell my son about these accommodations," she said, as she called room service, then propped herself on the bed like a perfect Southern hostess. What a dame. We pulled up chairs on either side of her. While I sketched, she offered up some ripe jokes, and Andy, always hustling, went off on a tangent about me doing a series for his magazine, *Interview.*

You could say that afternoon epitomized the crazy quilt of my life and my art. From a World War II bunker I'd sketched army buddies' likenesses to send back home. Now I was in a Manhattan hotel room sketching the country's first mom. In between I'd collected artists, athletes, politicians, gangsters, operators, playboys, and gorgeous femmes.

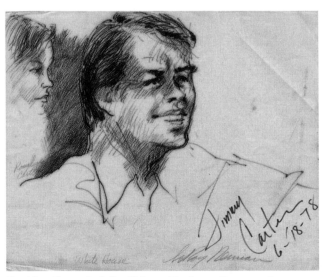

President Carter *by LeRoy Neiman. Marker on Paper, 1978.*
Author's Collection

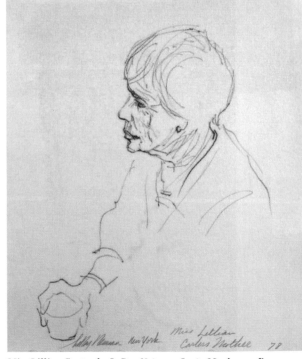

Miss Lillian Carter *by LeRoy Neiman. Sepia Marker on Paper,*
1978. Author's Collection

Presidents, Moguls, and Masters of the Game

Venice, May 14, 1998. I'm idly observing the passing parade in the Piazza San Marco from my favorite vantage point at the Florian, about to tuck into a final breakfast before heading back to New York. The Gritti Hotel has run out of the *International Herald Tribune* and in desperation I've decided to tackle the news in Italiano from a *Corriere della Sera* I picked up at a newsstand. As I unfold the paper, a heart-stopping headline reveals itself in 48-point bold type. E' MORTO FRANK SINATRA—UNA VOCE UNA LEGGENDA is not lost in translation. Forget breakfast. I down my espresso and am soon bouncing across choppy lagoon waters to Aeroporto Marco Polo with no other thoughts but getting back home. When I arrive at my studio in the early afternoon, a message is waiting for me from Frank's wife, Barbara. Hours later I am again racing to an airport. This time it's JFK for the last flight to the West Coast to say good-bye to Ol' Blue Eyes.

The funeral of Francis Albert Sinatra was stunningly simple and immaculately white—white pillars wrapped in garlands of white roses lining each side of the center aisle, sunlight filtering into the white chapel filled with thirty thousand white roses,

At Wingmead in Arkansas, 1983. Author's Collection/Photo by Lynn Quayle

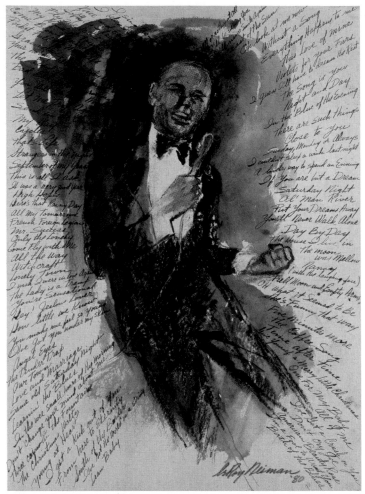

Frank Sinatra *by LeRoy Neiman. Watercolor, Pastel, and Colored Pencil on Paper, 1980.* © LeRoy Neiman

gardenias, apple blossoms, and chrysanthemums. It was so blindingly white, it was as if we were already in heaven.

Frank's pals were seated about the chapel, quietly reminiscing, rehashing all the wild tales that had become so legendary that even he believed them. Frank was no saint. He lived his wicked ways to the fullest and nobody was going to take that away from him. Among the solemnity, there were flashes of the old Sinatra wit. The comedian Tom Dreesen, who often opened for Sinatra, said that if Frank had been there, "He would have wanted it to last ten minutes, and then, 'Let's get outta here.'" Kirk Douglas said that once Sinatra got there, heaven would never be the same again. Frank Jr. was pretty direct about his father's temper. "Dad did have a short fuse," he said, provoking a ripple of suppressed laughter. The casket began its slow journey past the mourners, when suddenly we heard Frank's voice singing, "Put Your Dreams Away." People were stunned—it was as if he'd sat up in his coffin to sing us good-bye. Don Rickles was so overcome he threw himself onto the flower-covered casket and was dragged with it up the aisle, weeping uncontrollably.

Outside the church, a crowd of more than a thousand silent onlookers lined the streets. When the cortege pulled away, one of them called out, "Ciao, Francis!" as Sinatra's voice still streamed from the empty chapel. Into his coffin they'd put some familiar Sinatra objects: a bottle of Jack Daniels, a Zippo lighter, a pack of Camel

cigarettes, and ten dimes—as his daughter Tina said, "He never wanted to get caught not able to make a phone call."

That night over dinner at Spago's, as I traded stories with Sinatra crony Joe DeCarlo, I thought of all the times I'd drawn Frank—at nightclubs, on movie sets, on stage, posing for CD covers. I've caught him in action and slow-motion at boozy dinners, and throwing back a few too many at his favorite watering holes—Annabel's in London, Caesars in Las Vegas, or Patsy's and Rao's in New York.

Frank Sinatra Angry by LeRoy Neiman. Pencil on Paper, 1975.
© LeRoy Neiman

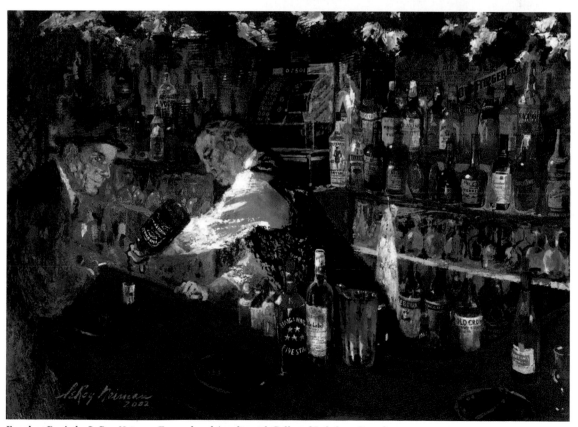

Frank at Rao's by LeRoy Neiman. Enamel and Acrylic with Collaged Labels on Board, 2001. Author's Collection

In '67 I was hired to sketch Frank on location filming *Tony Rome* in Miami. Those of us in his entourage stayed at the Fontainebleau, where Sinatra did two shows nightly following a full day on the set. We'd then carry on into the night until we closed the joint. The Fontainebleau—with its pure unabashed American glitz just this side of kitsch and its torch-song staircase going nowhere—was Frank's kind of place. One night after a show, I was sitting with Frank, his two bodyguards, and the ever-present duo, Jilly Rizzo and Mike Romanoff, when I realized I'd left my sketchbook behind. When that happens, I'll draw on anything I get my hands on—menus, napkins, tablecloths—so I grabbed the closest thing at hand, some sheet music from a band member.

As I was sketching, Frank glanced my way. "LeRoy, what the hell you doin'?" He snatched the sheets away from me and bolted out of the restaurant. When he came back a few minutes later, he handed me some of his own sheet music. "If you're going to draw on that stuff," he said, "you might as well do it on the real thing!" and tossed his hand-marked arrangements across the table. For the rest of the evening, I pretty much faked working on those precious sheets, later stashing them away for a keepsake. Who knows where they're at now?

Drawing on the set of Tony Rome *in 1967.*
Photo by Bill Sanders/© The Miami Herald. [1967]

One night at Jilly's, another Miami hangout, I sketched Sinatra flanked by actor Richard Conte, underworld don Joe Fischetti, erect and formidable, and an assortment of nubile courtesans—in other words, a big box of blonde bonbons. These women were gorgeous—and patient. They'd hang out at the bar while Frank drank until around two or three in the morning, when he was finally ready to turn in.

Next evening we collected in an alley where a segment of *Tony Rome* was being shot. Late into the night during a break, as I was leaning under the sallow light of a lamppost, a husky voice growled into my ear. "Joe Fish wants da drawin' ya did las'

night." I turned to greet two of Sinatra's body-guards, one breathing over me on my right, his partner towering menacingly on my left. These were real players who didn't need any motivation in this Hollywood-fabricated alley, and I'd been involuntarily cast in a part of my potential undoing.

I didn't take threats from guys like this lightly, but it irked me to turn over a drawing as good as this one without a peep. I looked over at Fish—expressionless—no clues there. Ah, Frank'll know how to get me out of this pickle.

"Hey Frank," I said, "these guys are putting the arm on me for the drawing I did at Jilly's last night."

Frank turned to look at me, then thoughtfully peered down the alley.

"LeRoy," he said with a shrug. "You better let the gentlemen have it."

But the whole affair stuck in my craw. Later, back at the Fontainebleau, I made a quick copy of the drawing and sent it to Fischetti's suite. Next morning I spotted Joe at the breakfast buf-

Joe Fish *by LeRoy Neiman. Pencil on Paper, 1967.*
Author's Collection

fet. He came straight over to me, eyes moist with gratitude, and thanked me pro-fusely. Those types always seem to choke up when you submit to their threats.

Sinatra wasn't above swiping my art either, like the night years later at New York's Jimmy Weston's. I had drawn Sinatra performing many times, but one day we were sitting around a bar, he had a hat on, he was half in the bag, and I drew him just like that. He loved that portrait. I made a monoprint of it as Frank in *The Detective,* and it now was hanging near the entrance to the restaurant. It was long after midnight—we'd closed the joint as usual—and as Frank headed out the door, he lifted the framed print from the wall and tucked it under his arm.

I watched him take off down 52nd Street with that Sinatra swagger, the limo, as always, purring alongside him, ready to pick him up on command. Frank was always in his own movie—that's what made him such a great actor—the cameras were always rolling.

Frank as Tony Rome *by LeRoy Neiman. Charcoal on Paper, 1967.* © LeRoy Neiman

Sinatra as The Detective *by LeRoy Neiman. Black Ink on Paper, 1968.* Author's Collection

Whether he was performing or holding court at table, Sinatra was the main man. He dazzled crowds wherever he went, throwing out flip one-liners and witty comebacks that could easily turn ugly as they mutated into stinging barbs when the alcohol flowed. At the Fontainebleau, he'd hold forth at La Ronde into the early hours in diminishing degrees of sobriety, hangers-on at the bar straining to catch his every word as they nursed warm drinks. When "the Pope," as they called him, needed to relieve himself, he required privacy. So when a trip to the john was in the offing, Frank's bodyguards would precede him and clear out the men's room so he could take a solo piss.

He had a big heart, but he could be cruel. He was unforgiving, yet he was a sweetheart. He wasn't going to live up to anybody's expectations—even his own. It's no secret that Sinatra could sometimes be ruthless, even to those close to him. He might empty his pockets for some random charity that pulled at his heartstrings, or brutally cut off an old buddy for some infraction significant

only to him. "My father's whole life was an anomaly," Frank Jr. said in his eulogy. "His birth was so difficult that the fact that he lived at all was an anomaly. That he even became a singer, that he became a great singer and that he made such wonderful movies, all this was an anomaly. . . . And how did he live to such a ripe old age, which was certainly not because he took care of himself? That's the greatest anomaly."

When Sinatra was romancing actress Lois Nettleton, famous for her Blanche DuBois in *A Streetcar Named Desire* on Broadway, he gave her one of his highly desirable clown paintings. A couple of months later, he presented himself at her front door after a night on the town and invited himself in. Lois said she had an early set call and needed her beauty rest. The rebuffed Frank behaved like a gentleman, but the next day, his secretary, Dorothy, showed up asking for the clown painting. Frank needed it, she said, to give to an orphanage charity auction. No nookie, no clown. Lois gave him back the picture, and Frank assured her he'd send another, but when it arrived it wasn't a clown, it wasn't a painting by him, it wasn't even a painting—it was a plate, albeit a LeRoy Neiman Royal Doulton Harlequin collectable. Lois was a good sport—she told me that she was just as happy to get something she liked, and done by a friend to boot.

Maybe Frank wasn't always chivalrous or the most unfailing friend, but he had a big romantic streak—how else could he have sung those torch songs as if the melancholy words just came into his regretful mind like an old flame walking into a bar? More often than not, dreamy thoughts would drift through his head after a night of partying. It was near dawn on one such occasion, and we were reeling up Sixth Avenue, all a little hazy and light-headed after an all-night drinking bout at Toots Shor's. Frank suddenly stopped in his tracks, his straggling entourage bumping into one another in a sorry, confused heap. Frank

Harlequin Plate *by LeRoy Neiman, 1974.* Author's Collection

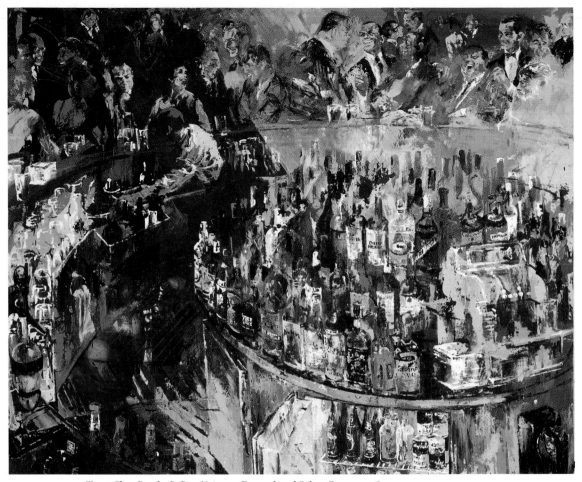

Toots Shor Bar *by LeRoy Neiman. Enamel and Oil on Canvas, 1969.* © LeRoy Neiman

had seen something in the night sky. Pointing above the shadowy midtown skyscrapers to the full moon lighting a blue velvet sky, he declared, "You know, LeRoy, that would make a fine painting of Manhattan!" It was the kind of moon that gets itself into love songs, especially the kind Frank sang. Had that moon also tugged at memories of the Manhattan skyline as seen by the kid in Hoboken?

Frank painted, and not only clowns. He actually did some interesting landscape paintings. They were of a patch of the desert you could see from his painting studio in Palm Springs. He'd put one color across the bottom, then another color across the middle, and then a third color on top. If you looked at them with an

open mind, they could remind you of Mark Rothko's mystic smoldering bands of color. Frank asked me if I could arrange for silk screens to be produced of one of these horizontal stripe desert paintings so he could give it to friends. When Frank made a request, you didn't refuse—in this case I was happy to contact my printer. The lush desert piece became three hundred pricey but NFS (not for sale) silk screens, signed by Sinatra. You had to be one of Frank's three hundred closest friends to get one, and, believe me, there were many more than three hundred people who held that they were Frank's best buddy.

Since you never quite knew where you stood with Frank, the stray compliment was always welcome. I got Sinatra-style kudos one night at '21' as a group of us wound down from dinner. Loitering at the table, the wife of a well-known record producer got it into her head that she was going to delve into Frank's motivation. "Tell me now, Mr. Sinatra," she said, leaning in to give the full benefit of her décolletage, "what moves you when you sing a love song?" No comment.

Toots Shor as the Babe *by LeRoy Neiman. Marker on Paper, 1976.* © LeRoy Neiman

"C'mon, Mr. Sinatra," she persisted, "what do you see or feel when you sing those songs?" Frank continued to contemplate his Jack Daniels. "Colors, Mr. Sinatra! Is it colors you see?" At that Frank looked up from his tumbler.

"You want to know what I see, doll? I'll tell you what I see!" Everyone held their breath—the woman was about to get her answer. Sinatra speaks! "When I sing a love song, honey," he said, casting a sly wink in my direction, "I see the colors of a LeRoy Neiman!"

It's two in the morning and I'm awakened by the phone. Sinatra calling. From the noise in the background—the clamor, the guffaws, the big band soundtrack—I'm clued into the fact that hard drinking is going on. "LeRoy!" The urgency in Frank's voice rouses me from slumber. I know that tone—it's more a command

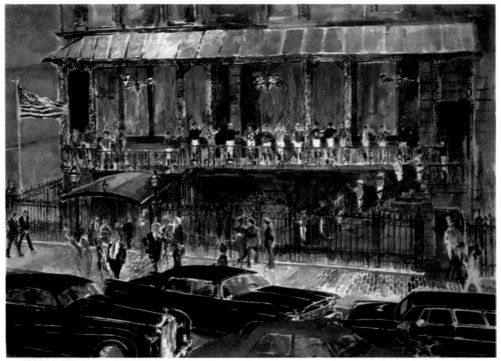

'21' Club Exterior by LeRoy Neiman. Watercolor on Paper, 1989. © LeRoy Neiman

than a salutation. "Leo Durocher has just bought a house near the Sinatra estate," he tells me. These guys have a habit of talking about themselves in the third person. "And, my friend, a housewarming gift is in order." I'm waiting for the punch line. "So me and the boys have been kicking around some ideas," Sinatra tells me, "and we decided it's got to be a portrait—by you. We decided unanimously— gotta be a Neiman." I'm flattered, but considering the nature of the beast on the receiving end of this gift, the feisty baseball immortal, I have to ask: "What kind of painting you thinking about, Frank? Durocher as a Cub?" Long silence—the background noise fills the void, then Frank answers, "Hey! You're the artist, LeRoy. Do it your way!"

No talk of money, of course, but Frank was always a generous patron of the arts. I finish the painting in two weeks—Durocher in one of his classic performances, hollering at an ump before getting the thumb. ("I never questioned the integrity of an umpire," he once said. "Their eyesight, yes.") He said a bunch of other funny things too, like: "Baseball is like church. Many attend, few under-

stand." And "Show me a good loser and I'll show you an idiot." His immortalized adage was "Nice guys finish last." And one of my favorites: "God watches over drunks and third basemen."

Anyway, I sent the painting express to Palm Springs. The night *Leo and the Ump* arrived, I get another call, same hour, same background din. Frank on the horn. "LeRoy, hold on, I'm going to put you on with 'The Lip'!" The next voice I hear is the sobbing Durocher. "I can't tell you what this means to me, LeRoy!" Durocher blubbers, his sentiment no doubt enhanced by prolonged imbibing.

From that night on, Leo and I became friends. He'd often call the studio when he was in New York, and took to referring to me as "my kind of guy." You could say that Durocher was a Sinatra "kind of guy." He was a loud-mouthed player, cantankerous manager, and controversial sports figure—to put it mildly. His palling around with undesirable and underworld characters turned out to be his undoing, well, that is, if getting his mug in a sports museum was his goal (which it probably wasn't). Durocher wasn't admitted in the Baseball Hall of Fame, a distinction he later shared with Pete Rose.

For me that painting was a gift to the St. Paul Saints's rookie with a 250 batting average I'd cheered on as a kid in '27, a guy who'd gone on, with a 250 lifetime average, to become one of baseball's early bigtime celebrities. I wouldn't fully understand Durocher's appreciation of the portrait until years later, when he passed away at eighty-six. At his request his widow, Laraine Day, hung the painting on the wall behind his casket. I'd rather have my painting there than in the Baseball Hall of Fame any day.

You can read about Sinatra's mob connections in any number of books, and that unsavory part of his reputation eventually lead to JFK's cutting ties with him in '62, which didn't sit too well with Frank's

Leo Durocher *by LeRoy Neiman. Enamel and Acrylic on Board, 1973.* © LeRoy Neiman

President's Birthday *by LeRoy Neiman. Enamel and Oil on Board, 1962.*
© LeRoy Neiman

mother, Dolly, a Democratic Party committeewoman. But Sinatra sang for most of the presidents, and one way or another I've painted them all (not always officially) since Eisenhower, my World War II commander-in-chief. But why not start in '62 with the Madison Square Garden commission to paint *The President's Birthday* at the party Peter Lawford put together for his brother-in-law, Jack. In one of the last public appearances before her death from an overdose three months later, Marilyn cooed, "Happy Birthday, Mr. President" in a dress I might as well have painted on her, backed by a full orchestra and flaming birthday cake. I sketched the Hollywood glitterati and D.C. aristocracy—debonair JFK on the dais with Bobby and Ted, Adlai Stevenson, Vice President Johnson, and Lady Bird.

The painting was hung in Suite 200 of the Garden. Years later at a party there, Liz Taylor approached me. "I'd like to have a word with you, Mr. Neiman," she said. I was flattered by her interest, until she led me to the painting and began to scold me. "Okay, Mr. Rembrandt, do you see me in this painting?"

"Uh, no, um . . ." I stammered.

"How the hell could you have missed me? I was wearing a fabulous scarlet off-the-shoulder dress," she said, taking my hand and guiding it across her generous endowments to emphasize her point. My attention now riveted, she directed me to the exact spot in the composition where my brush had disgracefully excluded her.

On the evening of November 22, 1963, I was on my way to attend the lavish

opening of the Continental Hotel on Michigan Avenue in Chicago for the unveiling of *The Lautrec* (a mural I'd painted for the restaurant) when the news of Kennedy's assassination came on the radio. The ceremony was cancelled, and in the period of shock and mourning that followed, the restaurant never opened, the hotel was sold and renamed, and my mural vanished.

In '68, I contributed drawings I'd done of Robert Kennedy on the campaign trail for a fund-raiser in the Garden. After RFK's fatal shooting on June 5 in the galley of the Los Angeles Ambassador Hotel, some of these drawings were shown at New York's Far Gallery on Madison Avenue, along with an etching I'd done incorporating quotes from his writings and speeches. Roone Arledge escorted Ethel Kennedy to the opening, and at dinner that night, we agreed I would do the poster for the first Robert F. Kennedy Pro-Celebrity Tennis Tournament.

That was the beginning of my brief association with the Kennedy family. Over a half-dozen years of contributing to the tournament annually, I was in on a few lively clan gatherings at Ethel's spread in McLeans, Virginia—always a great excuse to party. At New York's Rainbow Room one night, I did a felt-tip-on-napkin sketch of Teddy puffing on a cigar. Soon Ethel started eyeing what I was up to, and a sibling nearly snapped it from me in a tug-of-war, but I prevailed. Some things you just can't part with. I got pretty close to the Kennedys, but I never felt comfortable in that social set. I just felt I didn't belong—and I didn't—nor did I feel the need to. They liked to play lawn games and go out boating with the political aristocracy. I sported around in other venues.

If we can count Aristotle Onassis as extended family, then I sketched another part of the clan. I captured the pre-Jackie Ari at the Carlyle in London, at Regine's in Paris, on the Riviera, and for a *Wall Street Journal* front page portrait. But my favorite Ari moment has to be upstairs at '21'. It was late afternoon and the dining room was empty except for his table, littered with abandoned espressos, snifters, and piled high ashtrays. Onassis was holding court to an entourage of cigar-puffing executives, assorted celebrities, and a corps of '21' waiters (that vanishing breed of loyal lifers) circling the table like Indians on the ridge, waiting to divvy up the tip.

I sketched another power broker, Mae West. We met at some affair and I said to her, "I should draw you."

"Come up and see me sometime . . ." she said, or maybe I imagined it. So I went over to the Sherry Netherland Hotel where she was staying. Two big muscle guys checked me out when I walked into her room. They were fixtures in her suite, her personal bodyguards.

RFK Tournament poster with LeRoy Neiman artwork.
Author's Collection

Bobby Kennedy *by LeRoy Neiman. Sepia and Black Felt Pen on Paper, 1966.* Author's Collection

Ted Kennedy *by LeRoy Neiman. Marker, Pencil, and Colored Felt Pen on Paper, 1982.* Author's Collection

LeRoy's Aristotle Onassis drawing, which ran in the Wall Street Journal *in 1969.* Author's Collection/Wall Street Journal

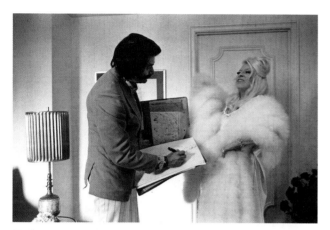

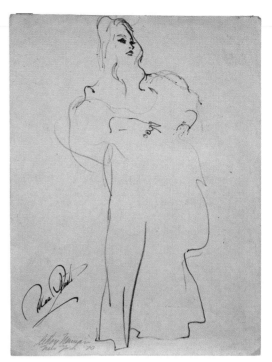

With Mae West in New York City, 1970. Author's Collection

Mae West *by LeRoy Neiman. Felt Pen on Paper, 1970.*
Author's Collection

She was getting on in years. I don't know how old she was, but she had all her original teeth, no glasses, no nothing, a health nut too. She talked tough, but she was a smart woman who wouldn't be trifled with.

I started to draw her and she said, "I don't think this dress is right."

I said, "You're right."

"I'm going to get us something better than this."

She disappeared, then came out in a whole new dress, jewels and all. It was inspiring—she put on a show for me. She could talk a blue streak, talk about herself or anything else. She told me she was pissed off because during the war they named a life jacket "the Mae West," and she said, "If I ever get my hands on that guy . . ." She did not approve! But she was wonderful to draw! She wrote some great movies too. Classics! All those one-liners, boy! "Is that a pistol in your pocket or are you glad to see me?" That was really her!

Back to US presidents. They know their currency goes up when they're seen on the go, and I've been lucky to catch a few of these moving targets. There's LBJ jumping gingerly from a helicopter onto the sheep meadow in Central Park, Bush Sr.'s aristocratic stride, and the pure Texas strut of Dubya. Surprisingly, it was Richard Nixon who I caught stationary. He was sitting at the piano at an embassy party in Moscow on the fourth of July in '86 during Ted Turner's Goodwill Games. Tricky Dick was playing a medley of Twenties songs and singing along to his favorite, "God Bless America," when the American ambassador, Arthur Hartman, coaxed him away for a photo-op with me.

As we stood next to each other, Nixon murmured out of the corner of his mouth, "I don't recall you ever doing anything of me during my presidency, LeRoy."

"But I did," I replied as bulbs flashed. "I recall that I did a drawing of you and Kissinger strolling on the White House lawn deep in conversation."

Nixon looked at me quizzically—I could see he was skeptical about my story.

"You both had your hands in your pockets," I continued, trying to pick out a telling detail. "Bad form, I might add, for world leaders."

At that Dick chuckled. "Boy, you sure got me that time, Neiman!" I was only slightly pulling his leg. Hands-in-pockets used to be an etiquette faux pas in the old days. Nobody cares about this stuff anymore in Washington, where, now, anything goes.

A few years ago I crossed paths with Kissinger at the original Le Cirque. He had caught me doing a surreptitious drawing in my pocket sketchbook—a quickie of him sipping soup with his napkin tucked under his chin like a bib. The drawing fell short, so when he asked to have a look I declined. Instead I told him about the Nixon sketch, hoping to provoke a reaction. At the mention of his old pal, the consummate diplomat shrugged his shoulders and gave me a noncommittal smile.

With Richard M. Nixon at the Goodwill Games reception in Moscow, 1986. Courtesy of the Nixon Presidential Library and Museum

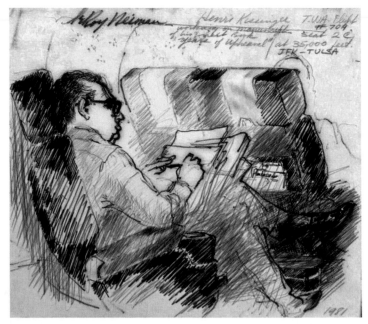

Henry Kissinger *by LeRoy Neiman. Colored Pen and Pencil on Paper, 1981.*
Author's Collection

One serendipitous afternoon in '60 when I was living in Paris, Janet and I stopped by Le Drugstore for one of their hamburgers with an American flag stuck in the bun—as if to say, "Zis is ze Yankee cuisine." We were making our way home down a street off the Champs-Élysées near the Arc de Triomphe when a small black motorcade came by flanked by a mounted Garde Nationale. It came to a halt in front of us. There, right there before our eyes, standing erect in an open Citroën like he had an umbrella up his back, was the president of the republic, General Charles de Gaulle. I reached for my sketchpad, oblivious to the fact that I risked being wrestled to the ground by gendarmes and thrown into the Bastille for possibly concealing a lethal weapon.

On another afternoon in Rome, I didn't get such a reprieve. As I was gazing down at the Spanish Steps from the grand stairway of the Hotel Hassler, another impressive motorcade pulled up. I watched as the door of a black Mercedes opened and out of it emerged the portly German chancellor, Helmut Kohl, as the car readjusted its weight.

"C'mon, Lynn," I said to my trusty sidekick, Lynn Quayle. "This is some catch."

I rushed down to the lobby, Lynn hot on my heels, squeezed my way into the midst of a surly security detail, and began sketching. Suddenly my concentration was blown by a menacing voice. "One step closer, and I'm going to have to remove you!"

I looked up to face my challenger, but the fearless Lynn, all five feet one inch of her, had already squared off against a massively threatening Prussian. I never knew when Lynn's ferocity might be aroused, so I was relieved to hear her reply in her Shirley Temple voice, "What are you picking on a little thing like me for?"

Stunned, the lug backed off. I put my pens away, and we retreated to the Hassler bar. I always knew I had a formidable companion when traveling with Lynn—she's

smart, sophisticated, quick-witted, resourceful, and when challenged . . . watch out! I often saw the Viking in that little frame, and I hear her father's people came from the Isle of Man.

In 2001 I had the rare opportunity to sketch Fidel Castro, up close in Havana, during a meeting set up by a consortium of Washington politicos. They'd invited me to join them on a mission to promote US business and tourism in Cuba, but I would have taken any excuse to gain access to this infamous enigma.

The prospect began sketchily at best, at a state dinner with all the trimmings—except El Presidente. When one of the American officials told me that it was looking doubtful I'd be able to draw Castro, I decided to avoid the middleman, as usual, and proceeded to wheedle an official-looking Cuban about doing a portrait.

"One has yet to be done of him," he told me, to my surprise. "Our President would be very pleased if you drew him."

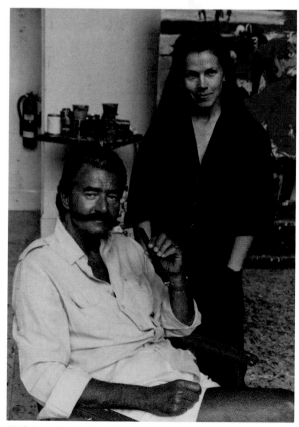

Next thing I knew, a driver was shuttling me solo to the home of some veteran in Fidel's posse. When I arrived, the guy got up from his dinner table to welcome me while my driver waited outside. He studied my papers.

"Why do you want to draw Fidel Castro?"

Wasn't it obvious from my documents? I'd have to wing it.

"Well, first off," I said, "he's one of the world's best-looking dictators."

He considered the guileless response. "Okay. Then you go see Fidel."

But when? The last day of our visit, our group was told to remain on call. Finally, after holding vigil in the hotel bar for hours, we were herded into two small vans. The exhaust-popping vehicles circled the same monument three times, and we were convinced we were on a wild goose chase, when at last the vans pulled up to the Presidential Palace. We were led into a narrow windowless room, relieved of all personal artifacts

With Lynn Quayle in 1987. Author's Collection / Photo © Arlene Schulman

(except my sketchbook), and arranged in a semicircle. Is this when the firing squad shows up? Finally Castro entered. After handshakes all around, we proceeded into an adjoining conference room with a long table—Cubans on one side, Americans on the other.

I wasted no time getting started, and over the three-hour meeting that lingered long past midnight, I developed nine charcoal renderings of the famous face and profile. Handsome, aging with grace, an aristocratic Spanish demeanor and playfulness dominated Castro's look—a striking combination of Don Quixote and Salvador Dalí. Reviewing my renderings at the evening's conclusion, he asked if he could have one.

"At your selection," I replied.

He chose one and asked me to sign it.

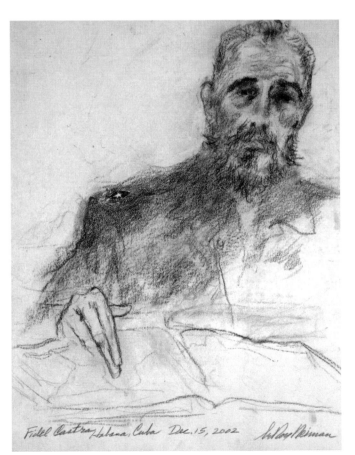

Fidel Castro *by LeRoy Neiman. Colored Pencil and Charcoal on Paper,* *2002.* Author's Collection

"Only if you sign one for me," I said.

I don't know if anything else came out of the meeting, but we were all given a box of Cohibas along with flowers for the women. And when Lynn piped up that the day's experience had aged her by a year—revealing it was her birthday—she walked away with two bouquets.

It's January 20, 1981, Inaugural Ball #40. And Hollywood-groomed Ronald Reagan is playing himself as President Ronald Reagan—an uncanny performance. I'm standing on a platform set up dead center in the Kennedy Center ballroom to do studies for a commemorative serigraph edition. A full complement of Reagan courtiers surrounds me—diplomats, Republican stalwarts, medal-encrusted members of the military, financial kingpins, and Hollywood nabobs—networking and nodding to the rhythms of

Count Basie's band. To my left is a heroic crystal-lographic head of JFK by Robert Berks. Below me, GOP Ronnie sweeps by with Nancy on the dance floor in their fairy-tale performance.

I climbed down from my perch to find Armand Hammer gesturing me over to meet retired General Omar Bradley. After being introduced, I told him, "We met many years ago, sir."

Bradley's jeep had bounced up to my field kitchen on a muddy road in Normandy in '44. He was well liked among the enlisted men, so I was honored to serve him a hot cup of java. Now, stand-ing before the wheelchair-bound general, as the inaugural ball swirled incongruously past us, that memory came vividly back to mind. Bradley sized me up as if recalling the moment himself, and said, diplomatically, "Oh, yes, of course, I remember the incident!"

He then snappily returned my salute and invited me to stop by his digs one day to trade war stories. He died less than three months later.

Full circle from the inaugural, I attended Rea-gan's final cabinet meeting, where I presented him with a serigraph of *The Minuteman,* commissioned to honor the heroism of Revolutionary War citizen volunteers. It had been only eight years since I'd seen him twirling Nancy around the Kennedy Cen-ter, but now the departing president looked some-what world weary as he sat erect in the Oval Office. His crisp white shirt and sizable cuff links became part of a ritual that day, as with each question, the Great Communicator would reach up to readjust his hearing aid, then straighten his arm and pull down his cuff again, reposition himself in the chair, and deliver his folksy response. Watching him handle his handicap with such aplomb made me realize it

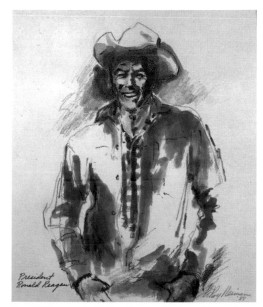

Ronald Reagan *by LeRoy Neiman. Watercolor and Colored Pencil on Paper, 1988.* © LeRoy Neiman

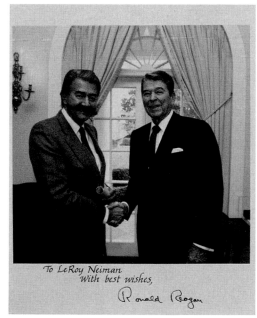

With President Reagan at the White House, 1988.
Courtesy of the Ronald Reagan Presidential Library

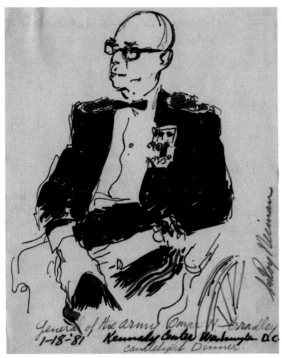

General Omar Bradley *by LeRoy Neiman. Marker on Paper,*
1981. Author's Collection

was time for me to own up to my own chronic hearing problem and get a hearing aid.

I was the last in the group to be introduced and photographed that day, shaking the lame duck president's hand, while outside in the hall, president-elect George Bush was pumping his own self-congratulatory handshakes. After presenting Reagan with the poster, I opened my sketchbook and chose the best out of a half-dozen studies I'd done that morning—one with Reagan in a Stetson hat that I'd impulsively added to the drawing. Handing it over I said, "I'm sorry I didn't have room for the horse, Mr. President."

Reagan lit up. In his velvet-toned basso, he replied, "Why thank you, thank you very much."

He took a moment to look it over, then shot me a broad smile and said, "You know what? I'm going to give this to Nancy."

I can't remember why, but that afternoon I flashed back to *Kings Row,* a Reagan movie I'd seen as a kid. He played a guy who'd lost his legs in a freak accident—"Randy, Randy, where's the rest of me?"—but regained his youthful spirit and pride. After losing half of my own leg in 2010 over circulation problems due to a faulty ticker—and my mobility along with it—that story has acquired a relevance I'd be happy to live without.

For a self-reliant codger like me who has never expected or asked for help, it's a daunting position to find myself in. Where I was always ready to hop on a plane as a guest of whoever on whatever commission to wherever, I'm now at anchor like a barnacle-encrusted old vessel.

My condition reminds me of my stint at Hines Army Hospital in Chicago, when I was recovering from postwar fatigue. A group of us were shooting buckets when a contingent of wheelchair-bound vets swooped down on the basketball court. They were mean SOBs, pissed off and fighting for their turf. You cut those guys slack for what they sacrificed for their country, but you also stayed out of their way. I'm not any happier about my disability—but for the most part, I'm opting

for sportsmanlike decorum, and when I feel like biting someone's head off, I'll just pretend I'm Ronald Reagan in *Kings Row.*

While we're in Hollywood, let's return to the acquisitive '80s for a minute. We're at Chasen's in Beverly Hills, where headwaiter Tommy Gallagher performs nightly, cooking up Chasen's hobo steak tableside, with flaming fanfare. One night in '83, after a game at Dodger Stadium, a gang of us showed up with pitcher Jerry Reuss to celebrate his shutout that evening. The group was in high form when my wandering eyes zeroed in on two Tinseltown legends seated back-to-back at opposite tables—Orson Welles and Fred Astaire. Always quick on the draw, I did a panoramic sketch of the dining room, highlighting the contrasting pair, a study in mass and line. The sketch was snatched up by Maude Chasen, who didn't miss a trick, but I heard Tommy eventually got his mitts on it.

I love it when subjects turn up unexpectedly. One sunny Beverly Hills afternoon while lunching at the Bistro Garden, I was struck by a table of well-preserved Hollywood dowagers on the umbrella-shaded patio chatting and gossiping as they munched on salads in their designer hats and coiffed hair. No doubt they had buried or divorced a few well-heeled mates, and some perhaps still tolerated husbands distracted by power, fame, and the golf course. There could easily have been a well-preserved silent screen diva among them, like Norma Desmond in *Sunset Boulevard.* They didn't notice me as I sketched them, and I've often wondered if they ever spotted themselves in the silk screen above the Bistro's back bar or on the cover of the restaurant's menu.

The cult of celebrity has grown since I was a boy. I mean, everybody liked movie stars and sport stars back then, but now virtually every magazine has to have a celebrity on the cover. These people might be good actors or golfers or whatever, but they're not always that interesting as people. Beautiful women are another story. In my time I've hung around with plenty of knockouts, but I was never tempted to get on that merry-go-round.

When it comes to public figures, I look at the way they present themselves, what they do intentionally to enhance their image. Famous people are highly aware of how they look and want to be portrayed—they've worked on this living sculpture of themselves their entire careers. They know uncannily how they are going to look in photographs, on TV, in paintings. And as an artist you want to capture that. To me, how these people work a crowd in public is often more revealing than their private lives, because it telegraphs how they feel about themselves and want to be perceived. For me a good portrait needs to show not only what's seen, but also what's known.

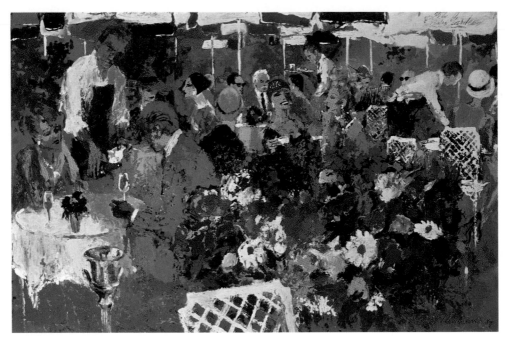

Bistro Garden *by LeRoy Neiman. Enamel and Acrylic on Board, 1987.* Author's Collection

So when you're dealing with someone who's always in the limelight, doing something fresh becomes a challenge. I've observed over the years that most in-the-spotlight people are reticent to make even superficial alterations to their appearance. Imagine Bill Clinton sporting a mustache, Michael Jordan with a rug, a bearded Mick Jagger, or an unbearded Pavarotti. Since the public knows what they look like, I want to try to find some unexpected slant, but at the same time, these characters are so conscious of how they look, should look, and (mostly) want to look, that catching an uncontrived, off-guard angle is tough.

In most cases I try to find some inherent dignity in their image, even if it's a little self-conscious, because if I went purely by the way the subject sees him or herself, vanity would be the overriding factor. I was once sketching the gracefully aging Max Factor at a nearby table at the Hotel Bel-Air, when he sent a waiter over to inform me, "Mr. Factor prefers not to be represented as a senior citizen." I could see how a realistic portrait of the purveyor of eternal youth might be compromising to his image.

After an interlude of Hollywood theatrics, it was time to fly back East and face New York's annual Rubber Chicken Circuit, a round of charity events where

sketching was a survival tactic in the face of endless mind-numbing speeches and lagging conversation—the women bare-shouldered, cleavaged, coutured, and sequined, and the men penguin-clad. If you were lucky, a real stunner would surface or some glimmer of arrogance, foolish vanity, or excitement might cross the face of a deadpan participant in these spectacles. That was always a windfall.

My problem is always from what vantage point to record these tedious affairs. When sketching a person around a dinner table, shoulder to shoulder, it can get awkward, people want to see what you're doing—and you're really too close to them to get any perspective. In contrast, sketching from a distance, you can get gesture and form and the setting, but you lack detail.

I like the role of detached observer, but it's not always possible. Painting people's portraits, you become a makeup artist, sometimes a plastic surgeon, sometimes an undertaker embalming your subject. The challenge of capturing the full range of human expression can lead to extremes. You can get models to express fear, laughter, sadness, joy, and anger, but some fanatics have gone over the edge in search of the elusive emotion. The eighteenth-century schizophrenic German sculptor, F. X. Messerschmidt, created dozens of busts as studies that ranged from weeping, grieving, yawning, obstinate, ill-humored, satirical, sinister, haggard, and hypocritical to "Just Rescued From Drowning." Culminating his oeuvre, he choked a model to death to reproduce the expression on the face of a dying girl.

Bill Clinton *by LeRoy Neiman. Enamel and Acrylic on Board, 2005.* Author's Collection

While I prefer that my subjects remain breathing, I'm not all that crazy about getting their feedback. Take the painting I did for Arnold Schwarzenegger back in '76. The full-length portrait of Mr. Olympia required two evening sessions at my studio, Arnold pumping, muscles bulging and popping in classic bodybuilders' poses. What I didn't know was that he was posing at artist Jamie Wyeth's studio at the same time. When I presented him the finished portrait, he said, "Mahv-el-ous!"—and then bought the Wyeth.

Arnold Schwarzenegger *by LeRoy Neiman.*
Ink on Paper, 1976. © LeRoy Neiman

But that wasn't the end of it. For years, whenever I ran into Arnold, he'd express fierce regret at not having bought the rendering. And still he'd never make an offer. Then one day he learned that TV writer/producer Glen Larson had picked it up for his Palm Springs pad. Now Arnold had to have it.

"I paid a good three times the original price for it," he complained to me after purchasing the piece. "I shouldn't have done daht."

To this day I don't know why he did. Was it because he wanted to look at himself hanging on his wall, or did he just want to snatch it away from an industry crony?

I like tough guys, and I guess they like me because a Hollywood tough guy, Sylvester Stallone, put me in the movies. The subject, boxing, was my own backyard. The part: an artist sketching a gym scene, and I was well versed in that. The movie: *Rocky II,* sequel to the film that put Sylvester Stallone on the map. Why I didn't get an Academy Award for playing myself I couldn't tell you, but it did win me a speaking part as ring announcer in the three *Rocky*'s that followed.

While I was hanging around the set of *Rocky III* waiting for my big on-camera moment, I got to know *Rocky*'s boxer vs. wrestler opponent, Terry Bollea, who in real life was eager to goose his journeyman wrestling career. Just as he hoped, he got the visibility he wanted, took advantage of the exposure, and went on to the World Wrestling Federation championship as Hulk Hogan.

Along with my role as ring announcer in *Rocky III,* I painted a portrait of Sly to be blown up on a twenty-four-foot canvas for one of the sets. The canvas was manually rolled up and down through a six-inch opening in the floor along the wall, so whatever area was being reproduced remained at eye level. This was old stuff to movie set artists, but the closest I'd come were those tarps of the bearded lady and the sword swallower I'd painted in my carnival days. It gave me a new respect for those Hollywood scene painters of the past who could render the Grand Canyon, a Mexican village, or the Shanghai waterfront—and did it so perfectly that no one even knew it had been painted. These artists went woefully unacknowledged.

Parts of *Rocky IV* were filmed in another place all too familiar to me, the MGM casino in Vegas. My command performance as ring announcer consisted of watching Rocky's former opponent-turned-friend, Apollo Creed (played by Carl Weathers), get pounded to death in the ring by a vicious Russian named Drago (Dolph Lundgren). From there the production relocated to Vancouver to shoot the prize fight in Moscow, where I painted a four-by-six-foot canvas, this time of the bloodied but triumphant Rocky standing over the vanquished Commie sprawled out on the edge of the ring's apron like a shipwrecked figure in Géricault's *The Raft of the Medusa* in the Louvre.

The fight was so brutal, I half-expected to read about it next morning in the *Vancouver Sun* and find a battered Stallone with a rearranged nose when I stopped by his dressing room. But with his fight makeup wiped off, Stallone didn't have a scratch on him. Hollywood illusion. It's a fantasy place, and I do my own version of that. I'm not a realist. Some may accuse me of putting too much gloss on reality, but as a kid I saw the playing field leveled by the Depression and I learned to neither glorify nor demonize—just take everybody at face value. All the same, I don't feel I need to emphasize people's flaws. The beautiful people and the scoundrels, they'll both have their day without my help. In the end, everybody reveals their own story.

1980, with Stallone on the set of Rocky III. Author's Collection

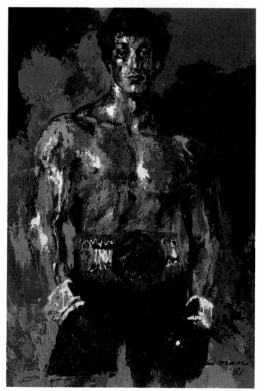

Rocky Balboa *by LeRoy Neiman. Enamel and Acrylic on Board, 1981.* © LeRoy Neiman

Rocky Balboa *by LeRoy Neiman. Ink and Sepia Pen on Paper, 1981.* © LeRoy Neiman

Stallone in Make-up *by LeRoy Neiman. Pen on Paper, 1985.* © LeRoy Neiman

I painted sports superstars, movie stars, and moguls, but the big-time gangsters, old-time pols, and high-rolling gamblers with their panache and daring provided equally inspiring subjects for the art I did of them.

And then there was Frank Costello. My spot in the press section at Madison Square Garden was conveniently located for observing the "Prime Minister of the Underworld" in his ringside seat. Costello was a movie gangster template, most notably George Raft's mobster persona. The "Man in Gray" was a regular at the fights and probably owned a piece of half the fighters. He'd sit there highly notice-able like a celebrity, his signature gray Borsalino resting on a camel's hair coat neatly folded in his lap, hair slicked straight back, piercing Bela Lugosi eyes, an Oval ciga-rette permanently poised between his manicured fingers. After testifying in front of the televised Senate Congressional Committee, he got a lifetime supply of those English cigarettes, and the smokes, not the FBI, eventually did him in.

I was deeply involved in drawing Costello one night at the Garden, when a hand clenched my shoulder. "Are you crazy, drawing Costello?" a voice hissed.

I turned around to see sports columnist Jimmy Cannon breathing heavily.

"You know you could get bumped off doing stuff like that, LeRoy. Hell, nobody even takes a picture of him!"

But I knew Costello was aware of what I was doing, even posing, so what was the problem?

A few weeks later, Teddy Brenner, "the Matchmaker," sidled up to me at a fight. "You know that drawin' yuh did of Costello? He wants it!"

I sized up the situation and lobbed, "I haven't got it on me, Teddy."

"Yeah, well, don't tell me yuh sold it, cuz Frank wants it."

"Then he'll have to pay for it, Teddy."

"Are yuh crazy, LeRoy? When Costello wants somethin', he wants it."

The cold-blooded killer was now reduced in my eyes to a common purchaser. I held out.

"Teddy, if he wants it, tell him it's for sale."

After the fight, we got a table at Abe's—Teddy, Costello, Abe's brother, Robbie Margolis, and me. Over drinks and espresso after dinner, Costello looked my way, and in his raspy, cancer-stricken voice, alluded politely to the portrait.

"The drawin' yah did . . ."

These guys don't talk a lot. I waited for a follow-up, but he left it at that. Hatchets never get buried with these guys though. As long as the subject was unresolved, I was ready for the other shoe to drop.

A few months after that dinner, it did. The issue was settled by the Big Boss when the heavy-smoking Costello was called to his maker. He was the last of his kind. The sketch remains NFS.

At an early Chicago Playboy Mansion party back in the days when Hef was still thrilled if celebrities showed up at his bashes, he pulled me aside to point out racketeer and gangland tsar, Mickey Cohen.

"LeRoy, you've got to meet the real thing!" he said, walking me over to introduce us. "He showed up flanked by bodyguards and has hugged the wall the whole night."

Hailing from the era of Jewish prizefighters, Mickey boasted headlining at the Chicago Stadium, so we talked boxing instead of hit men.

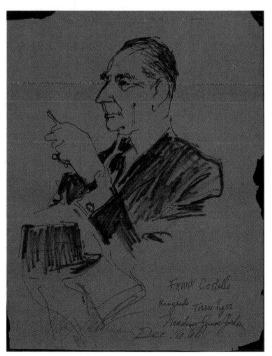

Frank Costello *by LeRoy Neiman. Black Marker on Paper, 1966.* Author's Collection

Like so many ex-pugs, he had that round, semi-flattened, puffy face and the constantly shifting eyes of a fighter in the ring. When I asked him why he was so low-profile at the party, he leaned in and said, "I never stand in the center of a room in public." Then, as if to clarify, he held his hands out to me. "Look at this! The Feds just raided my bungalow in L.A.! No watch, rings, cuff links. The bastards snatched all my jewelry! I feel goddamn naked!"

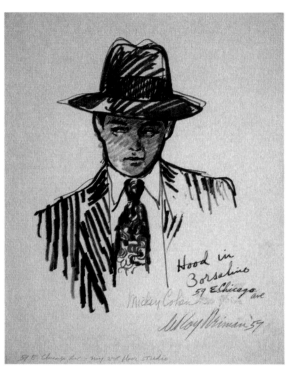

Mickey Cohen *by LeRoy Neiman.* ***Marker on Paper, 1957.***
Author's Collection

I made a drawing from memory of Mickey later that night, in a classic hit man fedora—another sketch hiding out somewhere in my warren of a studio.

❧

I'll concede that part of the excitement in being a gainful artist is the negotiation dance—coming to a price for an existing creation that's palatable to seller and buyer. Then there's the commission dance—settling on a price in advance that will measure up to the finished work. Over the years, I've learned that it's best for the artist to keep his own counsel, unless the advisor happens to be his mother.

My mother, Lydia, was a valued, if unwitting critic of my work and the only person I ever allowed to hang around my studio while I was working. Not that I encouraged it, but you just didn't kick her out. She assumed it was her right to be there, and, truth be told, I enjoyed her company. It was like having a parakeet in the studio, fluttering around day after day, making sure I was keeping busy. On her periodic visits from St. Paul, she'd show up in the studio every morning, chiming, "Well, what you going to paint today, kid?"

One morning I was working on a painting of O. J. Simpson. Training her keen eye on it, she challenged, "How much you getting for that?"

Somewhat evasively, I answered, "It's for Ralph Wilson, the owner of the Buffalo Bills."

"What does it matter who it's for?" she snapped. "How much you charging?"

It was easier to dodge Costello's goons than Lydia. I owned up to the price, a sizable sum in those days, and went back to work.

"Why that's chicken feed!" responded the woman who had skimped and budgeted every penny of her life.

I turned again from my easel to face her indomitable five-foot frame.

"It's just not enough, LeRoy!" she scolded. "Are you forgetting this painting is the only one of its kind ever?"

In light of what went down with O. J., I'd be curious to know what that painting would get today.

After Lydia had gone to bed one night, I took advantage of the stillness to work on a commission for the NFL. It was a commemorative portrait of a recently deceased coach, so I had to work from photographs. It looked good so I called it a night, laid it on the floor to dry about three in the morning, and hit the sack.

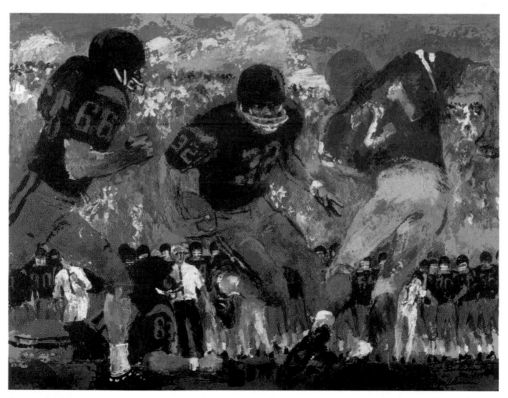

Crosstown Rivalry *(O.J. Simpson playing for USC)* **by LeRoy Neiman. Enamel and Acrylic on Board, 1987.**
© LeRoy Neiman

I was back at it bright and early the next morning when, like clockwork, Lydia burst into the studio. I waited for the customary critique. Not a peep. I watched her stand silently over the coach's portrait. She was frowning.

"When did you do this?" she asked.

"Last night, mother, after you went to bed," I said proudly.

"Did the man come over here that late?" she said, ever the skeptic.

"That would be a bit difficult," I said. "He died a couple of months ago. I painted him from photographs."

Lydia meditated on the painting at her feet, then released a long "Soooo! That's what's wrong with it!" her face brightening with relief. "It makes you feel like you're at a wake!" I waited for the inevitable explanation. "You know what I mean? It's like you're looking at the deceased all laid out there in the coffin and saying, 'Why, he looks just like he did when he was alive.' But you know he doesn't!"

She had come up with an interesting insight. Photographs are realistic but static, which is why I avoid using them as reference materials, unless acts of God dictate otherwise.

I had a curious experience painting a portrait of someone at death's door while living in London in the '60s. One night after the races, Janet and I had joined the Ascot crowd at Siegi's Club on Charles Street. I was perusing the room when Siegi approached, accompanied by an impeccably dressed Englishman.

"I saw your show at O'Hana Gallery," the gent said, but before I could say thank you, he came directly to the point. "You must do a portrait of my wife. No matter the cost." I didn't have to wait long for the catch. "The one stipulation is it must be done immediately. Time is of the essence," he said, a cloud passing across his face. "My wife is terminally ill. She may only have a week."

I looked over at Siegi, who solemnly nodded in confirmation.

"Well, I'm sorry, but I'm flying back to Paris tomorrow afternoon," I said, somewhat relieved I had a reason to excuse myself.

"In that case, my driver will collect you and your luggage at the hotel at nine a.m. promptly, and deliver you to Heathrow upon completing the portrait."

Next morning a Daimler was outside the Dorchester waiting to speed me to prime real estate in Connaught Square, where my anxious patron escorted me into a splendid sunbathed room. There lost among a heap of pillows on a silk chaise sat his wife. Her complexion was powdery pale, eyes sunken and dull, straggling wisps of hair clung to her gaunt face, a string of pearls traced her protruding collarbone,

and her frail figure was, wrapped shroudlike in a mink throw. She assumed a languid pose she doubtless intended me to paint.

Her husband squeezed her hand tenderly as he introduced me. Then, giving her a loving look, he said, "I'm sure I'll only be in the way here," and exited, leaving me to my own devices. I surveyed the room. The only suitable working surface was an ebony baby grand piano. I asked the hovering housekeeper for a bowl of water and a cloth to protect the piano, then spread out my brushes, pan of paints, Arches watercolor block, and Winsor Newton watercolors.

Everything was ready except the motivation. How to bring this withered spirit to life? My eyes darted about the room for inspiration—the Louis Quinze furniture, elaborate parquet floors, antique carpets, Venetian chandelier, then back to the piano. And there on the baby grand, among a collection of ornately framed photographs, was the lady as a vivacious young redhead of days gone by.

Brandishing my brushes, I began welding the youthful image with the mature, refined woman seated before me. I was adding the final strokes when her husband appeared. "I hope I'm not disturbing you," he said, approaching me.

I stepped aside to let him see the portrait. A stunned look came over him. He snatched it from the piano and brought it to his wife.

"Look my darling!"

At the sight of the woman smiling back at her all vim and vigor, she burst into tears. I left them gripped in each other's arms, a wad of ten pound notes in my pocket, and headed for the airport.

I heard nothing more of the incident until years later at Siegi's.

"Whatever happened to that widower you introduced me to?" I asked him one night, imagining the inconsolable man had eventually married his late wife's nurse.

"Funny you should ask, LeRoy, I just saw them several weeks ago," Siegi replied.

"Them?"

"Oh yes, they were in wonderful spirits. His wife staged a miraculous recovery, didn't I tell you? They're living it up in Marbella!"

I'll never know the full story. Had my watercolor suggested the promise of recovery? Or was it a couple playing out their private drama? I never found out and really don't care as long as everybody lived happily ever after, or at least got in a few more good years.

While we're on the subject, I want to add some words about Lydia before she passes into the beyond in this memoir. Along with her talents as an unforgiving

critic, my mother was no pushover with the gallery crowd. Once at an opening of mine at Hammer, I introduced her to Ernest Hemingway's widow, Mary, a collector of my work and contemporary of Lydia's. We were making the usual small talk when Lydia burst in with enthusiasm, "Say there, did LeRoy mention that your husband's name was Ernest?"

"Why yes," Mary responded, "Ernest Hemingway." Mother lit up.

"Well, my husband's name was Ernest!"

"How about that," Mary replied.

"My Ernest was an auto mechanic," my mother chatted on. "He owned his own garage for a time. And what did your husband do?"

Well into her eighties, you never knew when mother's devilish flapper streak would surface, like the night I took her to dinner in New York at Al Schacht's, a hangout for the sports cognoscenti to booze and chow. She was weighing in on my paintings displayed over the booths and back bar, when in walked Joe Torre, then the Atlanta Braves manager, with some of his coaches. He stopped at our table, I made introductions, and the group was seated nearby. Lydia and I returned to our usual chitchat, but as dinner progressed, I couldn't help but notice she was distracted.

Finally, over dessert I asked, "Mother, is something troubling you?"

She looked at me with a mixture of annoyance and titillation.

"You know that dark-haired man with the bedroom eyes who came by our table?"

"You mean Joe Torre?"

"That's the one!"

"What about him?"

"Did you notice he was coming on to me pretty strong when we were introduced?"

"Well, no, mother, to tell you the truth I didn't."

"Well," she continued, "can you believe that man has been making eyes at me through the whole dinner?"

I can't speak for Torre, but I'll wager it was Lydia playing the coquette.

Every life has a story to tell, and my mother never wanted to tell hers. When I'd ask about her days on the farm or running off with my dad, she'd say she had no recall of the past. Then she hit her eighties, and I started to get revealing letters. The girl with a grade school education wrote that she was ashamed of her life. The spunky, resourceful woman with three losers for husbands, who'd raised two boys to make their way in the world, thought she was a failure.

I last saw her twelve days before she died at eighty-two in '85. It was one of those bleak, bone-chilling March days that St. Paul pulls off so well. She acknowledged me like a cat, affectionately but with the coy, evasive demeanor of a woman who'd learned way back to keep her feelings guarded. Her slight frame was now further diminished, her gaze turned inward. She was drifting off into the past. I started to make an off-handed sketch, and she began to muse.

"My dancing days are over," she said wistfully. Then looking straight at me, the onetime flapper said, "My mother would have liked that. She always considered dancing evil, you know."

When Lydia died, the untold chapters of her life went with her. But what stayed with me was her fierce determination to make her own life for herself—no assistance from anyone, thank you—and have a good time doing it. Not surprisingly, the scrappy spirit who routinely flitted about my studio showed up about a week later for a bedside chat. I was padding around in the library-bedroom suite that overlooks my studio when I felt her palpably present in the room. Like those summer days on my visits home from art school when we'd chew the fat, the zestful, resolute Lydia was back.

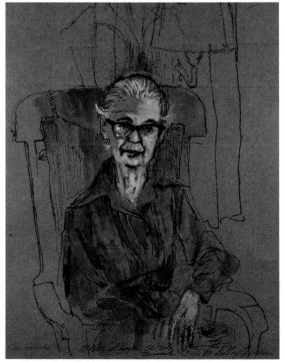

Lydia Hoelscher *by LeRoy Neiman. Acrylic, Watercolor, Pastel, and Marker on Paper, 1980.* Author's Collection

"You know, LeRoy," she said. "I just wish I hadn't always been so damn proud!"

I took it as a message for both of us.

Among the homeboy contingent who showed up at my mother's wake in St. Paul was Terrence Murphy, hard to miss in his monsignor's garb. We'd been grade school classmates before Terry decided to follow his calling and go into the seminary. I remembered him—fast, clever, and two-fisted—sparring in church-basement boxing. Terry was now president of the

University of St. Thomas and had volunteered to be the celebrant at my mother's funeral mass and gravesite burial.

Our paths had crossed previously on a visit to St. Paul when Terry had suggested the idea of my doing a mural for the college, at the time conveniently sidestepping any talk of money. Now he approached me with a firm offer and an irresistible proposal—that the mural could be in memoriam to my mother. The school would incur all costs, art students would be available as assistants, and at commencement, I would receive an honorary doctorate and give the keynote speech. I started the mural design.

Then an ill wind began to blow. A zealous graduate student started to stir up debate about my character. How could an upstanding Catholic institution like the University of St. Thomas consider a *Playboy* artist as a doctoral candidate? The student's parents added to the conflict, and the powers-that-be folded, including the good monsignor. I told them to get lost. So much for the old hometown.

Wait a minute! Half a dozen years later, a St. Paul business consortium approached me about a LeRoy Neiman Museum. Hadn't they put up a statue to another native son, F. Scott Fitzgerald, in Rice Park? So why not a LeRoy Neiman Museum? The idea was anointed by the city's mucky-mucks and supported by the *St. Paul Dispatch Pioneer Press.* What could go wrong? Again I took the bait.

A former women's club was selected to house the collection—not a good portent. All hell broke lose. This time there was real anger. A cabal of uptight citizens couldn't justify matching me up with their Saintly City. It was the *Playboy* artist stigma again, but I was over it. That was the last time I let St. Paul put me on a roasting spit.

And "*Playboy* Artist" wasn't my only claim to infamy. There was also that "Sports Artist" label I got saddled with early on—and I never shrank from that one either. But for me sports represented only part of my fascination with the world of play. Huizinga's *Homo Ludens,* exploring man's play in culture, has been my guide to life. Play is serious stuff, and sports is one facet of that play. Athletes performing at the height of their power have been a strong motivation in my art long before it became a multimedia industry and its stars were anointed mega-celebrity jocks.

I'm not even the diehard sports fan people take me for. For the most part I attended games and matches to fulfill commissions. Sure, I had my loyalties and favorites—my alma mater or home state, cities lived in or knocked around in—but other than that, who won or lost was of little importance to me.

What I was after was the athletic excellence, action, color, and drama. And having now sketched most of the great athletes for some sixty-plus years, I can say

that there are few areas in life where movement, beauty, grace, and the pure joy of energy are as visually expressed as in sports. That's what the ancient Greeks first saw, and that's what caught my interest and keeps it.

So did I get too deeply enmeshed in sports to the point where nobody could see me as anything but a recorder of athletic events? Casey Stengel neatly summed up my preoccupation with the scene a good forty years ago at Shea Stadium. Already beyond his prime as the New York Mets' manager—he was almost eighty at the time—he had dozed off, true to form, in the dugout during pregame practice. I was hanging around with Ron Swoboda and Ed Kranepool, when they launched into their habitual debate about who was going to wake him up. I had tuned them out when Ed turned to me and said, "Hey LeRoy, you're gonna do it!"

Reluctantly, I stepped down into the dugout and stood over the lightly snoring Stengel. Gently I shook the old man's shoulder. Slowly his lids lifted just enough to focus on me.

"LeRoy!" he said. "You draw pictures—I draw fans!"

I have a special attachment to the sports greats of my generation—DiMaggio, Mantle, Williams, and Musial, to name a few—because we essentially grew up together, developed our different talents as we went along. Back when I was a brash upstart showing off by drawing on my sketchpad at pregame batting practice, the players would often ask for my drawings. Their assumption was that what I did

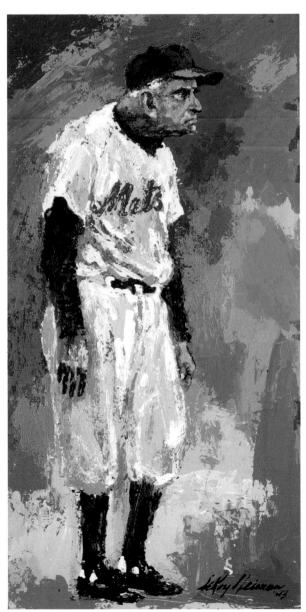

Casey Stengel *by LeRoy Neiman. Enamel and Acrylic on Board, 1993.* © LeRoy Neiman

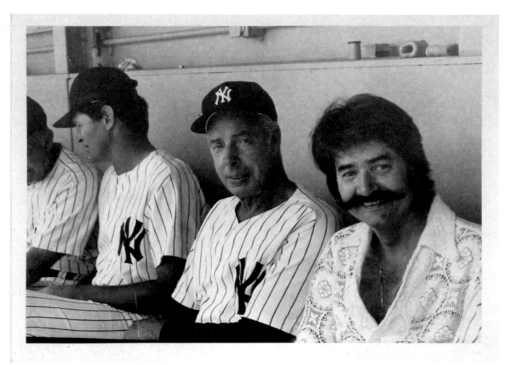

With DiMaggio in the Yankees dugout, 1975. Author's Collection

came easy, though it was no easier to knock off a quick sketch than it was for an infielder to scoop a hard-driven ball out of the dirt. But you just can't say that—and I must have given away dozens of drawings in the spirit of things.

As time has gone by, things have gotten more and more complicated. Enter the agent, and the once friendly swap became a business transaction. A commission to paint a leading athlete now involves the entire acronym alphabet—NFL, NBA, NHL, MLB, PGA, WBA—a tangle of red tape created by agents, team owners, commercial sponsors, contracts, reproduction rights, copyrights, and armies of lawyers. Too much monkey business!

I still have nostalgia for the one-on-one contact. Former stars, now retired, still call me up—they're sentimental about the drawings I did of them when they were at the top of their game. No negotiating, no nonsense. As recently as the late '80s, I could have a discussion about an official Michael Jordan painting (and the reproductions from it) with his mother, and it was all settled pretty much on the spot. Those days are no more.

Today's athletes are educated—they're world travelers, multimillionaires, and vain—it comes with the territory. For an artist looking for style, movement, and personality, vanity is actually a plus. Adding to the fun, players have become as persnickety about their looks as they are about their athleticism. Sometimes you have to be a plastic surgeon, sometimes a dentist. After I painted hockey star Bobby Clarke, captain of the Philadelphia Flyers, with his gap-toothed grin as he triumphantly raised the Stanley Cup overhead, he complained about the missing tooth. It took a white dab of the brush to placate him.

In one case an unflattering portrait became an inspiring remembrance of past failings. Back in the day when George Foreman knocked the crown off Joe Frazier's head and made short work of top contender Ken Norton, Foreman—with his trademark threatening frown—could be arrogant, nasty, and mean. Ali wiped some of that look off his face at Zaire in '74, and getting his lower teeth knocked through his lip (even though George won the brawl with Roy Lyle in '76) had a sobering effect.

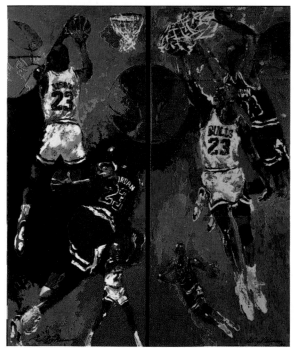

Michael Jordan Diptych *by LeRoy Neiman. Enamel and Acrylic, on Board. 1990.* Author's Collection

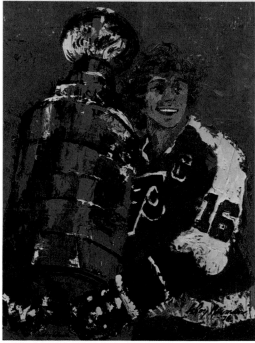

Bobby Clarke *by LeRoy Neiman. Enamel and Acrylic on Board, 1976.* © LeRoy Neiman

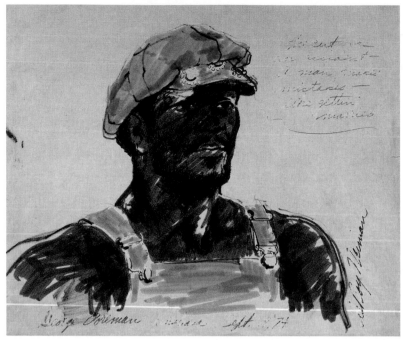

George Foreman *by LeRoy Neiman. Marker and Felt Pen on Paper, 1974.* © LeRoy Neiman

After he was out-boxed by Jimmy Young, George hung up his gloves in '77, later resurrecting his career after a ten-year hiatus at the age of thirty-eight. At age forty-five Foreman became the oldest boxer ever (at the time) to become heavy-weight boxing champion of the world when he knocked out Michael Moorer (age twenty-six) in November '94, and got back the title he'd held more than twenty years earlier. But who was this new guy that showed up, all smiles and pieties? The world knows about Foreman's religious conversion, but I'm hereby going to take some of the credit for his reformed cheery expression—and this isn't just my own theory, it comes from a conversation I had with him.

"Remember that sketch you did of me?" the now happy-go-lucky preacher asked me one night at the Garden. Not sure what he was getting at, I let Big George go the distance. "It was back in the '70s, LeRoy, remember? The Foreman Frown! I came upon it when I was getting my act together, took a look at that nasty face, and vowed to get rid of it for good!"

People love to rail about the corrupting influence of big money in sports, and you can certainly argue that moola has had its effects. But is it really just a contemporary phenomenon? A while back I came across a book my mother gave me on my

ninth birthday, *Babe Ruth, The Idol of the American Boy*. Want to know how the all-American hero was presented to kids in 1930? Here's a few chapter headings:

- Chapter One: "Ruth, the idol of the growing boy; stands out with new $80,000 contract, calling for larger salary than that of our President."
- Chapter Two: "Babe cites earnings of Dempsey and Sharkey to help justify growth of the $80,000 ball player."
- Chapter Three: "Ruth cost the Yankees $100,000 in cash, that is official; details of the deal with the Boston Red Sox."
- Chapter Four: "Babe safe from worry with $150,000 trust fund; Ty Cobb is lone millionaire of the player ranks."

Only after all this money talk to a bunch of woebegone Depression kids does the book finally get around to the Bambino's career and reputation as the "Home Run King."

For me a bigger question than monetary rewards is our idolization of sports stars. Sports halls of fame, which seem to be sprouting almost daily, have become shrines where fans pay homage to athletes—not through chapels and votaries—but through installations, films, and memorabilia. Photos, posters, and paintings of these stars are displayed with reverence formerly reserved for medieval saints—their achievements further embellished by association with art. Statues of these titans are erected in front of colossal stadiums not unlike how the ancient Greeks once displayed their Olympic heroes.

Will we next find these heroes on the public squares of cities where they've brought in championships and business? Will they replace monuments to generals and statesmen, poets and composers in our public parks? As worthy of tribute as these athletic leviathans are, how enriched will our culture be if we tap too heavily into role models from the ranks of sports? Then again, in today's celebrity-saturated culture, at least athletes work for their recognition through talent and discipline, instead of just showing up for the limelight. Even my favorite questionable personalities from the past earned their notoriety. Those canniest of rogues—slippery pols, dodgy tycoons, and outright hoodlums—at least stirred up our imaginations, even though their achievements are more dubious than virtuous.

Case in point: Back in '72 I was lunching with Carl Weinhardt, the director of the Indianapolis Museum of Art—prior to an exhibition of my paintings of the Olympic Games—when the conversation turned to local legends.

"As it happens," Weinhardt told me proudly, "the nineteenth-century poet, James Whitcomb Riley, author of the poem 'Little Orphan Annie,' is buried in the Crown Hill Cemetery right across the highway."

Always ready for a stroll in a cemetery, I said, "Let's take a look, Carl."

An enigmatic grin came over Weinhardt's face. "I think you'll find it well worth the trip, LeRoy—you're in for an interesting experience."

My curiosity now piqued, we headed across the highway, down a gentle slope, and through the heavenly gates of the cemetery. There it was, the monument to James Whitcomb Riley, a classic mausoleum, stern, dignified, and immaculate in white marble, a fitting honor to the revered Hoosier poet. Nothing unexpected here.

But my guide urged me past Riley's resting place. We descended farther along a well-beaten path, until we reached another headstone—or at least the remains of one. Its marker had been chipped and whittled away, leaving nothing but a jagged mound of granite. Weinhardt gazed at it reverently.

"That's John Dillinger's stone," he said. "Visitors are always hacking off chunks for souvenirs. The stone has had to be replaced more than a few times."

I gazed at the lovingly dismantled marker of Public Enemy Number One. It was about ready for another face-lift. How many of today's celebrities, in another half century, will be honored enough to inspire desecration such as this?

II
What's in a Name?

So, if I'm a storyteller, what's my story in a nutshell?

However critics, followers, or flatterers may choose to look at it, my art and my life have been a work of my own doing—a scrappy Depression kid with voracious curiosity, a dose of irreverence, a talent for drawing, and a knack for wrangling himself into places he didn't belong.

My sketchbook was my escape and my entrée. Uninhibited by authority and inured to criticism, I followed my own rules and drew what pleased me.

If my goal to connect with a wider audience led to my exclusion from the MoMA Rolodex, so be it. Didn't even the Renaissance masters like Dürer and Rembrandt market woodcuts and engravings to broaden their reach? I found my following, and they've never stopped knocking at my door.

If you want to marginalize me, do it. I love my margin. When I step back from the canvas and look at the world I've recorded, it's my life. It's a life that freed me to do the only thing that ever really mattered to me—to make pictures.

When I pull out a file drawer or open an old sketchbook, out pours a fantastic world— a nonstop spectacle that I observed with glee and took part in with relish. Carnival characters, mobsters, gangsters, presidents, premiers, moneyed moguls, jetsetters, Bunnies, sports

With my seventeenth-century Belgian tapestry in my New York City office, 1994. Author's Collection / Photo by Lynn Quayle

Dalmation *by LeRoy Neiman. Etching, 1980.* Author's Collection

Aboard the Big Bunny *by LeRoy Neiman. Felt Marker on Paper, 1970.* Author's Collection

legends, Olympians, movie stars, crooners, jazzmen, literati, bartenders, hookers, pool sharks, impresarios, high rollers, prima donnas, and ballerinas.

And that's just the two-legged creatures. Among the least domesticated or fetching of those I've had the honor to sketch is the feisty, suspicious, ambitious, and omnivorous warthog. Reputed to be the ugliest animal in the world, the noble warthog backs into his burrow rather than turning his back to the enemy, and then bolts out with ferocious confidence. I came nose-to-snout with this strutting, earth-rooting character in '94 during my second trip to Kenya. I'd made my first visit to the sweeping plains of Africa in '70 with Hugh Hefner and a collection of Playboy pals and Bunny hostesses aboard the Big Black Bunny plane. This time around we were traveling by puddle jumper and Hummer as guests of producer Robert Halmi, Sr. Our mission: to film a documentary on the safari as art.

My intent was to capture on canvas the lion, leopard, elephant, cape buffalo, and near-sighted rhino. I learned just how near-sighted a rhino can be while painting one near our camp on a six-by-twelve-foot canvas we'd hauled through the bush along with sixty acrylic and enamel cans of colors, watercolor tubes, pans, and painting paraphernalia. Like other bigheaded, vanity-prone subjects I've drawn, the rhino moved in for a closer look at what I was doing. When she'd got to within a few feet of my canvas, her jealous paramour circled in to make an appraisal. I stood stock still, wondering if this would be my swan song. Luckily, the two ambled off, leaving the painting to posterity.

Rhinoceros by LeRoy Neiman. Enamel and Acrylic on Board, 1994. © LeRoy Neiman

Warthog by LeRoy Neiman. Black Pen on African Map, 2002. © LeRoy Neiman

While doing these on-the-spot sketches of roly-poly sunbathing hippos, bickering monkeys, snorting and snacking baboons, aristocratic giraffes, dog-like cheetahs, big-hearted elephants, bleating zebras, and great silent herds of grazing cape buffalo, I thought about one of the things that always bothered me about nature documentaries: the need to show these proud and dignified creatures in constant copulation. Do we need wildlife photographers to satisfy our voyeuristic thrills? And do they ever show the spectacularly unattractive hyena or baleful jackal in assignation?

After gratuitous mating, my next least-favorite subject for nature documentaries is killing. You turn on an animal show, you think, "Here we go, we're in for some heart-warming scenes of adorable animals!" But in no time you get, "Unbeknownst to the grazing mother zebra, a hungry lioness spies her defenseless brood" Jeez! Sex and violence. There it is. Endless, hair-raising examples of wily creatures stalking unsuspecting prey. All we see is the bone-chilling kill, but in the jungle the kill is survival and every scrap is consumed. In Kenya we came upon the carrion of a previous night's supper—the lioness had fed her cubs, the hyenas had

Maasai Warriors *by LeRoy Neiman. Enamel and Acrylic on Canvas, 2002.* Author's Collection

Teddy Roosevelt *by LeRoy Neiman. Enamel and Acrylic on Canvas, 2009.* Author's Collection

stripped the carcass, and vultures had worked on the bones. Now it was left to the countless thousands of ants to clean up.

I was struck by the Maasai tribesmen—elegant, arrogant, aware of their good looks, a pure naturalness to their lean, graceful bodies. From generations of hunting and being hunted, they had the same dignified bearing as the animals—keen, alert, athletic—and in their innate sense of style, they saw no anachronism in adding a flash of Rolex to the native decoration.

The Maasai are supreme athletes. The lion may run faster, but the Maasai can run longer—a mile run is nothing to them. When Robert Halmi, our host, realized he'd left some camera equipment behind at his private airstrip about a mile from the compound, he asked his driver to go back for it while we waited. The man gave the Humvee a dubious glance.

"I'll be right back!" he said, sprinting off like a gazelle.

He returned minutes later like he'd had a walk in the park, lenses hanging from his wiry frame.

We climbed into a Cessna 407 and headed for Nairobi, where Bob put us up at the Norfolk. We toasted the day's adventure at a bar where Hemingway and Teddy Roosevelt had once wet their whistles, before sampling game du jour at the Carnivore Restaurant. Next day we visited the Natural History Museum, which was a dispiriting sight. Here were these once beautiful, formidable creatures—their teeth, claws, hooves, horns, and tusks now dusty exhibits. Their days of roaming free, mating with selection, scheming, and negotiating survival were now frozen in time. We left the primeval plains of Africa a few days later and returned to the United States via Paris and the Concorde. Back to fending off wildlife on the perilous streets of Manhattan.

And speaking of wildlife: At one time Salvador Dalí and I shared the same English publisher, and we'd gotten together on occasion—like the night of the Sutton Place soiree. It was one of those traffic-snarling New York blizzards that stops the city in its tracks. Dalí, his wife, Gala, my companion, and I crept across town in a limo in near whiteout conditions. We at last crunched to a halt in front of the apartment entrance, and waded through knee-high drifts toward the entrance where a blasé doorman indicated the direction of the elevator.

The elevator doors opened to a foyer filled with fashionably dressed guests surrendering their designer footwear and endangered pelts to a core of attendants. The three of us fell in line—but not Dalí. Without introduction, he tramped into the room in his unbuckled galoshes, leaving a deep soggy trail of footprints in the white pile carpeting as he squished past the astonished canapé-nibbling guests and flopped down on a silk settee.

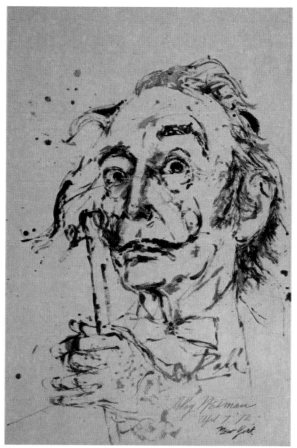

Salvador Dalí *by LeRoy Neiman. Sepia Ink on Paper, 1972.*
Author's Collection

Dalí beckoned me to join him.

"LeRoy, you must sit beside me. Let me tell you, if you possess great talent, you must be rhinocerosistic, the rhinoceros is the model of the artist. It is necessary to give a very hard kick to the right shin of the society that loves you. After that, they will always embrace you."

Throughout this tutorial, he sat erect, staring out at the room, unruffled, hands resting on his cane in a classic Dalí-esque pose, snow trickling down to a puddle at his feet. Soon our hostess fluttered over.

"So lovely to see you, Salvador! May we kindly assist you in removing your overshoes?"

Dalí's eyes flashed back at her. "You needn't bother," he replied. "I'll only be staying a few minutes."

He examined the crowd a while longer, then, raising himself from the couch, he signaled it was time to make an exit and headed for the door, leaving a slushy trail of footprints—unsigned—in his wake.

When it comes to an artist leaving his mark, it might be hard to top Jean Michel Basquiat's statement at a gathering at Mr. Chow's New York restaurant in the '80s. Michael Chow had cooked up a never-to-be-repeated gathering—artists now long gone, including Basquiat, Keith Haring, Robert Mapplethorpe, and Andy Warhol, along with many still standing, like Red Grooms, William Wegman, Alex Katz, and David Hockney.

Michael had collected us there for dinner to get everyone in sync for a follow-up group art instillation at Area—a happening disco near the Holland Tunnel frequented by leggy models and their wannabe boyfriends. We'd finally jockeyed for position around the table and settled down to a low roar when a sketchbook began circulating along with Chow's rarified Chinese fare. Evidently Michael was curious as to the kind of freehand spontaneous combustion he could get out of this crowd. Would we fall into a game of artists-up-manship? (Possibly.) Disdain? (Hypothetically.) Esprit de corps? (Unlikely.)

Some of us chose to play along, others were distracted by the art de cuisine—impeccably prepared and presented with the finesse Mr. Chow was known for from London to L.A. It must have inspired Basquiat, because when his mentor, Warhol, handed off the sketchbook to him, he laid it on the table, picked up his plate, smashed it down on the open pages, and slammed them shut around it. After the masterpiece had cooked a minute, he opened it, retrieved the food, and passed on his signature dish.

Switching from surreal to steamy, it's after midnight on a hot summer night in '81 at the late Elaine's legendary, East Side see-and-be-seen literati watering hole. Lee Majors and I consider ourselves peacocks on the loose after judging the Miss New York State beauty pageant. We grab a table and begin rehashing our evaluation of the candidates' physical assets. I'm just turning around to look for our elusive waiter when I notice an eccentric character at the next table in a Russian cap, all wrapped up in one of Elaine's checkered tablecloths. It's cold in this hotbed of literary chinwag because Elaine has the air-conditioning cranked up full blast.

As is my habit when something exceptional comes into my line of vision, I pull out a pen and make a sketch. My subject soon becomes aware that he is the focus of

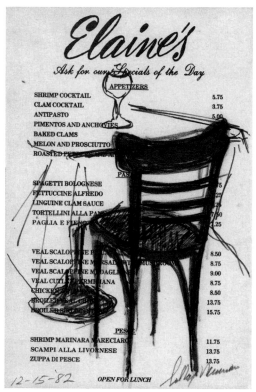

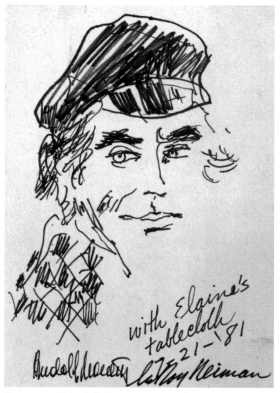

Elaine's Chair *by LeRoy Neiman. Marker on Elaine's Menu, 1982.* Author's Collection

Nureyev at Elaine's *by LeRoy Neiman. Black Marker on Paper, 1981.* Author's Collection

my work. He leans toward me and asks in a thick Russian accent, "May I see zat you have sketchit?"

I apply a few final touches and hand him the sketch, watching as he examines it.

"Ah yes!" he says like a tsar regarding his image. "You have caught the Tartar in me! You will zend a copy to my home tomorrow? Please!"

The next day I messengered a reproduction to Rudolf Nureyev at the Dakota.

Moving from steaming to sudsy, I have to confess to a loyalty to a particular afternoon soap opera that goes back to the honeymoon pad Janet and I shared, my makeshift Chicago studio. It was the advent of daytime soaps, and we became so hooked on the couch-smooching woebegones and connivers of *As The World Turns* that all meetings, errands, and deliveries were scheduled around it. When we returned from living abroad, we lost no time settling back into our afternoon rou-

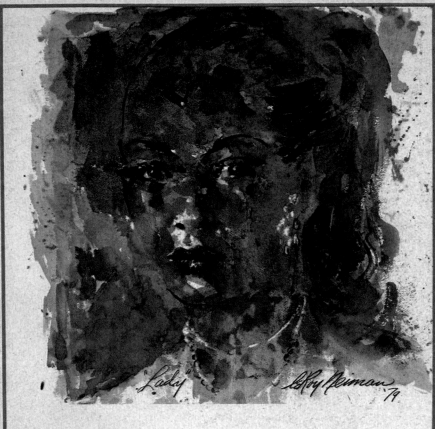

George Wein presents the twenty-sixth annual

NEWPORT JAZZ FESTIVAL
NEW YORK, SARATOGA

June 22 - July 1, 1979

1979 Newport Jazz Poster with my watercolor of Billie Holiday.
Courtesy of George Wein, Newport Jazz Festival®

tine—it was a guilty pleasure we soon found we shared with others. One day Andy Warhol confessed his anxiety about the imbroglio between Bob and Lisa. From then on we felt less guilty about our soap obsession.

One afternoon Dizzy Gillespie came by to sit for a painting for George Wein's Newport Jazz Festival. As I was prepping for the portrait, I asked him to get out his trumpet. He looked at me sheepishly.

"Well, wouldn't you know, LeRoy, I left the horn in Jersey!"

I was considering how to move forward when he said, "LeRoy, here's what we're gonna do." Pressing his forefinger and middle finger to his lips, he mimicked the signature Gillespie puffed-up cheeks. I knew I could improvise the trumpet, and we got down to it.

As we were finishing up, Janet poked her head into the studio.

"In case you want to know, LeRoy, *As The World Turns* is starting."

Diz lit up. "Hey, you two watch that show? I told my wife this morning she better fill me in on it when I get home!"

The session ended then and there. We all sat down to Janet's tuna fish sandwiches and watched the day's melodramatic intrigues. As the credits rolled at the end of the show, Diz took a seat at Janet's baby grand and treated us to a Mozart sonata.

Since we've gone longhair, I'll give you one more—Leopold Stokowski rehearsing his All American Youth Orchestra in shirt sleeves, his suit jacket carelessly flung over the back of his director's chair. At the time, he was over ninety years old, but during the entire two-hour rehearsal of the Mozart symphony, he never once sat down. I had settled in to sketch him when suddenly, in the second movement, he smacked his baton and called everyone to a halt.

"This is not Mahler's Ninth Symphony," he told them, "composed bitter and anguished when he was fifty. This is youthful! Joyous! Spirited! You must remember," he said, his eyes sweeping the room, "Mozart wrote this piece as a very young man! He was your age!"

He paused to take in the sudden silence. When it had sunk in that the eighteenth-century Mozart was once as young as they were, the music rolled along like a carriage rattling through the streets of Vienna.

When the rehearsal was over, the kids filed out, calling, "See you tomorrow night, Stokie."

He sat down at last and began to go over my drawings. The maestro was pleased, and slowly got to his feet. When I helped him on with his jacket, I couldn't help

Signing the Busker Alley *mural.* Author's Collection/Photo by Lynn Quayle

noticing that the fabric was shiny and neglected, its lining frayed, as time-worn and dignified as the wearer.

Despite my best efforts to run the show, my work has fallen prey to drownings, heists, divorces, Broadway busts, and acts of God.

Remember *Busker Alley,* the Tommy Tune tour de force on Broadway that closed before it opened? In early '97 producers Fran and Barry Weissler commissioned me to do a poster that would also run as a full page ad in the *New York Times* and appear on the façade of the St. James Theatre. It was invigorating to watch my image appear as a forty-foot mural on the Great White Way. Passersby stopped to kibitz and gawk as Tommy's elastic moves tap-danced across the yellow background.

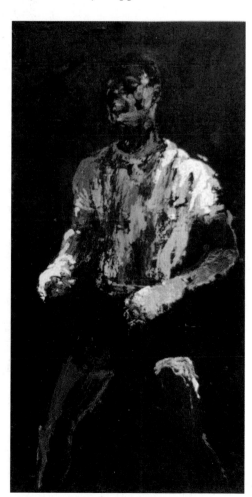

Then a week before the premiere, while the show was in out-of-town previews, word went out that Tommy broke his foot in a freak accident. Overnight the production was cancelled, the show was replaced by a revival of *A Funny Thing Happened On the Way To the Forum,* and my prancing Tommy Tune was erased with a coat of whitewash.

Here the disappearance of my art had been due to fate, feet, and *A Funny Thing,* but the next vanishing acts were cases worthy of Sherlock Holmes—or James Bond. My friend Charlie Feldman asked me to paint a gambling scene for the Bond spoof, *Casino Royale,* that he was producing. I painted the movie's cast on location in London—Peter Sellers, Woody Allen, David Niven, Ursula Andress, Joanna Pettet, and Orson Welles—all squeezed into a red casino. The film premiere on Broadway was a star-studded affair with my painting showcased on an easel at the entrance. Not for long. After the lobby cleared, a black hearse pulled up. Two solemn figures removed the five-by-three-and-a-half-foot canvas from the easel, put it into the back of the hearse, and disappeared into Times Square traffic.

More than a few of my paintings have been purloined in broad daylight. At Madison Square Garden's

Sugar Ray Robinson *by LeRoy Neiman. Oil on Board, mid-1950s.* © LeRoy Neiman

Farewell to Sugar Night, my eight-by-six-foot portrait of Sugar Ray Robinson was unveiled as part of the ceremonies. The next morning I called to arrange for the painting's return, but a U-Haul truck had beat me to it, backing up to the Garden's loading dock and making off with the goods.

A year into the opening of the Miami Playboy Club, a couple of keyholders snatched a five-by-four-foot oil of bikini-clad sunworshippers from the VIP room and scrammed out the main entrance, waiters in hot pursuit. They tossed it into a waiting Jag convertible and headed for the causeway, setting off a high-speed chase worthy of *Miami Vice*. The painting no doubt wound up in some bachelor pad. Still more pieces disappeared when clubs began to fold and syndicate owners just walked off with the art.

All of these and probably more still exist in some felon's lair. Worse yet were the Neimans cremated in a conflagration at the L.A. club—and the batch that went up in smoke along with a friend's marriage. A South Beach collector was parting from his wife of many years. Negotiations dragged on, getting uglier by the day. One night while calculating his losses, he had a premonition. The Neimans! He jumped into his Beemer and hightailed it over to his former spread on the beach to claim them. A silvery moon hung over Miami that night, but it wasn't to be an enchanted evening. Approaching the house, he saw flames lapping the night sky. He pulled up just in time to see the former light of his life heaving the last Neiman onto a bonfire.

Painting a new helicopter, 1981. Photo by Madeleine-Claude Jobrack

When you commission a portrait of you and your wife, you have to consider what will happen when things go awry. If you split, will you split the painting? I've endured the inevitable requests for creative erasure. When the marriage of Playboy Club entertainment director, Shelly Kasten, and his wife, Connie, folded, he asked me to paint her and the dog out of their portrait. I said no dice, which was just as well because soon afterward they got back together.

No painting of mine has taken a bigger dive than the one that got baptized in the East River. I'd painted a tiger on the fuselage of an NBC weather helicopter, an homage to the World War II Flying Tigers. After laying the groundwork at a US Marine air base, I finished it on the *Today Show* in front of a live audience in Central Park at Tavern on the Green. It flew weather missions over Manhattan for less than a month before it crashed into the East River. Salvaged intact, pilot and crew unharmed, the chopper was sold to a Seattle TV station, only to plunge into Puget Sound. Again it was fished out with no fatalities, and sold to a private party. So much for the friendly skies.

Of paintings that survived, there's always going to be requests from owners for occasional face-lifts. A couple of years after I painted Hef's brother Keith, he called from Aspen. The conversation went something like, "Hey, LeRoy!"

"Keith!"

"I grew a beard!"

"Keith!"

"Think you could add it to that fine portrait you did of me?"

"You grew it, Keith, you paint it!"

Dickens wouldn't be alarmed if he walked into Neiman Inc.—it's a nineteenth-century enterprise for the most part. My operation has run since hell knows when on a fax machine and one phone line—no call waiting—if the line's busy, we'll wait for you to call back. We graduated from rotary dial in the late '80s and finally capitulated to e-mail a few years ago. Some cell phones have been seen but not heard. The World Wide Web only recently invaded my studio, but its mysteries are kept from me for the most part.

Cars? Drivers? Limos? A New York car service or cabbie will suffice. Private jet? My talents as a freeloader have ensured gratis transportation to anywhere in the world I'm commissioned to go. I say leave the flying to them.

Time-shares? Yachts? Second homes? Janet and I considered a spot in Southern California once, but the prospect of pool maintenance and hedge-clipping seemed tedious. Besides, my idea of a weekend getaway is being able to work in the confines of my Manhattan studio on a Saturday afternoon when the phone's quiet and visitors are kept at bay.

When I moved to New York in '63, I set up my home and studio in a 1918 neo-Gothic affair near Lincoln Center. If my office is run along Victorian lines, the building where I live is medieval. There are dragons, griffins, and gargoyles crawling all over the place. A warren of loft apartments with cathedral ceilings, also

featuring an abandoned ballroom, and a semi-rehabilitated tiled swimming pool, it was originally conceived as a posh sanctuary for artist types. Previous tenants included Marcel Duchamp, Norman Rockwell, Noel Coward, Isadora Duncan, and Rudolph Valentino, and it's said they haunt the place. If so, I'm happy to have that crowd around instead of the pesky parade of publicists, managers, and dealers that have collected around artists today.

Keeping the whole operation glued together for the past thirty years, as point person, business assistant, studio manager, goodwill ambassador, and event photographer, is a committee of one—Lynn Quayle. I'll also add bodyguard to her curriculum vitae, since you haven't observed sweet Lynn in action until you've seen her swooping down on the memorabilia hawks who hover at my openings to cadge signatures. Then there's the wry Tara who handles things digital and archival that take place in hyperspace and in the multitudinous Neiman art vaults.

When I first met Lynn, in '80, she was a UPI stringer exported from the northern California mountains. It was at a Bob Guccione party in his East Sixties mansion filled with his impressive art collection and the crowd he hung out with—media types, the blue movie crowd, New York glitterati, and haute call girls. When Lynn's boss pointed me out as the artist LeRoy Neiman, she threaded her way through the Penthouse babes for an introduction. This petite Leslie Caron said she wanted to set up a meeting with me to talk about a commission for a Formula One poster.

We reconvened at an ossified Upper East Side Francophile restaurant, Le Perigord, on her tab. I had my own agenda; I wanted to recruit her into my business, which was growing fast. I was well into what I thought was a riveting presentation when Lynn broke in, "Oh look! That's Martha Graham over there!" Upstaged! But at least by a legend. I tore a page from Lynn's notepad and began sketching the Grande Dame of Modern Dance. That done, we returned to the business of me.

Lynn is a lifelong dance enthusiast—bordering on zealot—and at the time was taking classes at the Martha Graham Dance School. She set up a visit for me with Martha Graham at a company rehearsal. At the end of the session, I presented the half-dozen gouache drawings I'd made of her and her company. She examined each one carefully, as if she were reviewing the work of one of her students, and, as if instructing me, said, "It is good to sketch the dancers when they warm up and exercise. That's when they show their courage and their bravery."

Up until then I'd thought acts of bravery only happened in performance.

"What do you most like to see in your students onstage?" I asked.

"Beauty!" she said without hesitation. "Beauty is everything."

She was such a force of nature that I asked her, "Miss Graham, what fuels your energy?"

"Happiness!" she responded. "A sour mood is like an infectious disease. Unhappiness is contagious. If you are unwilling to smile, if you're unhappy, you do the world a favor and stay at home!"

The ever-cheerful Lynn is a supreme example of that, and happily for me, I've managed to keep her pirouetting around my irascible nature for nearly thirty years.

All of my studio assistants have been female—an eclectic group—and I've valued every one of them. My first aide-de-campe was Linda, aka Bonehead, a fiery Tex-Mex with suicidal tendencies. More on Linda later. Next came Pam, a masseuse and mime. Mary Lou was a writer who went on to become a published poet, playwright, and antiques dealer. Jennie, statuesque and intelligent, had been raised in Paris and didn't have much patience for my bluster. After leaving—some might say exiting my employ in righteous indignation—she ran a Village art gallery, then married a rock-and-roll musician/producer and settled in Santa Monica to rear a brood of kids. Then there was Patty, who camped out for a couple of years to edit my books and catalogs and work on this memoir. Not to be outdone, she stormed out too, until I lured her back to apply the finishing touches.

I'm not the easiest person to work for—I can be crabby as a coot. Even so, I've convinced myself that this alumnae have shown up annually for my female-only birthday party not only for the

Martha Graham *by LeRoy Neiman. Ink on Paper, undated.*
Author's Collection

champagne and caviar, but also because they harbor fond memories of my curmudgeonly charm.

Linda is the only one missing from these annual get-togethers, and the only one who has never looked back. Probably for the best, since her memories weren't all exactly nostalgic. I'd once barred her from the studio due to her wild antics. She appeared outside the door like a she-demon, announcing she had a can of turpentine and would engulf the place in flames if I didn't open up. I passed it off as an empty threat until I noticed the telltale smell and saw the acrid liquid seeping under the door. Then I heard the strike of a match. When Linda's monsters weren't in charge, few could resist her. She was vulnerable, yet feisty, utterly magnetic. Sinatra loved her, Budd Schulberg would talk to her for hours, and at the Ali camp she was a star. But finally even the stoically restrained Janet had enough when, after resorting to chasing her down the hall, the cornered Linda closed her chops down on Janet's finger. Biting the hand that feeds you is not recommended behavior, especially when it landed Janet at the doctor's office for a tetanus shot.

After a harrowing fifteen-year stint, Linda finally left New York for Houston, got religion, and started a new chapter in her life, becoming a registered nurse. She now works with terminally ill children.

While I've enjoyed playing the role of LeRoy Neiman to the hilt, the man behind the mustache has at times eluded me. When I was still a kid in peach fuzz, I painted a mustache on my upper lip hoping people (i.e., girls) would take me for Clark Gable. It was a boyhood aspiration that stuck with me well past the point when I should have realized it was a lost cause. Any illusion that there was a likeness between me and Clark Gable was quashed for good one evening at Wayne Newton's place in Las Vegas. I happened upon Gable's hat from *Gone With the Wind* in Wayne's collection of memorabilia. Putting on the fedora at a rakish angle, I swaggered over to a mirror. What I saw peering back at me in the gilt-framed reflection was humbling. The eyes were bird-like, the nose a chunk of putty, the minimal chin marred by a cleft. No wonder I've tricked out my LeRoy presentation with props—cigar, hat, handlebar mustache.

But can I be faulted for adding a degree of artifice when even my moniker was an improvisation? My father Charlie's lack of participation as a family man eliminated the need for my mother to maintain the Runquist name. When Jack Neiman came along, his patronymic came with him, like it or not.

It took my army boot camp drill sergeant to sort things out. At roll call he would always mispronounce my last name. I'd accepted Jack's "Neiman" as the

Clark Gable *by LeRoy Neiman. Charcoal and Watercolor on Paper, 1988.* © LeRoy Neiman

Deutsche-pronounced Nigh-man, but the sergeant kept calling me out as Knee-man. I must have corrected him a thousand times, but he kept it up and I kept on correcting him. Then one day I thought, why the hell not just be Knee-man? Anything to help erase memories of the luckless, taciturn stranger who had barely passed through my life. And that's the way it's been ever since.

After art school I briefly considered signing my name LeRoy Runquist-Neiman, but thousands upon thousands of signatures later, on serigraphs, posters, books, authographs, and memorabilia, I'm relieved I didn't succumb to a longer name. And since my brother never changed the pronunciation, nor did his daughters, Angela and Francesca, I remain the only Knee-man of the Nigh-man clan.

Now back to my mug. I've imposed myself into dozens of paintings, but rarely have I been inspired to paint my self-portrait. In '81, during a two-man show with Andy Warhol at the Los Angeles Institute of Contemporary Art, we tossed around the idea of a portrait swap, but Andy's condition that we pose nude didn't appeal. When he'd asked to photograph me in the past, I was never game either. And I'd already done enough sketches of him. One was in Tina Turner's dressing room at the Meadowlands, where I'd detected a similarity to Nureyev and

Willem de Kooning. Another was at the Factory, where I couldn't resist including his stuffed and mounted Great Dane, originally owned by Cecil B. DeMille. I never got around to Andy's live dachshund, Archie.

In '82 I agreed to a portrait exchange with Raphael Soyer. We worked at his studio in the West 70s, chewing the fat about art and rascal print publishers. Soyer carried on about his Russian heritage, his conversation sprinkled with offbeat remarks and non sequiturs. "Neiman!" he announced one afternoon while fiddling on my portrait. "I used to think I never blink when I'm painting myself—only stare—never blinking! Then I see a documentary on television where I am painting on camera—and blinking the whole time!"

Drawing Andy Warhol with Tina Turner, backstage at a Rolling Stones concert, 1981. Author's Collection/Photo by Maria Del Greco

Andy Warhol *by LeRoy Neiman. Marker on Paper, 1981 (drawn backstage at the Rolling Stones concert).* © LeRoy Neiman

Over lunch one day on Columbus Avenue, we were joined by a model who had posed in the nude for him—his favorite subject besides self-portraits was naked young women, often pregnant, poignant studies of nude girls who don't appear to be posing. Somehow we got on the subject of sex, and the girl who had modeled for him began to monopolize the conversation, methodically listing all the men she'd hopped in the sack with—by her tally they ran into the hundreds.

Finally Soyer broke in, "Why do you want to fuck so much? Only because you can?" Then he took her hand. "My dear, let me remind you of old Russian proverb," he said. "Man cannot jump above his prick!"

I was so familiar with Raphael's many self-portraits that I couldn't shake the images while painting him. In the end, my non-blinking Soyer likeness looked so much like

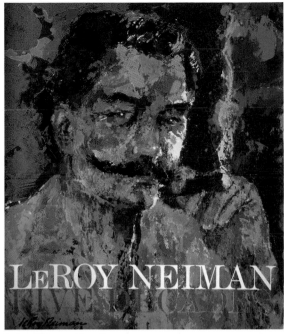

LeRoy Neiman, **Five Decades** *cover.* Author's Collection

one of his own, he insisted I write a qualifier on the drawing stating that it was done by my hand. As for Soyer's Neiman, he refused to show it to me, the bastard.

Finally, in my seventy-seventh year, I got a request from *POV* magazine for a portrait of myself at age twenty-five—now that intrigued me! With a mixture of enthusiasm and curiosity, I threw myself into my retro self-portrait, which then inspired me to paint an updated mug for the cover of *LeRoy Neiman, Five Decades*. With my age accumulating and the infrastructure disintegrating, I decided it was time to heed Martha Graham's words, "Vanity is everything."

Still, it's always been easier for me to spot it in others. I'm a noticer—relentlessly looking at others, observing their quirks and tics, assets and amenities, foibles and fetishes. It's been trickier looking inward. I wonder if in the long run I've become an enigma to myself.

Even more curious is the old character who's been peeking out from my paintings these fifty-odd years. I remember the first time he appeared, snappily dressed, looking wryly out at me as if to say, "And who are you exactly?" Ever on the lookout for images as reference for my paintings, back in the '60s in Paris I'd clipped out the

photo of a man who caught my eye in an issue of *Paris Match*. He was a Monet-type gent, white-bearded, slightly bent, dressed in black, with a fine walking stick. Every few years I'd insert him into a painting—promenading along the pier at Monte Carlo, on the beaches of Cannes and Waikiki, as a flaneur on the Champs-Élysées and the Boulevard St. Germain, among the crowd at the Kentucky Derby, or at the fights. He got around.

The fact that his doppelgänger, the white-bearded Claude Monet, had lived valiantly in Giverny, eyesight failing, prolific until his death in 1925 at age eighty-six, added a fondness and familiarity. Occasionally a buyer would spy my character when purchasing a print, but mostly he was my private amusement—a somewhat eccentric and dashing loner, content with his place in the crowd inhabiting my work. Then, on my eighty-fourth birthday in 2005, it suddenly dawned on me. In one way or another, this indomitable old crony had been me all along.

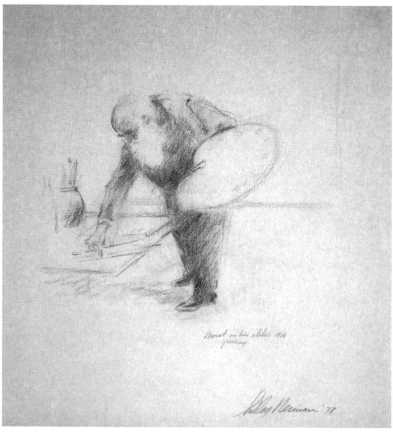

Monet in his Atelier *by LeRoy Neiman. Graphite on Paper, 1977.* Author's Collection

Summary of an Old-Timer

I painted things as I saw them, and that's how I've written my life. I was a noticer. Noticing is what exhilarated me. A product of my beginnings, I was consistent in my curiosities. The vibrant and roisterous scenarios of man at play that I was drawn to were more real and raw and genuine, even in their artifice, than the world of abstract conceits.

Critical appraisal, or should I say the lack of appraisal, has been a monkey on my back. But I wouldn't do battle. I didn't have time. My work was contagious. I had a code—a way of making and responding to my own rules. It gave me the right to break them when I wanted to.

Did it ever break me? When a hometown museum was asked why the local boy who made good was not in their permanent collection, the response was, "You can't have it all. He's got enough." Well I'd had enough of that. Collectively they knew it all, but I created me.

After a long run the engine is slowing down, but the phone still rings daily: a call for a commission on the other side of the world, a fan reporting that his daughter whom I painted as a baby is getting married, an innkeeper in Normandy wondering why I don't recollect my stay there twenty years ago, an athlete passing through town who wants to chew the fat and pick up another sketch for his collection.

I wouldn't have it any other way. While I wasn't accepted in some art circles, I was embraced by a public more loyal than anything I knew growing up. And if I could choose to take anyone with me, I'd choose them hands down. You, reader. I hope you've enjoyed this odyssey as much as I have.

Acknowledgments

A book on a life requires a lifetime of people to thank. Even with my fondness for running the show, since I've been penning this memoir for a good twenty years, I'm grateful to a few others for their help in keeping it, and me, honest and on track.

Credit goes to Hilary Volkman, Isabelle Balot, and Liz Gill Neilson for deciphering my scrawled script and bringing order to the chaos of my archives. David Dalton embellished the developing narrative. And Tara Zabor negotiated a warren of dusty storage rooms to excavate arcane sketches, photographs, clippings, and keepsakes, all the while seeing to the care and feeding of my website.

Patty Otis Abel answered the call not once but twice to work by my side, helping me shape this story and express it in my voice. Her dogged insistence to develop a proposal and round up a literary agent when I lured her back the second time around is a big reason this book is in your hands today.

The tenacious sleuthing of Steven Bond, loyal keeper of the books and the Neiman flame, brought agent Steve Ross of Abrams Artists Agency onboard. Steve deftly identified Lyons Press as the publisher who would go the extra mile to produce an artful memoir. Keith Wallman, my canny and patient editor at Lyons Press, exhibited an immediate instinct for maintaining the tone of this book and my narration throughout the machinations of production and promotion.

As ever, Lynn Quayle brought her unflinching dedication to this endeavor. When things started slowing down on my end, she picked up the slack through the rigors of editing, fact checking, and legal minefields, while keeping everything else, including me, running like a top. The many photographs that she has captured over the years grace this book as none others could have.

Finally, it is nearly impossible to properly and fully thank my wife, Janet, for believing in me from day one and putting up with me for all the days that followed. Her contributions to these pages are fifty years' worth and still counting.

I also want to acknowledge the friends who are no longer around to read, and most likely grouse over, my tribute to their place in my life. Top of the list is my partner-in-crime, Shel Silverstein, who died way before we had a chance to perfect the art of horsing around. Angelo Dundee checked up on me regularly during my own physical challenges before his death in 2012. Joe Frazier's autographs on the fight posters at my studio entrance are a daily reminder of those heady times doing battle against Ali. And lastly, a nod to my mother Lydia, who I know is out there somewhere dancing for me.

Index

About the Author

LeRoy Neiman has married fine art to popular art with his brilliantly colored, energetic depictions of sports, celebrities, America at play, life on safari, and famous locations. Born in St. Paul, Minnesota, he left high school in 1942 to join the US Army, returning four years later to obtain his high school degree. He then studied at the School of the Art Institute of Chicago (where he also taught for ten years), the University of Chicago, and the University of Illinois. Early in the 1950s he did fashion illustration for the department store of Carson, Pirie, Scott & Co., where he met *Playboy* founder Hugh Hefner in 1953. In the sixties, he moved to Europe and set up studios in London and Paris. He now lives in New York City, overlooking Central Park, where he keeps his studio, offices, archives, and penthouse.